For years I had wondered who Georgia O'Keeffe really was. O'Keeffe's secrets were not easily divined. So many people have idolized her that the real person has been clouded by the polite reverence of the worshipful. Mysterious, rugged, insular—during my grandmother's time, O'Keeffe had become not only America's favorite woman artist, but an icon of feminine self-reliance, a square shooter who survived by herself in the far reaches of New Mexico. "It's like an ailment," the artist once said of her need to be alone in the desert. "It's so far away and nobody ever comes."

O'Keeffe's isolation had reached obsessive proportions long before I met her. Destroying her correspondence with friends as well as her own paintings, she said that family members who talked about her were liars, and she had attempted to block others from writing about her in any form at all. In her autobiography, a slim volume of polished comments, she wrote, "Where I was born, and where and how I have lived, is unimportant."

—FROM *O'Keeffe: The Life of an American Legend*

ALSO BY JEFFREY HOGREFE

Wholly Unacceptable: The Bitter Battle for Sotheby's

O'KEEFFE

The Life
of an American Legend

JEFFREY HOGREFE

BANTAM BOOKS

New York Toronto London Sydney Auckland

This edition contains the complete text
of the original hardcover edition.
NOT ONE WORD HAS BEEN OMITTED.

O'KEEFFE: THE LIFE OF AN AMERICAN LEGEND
A Bantam Book

PUBLISHING HISTORY
Bantam hardcover edition published September 1992
Bantam paperback edition published February 1994
Bantam trade paperback edition / December 1999

Bantam Books are published by Bantam Books, a division of Random House, Inc. Its
trademark, consisting of the words "Bantam Books" and the portrayal of a rooster, is
Registered in U.S. Patent and Trademark Office and in other countries. Marca
Registrada. Bantam Books, 1540 Broadway, New York, New York 10036.

PRINTED IN THE UNITED STATES OF AMERICA

FFG 10 9 8 7 6 5 4 3 2 1

In memory of Luis Sanjurjo

Contents

· · · · · · · · · · · · · ·

Preface

· · · · · · · · · · · · · ·

For years I had wondered who Georgia O'Keeffe really was. I first spotted her stepping out of an old black Mercedes-Benz at a friend's parents' farm in the New Jersey horse country. It was spring in the early 1980s. With her weathered face, steely hair trained into a bun, and a long black gown, she looked like a silvery shadow from an old faded daguerreotype as she walked serenely into the gathering. The impression was timelessness. I spoke to her as soon as I could. I told her I had visited—and enjoyed—New Mexico, her home. She asked what I liked about the place. I said the sky, and she sort of smiled. Ansel Adams once observed that when Georgia O'Keeffe smiled, "the entire earth cracked open." It was a smile that said she knew something I did not, at once obvious and occult. She seemed potent and alive in her shriveled and shrunken body—a spirit that refused to let go of its shell.

O'Keeffe's secrets were not easily divined. So many people have idolized her that the real person has been clouded by the polite reverence of the worshipful. Mysterious, rugged, insular—during my grandmother's time, O'Keeffe had become not only America's favorite woman artist but an icon of feminine self-reliance, a square shooter who survived by herself in the far reaches of New Mexico. "It's like an ailment," the artist once said of her need to be alone in the desert. "It's so far away and nobody ever comes." O'Keeffe's isolation had reached obsessive proportions long before I met her. Destroying her correspondence with friends as well as her own paintings, she said that family members who

talked about her were liars, and she had attempted to block others from writing about her in any form at all. In her autobiography, a slim volume of polished comments, she wrote, "Where I was born, and where and how I have lived is unimportant."

Finding out where O'Keeffe was born and where and how she lived has not always been easy. Her family were not writing people or record-keepers, and the artist herself once declared, "Words and I are not friends." In fact, she placed more than three thousand letters between herself and Stieglitz under restriction in the Beinecke Rare Book and Manuscript Library at Yale. Tracing the trail of her life took me across America and through the archives of schools, libraries, and museums in twelve states and the District of Columbia. O'Keeffe was not always nice to people, and she wasn't always truthful, but her story poses big, important questions: How did a mad schoolteacher from the Texas Panhandle become the best-known American woman artist of this century? What connected her madness to her art? Was she a lesbian? What connected her sexuality to her art? From what was she running? What were her inner sources of strength? Hers was more than a basic story of overcoming adversity. There was something I had to get at, some clue as to why her art appealed to people who did not like art, and why her female strength did not threaten even the most chauvinistic males. O'Keeffe was a legend.

Fortunately, not only did I meet the artist herself, but several of her closest friends agreed to help me piece her life together. Juan Hamilton, who cared for her during her last fourteen years, along with his wife, Anna Marie, invited me into their homes and revealed what it was like to live and work with the world-famous artist. Although Hamilton eventually had second thoughts about the information he had shared with me and made it hard for me to learn more, for more than a year he assisted me in many ways—and I am eternally thankful to him for all his time and energy.

From our first meeting, in the New York restaurant Le Cirque on February 21, 1986, Hamilton introduced me to a reservoir of personal sources of information, showed me places where the artist had worked and played, supplied me with countless anecdotes, allowed me to accompany him on business trips to museums to oversee installations of her work, and on several occasions invited me to dinner with his family in their stark mountaintop adobe house in Abiquiu, New Mexico. He even rented a house to me so that I could work in New Mexico.

This is not, however, in any sense Hamilton's book. The artist's friend has not participated in—or even known about—the vast bulk of the arduous and time-consuming research that has gone into this book; nor has he reviewed— or even seen—the manuscript. However, his early assistance was invaluable, as it provided an intimate look into the inner workings of the artist's household and her private relationships.

So many other people have helped me learn about O'Keeffe that it would be impossible to mention all of them by name. To Robert Miller, the art dealer who was closest to O'Keeffe on her death in 1986—and who introduced me to the artist and gave me countless hours of time, assistance, and encouragement—I am forever grateful. I would also like to remember the late Luis Sanjurjo, a friend, who as an International Creative Management agent guided me through the early stages of this project and, when I did not want to, told me "Keep writing, darling." I would like to also extend my appreciation to Lynn Nesbit, who graciously took over when Sanjurjo could no longer work and placed this book in the enormously supportive hands of Steve Rubin at Bantam Books. To the rest of the staff at ICM—Binky Urban, and especially Kristine Dahl, who has shepherded this book on the rough road home—many, many thanks. I would also like to thank the staff of Bantam Books, particularly Rob Weisbach, whose thoughtful editing helped this book enormously, as well as copyeditor Janet Biehl. Most of all, I would like to thank Deborah Futter, Senior Editor at

Bantam, a rare and exceptional editor, about whom authors normally only read. Deb's deep reserve of patience, unwavering faith, and steady guidance over five years of work has provided a solid foundation upon which this book rests.

I would also like to thank all the relatives of Georgia O'Keeffe who helped me. Her nieces, June O'Keeffe Sebring and Catherine Krueger, and her nephew, Raymond Krueger, gave their time generously and told me practically everything they knew about her. I would also like to thank those people who worked for O'Keeffe, particularly Agapita Lopez, her secretary and friend, and Elizabeth Glassman, president of the Georgia O'Keeffe Foundation.

Of the many friends and acquaintances of the artist's who gave me their time and insights, I would especially like to thank Betsy Wittenborn Miller, Esther Underwood Johnson, Gretchen Johnson, James Johnson, Jennifer Johnson Duke, Harry Lunn, Carter Brown, Phoebe Pack, Eliot Porter, Louise Trigg, Virginia Christianson, Ashton Hawkins, Ford Ruthling, Theo Raven, Joni Mitchell, Jerry Richardson, Gerald Peters, Bruce Weber, Maria Chabot, John Cheim, Howard Read, Richard Pritzlaff, the late Frances Steloff, Andreas Brown, and the staff of the Gotham Book Mart. I would like to thank the many people in New Mexico who made my stay enjoyable and who gave me insights into the unique character of the people of the state, especially Gordon Miller, Miranda Levy, Natalie Schram, Charles Stockly, David Scot-Melville, Robin Laughlin, Joan Baker, and Sarah Moody.

I would also like to thank the following museums which opened their collections and libraries to me: the Whitney Museum of American Art, the National Gallery of Art, the Philadelphia Museum of Art, the Boston Museum of Fine Arts, the Metropolitan Museum of Art, the Museum of Modern Art, the Cleveland Museum of Art, the Chicago Art Institute, and the Museum of New Mexico, as well as the staffs of the Robert Miller Gallery in New York and the Gerald Peters Gallery in Santa Fe. Also, I would like to thank the Art Students League, Chatham Hall, the University of Virginia, and Columbia University for their assistance.

For the thankless job of photocopying the correspondence of Georgia O'Keeffe, I am forever indebted to the assistance of the Beinecke Rare Book and Manuscript Library at Yale University, the Center for Creative Photography at the University of Arizona, the Newberry Library in Chicago, the Archives of American Art in Washington, the Berg Collection, and the Mitchell Kennerley Papers at the New York Public Library. I would also like to thank the staffs of the Sun Prairie Historical Society and the Wisconsin Historical Society, as well as the Amarillo Art Association, in addition to the Carl Van Vechten Collection at Fisk University in Nashville.

Biographies are made possible only by hundreds of hours of painstaking sorting and filing of information. I am eternally grateful to Keith Easthouse, Joan Brown, Gary Grimm, and Rose Bell for doing just that; and to Scott Adams, the Computer Man of Santa Fe, who, when I thought the computer was possessed by demons, let me know in the gentlest possible way that a machine does only what it is told to do. Beth Rashbaum, who read the first draft of the manuscript and encouraged me to go on with the project and make the whole book as good as some of the parts, deserves a special thanks; so does Nathan Kernan, a valued friend and careful reader, whose comments on the second draft were invaluable. I would also like to thank my many other friends, especially Ann Biderman, Peter Simmons, Judith Auchincloss, and Frank Rose, who listened to me talk about Georgia O'Keeffe for five years without cease.

The work of a biographer is increasingly a legal quagmire. For helping me through the morass, I would like to especially thank Jerry Chasen, of Chasen & Lichter in Santa Fe, Lauren Field, of Bantam Books, Arthur Lofton of Santa Fe, and Eric Roper, of Roper and Barandes in New York.

I would especially like to remember my mother, Jacqueline Fullen Hogrefe, who died in 1988 while I was beginning to work on this book. A fan of Georgia O'Keeffe and an artist herself, Mother would have been proud of the outcome of this book had she lived to see its completion. And last

but not least, to the rest of my family—to my father, Joseph, stepmother, Jean, brothers, Mark and Scott, sister, Andrea Sala, and their partners—many, many thanks.

A note on punctuation: In her letters, Georgia O'Keeffe did not follow standard punctuation, nor did she spell many English words correctly. For the sake of verisimilitude, I have not corrected her grammar or her spelling.

"Making your unknown known is the important thing."

.

Prologue

.

I n the spring of 1973 a hapless young wanderer with hair down his back and only memories in his pockets arrived in a remote outpost on New Mexico's high desert. He told people he had been sent there, clear across the continent, by a spirit. He was not embarrassed to say so. Most of the residents of Abiquiu were not put off by John Bruce Hamilton—better known as Juan—and his other worlds. Isolated by high mountains and wide arid plains, in remote parts of New Mexico—like Abiquiu—natives occupied virtually the same sphere as their eighteenth-century Spanish forebears. It was believed that witches cast spells and snakes flew in the night. Grown men beat themselves with whips made of cactus barbs in the name of religion.

Being driven across the continent by a spirit was as commonplace as long sunsets and fantastic landforms in Abiquiu—a small place in a big land, peopled with a few hundred natives of a unique mixture of Arab, Basque, Spanish, and American Indian blood and consisting of a saloon with a swinging door, a one-room general store complete with saddles and tack, a collection of flat-roofed buildings made out of red mud, a large Catholic church—and an old white woman who lived by herself behind a high wall. Though some called her a *bruja,* or witch, she called herself an artist.

Having turned in conventional clothes for patched jeans, faded flannel shirts, a three-day-old beard, a bushy moustache, and a VW van coated with road dust, twenty-six-year-old Juan Hamilton looked like a troubadour or a gypsy

or a hippie—depending on your point of view. Sometimes he wore his brown hair braided in a long Chinese-style pigtail. Sometimes his hair cascaded across his shoulders and down his back freely. A tall man, slender and long-waisted, he had a way of walking that suggested there was no rush. He slunk. He used his brown eyes to good effect, either narrowing them to a squint to indicate displeasure or opening them wide like a puppy dog to please. Words left his mouth softly in a twang, like that of a lugubrious country and western singer. Some women found him sexy. Some men found him ornery. He liked to laugh.

Hamilton had driven thousands of miles across America to find and care for Georgia Totto O'Keeffe, an eighty-five-year-old artist whose impact on American culture was so enormous that no one was certain what to make of her—least of all, how to care for her. Hamilton believed he did. Something had told him he might find a place in her life. A spirit had taken hold of him. It compelled him to move into the unknown. It drove him across the continent and into what looked like a biblical firmament. "I believed," he said, "that maybe she was alone and needed a friend."

Successful beyond the dreams of most women and men, O'Keeffe operated a feudal empire in a vast desert valley. Seemingly fortified behind high adobe walls and across miles of cactus-covered plain, the artist was not exactly well situated to welcome strangers into her world. Over the years she had carefully trained people to accept her imperious ways and to do things as she wished to support the myth of who she was. Once O'Keeffe complained that she had to put up with a person who cared for her "her way," because she did not have time to train her "in mine." Even as a young girl, long before she achieved success, O'Keeffe had felt she could control others by using what she considered her special powers of persuasion. "When so few people ever think at all," she asked a friend, with remarkable cynicism for a fourteen-year-old, "isn't it all right for me to think for them and get them to do what I want?"

With the aid of a large staff and faithful companions, she

got people to do what she wanted and had arranged her life so that, between two houses some twenty miles apart, she could enjoy various desert landscapes from which she drew the subjects for most of her paintings. From one house, the sun rose in the morning over a verdant river valley; from another, the sun went down across bizarre land formations. O'Keeffe was enthralled by the desert. She referred to it romantically as if it were a make-believe place, and in some ways it was. She called it "The Faraway," "the end of the earth," or "mad country." "It is really absurd in a way," she wrote, "to just love country as I love this—."

In the twenties, as the first woman artist to excel in America alongside men, O'Keeffe became, for legions of women who had recently acquired the right to vote, "a religion," according to her late husband and guiding light, photographer and art impresario Alfred Stieglitz. The union between these two artists became the stuff of legend, but O'Keeffe's own fame came to exceed that of her already famous husband. Her sexually charged paintings of large flowers, in which people saw both male and female genitalia, attracted hordes of fans who sought her presence as if she were a movie star. She retreated to Abiquiu, where she found the solitude she desired as the only Anglo woman in a tiny village of fierce Spanish-speaking natives. "My pleasant disposition," she once remarked, "likes the world with nobody in it."

The myth of Georgia O'Keeffe grew in proportion to her isolation. Five decades later, occupying a "world with nobody in it" in her own Shangri-la, she still held America's imagination in her spell. As an octogenarian recluse who rarely ventured beyond the open space of Abiquiu, the artist attracted a new generation of disciples who wanted to be near her and know her, as if she were the Oracle of Delphi or the Dalai Lama. Unlike her initial following, which had been primarily female and largely urban, these pilgrims were both male and female, urban and rural, and sometimes were sorely misinformed about who the artist was. But for them, who she was was not as important as what she stood for.

Garbed in long black dresses like a nineteenth-century widow, veiled like a nun, growing her own produce in a harsh desert—a person of the earth—she symbolized bravery at a time when many felt compelled to live outside civilization, a period marred by America's invasion of Vietnam.

A conscientious objector to the Vietnam War, John Bruce Hamilton was born during the post–World War II baby boom, in Dallas, Texas, on December 23, 1946, the first and last child of his parents' marriage. He was raised in South America and New Jersey in a strict religious atmosphere. Allen, his father, a tall Texan with a slow drawl and quick temper, was a missionary who developed education programs for children of Presbyterian converts in Colombia and Venezuela and later held an executive position at the United Presbyterian headquarters in New York. A large Bible, opened to a passage for each day, rested on a lectern in the hallway of their house.

Hamilton encountered the spirit that would draw him to New Mexico in his van at Lake George, New York, where O'Keeffe and Stieglitz had spent their summers in the twenties and thirties in the Stieglitz family compound. As he drove along the shoreline late at night, past old mansions sunk into deep woods of pine and birch, Hamilton says, a premonition that O'Keeffe needed care came to him out of the mist on the clear blue water.

Hamilton had been heading from Vermont to his parents' house in New Jersey when he heard the voice. He was going home to recoup from a personal defeat and to gather strength to move on in his life. Following a brief and tumultuous union, during which he and his first wife had built a cabin in the woods of Vermont, she had asked him to leave. He now felt abandoned and scared. He was aware that O'Keeffe and Stieglitz had spent time at Lake George because his estranged wife had hung a reproduction of an O'Keeffe painting titled *Lake George with Crows* (1921) on a wall of their simple cabin. His first wife had been devoted to Georgia

O'Keeffe's work. Hamilton, too, admired the artist's use of space and light.

On arriving at his parents' home, Hamilton confided to them what had happened to his marriage. When they asked what he was going to do, he did not tell them about the voice or about his secret mission. He simply said he planned to spend a summer in New Mexico. His father offered to introduce Juan to his colleague, Jim Hall, who ran Ghost Ranch Conference Center in Abiquiu. Coincidentally, one of O'Keeffe's houses was on the grounds of Ghost Ranch, a remote retreat covering twenty-three thousand acres of badland—so named, according to legend, because from time to time the voice of a woman crying in the night for her dead husband had been heard echoing in the sandstone canyons.

Finding the artist would not be so easy. Looking for Georgia O'Keeffe was one of the main tourist draws to remote Abiquiu. Over the years, dedicated fans of the artist had employed all sorts of means to get through to her, but she had increasingly learned how to avoid them in the style of Greta Garbo, who wanted to be alone. Once, the story goes, a group of art students knocked on the gate to her house. O'Keeffe opened the gate herself. After listening to their request—they said they wanted to *see* Georgia O'Keeffe— the artist held them to their word and put on a show. "Front side," she said coldly. "Back side," she said, turning around. "Good-bye!" she added, slamming shut the gate.

When he arrived in New Mexico, Hamilton told nearly everyone he met his story: that he was an artist who had lived in Vermont and wanted to meet the great artist. People sympathized with him, but they would not help him. Seven months passed before he even spotted O'Keeffe driving her car. He lived simply, traveling, sleeping, and eating in his van. He swam naked on hot days in the cool waters of the snow-fed Chama River. Life was lazy. There were a number of large communes in the area. Hamilton found out where they were and began spending time with various commune

members who, like himself, had dropped out of society to live in the wilds of northern New Mexico.

One day, he was working in the maintenance department at Ghost Ranch when one of his co-workers asked if he wanted to go to O'Keeffe's house with him. Hamilton seized the opportunity. Something was wrong with the plumbing in her house, and she wanted Juan's co-worker to fix it for her. It was a summer day. The cottonwoods along the river drooped in the desert heat. Rattlesnakes sunbathed along dirt roadbeds. As he passed boulders the size of elephants and mounds of purple-colored earth shaped like cones on the approach to her house, it seemed he was entering another planet. A sandstone cliff, striated with bands of red and yellow, rose thousands of feet overhead, casting a long dark shadow.

On the patio of the U-shaped hacienda, bushy sage plants grew out of cracks in a flagstone patio. There was not another building in sight. A watercress salad glistened in an old Indian basket on a rough wooden table. Various skulls and rocks were arranged haphazardly around the interior of the cool, dark hacienda. Stark Navajo blankets—black crosses against a white background—covered the floors. Hamilton had never seen such a world, or met such a person.

O'Keeffe was a thin woman of medium height and small bones, with a face of coinlike clarity, like Abraham Lincoln's. There was a time when, because she was dark-skinned, people thought she was an American Indian, and she allowed them their fantasy—even promoted it herself. She was in fact a mixture of Irish, Dutch, English, and Hungarian blood—born of American parents in a woodframe farmhouse in the prairie of Wisconsin. Her brown eyes were focused in a narrow gaze, seeming to miss nothing. Her face was etched with what seemed a million wrinkles from constant exposure to the bright desert sun.

Her prominent Roman nose and high forehead were exaggerated by the way she pulled her steely gray hair from her face into a bun on the nape of her neck. She walked with a measured gait as deliberate as a metronome and as

vigorous as that of someone decades younger. Her posture was so erect, it seemed she could have balanced a cup of hot tea on the crown of her head. People did not seem to scare her, and in fact, by the way she spoke to the maintenance man about the plumbing, it seemed that she was the one who did the scaring. "Dealing with Georgia is very easy," a person who had worked with her commented, "provided you do *exactly* what she wants."

Hamilton was in awe of O'Keeffe. He studied her carefully and observed the way she had had her house decorated and how she dressed and talked to the maintenance man. She did not seem to mind that he was staring at her and inspecting her house. She talked to the maintenance man about the plumbing, and when Hamilton looked at her, in an effort to get her attention, she returned his advance with a frightening reply: "She looked right past me," he later said, "as if I were transparent." She did not need him. She already had enough help. And anyway, she had already had years of experience in dealing with people who tried to invade her privacy. "You know about the Indian eye," she asked later, "that passes over you without lingering, as though you didn't exist? That was the way I used to look at the Presbyterians at the ranch, so they wouldn't become too friendly."

Not even the Indian eye would dissuade Hamilton, however. He was obsessed. Meeting and working for O'Keeffe became his mission. He would not take no for an answer. Finally, months later, after several aborted attempts, the young artist entered the elderly artist's life. He went to her main house in the pueblo at dawn. As a friend had instructed him, he waited outside the gate for the artist to come to him—then proceeded to the back door when she did not immediately appear. "I am not a creature of habit," O'Keeffe had told people—"the only habit I have is getting up and seeing the dawn come."

O'Keeffe may have been old and barely able to see, but she knew what to look for. Hamilton was a tall, broad young man who could surely carry a load for her. The men who

had already worked for her were nearly as old as she—the young men of the village had abandoned the barren land to find work in cities. Since she had been raised on a nine-teenth-century farm where itinerants had been the mainstay of her family's help, O'Keeffe was accustomed to hiring people off the road to do work for her. These people were addressed imperiously without name. Hamilton was this kind of person. She called him "my boy."

Had she been better able to see, she would have noticed a striking resemblance between Hamilton and the young Alfred Stieglitz. Put their pictures together, and you would almost have the same man, separated by some eighty years. It was an eerie coincidence. O'Keeffe had not known Stieglitz when he was as young as Hamilton, but she had no doubt known him better than anyone else. Theirs had been a marriage about which books are written and movies are made. Like other women who marry older men, O'Keeffe had watched her husband die while she was still youthful. She had never remarried. The memory of Stieglitz remained a force in her life as she grew old. She told people that her male and female chow dogs represented herself and "Alfred."

What she did notice about Hamilton was his hands. His hands were like her own: long slender fingers and wide palms—working hands. She needed extra hands, and although she was not sure what to make of him, she asked him to stay and wrap paintings for her. O'Keeffe's hands were famous. Stieglitz had photographed them over and over, along with many other parts of her body. His ongoing portrait of her had spanned decades and included several hundred pictures of a striking woman in her thirties and forties in various stages of dress.

As Hamilton wrapped the paintings and put them into a wooden crate, she noticed that he was moving as she did: slowly and carefully, with measure and balance. A suspicious person who trusted no one, she watched carefully to make sure he did not steal from her. What she saw was impressive: He was wrapping the packages as she would have herself.

Here was someone who operated her way without having to be told.

The meeting of the young artist and the old artist soon became the freshest installment in the myth of Georgia O'Keeffe. As its details acquired the elusiveness of the rest of her tale, they became stylized to fit O'Keeffe's self-conception. Hamilton embraced the myth and became its most vocal proponent. Even the story of how he came to work for her became a fable. It is clear that the truth has many faces.

O'Keeffe seemed to bask in the pale light of notoriety. Taking what people thought was a lover young enough to be her grandson was a fitting finale to a life of independence. When others told her they regretted that they no longer saw her now that Hamilton was caring for her, she would say something utterly mystical. Although she rarely spoke or wrote about her beliefs, preferring to let her paintings do her talking, she occasionally made a passing reference to a higher power at work in her life. This was one of those occasions. "Juan was sent to me," she would tell those who questioned his role in her life as she grew old and weak and frail. Almost all believed her.

PART ONE

· · · · · · · · · · · · · ·

1887–1918

Chapter 1

· · · · · · · · · · · · · ·

She remembered little about her childhood, but seventy years later, Georgia O'Keeffe still recalled how it felt to be punished by a nun. Sister Angelique—the drawing instructor at Sacred Heart Academy in Madison, Wisconsin—had assigned her students to make a pencil drawing of a plaster cast of a baby's hand. Being away from home and on her own for the first time in her life, young Georgia was eager to win the nun's favor. Whetting the point of a pencil with the determination of a perfectionist, she recreated the cast in painstaking detail. But alas, when Sister Angelique saw that Georgia had drawn the baby's hand too small, her famous pupil later recalled, still smarting seventy years later, "she scolded me terribly."

Thirteen-year-old Georgia—one of seventy-eight "young ladies" who were enrolled for the year 1901 to 1902—was never the same after her term at the convent school. A stone mansion bordered by green lawns leading through birch woods to a clear northern lake, Sacred Heart introduced her to a world of women who lived in isolation amid great natural beauty, a world such as she would ultimately inhabit for most of the twentieth century. Instead of remembering the cruelty of the sister, as others in her position might have, Georgia later thanked the nun for having given her the first lesson "that made me think and feel like an artist." From that day, she vowed, she would never again draw anything small—a vow that, although not borne out in her work, may have contributed to her eventual success. "To find a woman painting consistently in life-size or larger," writes

feminist Germaine Greer in *The Obstacle Race,* a seminal study of women artists, "is to recognize an exceptional self-confidence."

Georgia's exceptional self-confidence had its roots on the American frontier. Francis Calyxtus O'Keeffe, her beloved father, who was named after the Christian patron saint of wildlife, was a farmer and had been born in a log cabin. Growing up on the one-hundred-acre O'Keeffe dairy farm in Sun Prairie, Wisconsin, the third of four sons of Pierce and Mary Catherine O'Keeffe—Irish Catholic homesteaders who had arrived in frontier Wisconsin in 1848 fleeing the potato famine—curly-haired Frank (as he was known) worked in the field from sunrise to sunset alongside his brothers, Boniface, Peter, and Bernard. On Pierce's death in 1864, Kate (Mary Catherine) assumed control of the farm. Georgia's grandmother was remembered long after her death for her pious and thrifty nature. Naming each of her sons after a saint, she attended mass religiously at Immaculate Heart of Jesus and Mary Church in Sun Prairie. In the log books of Dane County, the name Mary Catherine O'Keeffe appears as one of the few women to have loaned money in her own name—unquestionably, an influence on Georgia's later independence.

The O'Keeffes' was a textbook Irish Catholic matriarchy. Long after they had reached adulthood, the four sons lived at home with their mother. Frank, the prodigal son, left Wisconsin to homestead in the Dakota Territory, only to be wooed home after just one season by Kate. Recognizing her third-born's need for independence, Georgia's grandmother had leased a neighboring farm for him to work on his own. Years later, his own eldest daughter, Georgia, would embroider on Frank's wanderlust—comparing her need to travel with his and omitting, as she often did when referring to her father, his failures. "I think that deep down," she later said, "I am like my father."

The farm Frank O'Keeffe worked was owned by Isabella Wyckoff Totto. Born in New York into an old family that traced its roots to Dutch and English colonists, Isabella

Wyckoff had been orphaned as a young girl shortly after her family arrived in frontier Wisconsin. Penniless—and judging from the few pictures, so unfortunate-looking she probably had a difficult time attracting suitors—Isabella was eventually married to an older man, a Hungarian count named George Victor Totto, who was something of a rake. George established his family, which soon came to number six children, on a working farm in Sun Prairie, only to abandon Isabella and their offspring when he returned to Hungary and, by some accounts, another wife and family.

This was not what Isabella had had in mind. Not only did she detest farming, but as the inheritor of gold-edged family portraits, however penniless she was, she considered herself a notch above the simple Irish and German home-steaders, like the O'Keeffes, who lived around her in Sun Prairie. Leaving the farm to tenant farmers, she moved to Madison, the state capital and home of the University of Wisconsin, and established a matriarchy with her widowed sister, Eliza Jane Varney. Isabella too began to tell people she had been widowed—and she might as well have been. Georgia's grandmother never received a letter from Count Totto, although she clung to the belief that he would return one day—a family secret that doubtless caused considerable damage to the hopes of daughters and sons who believed in this illusion.

Out of the six Totto children, only one would marry. She was Ida, a dour-looking maiden who kept a diary and whose dream of becoming a doctor was laid to rest on February 19, 1884, when two businesses were joined by her marriage to the tenant farmer Frank O'Keeffe in a loveless union. Reviewing the successes of Georgia and her sisters—three out of five O'Keeffe daughters would die as rich women—one of the artist's friends concluded that Ida must have been an ambitious young woman whose goals were transferred to her offspring. Georgia later speculated that Ida would have been successful in business had she been born under different circumstances.

Moving with Frank into the pretentious, flat-roofed Totto

farmhouse, whose Hungarian-style turret and ornament contrasted with the plain white geometric boxes in the surrounding area, Ida insisted that her husband leave the Catholic Church when they were married and that their children be raised, as she had been, as Protestants. A Catholic boarding school was presumably chosen for the daughters because there was no Protestant alternative in the area. Ida tended a rose garden and formed a literary group of farm wives—known as King's Daughters—to read classics, but mostly, in her early married years, she cared for babies. She gave birth to Francis Calyxtus, Jr., the first of seven O'Keeffes, the year after she was married to Frank. On November 15, 1887, Georgia Totto was born, named after the mysterious count who had left her grandmother.

Being named for an errant grandfather was a curse. For years to come, Georgia regretted that she had what sounded to her like a boy's name. Moreover, because Ida treated her badly, Georgia felt ashamed when she thought of her. By Georgia's account, Ida clearly preferred Georgia's older brother, Francis, as well as her younger sisters, Ida and Anita, her younger brother Alexius, and her youngest sisters, Catherine and Claudia. When friends visited, Georgia later noted somewhat incredulously, Ida forced her eldest daughter to stay in a back room where she could not be seen. Georgia felt it was because she was ugly. Although she was not as beautiful as her sisters, Georgia was not ugly. Judging from an early picture, her eyes may have been a little too far apart and her forehead may have been a little high, but she had smooth skin and an expression of bemused contempt that gave her an air of dignity, even as a child. "As a little girl," she later confessed, "I think I craved a certain kind of affection Mama did not give."

Like most children, Georgia found affection where she could. Her father, Frank, as the son of a successful farm family, had the easy-going nature of children of success, compounded by what was most likely a case of alcoholism and the mysticism of those who follow the rhythm of the land. In his daughter's eyes, Frank was a magician and

worked a force of calm on her that she would seek in other men throughout her long life. Not even a splinter hurt her when Frank picked her up and chanted softly, "Speeny, Spawney, Go to the moon!" Frank took his eldest daughter to town in his wagon, helped her escape from her mother and sisters, and spoiled her with horehound candy and ice cream cones. Later, as a world-famous artist whose picture had been on the cover of *Life* magazine, she allowed a rare smile when a neighbor told her that she looked just like her father—and she did.

As her father's favorite and her mother's least favorite, Georgia occupied a special role in the O'Keeffe household— a role that had its own privileges. Out of the five O'Keeffe daughters, only Georgia had a room of her own for most of her childhood. When she was an infant, she had shared a room with her brother Francis, but as a child she occupied a small room of her own on the second floor, a position that seems to have reinforced her self-image. "I had a sense of power," she later recalled. Georgia exerted her sway over the five O'Keeffes who were born after her. Catherine later remembered her older sister as a bossy girl who would not be reasoned with. Georgia "run the girls," she observed ruefully; ". . . she was the queen that was crowned." The children were not allowed in the barnyard, but Georgia secretly took her sisters into the cow pen, where they put their hands in the docile beasts' mouths to feel their tongues. It was a contest to find out who was chicken. Georgia allowed that she enjoyed seeing the expressions in the cows' eyes as she felt their rough pink tongues with her hands. "From the time I was small," she once admitted in a rare display of candor, "I was always doing things people don't do."

Georgia's memory of her father was clouded by a trauma. Virginia Christianson—an analyst who worked for the artist in her old age as a companion—concluded that she had most likely been molested by her father. She normally refused to admit the betrayal, even to herself. Like many girls who have a close relationship with their fathers, Geor-

gia gave Frank a special place without judgment. Not only did she fail to acknowledge her father's subsequent and protracted business failures, which led to the eventual unraveling of the family, but she embellished his actual accomplishments. A telephone was installed on the parlor wall of the O'Keeffe house thanks to Frank's efforts; he sold subscriptions to the telephone service and helped string the lines. For years, even as a grown woman who might have known better, Georgia told people her father had invented the telephone.

Unfortunately, Frank was not always around to protect her when she needed it. The abandonment she must have felt when he left the family had repercussions in her later life as she refused to get close to many of her male companions. Her closest male friends were often homosexuals who did not seek sexual intimacy with her, and she frequently spurned men who did. What was more, during the thirties she indicated to her friend Florine Stettheimer that she had been abused by her brother Francis, a situation common in homes where sexual lines between children are established by parents who have crossed the lines themselves.

Georgia was actually raised by her mother's widowed aunt, Eliza Jane Wyckoff Varney—Auntie. Auntie had been married during the California gold rush of 1849 and was widowed shortly thereafter, when Ezra Varney was killed in a gunfight. Auntie's tragic past was not to be discussed, but after incidents when their grandmother's sister was particularly severe, the O'Keeffe girls comforted themselves by surmising that she was upset because Varney had been killed by Indians or eaten by wolves. Georgia loved the West and looked forward to being read aloud the tales of Natty Bumpo in James Fenimore Cooper's *Leatherstocking Tales,* to stories about Kit Carson and *The Life of Billy the Kid,* and to her father telling her, as he did at night before she went to sleep, stories about the Indians he had encountered in the Dakota Territory.

Auntie doled out the punishments. Because Georgia liked

to eat dirt from the freshly plowed furrows, she was frequently sent to her room to wash her face and later remembered being called "naughty child" repeatedly. She was also punished for teasing her sister Anita to the point of tears—a situation probably worsened when she stated with remarkable indifference that she found Anita's tears "funny." When Georgia was banished to her room with only bread and milk for supper, she responded coolly, "I like bread and milk." Punishment seems to have quickly become routine for her, a routine that she perpetuated throughout her life. As a mature woman, she frequently cut off friends whom she felt had wronged her and was known to slap young children on the face for minor infractions—both probably reflections of corporal punishment she had received in her childhood. Years later, her memory of Auntie was still clouded with resentment at being treated unfairly. Auntie, Georgia later recalled, was "the headache of my life."

Georgia became a different person at the Sacred Heart convent. The girl who had been repeatedly scolded by Auntie at home was transformed into an angel and at the end of the year was awarded a gold medal in "deportment." Georgia had attended the one-room Town Hall School for seven years, but instruction at the convent was so intense that, she later claimed, it was the only time she learned any new ideas in school. What those ideas were, she did not explain, but she clearly enjoyed instruction in art as well as in classical music. Music was an interest that she would pursue the rest of her life; later, she produced a series of artworks based on music, and once she even claimed, since she believed in reincarnation, that she would like to be reborn a beautiful soprano—and "sing very high, very clear notes, without fear."

Each Saturday, from the time she was nine, Georgia, Anita, and Ida were driven in a horse-drawn wagon to the village of Sun Prairie and the art teacher's, where they learned to copy paintings of art masterpieces from books. "I did a drawing of a spray of oats that I thought was pretty good," she said, "compared with the drawing in the book."

She became familiar with the materials artists used and with the techniques they employed to contain worlds of space, light, and color on a flat plane. Along with thousands of other art students at the time, she followed the instructions in the Prang drawing book, a copy of which she kept by her bed.

It would be a mistake to think that Georgia received art lessons because Ida and Frank O'Keeffe recognized her budding talent. Instruction in art had been a part of her mother's and of both her grandmothers' early education. Not only was her mother a lady who would want her daughter to be cultured, but farm women were expected to decorate their own houses and furnishings with colorful splashes of paint and floral patterns all over rural nineteenth-century America. Although the best-known examples come from the so-called Pennsylvania Dutch (who were in fact German, or *Deutsch*) descendants, painted furniture and stencil-decorated rooms were found throughout rural New England and the Midwest. The furniture in Georgia's bedroom was painted pale gray with a spray of pansies outlining the tops of the dresser and headboard—her first exposure to painted flowers, and possibly a lasting influence. "[Georgia] always wondered," noted her friend Anita Pollitzer, "if that was the start of what she later called her 'flower life.' "

Georgia began to look at creation as a way to express how she felt. Problems in art began to occupy her mind in ways that problems in writing and arithmetic did not. She remembered struggling to convey the image of the space occupied by snow under moonlight on a field outside her bedroom window. "I couldn't think of anything I could do about the snow," she said, "so I just left it white paper." By the end of the year at the convent, she had become an excellent art student. She won a prize for "improvement in illustration and drawing," for a watercolor of a hunter aiming his gun at a duck. When she told her mother about the award, Ida O'Keeffe responded coldly. "Why shouldn't you get a medal?" she said. "I would be surprised if you didn't."

The convent also fueled Georgia's interest in Catholicism.

The Frank O'Keeffes were nominally Protestant—the O'Keeffe girls attended the Congregational church in Sun Prairie, and Georgia was enrolled in Sacred Heart as a Protestant. But since Kate O'Keeffe and her sons were devout Catholics, the religion seeped into Georgia's life despite Ida's strictures. (In fact, Georgia probably would not have been interested at all in Catholicism if it had been her family's chosen religion.) Georgia later recalled that she looked forward to the times when her Uncle Bernard allowed her to accompany him to services at Immaculate Heart of Jesus and Mary. Immaculate Heart, with its stained glass windows, Latin mass, and incense smoke, appealed to the imagination of the artistic young girl in ways that the plain Congregational church could not match. What was more, Georgia admired and wanted to be like her Grandmother O'Keeffe, a grandmother from a storybook, with a long braid around her head and a stash of sugar cookies and raspberry jam for her grandchildren. Georgia told people she wished she had been given her name, Mary Catherine. "I love the Irish [in me]," she said later.

Catholicism and death were powerful images in Georgia's early life. Although she never actually converted to Catholicism, she remained deeply affected by its rituals and trappings throughout her life, using crosses as symbols of death in her paintings, dressing like a nun, and settling in a hamlet populated entirely by Catholics. Years later, on a street in Vienna, the world-famous artist would be mistaken—much to her delight—for a Catholic sister because of the way she was dressed. Death first stalked the O'Keeffes when Pierce, Georgia's grandfather, died, followed by her Uncle Peter, who died of tuberculosis in 1883, the year before Frank and Ida were married. Boniface died—also of tuberculosis—the year after Georgia was born. Kate O'Keeffe attended mass nearly every day and wore the black of mourning from the time Georgia was born, a possible early influence on the artist's later mature style. The Church was Kate's world, and it must have been disappointing for her that her grandchildren were raised outside of its boundaries. Georgia prob-

ably experienced more feelings of abandonment when Kate died of cancer when she was nine, before Georgia went to the convent. The following year, the grim reaper again stalked the O'Keeffes when Uncle Bernard, suffering from tuberculosis, moved into Frank O'Keeffe's house. Following a prolonged convalescence in which he was nursed by Georgia's mother, Bernard died in 1898.

Death also benefited the O'Keeffe family. By 1898, after inheriting both his mother's and his brother's properties, Frank controlled 640 acres—what was known as a section— and employed a large staff of farmhands. Although he seems to have been in debt and was sued in several significant cases around this time, by most standards Frank was wealthy. Still, since farm work was hard work, in which profits were generally plowed back into the operation, very few of his neighbors had cash to spare for school tuition or hands to spare to send their children away to board. (Frank even sent his son, Francis, Jr., to military school.) Frank's own resources were not inexhaustible—the convent cost him eighty dollars a year per child, at a time when a meal could be purchased for a nickel. Since the O'Keeffes could barely afford tuition for one child, they rotated children. In fact, although family history does not support this claim, it is possible that the school fees were partly covered by subsidies from the unmarried Totto sisters, who later did help pay for Georgia's art school. The next year, when Anita replaced her at the convent, Georgia was enrolled in a public high school in Madison, and she went to live with her maiden Aunt Lola in a small two-story brick house on the shore of Lake Mendota.

In many ways, Georgia's memories of life on the farm in Sun Prairie were buried deep in her subconscious for the rest of her life. As a mature artist she painted detailed sections of corn plants as well as barns, sunflowers, and other things that seemed to suggest her childhood farm. But these were subjects that she also had on hand in the garden she tended

in the summer at Lake George, New York. Once when she returned to the Sun Prairie farm with her sisters, she seemed to be distracted and commented on how small the place looked. The flat-roofed O'Keeffe farmhouse burned to the ground the year after the artist's ninetieth birthday. When a clerk in a gallery remarked on the news, the artist looked at her and "with a frightening detachment" told her not to worry because the O'Keeffes had received their mail in a hole in an elm tree in front of the house.

Virginia Christianson observed that O'Keeffe found it hard to draw upon the memory of either of her parents. Someone who had been a friend for more than forty years said O'Keeffe never spoke to her of her parents. Some of her friends thought she came from Texas, while others thought she was from Virginia. Georgia was so removed from the memories of her past that she sometimes claimed to have had a happy childhood—and on some level she probably did. But in moments of lucidity she admitted that remembering where she had come from and what it had been like was painful. "You'd push the past out of the way," she said a few years before she died, "if only you could."

Chapter 2

.

One day in the fall of 1905, at the tender age of seventeen, the young artist could have been seen running out of the stolid Art Institute of Chicago. What Georgia was fleeing with such determination was a naked man. As a part of the strictly prescribed curriculum for first-year students at the Art Institute's school, Georgia was required to take an anatomy class that used a human model. Since the time of the ancient Greeks, the male nude has posed a challenge to artists who have found in its curves and masses a subject worth drawing. For most of this time, women were barred from academies. But when women were finally admitted, "the question of the nude"—as art historian Linda Nochlin wrote in her widely regarded and controversial 1971 essay "Why Are There No Great Women Artists?"—presented an obstacle to most women's obtaining a thorough education. According to Nochlin, the male nude—and whether women would or would not be comfortable in its presence—was the reason why women had been denied entrance to the academies until around the time O'Keeffe was enrolled in school. As late as 1893, "lady" students were barred from life drawing at the Royal Academy in London. In 1905 women were segregated from men in anatomy and life drawing classes at the Art Institute. Male nudes wore loincloths over their genitals. "It was a suffering," Georgia later recalled.

O'Keeffe never articulated exactly why the nude had bothered her that day. Only the summer before, in the family's camp on the shoreline of the York River outside Williams-

burg, Virginia, where the O'Keeffes had moved a few years earlier, Georgia had seen men dressed in not much more than loincloths diving off low-hanging tree limbs into the slow-moving southern river. She had seen her brothers—Francis, Jr., and Alexius—practically undressed and her father and his farmhands in undershirts. Georgia had not been sheltered from men; nor was she particularly squeamish. Living on a farm, she had witnessed the complete cycles of life in the barnyard. At the sight of an anonymous male nude on the dais in a large hall in Chicago, however, she lost her normally cool self-composure and "blushed a hot and uncomfortable blush—." Possibly it was an aftershock of the abuse she had allegedly suffered as a child. But seeing the nude man was so upsetting that she considered dropping out of school because of the requirement that she complete anatomy and life drawing.

The summer of 1905 at the camp on the York River had been a time of passage for Georgia. Francis had invited some of his friends from the College of William and Mary, where he was entering the junior year in architecture; Georgia had invited her friends from her school. In June, along with seven other girls, she had graduated from Chatham Episcopal Institute, the precursor of Chatham Hall—then a church-subsidized boarding school for worthy daughters, primarily of Episcopal clergy—in Chatham, Virginia. The girls planted a tree in a bonding ritual that would link them as sisters for life—although that did not mean they accepted one another. Susan Young Wilson, a classmate who visited the camp on the York, was alarmed by the way Georgia's family lived. She said with a sniff that the camp was "teeming with O'Keeffes and undesignated others." After observing that the wooden table was "splintered" and plates and cups "tin," Wilson recalled with distaste that visitors "slept on mattresses on the floor."

For Georgia, however, the camp—and anywhere she could be close to nature—was nirvana. She loved to swim and sail, to muck in the bog for oysters and fish off the pier. And she liked eating off tinware and sleeping on the floor.

Her ample black-Irish pigmentation absorbed the sun gen-
erously, and by the end of the summer she was deeply
tanned. Unlike the delicate southern girls around her, Geor-
gia did not block the sun's rays with hats or gloves. She
worshipped the sun, and for the rest of her life rejected
sunglasses, tinted windows, or anything else that might
impede its force. "I like to see things exactly as they are,"
she said—and she often looked directly at the sun to ex-
perience pinwheels and starbursts.

It was an odd choice, Williamsburg. At one time an el-
egant colonial capital and college town, by 1903 it was a
decrepit southern backwater of fewer than a thousand peo-
ple, succumbing to slow decay that would eat away its foun-
dation until it was restored by the Rockefeller family in the
1930s. Amidst decaying mansions and crumbling brick
walls, Williamsburg had been overrun by gardens of dog-
woods, lilacs, azaleas, roses, magnolias, and other blooms
from countless plantings dating back to the seventeenth
century, when the old town had formed a foothold for the
English colonial empire. Old families, interrelated back to
colonial times, welcomed newcomers, particularly Yankee
newcomers like the O'Keeffes, as they would welcome a heat
rash. "Williamsburg," commented one observer, "never quite
got accustomed to O'Keeffe."

O'Keeffe never quite got accustomed to Williamsburg,
either. They had left Sun Prairie in order to avoid tuber-
culosis, as it was a common nineteenth-century practice to
avoid highly contagious diseases by moving away from them.
Frank O'Keeffe had fallen for some false advertising in the
Sun Prairie *Countryman* that had touted the advantages of
Williamsburg's warm climate and even claimed that the town
was "tuberculosis free." But Williamsburg actually contained
all the climatic conditions—hot, humid, and fetid—to breed
massive strains of tuberculosis bacteria. Frank does not seem
to have been bright enough to figure this out; nor was he
humble enough to admit he had made a mistake after they
moved. Catherine O'Keeffe, who was nine at the time, re-

membered being reassured by her father that it would be "so warm" in the South.

Like most children, Frank O'Keeffe's children believed in him and put a rosy face on his failings. At various times they told people their father had been unwell when they moved south. What had been wrong was never made clear. Georgia reported proudly that he had "overworked"—implying strength of character—and he probably had, in running a large farm, as his brothers who could have supported him, as well as his mother, died in succession. Overwork is not a condition, however; it is a symptom. Frank actually seems to have been a hypochondriac who was afraid of germs and disease, a condition most likely compounded by his alcoholism—a trait, not so strangely, that Georgia would later freely accept and even welcome in men.

Having given up the stability of an established family farm for the uncertainty of a depressed southern backwater, the O'Keeffes embarked on an odyssey of misadventure in a rambling house with barely a table from which to eat their meals. Along with their acreage, livestock, and equipment, the O'Keeffes had sold their farmhouse and all of its contents, netting $12,000. In 1903 this was no fortune, but it was enough for a fresh start. In order to impress people who came to call in their new home, Wheatlands, Ida brought out a chest of the Totto family jewelry. In a futile appeal for friendship, she even invented a pedigree, telling people in ancestor-obsessed Virginia that she was descended from a Russian czar. But her stories could not make up for the reality. Not only was there no furniture at Wheatlands, but the O'Keeffe girls did the housework themselves—other white Williamsburg families employed blacks to work around the house. Frank O'Keeffe was remembered unkindly as a rough Irishman who did not speak good English or use a knife and fork correctly.

The parents' reputation for strangeness extended to their children. From the moment Georgia arrived at Chatham Episcopal Institute, she had been considered rough, too.

The seven other girls in her class dressed like old-fashioned southern belles, their long hair curled into masses of ringlets and styled in pompadour hairdos. Their young figures were gathered tightly into corsets under crinolines and petticoats. Some of them even carried parasols to block the scorching heat of the Piedmont sun. But Georgia was dressed as sparely as a Quaker in a long tan skirt and suit coat. Her dark brown hair was pulled tightly from her oval face and fashioned into a simple pigtail. She did not even wear a corset, let alone a crinoline or a petticoat. She owned no parasol. Because her dress was so plain and her skin so dark, she was mistaken for a maid on her first day. Most of the girls spoke in thick southern accents. The new girl spoke as she dressed—in the simple declarative sentences of a woman of the prairie. "I knew door was door," she reflected wryly, "not doe."

For many schoolgirls at that age, the concerns of the group are more important than the needs of the individual. "Nearly every girl planned how she was going to dress Georgia up," recalled Christine McRae, who attended Chatham at the same time, but "the strong willed" girl who dressed as she pleased "would not be changed." One of her other classmates recalled patronizingly that because of the way Georgia dressed, "she would have made a strikingly handsome boy."

Georgia's distinctive sense of fashion must have seemed advanced in 1903 Virginia. Although she never consciously attempted to pass as a man, as many women did at this time—she always wore a skirt—the young artist used many articles of men's clothing in her wardrobe, including shoes, hats, and, of course, (straight-cut) suit coats. Throughout her life, because of the ways she dressed and the sternness of her gaze, she was often mistaken for a man. Juan Hamilton recalled that once when he was pushing the elderly artist in a wheelchair in an airport, an attendant asked him to move his "grandfather" out of the way.

O'Keeffe adjusted to her new school through her artwork. Within a few weeks she established herself in the art studio, where her drawings quickly attracted the attention of Elizabeth May Willis, the headmistress and art instructor and

a graduate of the Art Students League in New York City. Willis, a widow who was paralyzed on one side of her face, was the first of many people who had suffered through adversity who would help O'Keeffe. Recognizing O'Keeffe's talent, Willis gave her free rein over the studio, to come and go as she pleased. When the other girls complained about Georgia's special position, Willis pointed out that their classmate could produce more work of quality in a few minutes than they could in a few days. "In the studio," one of her classmates observed, echoing what her sisters had said about home, "Georgia was queen."

O'Keeffe was fortunate to have fallen into the hands of Elizabeth Willis. Boarding school in a small southern town might have been a nightmare for an artistic girl student who was thought to dress like a boy. In other settings, moreover, O'Keeffe might have been seen as a problem child, for the pious convent girl had turned into a hellion. During studio, she grabbed the other girls aggressively and disrupted their work. "Georgia," said one, "was in all kinds of mischief." She taught the other girls how to play poker and roasted wild onions on a wood-burning stove in her rooms. She ate dirt again, as she had as a child on the farm—and tried to convince the other girls to join her in this bucolic pursuit. Once she picked up some of her drawings and tossed them into a wood-burning stove. "One day I'm going to be famous," she declared with a flourish, "and I don't want these pictures floating around to haunt me."

As many boarding-school girls do, she entered what appeared to be a stage of adolescent lesbianism. Georgia not only kissed the other girls, she became known as "A Girl who would be different in habit, style and dress," according to the Chatham yearbook, *The Mortar Board*. "A girl who doesn't give a cent for men—and boys still less." Although there are no accounts of her having any serious boarding-school love affairs, Georgia was remembered for her firm handshake and unfeminine attire, for the "hugs and kisses and pats" that she directed to the other girls. She guided her fellow students into a special world of nature, as she

would with many female friends over the years. Ignoring the school restriction that prohibited girls from going off in pairs, Georgia took girlfriends on long walks through the beautiful southern pine woods. At creekbeds, she encouraged them to take their shoes off and dangle their bare feet in the cool water.

Many women have had lesbian affairs in boarding school, only to cease having sex with other women once they reach adulthood. (Female boarding-school crushes were so common in Victorian England and America that they were generally overlooked by authorities, who felt that women were unable to satisfy other women sexually.) But this does not seem to have been the case with Georgia. It has been revealed that as an adult she had several sexual relationships with women and openly flirted with women throughout her life. The extent of these relationships is not as easy to document as the extent of her relationships with men, and people have generally overlooked even the evidence of these relationships because O'Keeffe was married to a man for nearly thirty years. What was more, while she wrote many passionate love letters to men, only a few love letters to women have surfaced as of this writing. And yet it has become clear that the artist, like many married women during this period, maintained secret homosexual alliances. When asked whether O'Keeffe had any beaus, Phoebe Pack—a close friend for most of her later years—stated that the artist had had only women lovers when she knew her in New Mexico and that, as she understood it, her union with Stieglitz had been a "marriage of convenience." Virginia Christianson told me that "All her life, I think, Georgia had been a lesbian." The son of another friend told me that O'Keeffe was a part of a small and select group of women who lived around Santa Fe in the forties and fifties. He said that although many of the women had relationships with men, it was his understanding that they had sexual relations with one another.

In Santa Fe, there was a great deal of speculation about O'Keeffe's sexuality. Perhaps because of that, during a con-

versation about the artist's bedroom, Louise Trigg, one of her closest friends from the 1950s, took pains to say that she had never slept with O'Keeffe. She had not been asked if she had. And a socially active Santa Fe lesbian informed me that although people knew O'Keeffe had had women lovers, everyone "respected her privacy"—meaning that they did not talk about her sexual relationships with women. When I directly asked another friend of the artist's if she had had sexual relations with her, she looked shocked that I would even ask such a question and expressed dismay that I would suggest that O'Keeffe had been a lesbian. After some defensive posturing, she finally concluded dismissively, "Those kinds of people are always attracted to me."

Like many repressed homosexuals, O'Keeffe appears to have been ashamed of her attraction to people of the same sex and taken measures to cover her sexual inclination with smokescreens. Some of her closest friends as well as family members have denied knowing that the artist had women lovers; and, in fact, some of them have insisted emphatically that she was not a lesbian—protesting a little too loudly for people who did not really know her private life. She did not freely discuss her attraction to other women, and she led some people to believe she found sex with women repellent. In fact, she often ridiculed her sister Claudia—who never married and lived openly with another woman—for her choice of a female partner. "The problem with her," she told people—Claudia sometimes seemed high-strung—"is that she never had a man." When a young male friend confided to the elderly artist that he was attracted to men, O'Keeffe told him that Stieglitz had also been attracted to men. But she failed to mention her own experience, at a time when she could have provided some comfort and guidance to a person in need of it.

O'Keeffe was not alone in wishing to hide her homosexuality. Scores of repressed lesbians and gay men denied their sexuality during the period in which she lived and did so in earlier times as well. For years, in fact, no one knew for sure the homosexual identities of such well-known writers

as Herman Melville and Somerset Maugham. Even Walt
Whitman denied his homosexuality. Some people felt that
because Virginia Woolf was married, she was not capable
of lesbian relations, but it is now commonly known that she
had an affair with Vita Sackville-West. A recent biography
of Simone de Beauvoir fails to mention her affairs with
women, even though they have been well documented else-
where, particularly in the memoirs of Viollet-le-Duc.

These men and women had good reason to choose to
hide their true nature. For centuries, homosexuals have been
persecuted. Saint Augustine advised his sister not to engage
in sex with women, insisting that homosexuality was not of
God. Beginning in the nineteenth century, when the word
homosexual was first used as a medical description for what
was thought to be perverted sexuality, there was extreme
persecution of men and women who had same-sex relations,
and paranoia reached one of many heights in 1895, when
poet Oscar Wilde was imprisoned on charges of "gross in-
decency." This single event forced legions of homosexuals
to move to other countries where they could express them-
selves without fear of persecution, and it left a lasting impres-
sion on closeted homosexuals for decades thereafter. A single
accusation of homosexuality could ruin a person's reputation
and possibly result in blackmail and criminal prosecution
during most of the years when O'Keeffe was alive. She was
eighty years old when legislation barring same-sex relations
was repealed in Great Britain and some American states.

Because they had no acceptable outlet for their desires,
repressed homosexuals often expressed their sexual feelings
in their work and invented unique identities for themselves.
This seems to have been the case with O'Keeffe, who dressed
in men's clothes and found a channel for her desires in her
art—only, the result sometimes backfired on her and threat-
ened to expose what she was hiding. Since she was repressed,
she believed she had hidden her desires, and she was often
surprised when others found images of female sexuality in
her work. She denied to her last breath that she had meant
to depict women's genitalia when she painted a detailed

cross-section of an iris that looked vaginal to most eyes. Even as early as Chatham, O'Keeffe unwittingly expressed her homosexuality through her work. Copying the pen-and-ink drawings of English illustrator Aubrey Beardsley, O'Keeffe filled the Chatham yearbook with drawings of androgynous figures who blended both sexes in one. Beardsley, a decadent and an aesthete, had used his art to depict a world that was potent with unknown desires. The French writer Colette once said that on first sighting one of his drawings, she had felt "what is hidden in me"—the blend of masculine and feminine characteristics that were a part of O'Keeffe's life and times as well as Colette's.

Like a latter-day Transcendentalist, O'Keeffe found the greatest expression for her sexuality in landscapes. The way a hill looked or a river meandered, or the way a sea shell looked close up, revealed to her a world of hidden sensations and cloaked passions. From the time she was a young girl escorting her sisters into the barnyard, she had celebrated the wonders of the natural world with women friends. A New Mexico friend who felt she had been an object of her sexual desire later recalled that O'Keeffe often invited her to go on walks and on camping trips. And at Chatham, some of the girls glowingly remembered taking trips into the woods with Georgia, whose rapport with the natural world held them spellbound: "on the horizon far away," she wrote with pantheistic awe, "was the line of Blue Ridge mountains—calling—as the distance has always been calling me."

O'Keeffe's repression was not merely sexual. She dressed in voluminous gowns; she spoke in spare sentences, using monosyllabic Anglo-Saxon words; she applied paint in tiny, meticulous brushstrokes—in all these ways, she was always withholding some essential part of herself. It was as if she were trying to regain a part of herself that had been forever lost and could not figure out where it had gone. And for many people, the beauty of O'Keeffe's life and work lies in this very expression.

At Chatham, nearly all of O'Keeffe's energy was focused on her artwork, so her performance in other subjects suf-

fered. She had to retake a spelling test five times before she
achieved an acceptable score to graduate from Chatham. A
friend was startled to find her computing by using the fingers
on both her hands; she admitted sheepishly that she had
never learned how to add or subtract certain sums. She read
so few books that each one she did read impressed her
greatly. Later, she preferred to have other people read out
loud to her. Georgia was not a strong candidate for admis-
sion to a university, but then, she was not interested in
college. She wanted to become a famous artist—an option
most women would not even have entertained at this time.
She was fortunate not only in that her family could afford
her schooling, but that Elizabeth Willis encouraged her par-
ents to send her to art school. She was also fortunate that
her mother's unmarried sister and brother, Ollie and Charles
Totto had moved to an apartment on Indiana Street in Chi-
cago, near the elevated trains and the Art Institute. The fates
had conspired in her favor. "I guess you would say I was
very lucky," O'Keeffe admitted years later.

Luck had nothing to do with what O'Keeffe accomplished
in Chicago in 1905 and 1906. Close contact with her stern
aunt focused her wild energy, so that the year she spent in
Chicago crystallized a part of her that would later make her
a successful artist. For the rest of her life, her productivity
would be characterized by periods of outbursts of work
followed by complete breakdowns, in a creative seesaw that
she would struggle to balance like a person whose left side
is opposed to their right. Giving up all social life, she focused
her energy entirely on her work, admitting later that she
did not even enjoy going to the theater with her Uncle
Charles because it took valuable time from her work.

Competition at the Institute was fierce. Excellence was
rewarded with a seat near the front of a large classroom, in
a system that insured, like capitalism, that those who did
well would most likely continue to do well. Poor students
were relegated to the back, from which it was difficult to
see the subject for the drawing of the day. Georgia worked
hard. By the end of the first term, she had risen to the top

quarter of the class, with grades nearing one hundred—a perfect score. In a class on drawing the human figure given by John Vanderpoel—a hunchback whom O'Keeffe later remembered for his kindness—she received first place out of twenty-nine women, but aside from this, the young artist was not impressed by her instruction at the Institute. "I don't remember anything," she said later of her year in Chicago, "except that I finally became accustomed to the idea of the nude model."

Instruction at the Institute was conservative. In Europe, artists like Paul Cézanne and Pierre Auguste Renoir had for some time been stretching the limits of oil paint; in Chicago, realism was valued as an artist's ultimate goal. According to the Institute's awkwardly worded Circular of Instruction, the school intended to "maintain the highest efficiency the severe practice of academic drawing and painting." As artists had been doing since the Renaissance, students were forced to copy Old Master paintings in painstaking detail, repeatedly—an exercise that probably appealed to O'Keeffe's perfectionism. Originality was discouraged and, in some cases, punished. In 1913 a group of hidebound students at this conservative school set fire to a pile of modern artworks.

Communication was much slower in 1905 than it is today, so that the art of Cézanne was barely known in Chicago when Georgia was a student. Yet it had touched off a scandal when exhibited in Paris in 1895, and it is regarded today as arguably the most important art of the nineteenth century, designating a point at which art history moved in a new direction. At the heart of Cézanne's painting was a rejection of the tradition of Western art that tried to duplicate nature and tell a story. Instead, Cézanne made the painting an object unto itself, a complete and coherent world, a specific creation owing nothing to the previous traditions of art. He did this by combining colors to suggest shape and form, as well as mass—bypassing such academic practices as "severe" drawing. In a painting by Cézanne, colors play off one another in a concerted manner hitherto unknown to Western art. "When color is at its richest," he

wrote, "form attains its plenitude," an approach to art which O'Keeffe would later embrace in her own work.

Sometime during the year, Georgia became aware of a paradox in her education: As she excelled in her classes, she derived less satisfaction from the actual process of creating art. The harder she worked, the better her results were received but the less they felt like her own. She was rewarded for making her work look like that of others. Had she really depicted the way she felt upon seeing the nude male, for instance, she might have expressed confusion and annoyance, even perhaps revulsion and fear in her work. Instead, she abandoned her true feelings and produced a drawing that looked as though it could have come from the studio of Michelangelo, like the drawings of countless other artists in the previous several centuries.

O'Keeffe's discontent would be slow to percolate into action. Even before she reached Chicago, she had taken a vow to create art. It was through art that she would find her salvation. Art had become her passion, offering, as it did, a means for her to express how she felt and to organize her secret worlds. "I am going to live a different life than the rest of you girls," she had told her classmates at Chatham. "I am going to give up everything for my art."

Chapter 3

.

G iving up everything for her art was not going to be easy for O'Keeffe. Following a year of convalescence from a serious bout with typhoid fever, she returned to art school for a second year. This time, probably on the recommendation of Chatham's Elizabeth Willis, she enrolled in the Art Students League, on Fifty-seventh Street in New York. Paying for the expensive school was a struggle. Georgia subsidized her income by modeling for fellow students, allowing them to use her as a subject.

Modeling was not always easy. One day, Eugene Speicher, a handsome and accomplished fellow student, stopped her in front of the gray stone League building. Having pursued her to model for him for some time without success, Speicher this time bullied O'Keeffe. He blocked her way with his stocky body and claimed he was not going to let her pass until she agreed to model for him. When she protested— she said she did not have enough time to sit for him if she was going to get her own work done—he pointed out that in his opinion her time was not very important. "It doesn't matter what you do," he said. "I'm going to become a great painter and you're just going to end up teaching art in some girls' school."

Speicher was not expressing an original viewpoint. It was generally accepted that women at the League were training for careers in teaching. Georgia was rare among female students in her belief that she could become a famous artist. Like Rosa Bonheur, the nineteenth-century French equine painter who dressed in trousers and waistcoat like a man

and lived with a woman, O'Keeffe was discovering that, as Germaine Greer concluded in *The Obstacle Race,* "To be truly excellent in art was to be de-sexed, to be a woman only in name, to inhabit a special realm that no other women could enter, to be separated from all other women."

There were other women students at the League—and in fact O'Keeffe's friend of later years, Florine Stettheimer, was enrolled in the same courses as she at this time—but Georgia gravitated toward men. "The men were always more interesting," she confided to a secretary decades later. Her closest friend was a man from San Francisco who also appears to have been something of a beau. George Dannenberg was a fair-haired, smooth-looking, ambitious artist. In what later became her typical pattern of dominating handsome—and somewhat sexually ambivalent—younger men, O'Keeffe refused to allow Dannenberg to get too close to her and kept him in the shadows. She told him not to tell her that he loved her, and she kept his identity a secret.

Dannenberg seems to have acted as a foil for O'Keeffe's androgyny. When he accompanied her to a masked ball at the League, she dressed as Peter Pan, the "eternal boy wonder." At another dance, she pulled her hair back and wore a man's dinner jacket and black tie, foreshadowing the later chanteuse style of singer Marlene Dietrich. Dannenberg nicknamed Georgia "Patsy" or "Pat," after the Irish Saint Patrick—the name was commonly used in New York to call out for rough-drinking stevedores. In 1910, when Dannenberg encouraged her to join him and move to Paris, the capital of the art world, she turned him down, but he would not be deterred. "Honestly, Pat," he wrote of his unrequited love, "I feel like writing what I can't, because you won't let me."

Romance seems to have come last in O'Keeffe's list of things she wanted to achieve in New York. As Victorian women who, wanting to succeed, reined in their feelings when considering their marriage prospects, O'Keeffe began to consider her own choices like a microbiologist examining protozoa. If she stayed up all night dancing with Dannenberg

in the ornate ballrooms lining Broadway, she could not also work in her studio the next day. If she modeled for someone, she could not paint at the same time. O'Keeffe thereby devised a system by which she guided herself through the labyrinth of New York life. It was a system as old as Western thought: Aristotle expounded on it, the "Law of Noncontradiction," in *Metaphysics*.

First she took a blank piece of writing paper and divided it into two vertical columns marked "yes" and "no." In the "yes" column, she wrote something she wanted to do, such as go dancing. In the column marked "no," she wrote what she could not do if she did go dancing: work in the studio. In interviews after she became famous, she attributed her eventual success to this device. Later, attracted to the Zen Buddhist notion that less is more, she stated that her sole aim was to simplify her life. "I'd wish I lived in a tent," she once lamented, "and could open the flaps at both ends and let the wind blow everything out and start all over again."

The highlight of O'Keeffe's year at the League was a class in still-life painting taught by William Merritt Chase. A fop who wore a fresh carnation in his lapel every day, Chase burst into a large classroom of eager students enthusiastic to create a painting. In his classes, he required students to produce a small painting each day, one after the other. "There was something fresh and energetic and fierce and exacting about him that made him fun," O'Keeffe later recalled. He was the young artist's first introduction to the grandiose style of life that certain artists enjoyed. Wealthy because he painted portraits of rich people, Chase lived in an exotic town house in Greenwich Village decorated with tiger-skin rugs and suits of armor.

In Chase's class, O'Keeffe discovered that art could be fun. Much of her art school education had consisted of dissecting the human form and other arduous drafting assignments. With Chase, she could paint a small still life— what would later become her métier—in a single day. An orientalist who appreciated the world of ideas contained in a single bloom, Chase also introduced O'Keeffe to the idea

that "nothing [is] more difficult [to paint] than flowers." Most people at that time felt that the human form posed the greatest challenge to a painter. Although O'Keeffe would later downplay Chase's role in her development, a glance through his paintings shows striking similarities in his style and form with that of later O'Keeffe paintings, especially in the use of soft colors and orientalist subjects.

It was a cathartic year for O'Keeffe. By copying the still-life arrangements of copper pots and slimy fish that Chase put out for his students, she came to believe, as Cézanne had already suggested, that colors could create a picture by interacting not only to define a subject but to evoke a universe of sensation. For her, listening to Chase was like following a religious leader. "The successful picture ought to look as if it has been blown on the canvas with one puff," he declared to his classes—and he would have been proud of the polished efforts of his student in later years. He responded to her own internal struggle when he said, "Great work comes from the heart. When only from the head, it is uninteresting."

As O'Keeffe began to produce faithful renditions of Chase's work, however, she once again began to question what she was creating. Being an intuitive person, a daughter of a farmer, guided by an inner rhythm based on the rotation of the planet, she felt false merely imitating Chase's style. She felt her work was not from the heart. She wanted it to express the "wideness and wonder of the world we live in." When Chase told his students to "try to paint the sky as if we could see through it," Georgia took his words to heart and experimented by applying white instead of the usual dark hues to the foundation of her canvas. The result was luminous—and it excited her. She wanted more light, more originality. She later reflected on her struggle: "I saw that any idiot could come to copy another painting. I wanted to create a painting."

The personal struggle that O'Keeffe was experiencing is inherent to all creative endeavors; what was different in her case was that, as one of the first women to attend a major

art academy, she was opposed by the men she met at the League. Art schools are generally cutthroat, and stories of men opposing other men there are legion—Pablo Picasso once referred to Georges Braque as "Madame Picasso." But what was interesting was the way O'Keeffe dealt with the persecution. Rather than fight back, she tended to join the men, silently enduring the put-downs, as women have for thousands of years, and surrendering her femininity as she chose, like Bonheur, to become neither man nor woman in her pursuit of an art career. Because she finally agreed to model for Speicher, she actually can be said to have agreed with his prognosis for her.

Midway through their second sitting, O'Keeffe and Speicher were interrupted by a group of students who came by to take them on an outing. The group walked down elegant Fifth Avenue to an exhibition in a gallery named after its address: 291. The wrought-iron railing along the stone steps leading up to the front door was outlined in fresh snow. They entered a tiny elevator cage operated by a strikingly handsome and courtly West Indian black man named Hodge Kirnon. Kirnon smiled at the group of young students as he closed the elevator gate and slowly took them to the top floor. There was something knowing in his smile. When they arrived, there was a hush about the gallery similar to that of a fanatical political party or the clandestine wing of an occult group—which, in a way, was what it was. "There," wrote author Djuna Barnes, recalling the thought-provoking ideas to which she was exposed at 291, "insomnia is not a malady—it is an ideal."

In the small attic rooms of 291 were displayed faint drawings by the French artist Auguste Rodin. Although best known for his bronze sculptures, Rodin also produced drawings of figures in pencil on paper. These were no ordinary drawings. Instead of depicting a figure, they merely suggested its shape. It was hard to say exactly what they were: "some of them were supposed to have been done with his eyes shut," O'Keeffe noted in her memoir. Many academics, particularly at the League—where modern art was held in

low regard—dismissed the Rodin drawings as a hoax pulled on a public eager for anything new.

The trip to the gallery had been instigated by the students in sport, to spar with the director of the gallery, Alfred Stieglitz. A pioneer of art photography, a forceful orator, and a compelling writer, Stieglitz had single-handedly introduced modern art into America through exhibitions in his gallery. The works of Pablo Picasso, Henri Matisse, and Paul Cézanne passed into America for the first time through 291. By 1908, the handsome, square-jawed, American-born son of rich German-Jewish immigrants had spent a great deal of his life in Europe studying photography with masters and divining the mysteries of life through art. He consulted oracles, looked into crystal balls, and nearly always needed a haircut. When O'Keeffe first saw the man who would one day guide her through a Faustian maze of sensations, she thought very little of how he looked or acted. He scared her.

Stieglitz was yelling in a rage at two boys in her group who had challenged the validity of the Rodin drawings. He was telling them, probably, that Rodin had more knowledge of life in his little finger than they would ever have in all their years put together. These were not just drawings of an event from history but were an expression, a clear expression, of the soul of a human being and, consequently, of all souls of all beings. Stieglitz's white face turned red with anger. His bushy moustache quivered. The boys shouted back, and Stieglitz returned their volleys with fast replies. He strained the boys, unaccustomed to a European style of argument. If they were anything like others who had similar experiences, they left the gallery feeling as though they understood very little about either art or life.

O'Keeffe shrank with horror into a corner of the gallery where no one could see her. The intense fighting upset her. As in her encounter with the male nude in Chicago, there was a masculine energy here that both attracted and repulsed her. She thought that the drawings were not important and

that the men were fighting simply for the sake of argument. The gallery was tight and cramped, heated by a large pot-bellied wood-burning stove, the walls covered with green burlap fabric. In the main room on a low table was a large, empty brass bowl, like those that some Eastern religions use. O'Keeffe wanted to escape, but she could not, she later recalled: "There was nothing to sit on—nothing to do but stand and wait."

Then there was the August 1908 incident at Lake George. A little more than a hundred miles north of New York City, Lake George was a large Adirondack lake set between pine- and birch-laden mountains, a summer resort where rich people escaped the heat of eastern cities at the turn of the century. O'Keeffe had won first place in the Chase still-life competition for *Copper Pot and Dead Rabbit* and as her prize received a full scholarship to the League's summer school at the lake. One day in the summer of 1908, O'Keeffe and Dannenberg were crossing the deep northern lake in a little red sailboat. Dannenberg was upset with his friend because she had once again rejected his sexual advances and had insisted that they take another young man along with them in the boat. When they reached the other side of the lake, the boat was stolen, which only added to her suitor's fury. The threesome had to trudge around the lake through the woods to return to the summer school.

But out of this misunderstanding came a breakthrough for O'Keeffe. The heat of emotion generated in the boat produced a prescient state in which she was actually able to express something in paint that she considered all her own. Suddenly she felt the way the landscape appeared to her along the shoreline—"wet and swampy and gloomy, very gloomy." Rushing back to her student quarters, she put down on paper with watercolor and brush how she had felt during Dannenberg's advances in a sailboat on a misty north-ern lake. It was an epiphany. Alas, the resulting painting was seized by Dannenberg. But the freedom to create such a thing could not be taken away from her. She had unblocked

what was really inside her, and the gap between what she wanted to produce and what she could produce had narrowed considerably.

When she returned to Williamsburg at the end of the summer of 1908, she discovered that her family had fallen on hard times. The economic crash of 1907 had exhausted most of Frank's capital from the 1903 sale of the Wisconsin farm. He had expended the remainder on an ill-fated business manufacturing hollow cement building blocks (an enterprise that would soon take off in other hands, and the blocks would be used all over the South). Apparently no one wanted the blocks that Frank produced, which were made out of a mixture of cement and shells from along the banks of the York River. He was now stuck with a warehouse of hollow blocks. Wheatlands, the seventeen-room southern mansion to which Ida O'Keeffe had pinned her genteel aspirations, was now sold; the acres around it were subdivided into building lots. After spending a brief period in a rented house, Georgia's family moved into a sad folly next door.

Built entirely by Frank O'Keeffe and sons, the two-story house was a shabby cement-block copy of Wheatlands—and it looked it. The windows were askew, the doors were off center. The pillars capping the facade of the house were so spindly, it seemed they might tip over if one leaned on them too hard. One of the neighbors dubbed the sad house "the prison," a name that fit the situation inside as well. Swallowing her pride in her pedigree, Ida took in boarders and lodgers and turned the dank cement-block house into a down-market rooming house. A lodger at the time recalled helping buy food for the table. Frank, without farm or work, was like a hound that could not hunt. His daughters recalled that he drank too much alcohol, and Georgia confided to a friend, "[Father] is having hard luck these days but never says much because he doesn't like to own up to it, even to himself, I guess."

Georgia didn't like to own up to the difficulties of the family situation, either. She reacted abruptly and angrily to

the news that she would not be able to return to the Art Students League in the fall because the family could no longer afford it. Yet financial straits did not deter many of her fellow students from continuing their studies. Dannenberg's education, for one, was subsidized by a full scholarship, as were others'. In fact, on learning that she had quit painting, he wrote encouragingly to her: "You are and always will be an artist." Having won first prize in the Chase contest, O'Keeffe could easily have found some support had she wanted to return. But instead, packing her bags, she returned to dreaded Chicago, where she moved in with her relatives in the Totto apartment on Indiana Street and abandoned painting altogether. When things went wrong at home, boarding a train for Chicago and the aunts may have been the obvious solution to her predicament.

What she found in Chicago was no picnic. Like thousands of people who were streaming into the city every day looking for work, O'Keeffe became a version of Theodore Dreiser's Sister Carrie, a faceless cog in the wheel of industry. For nearly two years there is no record of her activities. The firms that employed her have since folded, and her name does not appear on tax rolls. She wrote no letters—and later referred to what happened during that time only vaguely. She had recoiled into a place where no one could see her, like a wounded animal retreating into its warren. Toiling for little remuneration and with no relief from her burden except brief excursions into a Catholic church—where she found comfort in the words *hoc est enim corpus menum*—Georgia illustrated lace panels for advertising agencies twelve hours a day, six days a week.

Having wanted to become a famous artist for so long, it is hard to understand why she suddenly seemed to abandon her goal. The underlying events that led to her action are forever lost—although it is probably safe to conclude that she felt too much pressure from men in the art schools to continue. Seventy years later, when she tried to explain what had happened, the bitterness underlining her decision was

evident: "I'd been taught to paint like other people, and I thought, what's the use? I couldn't do any better than they, or even as well. I was just adding to the brush pile. So I quit." For nearly four years, Georgia O'Keeffe did not pick up a brush. The smell of turpentine, she later recalled, nauseated her.

Chapter 4

· · · · · · · · · · · · ·

I n 1912, Amarillo, Texas, appeared to be the end of the earth—and in many ways it was. A dusty collection of frame buildings in a stretch of geography known as the Great Plains, the town rose in defiance of miles of openness in all four directions of the compass. The sky was blue and wide. The earth was flat and long. Located nearly a thousand miles from Houston in a corner of the state known as the Panhandle, it was so isolated that even expansive Texans sometimes failed to claim it as their own.

For Georgia O'Keeffe, however, as she stepped off the Santa Fe Chief on a clear day in September 1912, Amarillo was the beginning of the earth. She had never seen anything like it—and for years to come she referred to her first sight of a West Texas morning as though it were a mystical encounter with Genesis—where the water was separated from the firmament and the earth shook: "and the SKY—you have never seen SKY—it is wonderful—," she exclaimed to a friend. Living in the West was something she had looked forward to ever since, as a little girl, her mother had read to her about Natty Bumpo, Kit Carson, and Billy the Kid, and her father had amused her with tales of the Indians in the Dakota Territory. "This was my country," she later declared possessively. "Terrible winds and a wonderful emptiness."

Georgia was ready for a big change. After spending two years as a cipher in Chicago, she had returned to Virginia in the fall of 1910 to recuperate from a deadly case of measles, which had left her temporarily blind and unable

to continue working in the commercial art field. Settling into a life of domestic drudgery, she cooked and cleaned like a servant for her father, as well as for Catherine and Claudia, her two little sisters who remained at home in Williamsburg. Her mother and her two older sisters had moved to Charlottesville, while the two O'Keeffe sons had left home.

Georgia was not the only O'Keeffe who had been sick. Ida had moved to Charlottesville, probably on the advice of her doctor, to be near the Blue Ridge Sanatorium for tuberculosis sufferers. She may have contracted the deadly consumption from her brother-in-law, Bernard O'Keeffe, whom she had nursed in Sun Prairie. In any case, Ida's move reflected the popular wisdom of the time, which held that relief from incurable tuberculosis was to be found in drier climates. Wet, coastal Williamsburg irritated the lungs of tuberculosis sufferers. Charlottesville, although hardly arid, was drier because it was located in the inland mountains. Ida and the two older girls—Ida and Anita—opened a rooming house there, as they had in Williamsburg. Ever since their father had fallen on hard times, room and board had continued to be the O'Keeffe family business.

Located only steps from the entrance to the campus of the University of Virginia, 1100 Wertland Avenue—a narrow, two-story nineteenth-century red brick structure of no particular style, fronted by thin Greek Revival columns and a continuing warren of small rooms encroaching on the backyard—was an ideal place for a rooming house. Wertland Avenue was one of Charlottesville's grandest addresses—and if neighbors later recalled that the O'Keeffes were not a friendly family, it was only partly because they were not particularly sociable by nature. Ida O'Keeffe and her two daughters were hiding a big family secret. Because tuberculosis was highly contagious, in 1908 the Commonwealth of Virginia had passed an act barring tuberculars from renting rooms. It seems highly unlikely that lodgers would have boarded at the O'Keeffe house had they known of the condition of the landlady. Although Ida had been

very sick in Williamsburg, by the time they arrived in Char-
lottesville, the tuberculosis had gone into remission. Tu-
berculosis tends to move slowly; the early signs are generally
a faint cough and pale pallor—symptoms easily disguised
by southern belles, who were expected to look faint and
pale anyway.

Nurturing secrets and hiding from others were extremely
prominent traits in the O'Keeffe family. While Georgia was
growing up, no one had ever talked about the rakish Hun-
garian count who bolted, even though she had been named
after him. A little later, no one had talked about Frank
O'Keeffe's repeated business failures or his alcoholism. Now,
no one talked about the mother who was dying—in fact,
the year she finally died, one of Georgia's teachers was sur-
prised to learn that she had been sick—the secret that had
actually placed the family on the wrong side of the law. In
later years, Georgia could not bear for people to know such
truths about her and would fire writer after writer who
attempted to tell her story. "Oh, now I suppose you'll tell
everybody about me!" she once exclaimed to a cook after
she had dismissed her in a fit of ill temper.

Georgia hated this period of her life. Years later, she con-
fessed that for the first time in her life, marriage had seemed
like an option in these trying days. Dannenberg, her beau
from the League who had been writing to her sporadically
from Paris during the intervening years, asked her to ac-
company him back to Europe when he next returned to the
States. She would have left with him if he had actually come
back, but he failed to materialize. In fact, O'Keeffe long
attempted to avoid a legal union with the man she finally
did marry, refused to take his last name after they were
married, and eventually left him as her mother had left her
father.

In the spring of 1911, O'Keeffe's old headmistress and
friend Elizabeth May Willis came to her rescue by inviting
her to Chatham to teach art for a few weeks in her place.
The words of Eugene Speicher—that she was only going to
become a teacher in a girls' school—must have rang through

her head at that time, but teaching seems to have been a welcome respite for her from what she had been doing in Williamsburg—and would continue to do for the next year.

In Williamsburg, Georgia had become Auntie to her two little sisters, whom she bossed like a magpie. She allowed her later-famous temper to surface and exerted the same control she attempted to exert in relations with her sisters for the rest of her life. Catherine, a plain-looking young woman (and the only O'Keeffe sister who would outlive Georgia), fought back with mixed results. "No one ever told Georgia what to do," she later pointed out bluntly. "She was it. She had everything about her way, and if she didn't she'd raise the devil." Claudia, who was an unregenerate tomboy as Georgia herself had been, preferred to wear mannish clothes and was the baby of the family. She idolized her eldest sister and gave in to her demands. Georgia would share more of her life with Claudia than with any of her other sisters. Many people who knew both sisters when they were older thought that Claudia was merely a pale reflection of Georgia. "You," the elderly artist would say to Claudia in their dotage, "were always like that!"

It is no wonder that Georgia appears to have been out of humor as she approached her twenty-fourth birthday in November 1911. The future offered her only menial employment in her family's house. Her father was going out of his mind, while her mother was slowly dying in another city. Her goal of becoming a famous artist had failed to materialize. Her swain had left her behind. Like Atlas, she felt the responsibility of her little world resting on her shoulders. She bent over a stove every day, kept after a couple of adolescent girls the rest of the time, and was both daughter and wife in an incestuous tangle to an indigent father who rarely spoke. Ten years later, artist Marsden Hartley detected an undercurrent of her past suffering when he wrote tellingly, "Georgia O'Keeffe has scorched her feet on the laval effluence of terrible experience." O'Keeffe recoiled with horror at these words. Her past was a private matter, for her.

Yet there are many miracles in O'Keeffe's story, and the

most remarkable of them occurred in the summer of 1912. It was a halcyon summer in which new ideas were coming to fruition all over the world. Igor Stravinsky was changing the course of music with *The Rites of Spring*. Pablo Picasso and Georges Braque were dancing an artistic pas-à-deux in Paris. In Vienna, a physician and neurologist by the name of Sigmund Freud was seeing his ideas about sex accepted in languages other than German. At the University of Virginia, male faculty members defined themselves as feminists; and in a pristine white studio on the elegant Georgian campus that Thomas Jefferson had laid out according to the sacred principles of geometry, a spritely man with bright red hair was teaching a group of women the principles of modern art.

Alon Bement was a disciple of the revolutionary art educator Arthur Wesley Dow. His method of teaching art had been slowly adopted in sophisticated communities, primarily in New England, since the turn of the century, replacing the traditional method of teaching art. It was also being taught at the University of Virginia. During the summer, Anita O'Keeffe and her sister Ida had been attending classes at the university to acquire teaching certificates. Returning home after the first class, Anita excitedly told Georgia about the new way of learning art she had discovered in school. (Georgia had moved to Charlottesville with her father and the little girls when her parents were reunited in 1912.) From what Anita had grasped on her first day, the class seemed like something that would interest Georgia. Like many of her friends and family members, Anita was disappointed that Georgia had stopped producing art; she wanted her to continue her studies. Georgia was interested in what Anita told her and decided to visit the class.

Alon Bement was an effeminate man who sometimes distracted his students by wrapping bolts of brightly colored Oriental fabric around his torso like a sarong, but Georgia had no trouble getting at what he was saying. The scales fell from her eyes, and suddenly she could see. Instead of copying the works of others, the Dow Method, as it was known,

advocated that students produce original artwork from the beginning of their instruction. Unlike other programs Georgia had taken, the Dow Method actually discouraged students from copying the works of other artists. "That which *anybody* can do," Dow outlined in an 1899 edition of *Composition,* "is not worth doing. If your drawing is just like your neighbor's it has no value as art."

Practically everything Georgia O'Keeffe would become as a mature artist, she acquired in those few classes during the sultry southern summer of 1912. She drank Bement's ideas in slowly and fully, savoring each drop of the precious new liquid of learning. There was no rush, no pressure, no competition. Almost immediately, she became Bement's star pupil—a hollow distinction, to be sure, for it was a classroom of women being trained to teach young children, not potentially famous artists pressing to get a seat in the front of a crowded classroom. But nor were there young men telling her she was not going to succeed. Georgia painted as she wished, without fear of rejection or censure. She had embraced the freedom to be a fool that is the hallmark of creativity. For the rest of her life, she would seek to recreate these ideal conditions, a search that would ultimately take her to a remote desert village of mostly primitive Spanish-speaking people and force her to drive away all but the most necessary influences.

To many people in 1912, the work Georgia created that summer would have appeared simpleminded. A series of exercises designed to train the eye to feel instead of to think, Dow's course of study was based on an Oriental model of beauty in which less was more. Using brushes and pots of ink, students were asked to make clear lines on a piece of plain paper, defining vertical and horizontal space with boxes and repeated lines. In each succeeding exercise, lines were added to the drawing. Finally, the finished artwork suggested, perhaps, a tree and a house—or some other simple composition. Colors were added sparingly. Purity was valued. Originality was encouraged. Goals were simplified.

"The most important fact relating to a great work of fine art," wrote Dow, "is that it is beautiful."

Alon Bement and Georgia O'Keeffe struck up a friendship that would last for years. In a certain way, they actually complemented each other. Bement, nicknamed Bementie, appeared as effeminate as O'Keeffe was manly. He was probably the first feminine man with whom she had close contact—and when Ida and Anita laughed at him, she came to his defense. "My sisters think he is a joke—almost detestable," the young artist explained. ". . . I am really very fond of him." O'Keeffe—single, without a beau at twenty-four, stuck at home with her younger sisters—could easily sympathize with others who, like her, were different. At the end of the term, Bement returned to New York, where he taught the Dow course at Columbia University's Teachers College during the winter. The following summer at Virginia, he asked O'Keeffe to help teach his class. O'Keeffe seized the opportunity like a starving person who has been offered a morsel. Would she? Of course she would. To satisfy a university requirement that instructors in the education school have a year's experience teaching in a public school, Bement even arranged a job for her, through the placement office, in Roanoke, Virginia—a small industrial city in the Blue Ridge Mountains approximately a hundred miles south of Charlottesville.

O'Keeffe wrote excitedly to her school friends from Chatham, reporting this turn of events. Having watched their friend buckle under the demands of her family, her classmates were thrilled to learn of her new prospect. News even reached Alice Beretta, a classmate who had not thought much of Georgia during their years together in boarding school. Beretta had returned to Texas, where her family lived, after her graduation from Chatham. She now wrote to tell Georgia of an opening in the public schools in Amarillo for an art instructor. Georgia applied for the job, and with the recommendation of her classmate, she received an offer to come to Texas.

In 1912, Amarillo was a place of considerable wealth but almost no sophistication. Believed to have been named after the Spanish word for yellow, probably because of the surrounding grasslands, Amarillo was founded in 1887—the year Georgia was born—as a settlement of tents occupied by western buffalo traders. A few years later, a north-south rail line crossed an east-west line, an event destined to create a real town—and it did. The site of a brisk trade in buffalo and cattle byproducts, in no time Amarillo held the dubious distinction of bone capital of the West—possibly an early source of the artist's interest in bones. In 1912, when O'Keeffe arrived, a large stockyard occupied downtown, and giant frame mansions rose on the plain along wide avenues named after each of the states. There were no trees more than four feet tall. A single road stretched out of town to a place where land met sky.

Amarillo was not an easy place to live. The wind blew for weeks, sometimes months, without cease. In summer it was hot and windy. In winter it was cold and windy. Even in the days before the discovery of petroleum, people settled in the area because they wanted to escape life back east and strike it rich. O'Keeffe was rare among settlers to find the desolate geography a thing of beauty, and she flourished in the maddening climate. "To see and hear such wind was good," she said. "I can remember a buggy being blown a block, a house being turned over. When the creeks overflowed, they washed benches down the stream."

She could not escape convention, however. Even in Amarillo, at the edge of civilization, her eccentric ways raised eyebrows. She settled in the Magnolia Hotel, a low-life trade hotel next door to a raucous saloon with a swinging door. The month she arrived, a man was killed outside her hotel. Most of the other teachers roomed in a boardinghouse run by the Methodist Church. Watching with awe while cowboys, hungry from their work on the plains, ate "three dinners, one right after the other," the artist reveled in her new life. She played poker and dominoes with the men and became friends with them, seeming to enjoy being taken for

one of them, as she had in the past and would in the future. "She dressed like a man," a student exclaimed seventy years later. ". . . I mean man-tailored suits and oxfords that were square-toed. Her hair was cut just like a man's—short."

It would be easy to conclude that O'Keeffe lived in the Magnolia Hotel so she could pursue a hidden sexual agenda. Homosexuality was prevalent on the edge of the western frontier—historians now know that San Francisco contained the same high percentage of gays in the nineteenth century as it does today—and it would have been easier for the artist to form liaisons away from the disapproving gaze of her fellow teachers. And in fact, O'Keeffe later allowed that she had lived in the Magnolia and avoided other teachers because she was afraid she would be exposed as a fraud. In a way, she was. Having taught for only a couple of weeks at Chatham, having received only one term of instruction in education at the University of Virginia, and having completed only two years of art school, she felt that she was not fully qualified to teach in the school—and she probably had lied to get her job. There was no BA or MA after her name, but the *Amarillo Daily News* listed Georgia O'Keeffe, teacher in art, as "recipient of the highest degree known to her profession."

O'Keeffe hardly kept her feelings to herself, however. Within a few weeks she was embroiled in a controversy over the course of instruction of art. She refused to accept the Prang drawing book that the school district had ordered for her classes. Although she herself had used the book as a youngster, she saw no reason to saddle her students with its repetitive exercises. She requested to use the Dow Method that she had learned the previous summer in Charlottesville, asking her students to bring grasses from their yards to draw. One day, at her urging, a student brought his horse into the classroom to draw, prompting the principal to reprimand her.

O'Keeffe was a gifted teacher, one of those rare instructors to whom students felt particularly close. Seventy years later, one of her students recalled fondly that she took her class

out into the plains to look for beauty in everyday things. "And we never thought the plains were a beautiful place," the student marveled. Another student pointed out that O'Keeffe's classes were never noisy like most of the other ones in the school. "Everybody," he said conclusively, "was interested." Many of the students in Amarillo came from rough backgrounds, and Georgia shared the strength she had found in her twenty-four years to overcome adversity. This was the beginning of her lifelong interest in youngsters—particularly boys—who struggled against the world, an interest that would eventually lead her to befriend a young man in prison and to allow another troubled young man to guide her as she grew old.

In many ways, Amarillo was lucky to have her—and she was lucky to have found the place. Had she gone to Roanoke, as she had originally planned, she might never have discovered the West. The students in her classes had been conditioned to think of their surroundings as bleak and desolate, and that beauty was a thing found in the East and Europe. Borrowing from the philosophy of the arts and crafts movement and the teachings of Arthur Dow, O'Keeffe taught her students that there was incredible beauty to be found in a simple basket, in a long sunset out on the plain, or in a patchwork quilt on their mother's bed; that there was music in the sound of cows braying in a stockyard.

Artistically, Amarillo was a blank slate. Left alone out on the plains with a copy of Dow's *Composition,* the nascent artist could develop her own mystical expression of the western landscape. It was a heady time for O'Keeffe. Freed of filial obligation, away from the grime of Chicago, the chauvinism of New York, and the claustrophobic southern life of Virginia, she practiced her art without criticism. Instead of ducking into a dark church for spiritual sustenance, as she had in Chicago, she rode out onto the plains and drank in the high blue sky. Instead of copying the works of masters, as she had in Chicago and New York, she found inspiration in fields of grasses on a treeless plain.

At one point, during the first of her two years in Amarillo,

she rode south on the plain and discovered one of the wonders of the American West. Known as the Grand Canyon of Texas, Palo Duro Canyon was a slit in the plain several miles deep. Like the Grand Canyon, Palo Duro encompassed a wide range of beautiful sandstone formations in many shades of red and yellow. To stand at the bottom of the canyon was like standing in a bowl of red light. O'Keeffe felt compelled to capture the beauty of the place on paper. Expressing its size and shape and color eluded her, however, and for nearly four years she would struggle to put down how she really had felt at the bottom of that crevice in the otherwise flat land of West Texas.

After her years in Amarillo, she would never be the same. She did not save her work from this period and would not create her great Texas pictures for several more years, but she had found something she really wanted to depict in the land out west. Like many other landscape artists, she had seen shapes and figures there that she had seen only in her mind before. Something changed in her approach to art, and she began to produce distinctive artworks that were all her own. When she returned to Charlottesville for the summer of 1913, her sister Catherine was among the first to notice the difference. She observed that when Georgia came back from Texas, she "seemed to be drawing just for herself." The artist's work was, she said, "like that of no one else."

Chapter 5

· · · · · · · · · · · ·

Alfred Stieglitz was working late the day Anita Pollitzer arrived at the 291 gallery. It was New Year's Day 1916, as well as Stieglitz's fifty-second birthday; but the art impresario normally stayed behind after most people had gone home, even on holidays. Married in a loveless union whose purpose had been to join two family fortunes, Stieglitz was now one of those sad middle-aged men for whom home brings little cheer at the end of the day. From his large overstuffed club chair next to a black pot-bellied stove in the gallery in the eaves of the town house at 291 Fifth Avenue, he conducted his social life. Years had passed since his grandiloquent wife, Emmeline (née Obermeyer), had barred artists from their apartment. She found them, she had said, "dirty and anarchistic."

Pollitzer fit that description—she even described herself as "part Marxist, part anarchist, a believer in free love, female dress reform, women's suffrage, birth control, and the right of workers to strike." On this day she was also the self-appointed bearer of her best friend Georgia O'Keeffe's latest artworks. For the past two years, Pollitzer and O'Keeffe had been exchanging drawings in the mail as O'Keeffe pursued the career in education that she had begun in Texas and that had most recently taken her to South Carolina. O'Keeffe was often insecure about what she produced, and Pollitzer gave her needed feedback. The latest group of artworks—charcoal drawings of abstract landscapes influenced by the years she had spent on the western plains of Texas—particularly unnerved their creator. "I wonder if I am a raving

lunatic for trying to make these things?" O'Keeffe asked her friend. She reminded her that they had agreed to keep the drawings between themselves.

Pollitzer was a loyal friend who normally kept her word, but as soon as she saw the drawings O'Keeffe had sent to her, she knew she had to ignore her friend's request and show the drawings to Stieglitz. As she later said, "At certain moments in our lives, we know what we must do and when I saw Georgia's drawings it was such a moment." From the years she had been attending exhibitions in his gallery, she knew that Stieglitz was looking for works that were true expressions of the inner soul of their creator—a search that had enabled him to introduce to America such exotica as the carvings of African tribesmen, the art of the insane, and the art of children. Pollitzer decided to show the drawings to him, and she was right to have done so. Stieglitz looked at O'Keeffe's drawings as if he had found the solution to a puzzle that had eluded him for a long time.

"Finally," he exclaimed, "a woman's feelings on paper!"

Something happened to the art teacher out on the dusty plain that people would later spend decades trying to decipher: In less than two years she would be canonized as the woman artist of her time. But in the fall of 1914, her mind was still on more practical concerns. Having labored under the second-class citizenship of those who lack degrees—even though she had completed two years of summer school using the Dow Method in Virginia—she returned to New York to complete the requirements for a BA with Arthur Dow himself. With the assistance of her Wisconsin aunts, she rented a room for four dollars a month near the entrance to the Columbia University campus, where she enrolled in Teachers College. She also attended studio classes in painting at the Art Students League.

O'Keeffe was a different person this time in New York. Instead of the fearful and resentful young art student who had dramatically given up painting after a year at the League

in 1908, O'Keeffe at twenty-seven was a mature woman with a studied, personal style all her own. She may have appeared enigmatic and rigid to some, and she had the normal self-doubts of any artist, but she was no longer easily upset by the opinions of others. Being enigmatic was becoming a cloak for Georgia O'Keeffe, like the long black dresses she had begun to don, as if she were a very young, very mysterious widow. "There's something about black," she explained; "you feel hidden away in it." In her tiny room, which could accommodate only a single bed, she stripped her possessions down to a minimum in what would become her signature look. Painting the walls white and leaving them bare so as to suggest space, she covered the iron bed with white muslin, which she also hung over the window. The only color was provided by a single six-inch pot of red geraniums on the fire escape outside the room. Decades later, big-city newspaper reporters who did not understand modernist simplicity would compare the style of her quarters to a room in an asylum.

O'Keeffe even had the courage to write her own program of study. She convinced Charles J. Martin, an instructor of oil painting at the League, to allow her to work away from the rest of the class on still-life arrangements of her own. O'Keeffe permitted Anita Pollitzer and a third woman, Dorothy True—no men were allowed—to join her in a private section of the class, curtained off from the doleful glare of the disapproving. Pollitzer and True had become close friends the year before, when they were first-year students. But because she was older and more worldly, O'Keeffe immediately took the lead in the threesome, a lifelong pattern in which her work was the focus of an intense and sexually charged group of admirers.

Both Pollitzer and True were infatuated with O'Keeffe, who was seven years their senior. It was as if their older friend had blazed a trail that they wanted to follow, had been places and done things—had lived out in the wilds of the West by herself. It must have been quite a group, O'Keeffe, Pollitzer, and True. Pollitzer, at five feet, made up

for her diminutive stature with verve. With her strong po-
litical convictions, she would often climb the steps of a New
York brownstone to reach the height of the person with
whom she was arguing a political point. The daughter of a
prominent Charleston, South Carolina, surgeon, she wanted
to make her way in the world without the aid of a man and
to help other women achieve the same goal. Although she
was enrolled in an art program for teachers, O'Keeffe's best
friend would eventually devote her life to politics, rising to
the presidency of the National Woman's Party. A few years
later she would be jailed and tortured for voicing her beliefs
at a rally in Washington, D.C.

Dorothy True, born into an old New England family in
Mechanics Falls, Maine, had arrived in New York with little
of the confidence with which her patrician background
might have endowed her; she would never be jailed and
tortured for her beliefs because she was not sure what they
were. Blond, fine-featured, with the ever-present sexuality
of those in love with love, True was probably something of
a vamp: She bobbed her dusky blond hair, painted her full
lips ruby red, wore black fishnet stockings under slit skirts,
smoked cigarettes—and most of all, wanted others to like
her with the intensity of a person who is never fully satisfied.
Stieglitz used her image in a surrealistic photographic mon-
tage of body parts that pays homage to Man Ray. O'Keeffe
probably used her as well for an Art Nouveau–inspired
portrait of an unidentified full-lipped woman encircled by
cigarette smoke.

O'Keeffe seems to have been in love with Dorothy True.
Whether her love was requited is not known at this writing
and, since both partners are dead, will probably never be
known. But judging from the existing documentation, it is
safe to conclude that their relationship was more intense
than most same-sex partnerships. Adopting the dominant
masculine role that characterized certain lesbian couples at
that time, O'Keeffe often spoke of True as if she were a
hapless beauty who needed her direction. Protectively, she
asked Pollitzer to keep from True certain information that

she was afraid would hurt her. Marveling at True's deep fears and studied insecurities, O'Keeffe wrote that she wanted to "pick her up and lift her above and away from all the things that bother and worry her so . . . take her away from it all for always."

If O'Keeffe's relationship with True seems to have been visceral, her relationship with Pollitzer was intellectual. O'Keeffe confessed to Pollitzer that "you are little you know and I like you little but I also like you a lot," which has a flirtatious ring, but it appears to have been said playfully rather than sexually. An undercurrent of complicity seemed to bind the two women closer than most friends—but theirs was a complicity of colleagues. "Your letters," O'Keeffe wrote, "are . . . like drinks of fine cold spring water on a hot day— They have a spark of the kind of fire in them that makes life worthwhile—That nervous energy that makes people like you and I want to go after everything in the world— bump our heads on all the hard walls and scratch our hands on all the briars."

Pollitzer says of this period that O'Keeffe was producing "daring, imaginative designs, quite unrelated to Dow's own work, or to the work of his students." O'Keeffe, for her part, felt what she was creating was "rotten" and expressed confusion and consternation over where she was going with her drawings. Living out on the Texas plains had freed her to do as she wished with her artwork. There, no one had cared about what she did, and no one had told her she could not do what she did. But being back in New York was another matter. Once again, she felt the pressure of the marketplace to create what others wanted her to, resulting in some rather self-destructive behavior because she would not relax. "There was never an idle moment," Pollitzer later wrote of her friend, "or gesture."

Pollitzer gave O'Keeffe confidence, and nearly everything the artist created went to her friend for review. After they parted at the end of the term, O'Keeffe mailed her tubes of rolled drawings almost weekly. "So far no one but you and

I like the flower study but I think it one of my best," she wrote her friend and guide.

O'Keeffe was thrilled to have found friends with whom she could share her work now. Although her friendship with True is less well documented, she and Pollitzer wrote each other nearly every day they were apart for three years and kept in touch for the rest of their lives. Pollitzer enhanced O'Keeffe's artistic life at a time when she was insecure about what she was creating and where she was going.

O'Keeffe enjoyed the security of a group. Being with True and Pollitzer, both of whom were more outspoken and assertive in public than she, enabled her to remain invisible when she went out. At 291, she remained on the sidelines; in fact, when Stieglitz later saw her drawings, he could not remember who she was, although he knew Pollitzer and True well. O'Keeffe found a different approach to art at 291 each time she went there: in exhibitions of Picasso's cubist works, of African masks and pre-Columbian figures, of pseudomechanical, cerebral Dadaist work by Francis Picabia, of childlike Abraham Walkowitz drawings. Although all three women were education majors intending to teach art, on the rare occasions when they dreamed of being artists, they agreed that 291 was where they would want their work to be shown.

Yet O'Keeffe was not even sure she wanted to show her work. Pollitzer felt that her friend was the leading woman artist in their group, and later recalled worshipfully that O'Keeffe's palettes were always "the cleanest" and her colors "the brightest." But the idea of a public exhibition of her private drawings brought the young artist considerable fear. Having been conditioned from an early age to keep family secrets, she probably felt that an exhibition would reveal far too much.

O'Keeffe was still bound to her family. In 1915, as in 1913 and 1914, she returned home to the O'Keeffe rooming house in Charlottesville to attend the University of Virginia summer school and help care for her invalid mother. (Her

father was often absent from home those days; of her sisters, only Claudia and Ida remained with their mother.) But this summer, through her friendship with Alon Bement, she met a younger man whom she liked as much as she had liked George Dannenberg, her beau from the League. An instructor of government at the university summer school, Arthur Macmahon was a pleasant-looking, fair-haired intellectual who had been valedictorian of his class at Columbia. Sexually ambivalent, painfully shy, a self-proclaimed feminist, Macmahon seems to have been allowed into O'Keeffe's inner circle, as other attractive men would be in her life, because he made no physical demands on her whatsoever. In another indication of the depth of her relationship with True, O'Keeffe asked Pollitzer not to tell their mutual friend about her friendship with Macmahon. She was afraid that True might imagine something that was not there and would become jealous. She reported with relief that her new friend never got "mushy."

O'Keeffe did not discuss her art with Macmahon; nor did she reveal to him what was on her mind. By turns awkward and self-conscious, the surviving letters show her attempting to forge an intellectual relationship with him by discussing what he was interested in. She expressed concern over the state of contemporary education—a topic she does not seem to have bothered with on any other occasion. Macmahon introduced O'Keeffe to the analysis of historical European battles, a popular intellectual pursuit at this time, and gave her an understanding of the deeper meanings of Thomas Hardy's *Jude the Obscure,* and a quick review of the latest articles from the left-wing *New Republic.* Soaking up his knowledge during long walks in the southern mountains, the young artist expanded her education in lessons from her erudite suitor.

Macmahon also introduced O'Keeffe to a book published in 1913 by Floyd Dell, another male feminist: *Women as World Builders.* This book, a popular study of feminism written in an easily digested style, presented seven women— among them Isadora Duncan, Beatrice Webb, Emma Gold-

man, and Jane Addams—as feminists who put themselves before the needs of men or family. "The woman who finds her work will find her love . . . ," Dell wrote, a cornerstone of O'Keeffe's later beliefs. "But the woman who sets her love above everything else I would gently dismiss from our present consideration as belonging to the courtesan type."

Feminism was easy for Georgia to accept—strong women populated her entire family, from her grandmothers O'Keeffe and Totto to her aunts Lola and Ollie. Even her younger sisters were emerging as independent women. Unlike many middle-class women in the early twentieth century, O'Keeffe did not have to break the chains of marriage imposed by a rigid family; marriage was actually discouraged in her family. Of course, she agreed with feminists that women should have the right to vote and receive equal pay. But the feminist movement itself often eluded her grasp, in part because she did not subscribe to a belief in the underlying cooperation among women, which is the spirit of feminism. O'Keeffe tended to dominate other women, and she looked up to certain men as superior beings—neither of these are feminist traits. As a very old woman, O'Keeffe turned her back entirely on feminism—a move that confused those who had used her as a role model of a strong woman. In the early seventies, sounding like a unregenerate curmudgeon, the elderly artist told a writer that she did not see what feminists could achieve by "jumping around that way."

Two miles from Columbia, the capital of South Carolina, Columbia College was a demoralized southern finishing school operated by the Methodist Church. It was possibly the last school on earth where one would expect to find as a teacher a radical artist whose friends were self-proclaimed anarchists. O'Keeffe arrived late for the fall term of 1915, indicating that she had chosen to take this job in a last-minute decision because she once again had no money to return to school herself. A few weeks after she arrived, she

was told by the daughter of one of her colleagues that she looked like a man, reopening an old wound that had been closed during the period she lived in New York. A few weeks later she complained that she went to bed every night with a headache. Nevertheless, she began to report that she was making some breakthroughs with her art, as if she needed to be alienated in order to work. Once again she had chosen a place so provincial that no one would care what kind of mad scribbles she wanted to call art, a place where she could hide from the world, as she had for two years in Amarillo, to put down on paper that which was "truly mine," to uncover the "things in my head that are not like what anyone has taught me—shapes and ideas so near to me—so natural to my way of being."

O'Keeffe's determination was reinforced by a visit from Arthur Macmahon. Struggling by herself in the depths of South Carolina was not easy—and it helped to have a familiar face before her. During the fall she had been writing increasingly passionate letters to her suitor. In fact, her letters were so fiery that in a letter to Pollitzer she wondered— with good reason—if they really expressed the way she felt about him. She was also afraid that she was using him as an emotional outlet for her feelings about other people, possibly Dorothy True. Finally, in November, Macmahon made an overnight train journey from New York to visit her for Thanksgiving. "I'm the gladdest person in the world," she wrote back, an indication as much of her love for him as of her desperation in South Carolina. They took long walks in the southern pine woods, held hands. At O'Keeffe's instigation, they made love. "The world looks new to me," she wrote Pollitzer the day after Macmahon left.

One night after Macmahon left, using the wide and flat Texas landscape as a point of reference, the artist closed her eyes and imagined how it felt to be standing on the plain outside Amarillo. She put a roll of paper on the floor, knelt down, and began to draw with a piece of black charcoal. From the time when a boy had made a pass at her on a boat at Lake George, O'Keeffe had visually experienced land-

scapes when she considered her sexual feelings. Now, fresh from her sexual encounter with Macmahon, she was going to put it down on paper once again—this time for posterity. She had found her talent: an ability to interpret a psychosexual landscape in a way with which millions of other people could identify. When she imagined West Texas, she saw dust roaring off the plain in bulbous clouds and heat rising from the flatness in waves of gases. She recorded these impressions as a clairvoyant receives messages from the other world. The act was as spontaneous as it was frightening: there on the paper was her soul in a horrific mass of lines and forms. "Did you ever have something to say and feel as if the whole side of the wall wouldn't be big enough to say it on?" she asked Pollitzer after she had completed the drawings.

If it were not for the friendship she had forged with Anita Pollitzer, O'Keeffe might well have tossed the drawings into the wastebasket, as she had been doing for years and would continue to do with anything that bothered her too much. Although O'Keeffe had insisted she keep the drawings private, she could not control what Pollitzer did with them. Now her friend needed to talk to someone about her work, an indication of just how great they were.

Stieglitz was entranced from the start by what he saw. For the better part of an hour, he examined each drawing carefully, holding them as though they were fragile ancient manuscripts.

"What woman did these?" he asked.

"Georgia O'Keeffe—my friend ..."

"Are you writing to this girl?" he asked.

"Yes."

"Will you tell her for me," he said softly, "that this is the purest, most sincere work that has entered 291 in a long while."

There was a pause while he again focused on the work. He stroked his bushy moustache. He adjusted his pincenez. He loved what he was seeing. Years later, O'Keeffe maintained that Stieglitz fell in love with her on that day,

before he even knew who she was, insisting that it was the work he really loved, not the person. A Santa Fe woman told me once that when she was young, she went to 291, where she introduced Stieglitz to a friend who knew him as the husband of Georgia O'Keeffe. "Madame," he said, correcting her gently, "you are mistaken. These," he said, pointing to O'Keeffe's paintings, "are her husbands."

Pollitzer tried to take the drawings back. Stieglitz held on to them with his thick fingers as if he could not let them go. And then he said, under his breath, as if to himself, "I think I will give these drawings a show."

Chapter 6

.

In the spring of 1916, Georgia O'Keeffe returned to New York to complete her degree. One day she was in the cafeteria at Columbia eating lunch by herself when a fellow student asked her if she was *Virginia* O'Keeffe. Amused that the man had confused the name *Georgia* with *Virginia*, another southern state where she had once lived, she laughed and replied that she was in fact *Georgia* O'Keeffe. The student replied, "Oh, Virginia O'Keeffe's having a showing at 291."

Without finishing her lunch, O'Keeffe ran out of the cafeteria and rushed down to 291 on the Fifth Avenue omnibus. In a little less than an hour, she arrived at the gallery. She was certain that only one O'Keeffe could be showing at that avant-garde showplace—and she was right. There on the grass-cloth-lined walls of the tiny gallery were her private drawings of how she had felt sexually when she considered the western landscape. For years, seeing her work on the walls of a gallery would throw the artist into a tailspin. Even after she had become established, she took to her bed for weeks after shows. This time she was enraged.

Since Stieglitz was away on jury duty the day she arrived at the gallery, O'Keeffe had to wait until the next day to confront him. Even so, she was still furious. Her fear of losing something she could not regain came bursting out of her otherwise calm exterior like water over a dam. She threw herself into an imbroglio with Stieglitz that resembled the fight she had witnessed in 291 in 1908 when she was a young schoolgirl.

"Who gave you permission to hang these drawings?" O'Keeffe demanded to know.

"No one," Stieglitz answered calmly.

"You will have to take them down!" she insisted.

"I think you are mistaken," he pointed out. Stieglitz was unaccustomed to people challenging him. He indicated that he found her troublesome by raising his voice an octave. But O'Keeffe would not be bullied.

"Well, I made the drawings. I am Georgia O'Keeffe," she declared possessively, motioning to the works on the walls with her hand.

By any conventional gauge, O'Keeffe should have been thrilled to be included in a show at 291. 291 was the premier showplace for the type of art O'Keeffe was creating. Her work would have been seen by writers like William Carlos Williams and Sherwood Anderson, by collectors like Walter Arensburg and Leo Stein (the brother of Gertrude), by social arbiters like Frank Crowninshield, the editor of *Vanity Fair*. A show at 291 gave artists and their work the widest possible exposure to the world of people who wrote and spoke about contemporary art.

The artists in Stieglitz's orbit were not just painting pretty pictures. Through varying degrees of abstraction, they were pursuing universal truths about the nature of civilization. Quoting from the philosophy of Friedrich Nietzsche and Wassily Kandinsky's *Concerning the Spiritual in Art,* these well-read intellectuals were considering the latest topics of human discourse in art. Many of them, like O'Keeffe, were exploring the American landscape through modernist eyes. John Marin, a compact man who wore his hair in bangs, composed landscapes of the Maine seacoast using the geometric, cubist idiom. Arthur Dove—quiet, pipe-smoking, aristocratic, a farmer who had been living near Long Island Sound in Connecticut—composed small, tightly constructed abstractions detailing his inner experience with the land.

Others, like O'Keeffe, were exploring their interior landscape through their work. Marsden Hartley, a regular con-

tributor to exhibits at 291, was a secret homosexual who had expressed his desire for other men while living in Berlin, where he fell in love with a German soldier. Possibly because she recognized her own repressed desires for the same sex in Hartley's work, O'Keeffe was fascinated by the colorful, geometric shapes in his canvases. Although she later dismissed Hartley's work—"a brass band in a small closet" was what she called it—she was so entranced by it in 1916 that when Stieglitz observed her studying the paintings, he offered to let her take two of them home with her to complete her experience with them.

291 was no ordinary art gallery. It was intended to be a spiritual place, often referred to as a cathedral or laboratory, and Stieglitz refused to discuss money with people who came in off the street. The work came first. When asked how much a work of art was worth, he would often reply, "Invaluable," a sales device that tended to whet the appetite of the purchaser and often resulted in very high prices for the sale of certain pieces. That is, if he ever would sell the work at all. Stieglitz often permitted people like O'Keeffe to take home work that they could not afford to buy and at the same time refused to sell work to people who could afford to buy it because he did not think they appreciated what they were getting.

Instead of forcing artists to sell their works to just anyone to pay for their expenses, Stieglitz arranged for wealthy people to underwrite artists' careers, dunning people to help Hartley live in Europe, others to subsidize a crippled artist who could not afford food. When a wealthy friend of O'Keeffe's later went to the gallery to see about buying a painting, Stieglitz told the woman and her husband that the price would be two years of the artist's living expenses. When Stieglitz became upset because John Marin had used his annual stipend from 291 to buy an island in Maine, O'Keeffe was amazed to learn that anyone could even make a living making art—let alone buy an island.

291 was a wonderful place for an artist to have been connected in 1916, assuring, as it did, complete artistic

freedom as well as a certain type of security. Even O'Keeffe's initial reaction on learning that Pollitzer had shown Stieglitz her work—and that he had liked it—had been one of bemused gratitude. Life in South Carolina had been very lonely and tragically isolated, any news would have been welcome. She even doubted her sanity: "you get mightily twisted with yourself at the tail end of the earth with no one to talk to." So when Anita's letter appeared on January 3, O'Keeffe was thankful, although strangely detached from the news. "There seems to be nothing for me to say," she wrote wistfully to Pollitzer, "except Thank you—very calmly and quietly. I could hardly believe my eyes when I read your letter this afternoon—."

Within a few days, however, the news had sunk in and O'Keeffe succumbed to self-doubt. She wanted to know why Stieglitz and Pollitzer thought her drawings were exceptional, wondered what right she had to express her feelings. She knew herself that they were "essentially a womans feeling . . . things we want to say—but saying them is pretty nervy." Releasing expressions as private as these early charcoals awakened a fear of exposure in the artist, a fear that was only encouraged by her family's secrets about illness and infidelity and abetted by her growing recognition of her own homosexual feelings and the woeful lack of outlets for them.

In a series of stiff, deferential correspondences, O'Keeffe wrote to Stieglitz himself to find out what he thought of the drawings firsthand. At fifty-two, Alfred was the same age as Georgia's mother and a world-renowned figure in the art world. O'Keeffe was an uncredentialed teacher in a southern finishing school. So when she wrote to him, she did so cautiously, blurting out in one sentence: "If you remember for a week why you liked my charcoals that Anita Pollitzer showed you—and what they said to you—I would like to know if you want to tell me." It was as if she did not believe that Pollitzer had told her the truth and needed reassurance from Stieglitz himself, as if she were saying, pinch me so I'll know I'm not dreaming. The doubts that hung over her

creation would linger long after she had achieved great fame. And she would often feel that people liked her artwork for the wrong reason. "I am afraid people wont understand— and I hope they wont—and am afraid they will," she explained in 1915. She always thought she needed to let others know how she had felt when she was making a picture, in the hope that they would feel the same way. After Stieglitz told O'Keeffe himself that he had in fact said what Pollitzer had reported to her and told her how great her creation was, their correspondence stopped abruptly for no clear reason.

It was a few weeks after she received Pollitzer's letter that O'Keeffe quit her job in South Carolina in the middle of the term to return to New York to complete her degree in education. A school by the inauspicious name of West Texas State Normal College had offered her a job teaching art to home economics students beginning in the fall of 1916, on the condition that she complete her degree at Columbia in the spring. She was more excited about this job than she was about the prospect of showing at 291, or about her relationships with her New York friends Pollitzer and True, or about Macmahon or Stieglitz. It seems that O'Keeffe loved the plains of West Texas more than any art gallery and more than any dream of becoming the first female Picasso. She found her reason to live in landscapes, spending much of her life in pursuit of them and of what could be called a spiritual union with the natural world. "Kick your heels in the air!" she exclaimed to Pollitzer in late February. "Ive elected to go to Texas and will probably be up next week. . . . I'm going. I'm chasing it—hunting for it at a great rate."

This time in New York, O'Keeffe worked very hard and lived on very little. Having arrived in the city with only a few cents to her name, she lodged in a spare room at Anita Pollitzer's uncle's house and worked overtime trying to cram the rest of her degree requirements into one term. Her tuition was presumably picked up by the university in Texas that had required her to attend school. She cut off her affair with Macmahon before they were able to sleep together for a second time, heartlessly telling him that she wished he were

a girl so she could like him more and that she regretted having told him that she loved him.

Along with Pollitzer and True, O'Keeffe attended several exhibitions at 291, including the Marsden Hartley show, where Stieglitz gave her two pictures to take home and study. There is no record of what they said to each other when they first met in the gallery, nor any record of what O'Keeffe asked Stieglitz to do with her drawings, about which they had corresponded. It seems never to have occurred to her that he might decide to hang them without first consulting her. But Stieglitz could hardly keep the drawings to himself, showing them to everyone who walked into 291. Hartley began to refer to O'Keeffe's work as Stieglitz's "celestial solitaire."

As O'Keeffe stepped out of the small elevator, she was determined not to give in to Stieglitz's demands. Like many otherwise shy people, O'Keeffe confronted those who opposed her with a blast of fury. She needed to build her strength, like a wave rising out of an ocean, to crush her opposition with the power of her convictions. She had not yet learned the art of gentle persuasion—nor, it seems, would she ever. Nearly everyone who came near the artist recalled her short temper. Juan Hamilton called it "the snakebite." Stieglitz watched with bemused detachment while O'Keeffe fumed. Years later he maintained that what he found most remarkable about his first confrontation with her was the way she continued to smile as she upbraided him for exhibiting her work. Seeing her smile was an occasion few people ever enjoyed—and it was strange that she would smile only when she was upset and not when she was pleased, normally. It was a stand-off, typical of the disagreements they would have for years to come. O'Keeffe found it nearly impossible to convince Stieglitz to do what she wanted him to do, and he found it impossible to get her to do what he wanted her to do—although each of them would have insisted that the other always got their own way.

"You don't know what you've done in these pictures," Stieglitz pointed out arrogantly.

"Do you think I'm an idiot?" O'Keeffe asked rhetorically, as she repeated her request that he take her work down from the wall and give it back to her.

Stieglitz was intractable. He would not take her work down. Nor did he need her permission to show artwork in his possession, pointing out that she had "no more right to withhold those pictures than to withhold a child from the world." He was echoing a common modern art assumption that the work of an artist was the offspring of its creator, whose rights to it were usurped the moment the work was created. O'Keeffe was fascinated by the analogy between creation and giving birth—a notion generally uniformly applied to both men and women, although some misinformed observers have felt that it was applied only to women. Even after a lifetime of work, however, the artist refused to let go of certain artworks that she wanted to keep nearby and often sold her work with restrictive conditions and later even tried to reclaim other artworks.

Their disagreement was ended when Stieglitz invited O'Keeffe to luncheon at the nearby Holland House. His wife had given him an allowance to take the "anarchistic" artists out to lunch. Alfred Stieglitz was going to enjoy his first meal with Georgia O'Keeffe.

Chapter 7

.

O'Keeffe stepped into the tiny elevator and once again rose to the top floor of the brownstone at 291 Fifth Avenue. A year had passed since she had last visited the gallery. This time the tables were turned, and it was she who was going to surprise Stieglitz. Without alerting him, she had returned to New York from Texas specifically to see the first solo exhibition of her artworks. Stieglitz had mounted the show in her absence.

The past year came back to her as if she were a movie actress reviewing rushes of film over a year's time. Nearly all the displayed work had been inspired on the plains of West Texas, where she had been teaching at West Texas State Normal College in Canyon. The wide open land had become as important to her as Mont Sainte-Victoire was to Paul Cézanne. "I am loving the plains more than ever it seems," she had reported enthusiastically to Pollitzer shortly after arriving in Canyon in September 1916. In the series of complete abstractions, primarily in watercolors, now hanging on the walls of 291, she could see again the first light of the open sky of the flatland at daybreak, stars at night, a train on the plains. Remarking, after he had received a roll of drawings from Texas, that he was "riveted" by the work, he had concluded in awe of what he regarded as his discovery: "—the sensual quality of it is staggering—."

Knowing that Stieglitz would welcome anything she produced had freed her to stretch her work to new limits. She had seized the opportunity and made a piece of sculpture that was included in the 1917 exhibition. Sculpture was not

her forte—she would not produce another piece of three-dimensional art until the 1930s. But *Bending Figure* was perhaps the most personal expression O'Keeffe would create in all her long life, inspired as it was by the death of her mother, Ida, on May 2, 1916 (a few weeks, coincidentally, after O'Keeffe had demanded that Stieglitz take down her work from 291).

The final chapter of Ida Totto O'Keeffe's story had been horrific. With her husband once again absent, she had been left alone with two of her daughters: Claudia, a high school student, and her namesake Ida, who was listed as a teacher of art but did not seem to make enough money to pay the rent or buy food for the household. Georgia's mother was living in a state of abject poverty, made all the worse by her grown children's inability or unwillingness to support her—or themselves. Georgia was still a student at twenty-nine. Twenty-five-year-old Anita, although she would grow into a woman who seemed armored against the world, was not yet stable, either. Earlier in the year she had returned home from nursing school suffering from what appears to have been a nervous breakdown. Then, following her own logic, Anita had aborted a child she had conceived with her beau, only to marry the father a matter of days before her impoverished mother passed away. Anita's husband was nineteen-year-old Robert Young, a University of Virginia dropout who would one day become one of the world's wealthiest men. Nor were the two O'Keeffe sons around at the time of their mother's death. And Catherine, who later remarked that the O'Keeffes "were never a close family," said she did not remember her mother's death.

How anyone could have forgotten the death of Ida O'Keeffe remains a mystery, for the events surrounding her death were as tragic as a Russian novel. The day she died, the landlady came to the door of 1100 Wertland Avenue and demanded the long-overdue rent. Her daughter Ida answered the door. Father was "on the road," working in the "trucking industry," she told the landlady, in a proud effort to make his truck-driving job sound professional but

insisting that there was no money for rent. The landlady would not be moved—she refused to leave the house until she saw Mrs. O'Keeffe herself. Georgia's mother arose slowly from her sickbed, and after a few feeble steps, she collapsed on the floor in front of the shocked landlady and her two daughters. She gasped for air—and died in a pool of her own blood. No one outside the family knew how close to death Ida had been. The landlady had not even known that her tenant was suffering from tuberculosis. Her condition had been a closely held secret, as was the state of the family's larder. Neighbors who came to help the O'Keeffe girls prepare for the funeral discovered to their dismay that there was no food in the house. Claudia later told a niece that they had subsisted on squirrel meat from prey she herself had shot.

For Georgia, the story of Ida Totto O'Keeffe's death would become an albatross that she would carry around with her shamefully. The most obvious conclusion had been that Ida had found it preferable to eat squirrel meat rather than let other people know there was not enough food. When things were going poorly for the artist, she too would find it extremely hard—if not impossible—to reach out and let others know about it. Nor was she generous when things were going well. Her sister Ida suffered from an economic collapse during the fifties, to which Georgia and Anita—both wealthy women—responded coldly, with grudging extensions of charity and demands of repayment under tough conditions. As a very old woman, Georgia attempted to care for herself, even as she lost her sense of balance and her eyesight. But no one would ever call O'Keeffe shy about asking for what was hers. In fact, some of her friends would remember her fear-driven audacity in demanding that which was clearly not hers.

Georgia was devastated by the turn of events. Primarily because she was in school and low on funds, she did not attend either the funeral, which took place in Charlottesville, or the burial at the Totto family plot in Madison. In June, with Frank and her older brother absent, Georgia assumed

the role of head of household by returning home to close the house and sell Ida's few remaining possessions. But being back in Charlottesville only made things worse. She drifted into a catatonic state of depression and remorse, teaching her classes at the university mindlessly and sleeping for days, as she reported. For six weeks she wrote to no one, talked to no one. Finally, referring to her mother's absence, she let out a wail that is every child's lament on the passing of a parent: "I can't believe she isn't here."

The pain Georgia felt at the death of her mother found its expression in a table-size abstract statue fashioned out of Plasticene, a substitute for clay. *Bending Figure,* as the title indicates, depicts an abstract figure bowing its head from the neck. For years to come, people would compare the shape of this figure to that of an enlarged penis, an analogy that would drive the artist, who did not see sex in her work, into a state of despair. Even Anita Pollitzer referred to it as "a cucumber-shape . . . standing unaided." A writer once referred to it as a phallus to Juan Hamilton, who bristled as he pointed out that it was a tribute to the artist's mother. Georgia's small sculpture reveals a deep kinship to the suffering that Ida quietly withstood on her own, a kinship with a mother to whom she had regretfully longed to become closer.

In August, Georgia left the burdens of family life in Virginia to rush back to Texas and the comfort of wide open spaces. She stopped only for a brief camping trip in the Great Smoky Mountains with a woman by the name of Katherine Lumpkin. Within weeks of saying good-bye to her family, Georgia arrived in dusty Canyon, Texas, a stop on the north-south train line from Lubbock to Amarillo. In what most people would have considered a poorly advised career move, the former winner of the William Merritt Chase still-life competition now taught home economics students at two-year West Texas State Normal College the fine arts of basketweaving, interior decoration, dressmaking, drawing, and painting.

Canyon, a brand-new town, stuck out on a treeless plain

twelve miles outside Amarillo. The wind howling through the settlement at ninety miles an hour from the north was the main event of the year. This was tornado country. Prairie dog country. Dust-devil country. Nowhere. And O'Keeffe loved it. She became rhapsodic over the sky, writing descriptions charged with sexual energy: "Tonight," she announced to Pollitzer in September 1916, shortly after her arrival, "I walked into the sunset—to mail some letters—and the whole sky—and there is so much of it out here—was just blazing—and grey blue clouds were rioting all through the hotness of it . . . bunches of clouds—different kinds of clouds—sticking around everywhere and the whole thing—lit up—first in one place—then in another with flashes of lightning—sometimes just sheet lightning—and sometimes sheet lightning with a sharp bright zigzag flashing across it—."

The artist exploded with creativity in Canyon. As dry earth gives life to vegetation after a downpour, O'Keeffe could not stop producing new art—or writing about it. She wrote to Stieglitz and Pollitzer, and both of them marveled at the new world she had stumbled across and her accounts of it. Canyon was so called because twelve miles from town the earth dropped into a crevice of red and yellow sandstone. O'Keeffe had first discovered Palo Duro Canyon when she was in Amarillo. Now, she began to spend nights in what she referred to as "the slit." She wrote of one foray into the canyon, "There was no wind—it was just big and still—so very big and still. . . . A great place to see the nighttime because there is nothing else—."

The artist now entered a manic phase of her development. Fleeing the horrible series of events surrounding Ida's death with the determination of a wounded animal, she poured her massive reserve of energy into things and people outside herself. Work became the focus of her energy in this period, and for the rest of her life it would generally be the solution to any problem. Juan Hamilton recalled that as an old woman she advised him to "get to work" when he was feeling low. As an

artist, she felt that all problems worked themselves out in the studio. This time, however, it seemed they would not go away.

Staying up all night, she devoured very difficult reading, comprehending Wassily Kandinsky's *Concerning the Spiritual in Art* by underlining and memorizing passages. The Russian abstract painter had put forth in that revolutionary text an idea, supported by the writings of Friedrich Nietzsche, that artists were the true spiritual guides of the modernist period. In ponderously theoretical terms, Kandinsky expounded on the esoteric meanings of such spiritual concepts as "visions," "inner sounds," and "mystical necessity." Maintaining that the artist's "eyes should be always directed to his own inner life," Kandinsky even concluded that an artist's duty was to "obey . . . the voice of the Lord." Struggling against the forces of darkness on the plains of West Texas, O'Keeffe found comfort and guidance in Kandinsky's text, reading it for inspiration as if it were her bible. (In fact, on her deathbed more than seventy years later, she asked a nurse to read her the same passages she had outlined as a young woman, once again seeking comfort in the words as she faced another darkness.) "I don't sleep well nights," she now wrote Pollitzer in 1916, "—only go to bed because my eyes will only work a certain number of hours out of the 24—."

For entertainment, O'Keeffe often relied on her own company. "Well I just sat there and had a great time all by myself—Not even many night noises—just the wind—," she wrote of one evening. She rode a horse out onto the plain by herself to see the sunset. She shot bottles with her twenty-two. One day she cut a branch from a small pine tree, then ran across the plain holding it next to her ear to simulate the sound of wind passing through a grove of pines—there were no groves of pines on the plains. The only trees were locusts less than ten feet tall, planted hopefully in rows to block the wind. In the evenings O'Keeffe stood on the train platform with the rest of the town, the arrival of the steam-powered train from Lubbock to Amarillo being the main event of the day. As the train approached

the frame platform, its light visible for miles across the flatness to the south, like a beacon on a ship at sea, O'Keeffe envisioned the watercolor drawing that became *Train at Night in the Desert*. This drawing also paid homage to Stieglitz's photograph *The Hand of Man*, an early sign of the cross-fertilization between the two artists.

In no time she acquired a reputation as something of an eccentric. Her landlady was surprised to learn that the interior decoration teacher not only wanted to paint her room black but took down the curtains and left the windows bare. She sat alone in the dark looking out at the stars. Natives to West Texas did not understand how beautiful the clear stars of the prairie night were to newcomers. One day she brought back a number of drawings from the canyon. After studying the abstract drawings, her landlord asked if she was sure it was the canyon she had been painting. O'Keeffe explained that it was a depiction of how she had been *feeling* down in the canyon. "Well," the slow-speaking Texan joshed, reconsidering the swirls and bubbles the artist used to suggest space, "you must have been feeling like you had a stomachache when you were down there."

It did not take much to be noticed in Canyon—life on the frontier was in some ways more rigidly prescribed than life in the center of civilization. O'Keeffe went to the barber shop for a shoeshine, when it was the custom for ladies in Canyon to care for their shoes at home. One morning people noticed the art teacher carrying a cottonwood tree branch from the canyon and using it to decorate her room. People in Canyon in 1917 did not bring tree branches into their homes: "it is a shame," she wrote of the opinions of her peers, "to disfigure anything as wonderful as these plains with anything as little as some of these darned educators."

She made friends with her students, which stretched the boundaries of acceptable behavior for educators in Canyon even further. One night she invited Ted Reid, a striking football star and local hero who wanted to become a pilot (she had helped build sets for a play with him), to her room

to see some photographs Stieglitz had sent to her. When her landlady told her she could not entertain male students in her room, she acted perplexed. Reid was also informed that he was jeopardizing his own position in the community by seeing the schoolteacher. He dropped her, the artist later recalled, "like a hot cake." Although Reid had once put his arm around her shoulder, she claimed she had no interest in him as a sexual partner and was surprised others felt she had, a continuation of her own obtuse interpretation of how she expressed her sexuality, which extended from her artwork to her behavior.

O'Keeffe then invited a young Yale-educated prosecutor to her home. After being reminded that the ban on entertaining men in her quarters extended to all men, not just students, she asked him to drive her out onto the plains in his car. One moonlit night, she leaned forward to enjoy a view of the flatland, then discovered on sitting back that he had his arm around her. This was not what she had had in mind. In fact, one woman in Canyon told me that she believed O'Keeffe had merely been using him for his car. There were only a few cars in town at this time, and it was hard to get to the canyon without one. "I almost died laughing," she reported to Pollitzer, "—of all the people in the world to find themselves out at the end of the earth—The barest hills you ever saw in front—nothing but plains behind—beautiful lavender moonlight—and that well fed piece of human meat wanting to put his arms around me—." She became lost in her own confusion: "I wonder that the car didn't scream with laughter—." Finding herself in awkward situations because of her repressed sexual energy was a pattern that would recur throughout her life. One of her female caretakers later said she felt that the elderly artist had desired her sexually. A relative recalled that she flirted openly with him. The daughter of a friend observed that when she knew her in the 1950s, "Georgia was a sexpot." Freud would have called her a sexual hysteric. She called herself "a pink pill" in a letter to Pollitzer, "with wheels in my head."

* * *

The 1917 showing of her watercolors at 291 was an occasion in the art world. O'Keeffe, still out on the plains during the opening night, was like a huntress who had sent trophy heads back from the field. Her America—the land to which she would long to return whenever she was away from it—was as foreign as Outer Mongolia to most New Yorkers. She had divined the secrets of this flat land in the far reaches of Texas. The light, the space, and the spiritual quality of the landscape were evident in these small (mostly nine-by-twelve-inch) drawings and watercolors of penetrating luminosity. So familiar was she with the land in West Texas that for years even those who knew her well thought mistakenly that she was originally from Texas.

The reviews were generally unanimous in her favor. Writing in the May 4 edition of *The Christian Science Monitor,* Henry Tyrell concluded knowingly that what appeared to be V-shapes and holes in O'Keeffe's drawings were "veiled symbolism" for "what every woman knows." It was the first of scores of reviews by men that focused on the female imagery of O'Keeffe's works as if that were their only distinctive feature—a situation Stieglitz can be credited with promoting, if not initiating. Ever since Anita Pollitzer had brought him the first drawings, the art impresario had been enormously impressed that a woman had created them. Stieglitz had also introduced the art of the insane, the primitive, and the child with equal enthusiasm, and as a result his promotion of O'Keeffe's work took on a ring of exoticism. Nor was he alone in his reaction. Historically, in the eyes of men, observes Germaine Greer, "any work by a woman . . . is as astonishing as the pearl in the head of the toad. It is not part of the natural order." Stieglitz was no exception to the view Greer describes. He had doubtless coached Henry Tyrell on how to see and what to write about O'Keeffe's work as well. He often instructed critics who entered his lair in how to think about the works on view.

Tyrell concluded, as if from Stieglitz's mouth, "Now perhaps for the first time in art's history, the style is woman."

If her style was woman, it was hard for O'Keeffe to accept it as such—and with good reason. Who wants to be responsible for representing half of the entire world every time a mark appears on a piece of paper? What was more, O'Keeffe was frequently told she looked like a man; nearing thirty, she dressed like a mysterious widow and acted shocked when men made passes at her. That she could possibly claim to represent womankind was an issue that could well have been debated. Whether she *wanted* to represent womankind needed no debate. O'Keeffe told critic Henry McBride she was not a "woman artist," and preferred to be thought of as an artist, period.

O'Keeffe left for a brief trip to New York as soon as she could get away from her work, landing in the city in May without notifying Stieglitz, on the weekend of Decoration Day. She walked straight from Pennsylvania Station to 291. Stieglitz promptly rehung her show before she could protest. It was difficult for O'Keeffe to look at her own artwork on the walls of the gallery. She had entrusted Stieglitz with her drawings unconditionally, as a child trusts its parents to feed and nurture it, but she had also said in a note with a package she had sent from Texas, "I don't care what you do with them, so long as I don't have to see them."

But by the time she arrived in New York, her work was no longer hanging on the walls. Stieglitz had dismantled the exhibition and was beginning to shut down 291—for good, rather than for the season. During the years before air conditioning, New York art galleries generally closed for the summer months, but this time 291 would not reopen in the fall because Stieglitz could no longer subsidize its rent. His income had been threatened by the drumbeat of Prohibition, soon to become a law across America, which threw breweries like that of his wife's family out of business. Upon O'Keeffe's arrival, Stieglitz rehung the exhibition so that she could see it. No record exists of what the two artists said to each other

during that private viewing of O'Keeffe's artwork in May 1917, but judging from the content of the letters that had been passing between them for a year, it probably veered between awkward and tender. In those intervening months Stieglitz had written to O'Keeffe nearly every day, professing his love for her, promising to care for her drawings as if they were his own, ending with: "Here's my hand—do you wish to put yours in it——."

The next day Stieglitz photographed O'Keeffe with her drawings as a backdrop. It was an innocent gesture—he photographed nearly everyone who came near his camera. At the time, neither of them could know that this session would lead to one of the most famous photographic portraits in history. Stieglitz's portraits of New York City and of the famous people who passed before his camera are well regarded in photographic circles today, but his series of several hundred photographs of O'Keeffe are probably his best work. In one of the pictures, she looks straight into the camera without blinking, as if she were transfixed by the photographer. And in a series of other pictures she cups her hands under her breasts and alludes to unbuttoning her blouse in what was to some eyes a prolonged striptease, ending a few years later in total nude portraits.

Soon, however, O'Keeffe began to question her mentor's role in her life and to put up the same resistance she had been showing to other people who tried to get close to her, beginning with George Dannenberg nearly ten years before. Because he was considerably older—fifty-two—Stieglitz was not as threatening to her as younger men were, and he offered her a parental figure to look up to, an attractive feature now that her mother was dead and her father absent. Stieglitz had given a home to drawings at which people in Canyon had laughed. He had also introduced her to a world of people who could nurture and comfort her. But when he offered to take care of her and asked her to stay in New York, she resisted.

Stieglitz was not the only man O'Keeffe was keeping at arm's length at this time. She was moving restlessly from

person to person like a taxi dancer in the ornate ballrooms lining Broadway. When Arthur Macmahon offered to marry her, she turned him down flatly—and even though they had made love in South Carolina, she consented only grudgingly to see him when she was in New York in May. Her most intense relationships were conducted from afar, through the safe space of the U.S. Post Office, freeing her from the complications of having to relate to someone physically.

The day before she left New York, she accompanied Stieglitz and one of the other artists in his orbit—Paul Strand— to boisterous Coney Island for Decoration Day celebrations. There they visited Henry Gaisman, a rich inventor and patron of the arts who owned a big Victorian house in a private gated section of the crowded beach resort. Gaisman had invented an autograph camera, to which he had sold the rights to Kodak for $300,000, the highest price ever paid at the time for a single invention and a considerable sum of money in 1917. Against the glare of the red, white, and blue spotlights that commemorated America's entry into World War I, Stieglitz and his patron engaged in heated political discussions while O'Keeffe and Strand entertained each other by flirting and riding side by side on a Ferris wheel above the honky-tonk boardwalk.

O'Keeffe had turned her attention one more time on another man, forming a mutual admiration society with Strand that would deepen considerably in the years to come. In a way, O'Keeffe had more in common with Paul Strand than anyone else at that time. At twenty-six, Strand was only a few years younger than she. A quiet, worried, pensive man, Strand's hooded dark eyes revealed a burning passion for art. His dress, in the plain clothes of a laborer, nonetheless betrayed his upper-middle-class upbringing. He had been born Paul Stransky in New York City in 1890 and had been graduated from the elite Horace Mann School in Riverdale as Paul Strand. Following a period of patronage under the socially conscious photographer Lewis Hine, Strand fell into Stieglitz's group of geniuses just before O'Keeffe, too, found

her way into the fold. Both had recently had their first solo shows.

After the Ferris wheel ride, they rejoined Stieglitz and Henry Gaisman. As the sun went down, the spring air turned chilly. Stieglitz placed his black wool loden cape lovingly over O'Keeffe's shoulders, but her heart was being warmed by another. On the train back to Canyon she wrote the first of many passionate letters to Strand. She offered her hand to him, as Stieglitz had offered his to her, thereby forming a love triangle that would be fraught with complications.

"Did you meet Paul Strand?" O'Keeffe queried Pollitzer. "I . . . fell for him."

Chapter 8

.

I n June 1917, O'Keeffe stepped down from the train into the dusty Canyon station to discover brass bands playing patriotic songs under a festoon of red, white, and blue banners. Entire houses were surrounded with bunting. The Red Cross had set up a big stand to recruit soldiers to go off to fight in the trenches in Europe. Since the United States declared war on Germany in April, the people of Canyon had become warmongers whose zeal seemingly knew no bounds. It was widely believed that Mexico, in exchange for siding with Germany, was to regain its former territories— which included Texas—in the event of a German victory. The people of the little outpost of Canyon had fear gripping their hearts.

O'Keeffe was more afraid of the people of Canyon than she was of a German conquest of the area. She complained to Paul Strand that her students made her feel boxed-in. O'Keeffe blamed the war for how she felt and said she had no one to talk to about it.

Unable to stop creating art only months before, the artist now entered a period in which she could not start creating at all. Nothing would come out. What she had wanted to say about the plains seemed already said in the pictures shown at 291. O'Keeffe was at an impasse. Nearly every artist fears that one day the well will dry up and there will be no more work. For O'Keeffe to face that dilemma so soon after she had resumed creating art must have been devastating. Writing to Strand of her continuing appreciation of the plains and inability to articulate it, she doubted she

would be able to express how she was feeling again. She said she did not even want to try.

The artist transferred her enormous energy to her relationship with Strand, pouring out sexually charged confessions to the young photographer in a stream of passionate letters. Even though she barely knew Strand and had never made love with him or even kissed him, she released years of pent-up emotion as she disclosed that she was naked while writing him and asked him to take her to Riverside Park (a popular New York make-out spot). She said she wanted him to hold her, that she could only sleep if he were next to her, that he had reached her, to her fingertips. As she had in the past, she found the prospect of sex excited her from afar, and she poured her libido out to him, as she had to Macmahon.

At the same time, she was expressing similar feelings to Stieglitz, without regard for his friendship with Strand or the triangle she was forming with the two men. Stieglitz was more of a parental figure for her—the foundation against which she would rebel when she needed to protest her condition in the world. Strand was a focus for her wild sexual energy. The relationship between O'Keeffe and Stieglitz existed on a professional plane—and, in fact, throughout history, women artists have often been attracted to more famous males. "The single most striking fact about the women who made names for themselves as painters . . . ," notes Germaine Greer, "is that almost all of them were related to better-known male painters." Theirs was an incestuous relationship, as is any relationship that mixes various functions inevitably—not only in the sense that Stieglitz was old enough to be her father, but in the sense that he held the key to the world she wanted to inhabit. He was the boss, she was the employee. Without him, she had no career as an artist. And she wanted to be an artist—not a wife. That she would eventually have to accept both roles in order to have the one she wanted would be a source of endless pain for her.

* * *

In August 1917, Georgia and her sister Claudia vacationed
in Colorado. Claudia had arrived in Canyon in January to
attend the normal college. At seventeen, having spent her
high school years nursing her mother, Claudia was an ex-
tremely needy person who latched onto her older sister as
she would a parent: by dressing like her, talking like her,
even wanting to be like her. Georgia found her sister's ad-
oration intoxicating. Whatever Georgia wanted to do, Clau-
dia would follow—a complete loyalty such as the artist
would later demand of her friends. Claudia complained that
walking with her older sister was just like being alone,
but for the most part she liked doing what Georgia wanted
to do.

Georgia had offered Claudia the vacation trip as a reward
for enduring the hot Texas summer, when temperatures
often hovered in the upper nineties. She told Claudia she
could pick their destination. Claudia chose Colorado be-
cause it sounded cool—and it was. The sisters camped near
Estes Park in the high Rocky Mountains. Georgia paid for
both their fares with the four hundred dollars she had earned
from the sale of a watercolor drawing of a train.

Here the artist could work once again. Sketching pine
trees and tall peaks for the first time in her career, she made
several watercolors of the mountain range that suggested, in
wide swatches of blue and green, a Japanese brush painting.
The thin mountain air calmed her nerves and she wrote
placidly that it seemed like the first rest she had found in
years.

On the way to Colorado the train detoured through New
Mexico. Georgia was overwhelmed by the drama of the
desert. In New Mexico, she exclaimed in a letter to Strand,
the expanse was even greater than in Texas, comparing the
flat plain to the ocean. She remarked that it was so vast that
a flock of sheep in the distance looked like specks. Georgia
and Claudia spent a day in Santa Fe exploring the old Span-

ish colonial capital. Wondering at the contrast of brilliant blue sky against gold-colored adobe buildings, she wrote rhapsodically of the air that smelled like piñon wood fires and of the Indians weaving brightly colored panels along the Rio Grande. After centuries of Spanish-speaking rule, New Mexico had been admitted to the union as a "sovereign" state only six years earlier. Georgia said she knew she would return.

Back in school in the fall of 1917, O'Keeffe discovered that her vacation had been only a temporary respite from what was bothering her. She complained in a letter to Strand that she had produced nothing of which she was proud, and added that her work made her sick. She felt the drawings she had made in Colorado were terrible. She returned to themes she had used the year before—the evening star, daybreak on the plains, zigzags—she produced capable like-nesses of the originals, but without the spark of brilliance that distinguishes great works of art. On a few occasions she allowed herself to delve into what was bothering her—the result was a muddy watercolor. O'Keeffe could not handle depictions of negative emotions very well—and she quickly abandoned the effort. In her letters, however, she expressed clearly how bad she was feeling, saying she could barely tolerate herself.

The shame O'Keeffe expressed here coincided with the emergence of a relationship with another woman—a situation that could easily prompt an attack of remorse in a person who was repressing their homosexual feelings. Leah Harris was a home economics professional who traveled throughout Texas lecturing to homemakers. Slender-waisted, with short dark hair cropped in a mannish style like O'Keeffe's, Harris was a rugged-looking, blunt-spoken native Texan who grew up on a ranch in the fertile southern part of the state. Georgia and Claudia visited Leah on her family's ranch when they returned from Colorado in the fall, the start of Leah and Georgia's sexual relationship. O'Keeffe's affection for Harris was shown in the series of watercolor nudes she completed using her friend as a model. The identity of the model, as

well as the nature of the relationship, has only slowly come to light over the years. She did not write of their relationship—as with other women lovers she would have, she kept the details to herself, making it difficult for future writers to put the pieces together. Harris, however, was not uncomfortable about openly declaring her love for her artist friend. "I've been looking for Georgia," she said, "all my life."

Around this time, O'Keeffe's letters to Strand suddenly became hostile. She no longer expressed sexual desire for him. In fact, in a guarded confession she told him that she was not the woman he thought she was. She said she felt that the person she really was was spoiling the image of someone he had made up and who gave him pleasure—a curious accusation, since it was O'Keeffe who appears to have invented him. She admitted that she had been writing letters to other men, too, stringing each along without letting the others know, a behavior, she observed proudly, that was more common among men than women. She announced in a letter to Strand that she was finished with relations with men—and glad of it.

The artist subsequently became even more irate. In letters to Strand and to Stieglitz she reported gleefully that she had attacked a dour Texas Baptist in a starched collar. The Baptist had made the mistake of launching a public assault on the character of Nietzsche within earshot of the home economics teacher. Because of his *Übermensch* concept, Nietzsche was widely regarded as the intellectual fountainhead of the war and was often credited with having asserted the menacing German character onto the world. As the preacher attacked the philosopher, Georgia grew increasingly incensed. She finally told him that he did not understand the philosophy of Nietzsche, nor could he ever have read Nietzsche. He was intellectually lazy and morally wrong for attacking the character of a great philosopher based on his nationality.

It seems that after this, the good people of Canyon began to cross the street when they saw O'Keeffe coming. As in the gallery when Stieglitz had first showed her work, it seems that O'Keeffe did not know how to express dissatisfaction

without becoming enraged—a characteristic that would lead people to view her as an "angry woman." Her sex would always be attached to the word *angry,* as if linking the two were unnatural, as if she were not a person capable of anger but that anger was who she was. In reality, her feelings were so blocked up inside her that in order for them to come out, the dam of her emotions had to break and spill over those who were near her. Before Christmas, she shocked a group of people in a card shop when she demanded that the shop stop offering a Christmas card that stated, "Kill Huns." "Both entirely against what they all profess to believe," she wrote Stieglitz's niece, Elizabeth Stieglitz, "—and certainly not in keeping with any kind of Xmas spirit I ever heard of."

O'Keeffe soon came to be regarded as the town madwoman. There she was, the only woman at a stag eggnog party in a town where men drank alcohol once a year in their eggnog. There she was, encouraging Ted Reid to complete his education rather than enlist in the army. Then there she was, standing up in a faculty meeting and telling the other teachers that "their course of study was a failure," that they were incompetent. She had "just knocked everybody's head against the wall," she reported gleefully, "and made hash." She said she expected "halfway to be run out of the room—." "It was great to just Knock things right and left and not give a DAMN. . . . It seems that it was an explosion Ive been growing to all my life—and I tell you I had it—I took each old boy in turn—Fatty Stafford—Latin first and knocked him down and jumped on him with both feet—."

O'Keeffe's rage probably had two underlying sources. Many homosexuals, in the lengthy and painful process of coming to grips with their sexuality, go through a period of rage. This rage is directed outside of the person at people or institutions who are perceived as disapproving of homosexuality and restricting the person from expressing his or her true sexual desires. What was more, and what complicates her case, was her unresolved childhood encounters

with her father and brother. One of the commonest signs of childhood abuse among adults is uncontrollable rage. No one will ever really know for sure whether the artist really was abused as a child—so many people who were molested cannot remember exactly what took place—but experts in the field tend to look for the external signs of childhood incest that surface in adults, and O'Keeffe displayed many of these. People who have been victims of incest often wear loose-fitting clothing, as O'Keeffe did, and try to appear unprovocative and sexless. They have a terror of other people's nudity, as O'Keeffe did. Fear of being touched is yet another sign; her friends told me that she could touch them, but they could not touch her. On a more complex level, incest survivors often seek out betrayals, as O'Keeffe did when she left her drawings with Stieglitz and then acted shocked that he exhibited them. Each of these characteristics, according to Sara Butler's groundbreaking book, *Conspiracy of Silence: The Trauma of Incest,* is a sign of incest. Taken together, O'Keeffe's psychological makeup fits a standard adult profile of an abused child.

In February 1918, O'Keeffe was granted a leave of absence for reasons of health from West Texas State Normal College. An influenza epidemic had swept the nation, and O'Keeffe appears to have felt she had it, too. It appears that she had actually suffered from a nervous breakdown that included various flu-like symptoms and tuberculosis-type congestion—although it has been reported elsewhere that she really did have the flu and had entered a preliminary stage of tuberculosis. After a few weeks, during which none of her New York friends knew her whereabouts, the artist surfaced on Leah Harris's family's ranch outside Waring, Texas, several hundred miles south of Canyon. O'Keeffe recuperated slowly from her illness in the balmy South Texas spring, allowing Harris to nurse her back to health.

Although her relationship with Harris appears to have developed sexually, by the time the two women were settled, O'Keeffe began to take back her affection, possibly because she generally recoiled emotionally when she got close to

people, possibly because she was afraid of the implications of a homosexual partnership. O'Keeffe spun like a top from men to women without being able to make a decisive move. This studied ambivalence would characterize her to the end of her life as she flirted with both men and women, surprising people at ninety-two by acting jealous around Juan Hamilton's love interests, alarming a female nurse who felt her elderly patient wanted her sexually. "We are both cold women," O'Keeffe wrote tantalizingly to Strand, referring to herself and Leah, wondering whether he could make them both feel warm.

In New York, Strand and Stieglitz conferred late into the nights on the matter of O'Keeffe's health, discussing the situation in code names like letter X and Miss O, wondering whether she would live, and if so, how they could get her back to New York—treating her like a project instead of a person. Stieglitz felt proprietary about all his artists, but of O'Keeffe he was madly possessive. Marsden Hartley noticed with jealousy that Stieglitz carried O'Keeffe's drawings with him at all times. Under Stieglitz's direction, a covert campaign was mounted to rescue O'Keeffe. He implored her to return to New York, where he felt certain the doctors were better than the ones out west. A sanctimonious New Yorker, he believed nothing worked well in the rest of America. Elizabeth Stieglitz wrote to offer her the use of her studio. O'Keeffe wired that she was too sick to travel.

Two weeks later, Paul Strand arrived in San Antonio, where he was met by an anxious O'Keeffe, who had traveled from the ranch into the historic town to meet his train. Dressed in black and appearing considerably healthier than her earlier telegram had indicated, she told Strand that she and Harris had been stalked one night by a neighbor, whom they had managed to scare off by pointing a gun through an open window. It seems that the rough neighbor had been making disparaging remarks about the two women and may have come to attack them sexually. According to newspaper accounts, lesbians at this time often found themselves prey to men who wanted to prove their power over them, the

general population having only recently awakened to the possibility of same-gender sex. Calling them unnatural, an American doctor in 1915 identified lesbians as "female inverts."

A few days after Paul Strand moved in with O'Keeffe and Leah Harris, he sent Stieglitz a twenty-five-page letter outlining what he had found there. He relayed the contents of separate discussions with both Harris and O'Keeffe, and in a comical juggling act he tried to determine what was best for both women, as well as for his own and Stieglitz's interests. His efforts achieved naught: Neither Stieglitz nor O'Keeffe gave a bean about his analysis. Stieglitz simply wanted O'Keeffe to return to New York, while O'Keeffe wanted her health back and to know what she was going to do in the future for money. Harris wanted O'Keeffe. Where Strand fit in is not clear, although it seems he wanted to please Stieglitz—or else he would not have bothered to make a study of the situation.

In a symbolic move that would send ripples into the future, O'Keeffe finally left Leah Harris and Texas in June. With Strand at her side to steady her, she traveled back to New York by train. Penniless, coughing like Camille, without a job, and dressed in a black man-tailored suit coat, a long skirt, a man's hat, and square-toed shoes, the young artist arrived in Pennsylvania Station on Sunday, June 8, at 7:30 A.M. She was met there by Stieglitz.

Chapter 9

.

O'Keeffe had never been inside a place as grand as 1111 Madison Avenue. Accustomed to Stieglitz's taste in the 291 gallery—which, like hers, had kept furnishings to a minimum and placed a single small painting on a large wall—she was surprised here to find the apartment he shared with his wife Emmeline (Emmy) and daughter Katherine (Kitty) decorated in his wife's taste, with a collection of ornate trappings, including a huge romantic gold-framed painting depicting a ribald scene of a snake coiled around a naked young woman and marble statues of young men. Having only returned to New York a few weeks earlier, the artist was not fully recovered from the illness that had come over her in Texas. She had probably been a little uneasy as Stieglitz ushered her under the green canopy, past the uniformed brass-buttoned doormen, and into the cool marble-lined lobby.

Alfred and Georgia stole through the hallway and into the apartment, their bond solidified by a clandestine mission. While Emmy was away shopping for her fall wardrobe, Alfred and Georgia continued the peculiar romance that they had begun in earnest on Georgia's return from Texas. The romance was peculiar because it had centered on Alfred photographing Georgia in the nude. As far as can be told, there was no sex between the two at this time. Georgia never spoke of their sex life, except to later confess that Stieglitz had been with men when she knew him. People assumed they did not have sex. It seems that Alfred remained clothed while Georgia posed in the nude in various positions. Being

nude, she had discovered, freed both her body and her mind. She had been living for the most part without clothes in Elizabeth Stieglitz's top-floor studio—primarily, she pointed out sensibly in the heat of a New York summer, because it was cooler.

Suddenly, Emmy walked in on the duo. A former beauty whose years had added inches of flesh to her ample girth—now hidden under layers of velvet and silk—Emmy wore her hair piled decoratively on top of her head and carried herself as imperiously as a monarch. And, in a way, she was American royalty, being one of the principal heirs of Rheingold, an enormously profitable brewery. In the twenty-four years that Alfred and Emmy had been married, he had presented a stream of challenges to her conventional ways of thinking, but this time he had gone too far. In spite of his protest that he and O'Keeffe "weren't doing anything," Emmy unleashed a volley of abuse on both her husband and his nude companion. O'Keeffe dressed hastily while Stieglitz tried to comfort his distraught white-gloved wife.

In the years to come O'Keeffe would block this memory from her recall, finally attaining the blissful state that permits some people to deny that certain events ever took place—a state she seems to have attained previously, when her father allegedly molested her. Stieglitz, on the other hand, not only admitted what had happened, he embellished the story with total recall of what he did in the forty-eight hours after his wife issued an ultimatum to him to either stop seeing O'Keeffe or stop seeing her. She seems like a fool, while he seems like an impotent fifty-four-year-old man trying to bait his wife and excite his humdrum marriage with a secret alliance.

People who have an image of Georgia O'Keeffe as a determined old woman who seeks only her own counsel may find it hard to picture her as the malleable young woman she was in 1918. According to Sarah Greenough, a scholar at the National Gallery of Art who has studied the O'Keeffe–Stieglitz correspondence, in this period of O'Keeffe's life, the artist was under the sway of Stieglitz almost entirely.

"Here, O'Keeffe is an . . . unknown artist who's seeing the overwhelming all-encompassing attention, praise and love of the most famous person in the American art world . . . these photographs . . . were staged events directed by Stieglitz."

O'Keeffe probably had not known the extent of the marital trap she was entering when she passed under the awning at 1111 Madison Avenue for the first time on a June day in 1918. Not that the artist respected the institution of marriage. Throughout her life, she would surprise friends by refusing to acknowledge their partners once she decided she did not like them and by flirting openly with married people of both sexes. Only a few weeks earlier, she had descended from the train in Pennsylvania Station on the arm of her savior, Paul Strand. In the meantime she had been installed by Stieglitz in the Fifty-ninth Street studio of Elizabeth Stieglitz, Alfred's niece and her new friend.

Born on January 1, 1864, in Hoboken, New Jersey, Alfred Stieglitz was the adored first son of Hedwig and Edward Stieglitz. Self-taught and self-made, Edward was the embodiment of the American dream, a penniless German immigrant who had amassed a fortune during the Civil War by profiting from shortages brought about by the conflict, then retired in luxury before the age of fifty in a mansion on Sixtieth Street, off Central Park. Like many successful people at this time, Edward owed his accomplishment in part to a tyrannical, perfectionist streak. In a full-bodied mixture of German, English, and Yiddish, he demanded that his soup be exactly the right temperature for his palate. He even insisted that the servants clean barefoot because the noise of their shoes bothered him.

Edward and Hedwig adored their eldest son, who was a beautiful baby and became a handsome young man. With curly dark brown hair and deep brown eyes, Alfred had been nicknamed Hamlet by his aunt, according to family lore, because he resembled the handsome Shakespearean actor Edwin Booth—although there were clearly other resemblances to Shakespeare's tragic character. In 1871, seven-

year-old Alfred accompanied his parents on their delayed honeymoon to the fashionable watering holes from Niagara Falls to Saratoga Springs, New York. While Edward attended horse races in Saratoga Springs and stayed up all night gambling in plush casinos, Hedwig and Alfred read novels together, attended concerts, and strolled from hotel to hotel in the handsome resort. Ignored by her husband, Hedwig transferred her affection to Alfred. Reflecting the Victorian preoccupation with health, she insisted, despite evidence to the contrary, that he was delicate and frail. Along with her maiden sister, Rosa Werner, who lived with the Stieglitzes, Hedwig coddled and comforted him by shielding him from the slightest chill or draft. Edward contributed to the hothouse of emotions by spoiling Alfred with expensive oranges and imported chocolates.

Alfred was eager to please his father. Becoming what appeared to be his father's valet, in what today would be considered a deeply incestuous relationship, Alfred performed services for "Pa" that included massaging his feet and fetching him rare bottles of French wines and Havana cigars during his all-male soirées. The elder Stieglitz, an amateur painter who generally kept a couple of starving artists for companions, entertained only cultured men and prohibited business talk during these gatherings. For each task he performed, Alfred demanded—and received—payment, assigning it an arbitrary value in a log book. Edward went along with the scheme until Alfred was at university, pleased with his son's ingenuity.

Like his father, Alfred, too, became a perfectionist. After watching Edward and his friends play billiards, Alfred beat his father on his first try at the game. On another occasion, Alfred set up a track for a self-timed foot race around the basement of the Stieglitz mansion on Sixtieth Street. Enrolled at the Polytechnikum in Berlin, young Alfred became so distraught that he could not make first place that he dropped out. He gave up painting when he discovered he could not excel at it, either. One day he went into a camera shop and purchased an entire kit for producing photographs. In a

recent invention and a field dominated by upper-class am-
ateurs, Alfred had found a pursuit in which he could rise
to the top—and he did. Unfortunately, there was no money
to be made in photography at this time. After several years
of financing his son, Edward set Alfred up in business with
Louis H. Schubart and Joseph Obermeyer, a family friend.
A few years later, Alfred fell prey to a devastating nervous
collapse—the first of his yearly self-diagnosed collapses. He
retired to the family's summer house at Lake George, where
he was nursed slowly back to health by his mother and aunt.
He left business to pursue art.

The only Stieglitz son not to enter a conventional profes-
sion, Alfred occupied the Hamlet-like role of spiritual me-
diator, truth-teller, soothsayer, and sexual libertine in his
bourgeois family. From his Polytechnikum days in Berlin in
the 1880s, Alfred had gravitated toward the otherworldly
and the mystical. The Stieglitzes were not religious, or even
nominally spiritual. Alfred developed his own beliefs
through the lens of his camera and through the writings of
his day. During dinner on one cold night, he startled his
parents when he pushed away from the table to go out into
the street and give money to an organ grinder. Later, when
his mother asked him why he had braved the cold to give
to the musician, he replied, "Ma, I was the organ grinder"—
invoking the spiritual maxim that holds that there is only
one of us and we are all one. His mother told him he was
insane. On another occasion, he told a friend his goal was
to achieve through his work "the throbbing essence . . .
which is God."

A year before his thirtieth birthday, Alfred was married
to Emmeline Obermeyer, the sister of his former business
partner, a friend of his sisters, and an integral part of the
small group of upper-class German-Americans in which the
Stieglitzes traveled. Alfred and Emmy soon realized on their
four-and-a-half-month European honeymoon that they were
mismatched. While Alfred stole away at dawn to photograph
a Venetian gamine, Emmy wanted to listen to soufflé waltzes
and bathe in the Lido. As many people in their class did,

they soon arrived at a marriage of convenience for the sake of Kitty, their only child, who was born in 1898, five years after they were married. Alfred was a modernist who wanted to pursue the rights of individuals to find their own path in an increasingly mechanized society that valued sameness. Emmy was a Victorian-bred traditionalist who wanted to mesh with a certain group of people who frequented the same places and wore the same clothes. Their differences were only exacerbated by their physical proximity. So Emmy raised Kitty by touring Europe each summer, while Alfred pursued his interests at 291, from 1905 until it closed after O'Keeffe's show in the spring of 1917. Kitty was so sheltered from her father that one day in school when she was asked what his occupation was, she replied that she did not know. Her teacher, who considered Alfred to be one of the great artists of the period, contacted her parents to find out why. In fact, Kitty did not know what her father did because her mother would not permit her to go downtown to his gallery.

And rightly so. 291 was no place for a child who did not want to think. On its walls were African masks and cubist drawings, full-body nudes of men and women, and the art of the insane. Artists who were openly seditious visited its rooms. From his small attic quarters, Stieglitz published one of the most elegant periodicals of the modern period, *Camera Work,* which contained stellar examples of modern art, printed peerlessly on superior linen paper. In recent years its pages have been cut apart and sold individually as pieces of fine art in themselves. Issues were devoted to the work of Picasso and Matisse, to essays by Gertrude Stein, and to countless photographs that are today considered masterworks of the art—including Stieglitz's own starkly realistic *Steerage* and *The Hand of Man. Steerage* depicts a group of immigrants crowded in the under class of a transatlantic ship. *Hand of Man* is a powerful picture of a railroad train in which smoke shrouds the entire view. *Camera Work* was a part of a general movement in modern art that questioned the meaning of art and life. This movement was more than an aesthetic expression; it was a cogent world

that sought to penetrate "deeper meaning" and "the development and exposition of a living idea." A page of promotional literature declared cryptically that "Camera Work is published for those *who know or want to know.*"

Emmy and Alfred rarely went out together. Emmy did not know or want to know and complained of being "bored" when she accompanied him to artists' gatherings. When they did dine out, she often insisted in the stentorian tone of an upper-class lady who is accustomed to ordering servants that he consume an entire seven-course meal, when his delicate digestion wanted only soup. "Not to do so," she said, "wouldn't look right." Alfred often had sick headaches. Each summer, he would collapse and retire to his bedroom at Lake George, where his mother and aunt would minister to his needs. Following Edward's death in 1909, when Alfred's income dropped, Emmy supported him with an allowance from her income from the Rheingold brewery. In a scheme to extract more money from his wife, he convinced her to pay him to accompany her to the opera or theater—or to restaurants for seven-course meals.

Georgia was not Alfred's first extramarital affair. Over the years he had engaged in passionate—and fairly public—dalliances with other women and with men. Although the extent of his homosexuality has not been documented, it is likely that one, if not many, of his close relationships with other artists was sexual, since O'Keeffe told people that he had been with men. Edward Steichen, for instance, was so close to him that it seemed to some people that they were related. An unregenerate flirt and a womanizer, Stieglitz appeared as oversexed to some people as O'Keeffe appeared chaste. Being caught in the act seems to have been another aspect of his sexual makeup as well. When asked over the years why he had married Emmy, who seemed poorly suited as his mate, Alfred explained that he had compromised her dignity during a sleigh ride in full view of her brothers, who then insisted he marry her.

In New York, O'Keeffe was entering a bohemian world of free love that would change the direction of her life. Her

friend Elizabeth Stieglitz was a painter and a sexual libertine who had entered into a ménage-à-trois with Donald Douglas Davidson, her future husband, and another unidentified man. An early hippie, Elizabeth had painted the walls of her Fifty-ninth Street studio yellow and her floor bright orange to please Donald, who, having worked as a gardener on the Stieglitz estate on Lake George, was nicknamed "Mr. Flower." She was also a former lover of Paul Strand's—and in this web of intrigue, she was the self-appointed Cupid for Uncle Alfred's bid for O'Keeffe's hand. It seems to have been Elizabeth's insistence, as well as Strand's—in his role as Tristan to O'Keeffe's Isolde—that lured O'Keeffe back to New York. *Tristan and Isolde,* the Wagner opera whose plot paralleled the Stieglitz–Strand–O'Keeffe imbroglio, was Stieglitz's favorite libretto. Life, in this case, imitated art.

O'Keeffe was completely worn down. Most of her possessions, including many of her drawings and watercolors of the past year, were still in Canyon. Although she had insisted in her letters to Elizabeth that she did not want to live with Stieglitz, she had found him in her studio photographing her day and night. O'Keeffe, oddly, responded favorably to the adoration, even relishing, along with him, the results of his efforts: "I was photographed with a kind of heat and excitement and in a way wondered what it was all about." Stieglitz photographed the nude O'Keeffe in many positions. He even stood under her as she perched on top of a radiator: "that was difficult," the artist wrote matter-of-factly—"radiators don't intend you to stand on top of them."

The ongoing nude portraits of herself excited O'Keeffe almost more than they excited their creator. The duo became involved in a conspiracy of sorts in which her body was a shrine and a secret that only they could know. Having for many years thought of herself as a manly and unattractive woman—whose sisters had received her family's quotient of beauty—O'Keeffe marveled at the way she looked undressed. And with good reason. Her body was as curvaceous as a Roman statue, with a round bosom and a slender waist echoed in full hips and long shapely legs. Her hands and

arms were exquisitely proportioned. Looking back, O'Keeffe
was surprised by how different she looked from portrait to
portrait: "There were nudes that might have been of several
different people."

There was a charge in Stieglitz's nudes of O'Keeffe, an erot-
icism found in the various parts of the nudes and in their
androgyny. Her armpits were hairy, and her breasts were
full. Her skin seemed aglow with heat. The sticky New York
summer, as it rose to the top floor of the brownstone, was
recorded in these pictures of the artist, to whom their creator
referred as "The Great Child—purely—truly—unspoiled."
Often the expression on her face was pained, as if she had
been caught unwittingly, without her clothes on, stepping
out of the bath. There were pictures in which she looks like
a very handsome boy trapped in a woman's body—which
may have been intentional. "Stieglitz," O'Keeffe once con-
cluded, "was always photographing himself."

All Emmy, however, knew was that her husband was
photographing a nude woman in her house. And she dis-
approved. Within forty-eight hours of being caught, Alfred
ended a union of twenty-four years and moved out. Ap-
pealing to O'Keeffe that he had nowhere to go, he tempo-
rarily lodged with her in Elizabeth's studio. Within three
days, Emmy asked Alfred to come back, but he refused. He
partitioned a room for himself in the studio by draping a
curtain from wall to wall and was happily photographing
his model, O'Keeffe, whenever the muse spoke to him. For
the first time since he had been with his mother in Saratoga
as a young boy, he felt he was with a woman with whom
he belonged, as he told people.

Having heard through the grapevine of Alfred's latest
adventure, Hedwig Stieglitz summoned her son and his com-
panion to the rambling Stieglitz mansion, Oaklawn, on the
shore of Lake George in August—the same Lake George
where O'Keeffe had studied art ten years earlier. An old
German-born widow, who, as O'Keeffe put it charitably, "was
neither tall nor thin," Hedwig worried incessantly about her
children. Keeping an open mind for Alfred's mistress must

have been an ordeal for her. Relatives recalled that Hedwig's friends were opposed to Georgia merely on the grounds, sufficient in 1918, that she was not married to Alfred, even though no one seems to have liked Emmy, who had been barred from the lake since 1914, when a terrific rage had turned all of her in-laws against her. Years later, Emmy was referred to as a "frothy creature" by Stieglitzes.

After supper each night Alfred and Georgia rowed a red boat out on the teal blue lake. They rowed to the middle of the lake and watched the sun play on the water as it descended behind the range of pine-laden mountains. Hedwig paced the veranda until her son returned. "She knew he was a swimmer and as safe as anyone in a boat," O'Keeffe recalled, "but he might some way drown."

Chapter 10

.

Opening nights of art exhibitions were not normally popular events in February 1921, when Stieglitz unveiled 145 of his own photographs in the plush Anderson Galleries on Park Avenue in New York. In a gallery where antique French furniture generally vied with Old Master paintings for prominence, Stieglitz presented his starkly modern master prints from the 1880s to the present, including *Steerage* and *The Hand of Man*, as well as forty-five photographs of Georgia O'Keeffe in various stages of undress. It was a sensation.

On the first night, hundreds of people jammed the wood-paneled elevators leading to the gallery. Within two weeks, three thousand people had braved icy winds to see the show. They did not come to see *Steerage* or *The Hand of Man*, French furniture, or Old Master paintings. They came to look at nude photographs of the mysterious young woman who was only identified as "A Woman" in the catalogue. O'Keeffe herself—who appeared to a newspaper reporter as "an ascetic, almost saintly appearing woman with dead-white skin"—appeared briefly at the opening, only adding to her allure by dressing in funereal black and bearing a deep pensive frown, then vanishing alone into the cold dark night before the event was over. Recalled critic Henry McBride, the show "put [O'Keeffe] at once on the map. Everybody knew the name."

That O'Keeffe's meteoric rise to the summit of the world of personalities happened overnight was all the more remarkable in that it followed a period of intense isolation. In

the nearly three years since she had moved to New York, the artist had rarely spoken or written to—or, for that matter, seen—anyone. Her friends from school were treated only to glimpses of the enigmatic mistress of Alfred Stieglitz. Stieglitz did the speaking and writing for both of them, binding them as tightly as glue in the years to come. O'Keeffe modeled patiently for countless photographic sessions. All her spare time was spent behind her white-painted easel. They were balmy years, 1919 and 1920, and the artist basked in the last breath of anonymity she would know in her life. As she had desired ever since she was a little girl on the farm in Wisconsin, O'Keeffe had become a bona fide artist— and she was thrilled. "We were very happy here," she wrote Elizabeth Stieglitz from Lake George. "—I was never so happy in my life."

On her return to New York from Lake George, O'Keeffe set up a studio in the yellow-and-orange room on the top floor of the brownstone house on Fifty-ninth Street. It was "not a very good place for painting," she recalled, "but it was exciting. It made me feel good and I liked it." With a passion for walking great distances, she paced up and down Park Avenue, a European-style boulevard lined with the private brownstone residences of New York's bourgeoisie. At ground level on some of the street corners were flower shops, selling exotic blooms in the middle of the winter to rich people who lived in the area. O'Keeffe marveled at the size and the beauty of the lilies and orchids and tulips. Accustomed to seeing cut flowers only in season in other places she had lived, these rare blossoms in winter provided a key sensation in those quiet years.

Before long, O'Keeffe had exhausted her meager savings and was entirely dependent on Stieglitz for financial support. She did not work at all for money. Stieglitz had promised to fund her for a year while she created a body of work, as he had done for other artists in his stable when he had a gallery. The difference now was that he did not have a gallery; and in fact, he himself was entirely dependent on his brothers, Lee and Julius, for lodging and most support.

He drew $1,200 a year from a family trust fund—barely enough to support one person. To a friend visiting from Virginia, the normally cool O'Keeffe sounded surprisingly ecstatic over the phone as she invited her to breakfast. "Oh," the artist added sportingly after she had told her where they were living, "you'll have to bring an egg, too."

Living on nothing was hardly new for O'Keeffe, who had scrounged for most of her life and knew how to forage for second-day bread and choose from among wilted produce at cut price. She did so with great aplomb. When they ate out, which they did every evening even during those lean times, O'Keeffe and Stieglitz made a meal out of a crock of French onion soup or a bowl of noodles. She had spent several years cooking and cleaning for her father and the younger children in Williamsburg, and doing the same thing for herself and Stieglitz was but a different version of the same challenge—under circumstances of considerably greater freedom. She was in love with Stieglitz. She had her entire day free to paint. There were no more students or faculty members breathing down her neck. The big events of the day came out of a tube of paint.

Stieglitz comforted and coddled her as if she were not an adult in her early thirties, but a child. His insistence on infantilizing their relationship amused her, and at times it comforted her—later, it annoyed her. When her father died tragically after a fall from a roof he was repairing in Virginia in November, she was devastated. Stieglitz told people not to mention the word *death* in her company—he said the word would trigger a torrent of emotion from the otherwise calm O'Keeffe. Like many of the art impresario's attempts to explain the O'Keeffe phenomenon, this insight only fueled people's interest in the mysterious artist who would one day meditate on the shape of bones.

The death of her father seems to have signaled the end of childhood for Georgia. Whatever her feelings were about Frank—and they seem to have been deeply buried and unresolved—it was not easy for her to talk about them. She rarely spoke about him. She kept no pictures of him. And

yet he was on her mind. Although she later concluded that he had sexually abused her, she hung on to his memory now as a positive force in her life. She wanted to be like her father: a man who had built a barn. And she was alluding to their closeness when she wrote: "The barn is a very important part of me."

Living with Stieglitz might have seemed like an attempt to recapture her relationship with her father. And there was a side to the relationship that was incestuous, as Stieglitz spoke and wrote for O'Keeffe, referred to her as "child," shielded her from hurtful words when her own father died, gallantly attempted to support her when he himself had no money, and treated her as his mother and aunt had treated him—like an invalid. His smothering ways often appeared excessive to others. O'Keeffe, however, had longed to be smothered, it seems. Her own family had been cold and detached. Catherine O'Keeffe recalled that their parents had shaken hands on greeting each other. Stieglitz not only smothered her, he recreated the incestuous bond that had been established by her father. He was the ideal mate for a person who had been molested as a child. Some of his relatives believed that he later sexually abused their daughters: "The parents and grandparents of all Alfred's postpubescent friends were discomfited, at one time or another," wrote his niece, Sue Davidson Lowe, "by the long hours their little girls shared with him."

Living with Stieglitz was not only emotionally complicated, it was socially daring. Few people in 1918 actually cohabited outside marriage. Not only was it against the law, it was nearly impossible to rent a place in New York under those conditions. If it weren't for the fact that Alfred and Georgia lived in a studio that had been rented by his brother Lee, they probably would not have been able to occupy the same room. Her prim friends from boarding school—as well as her sisters and brothers—were shocked that she was sharing a conjugal bed with an older man who was married. (Ida eventually came to like Stieglitz very much and approved grudgingly of the arrangement.) Her brother Francis

later made anti-Semitic remarks about Stieglitz, to which Georgia responded by cutting him off.

O'Keeffe worked well in her new yellow studio. The traumas of her last year in Canyon and her father's death seem to have receded as she began to tackle larger paintings in oil on canvas—a medium she had not used since her days at the Art Students League. She looked forward to stretching to new limits. Shortly after she and Stieglitz returned to the city in the fall, O'Keeffe sent for the things she had left behind in Canyon. They arrived in a big oak shipping barrel. After poring over the uncompleted drawings, the artist decided to throw them away and start over again—a process of weeding and digging that she would continue throughout her life; she discarded paintings at a landfill in the desert outside Abiquiu sixty years later. She put them in the trash outside their place. "That night when Stieglitz and I came home after dark the paintings and drawings were blowing all over the street."

Work was going so well that when the summer heat descended on New York in June 1919, O'Keeffe and Stieglitz remained in town, painting and photographing "like mad people," as they had the summer before. O'Keeffe once again worked in the nude while Stieglitz continued his ongoing portrait of her. His camera was always positioned, "so he could grab [it] if he saw something he wanted to photograph." At first, O'Keeffe returned to themes she had begun in Texas, painting the flat landscape of the plains in simple colors—as in *Red and Orange Streak,* which captured the essence of a sunrise on the plains. Then her palette suddenly shifted to bright hues of red and yellow and pink—feminine, virginal colors that were not generally found in the standard 1920s modernist palette. Although the paintings were abstract and, according to the artist, were based on spiritual values, to many people awakened by Freud they suggested female genitalia—continuing a thread that had begun with the sexually charged 1915 watercolors that Anita Pollitzer had brought to Stieglitz.

Living with Stieglitz was a challenge. A born debater who thrived on disagreement, he surrounded himself with people who, like himself, lived in words and ideas, a sphere that made the intuitive O'Keeffe uncomfortable. He read to her, he argued with her, he practiced theories on her. And when he wasn't doing that, he photographed her. Sometimes she awoke in the morning overhearing him arguing one side of a debate with someone who had stumbled into their garret, while in the afternoon he would take the opposite side and argue it just as compellingly. "For me he was much more wonderful in his work than as a human being," she recollected. "I put up with what seemed to me a good deal of contradictory nonsense."

Being photographed by Stieglitz required patience. Using equipment that demanded a sitter to hold a pose for several minutes without stirring, Stieglitz would curse loudly in German if she moved before he was finished. To achieve more naturalistic poses, Stieglitz took many shots of the same subject, forcing the model to sit stock-still for hours. Periodically, he peered out from under the black headcloth behind the camera. He used only natural light to illuminate his subject. He and O'Keeffe arranged to be at home during a certain period in the afternoon when the light in the studio was perfect for his needs.

Taking care of Stieglitz was a full-time job itself. Accustomed to the solicitous attention of his mother and aunt, he had been raised to view life as a long illness punctuated by brief periods of health. He was constantly complaining about various problems. His digestion was a complex system of malfunction. His sinuses were inflamed by the slightest breeze. He suffered from prolonged migraines, demanding complete quiet during these periods, as his autocratic father had. He was prone to imagine that others were as ill as he was—particularly O'Keeffe. Having actually never been very healthy herself, she tended to believe him. In the winter of 1919, both of them endured prolonged colds that forced them into their separate iron beds (they always had separate

beds; sometimes, separate rooms) for weeks at a stretch. Only as a late-middle-aged woman, when she left Stieglitz, did O'Keeffe regain her rightful health.

Not that O'Keeffe was a stranger to hypochondria. Having moved from Wisconsin to Virginia as her wayward father searched for the health that had eluded his brothers, she was accustomed to people who were overly concerned about disease. Her mother had died after an illness of almost ten years. Nursing and taking care of frail people seems to have been something she was equipped to do, having been trained at an early age to look after the needs of those who could not look after themselves. Years later, when asked to recall her life with Stieglitz, O'Keeffe would simply state that he had been sick nearly all the time she knew him. "She told me Stieglitz always had problems with his digestion," recalled art dealer Robert Miller, who first met her when she was eighty-six years old; "it was interesting because that was all she had to say when I asked her about him."

At the end of July 1919, Stieglitz and O'Keeffe were back at Lake George for what would be the last summer at Oaklawn. Oaklawn was a grand old pile of a house with a turret, a porte cochere, and a veranda, one of many houses along the lake on what was known as Millionaire's Row. It was furnished in the style of the 1880s with what O'Keeffe referred to as a disgusting collection of bric-a-brac, including a marble bust of Judith that finally, some time later, was buried on the property as a joke. Having exceeded her income, Hedwig Stieglitz had to sell the big house and lakefront property and move her summer residence to a nearby farmhouse on what was known as The Hill, a gentle rise across Bolton Road from Oaklawn. The Hill was a former pig farm and plain Victorian frame house nestled into a pine and birch grove. As the future executor of Hedwig's estate, Alfred was pressed into service to oversee the sale of the house, although he convinced his brothers to help him out, pleading that he knew "nothing about such matters."

In the fall of 1919, Georgia and Alfred returned to New York, where they occupied separate bedrooms on different

floors of Lee Stieglitz's new brownstone house on East Sixty-fifth Street and Park Avenue. They were as poor as foundlings and entirely dependent on the generosity of Stieglitz relatives. They ate dinner in cheap Italian bistros with red-and-white-checked tablecloths under the roar of the elevated train on Third Avenue. O'Keeffe stitched her own garments and saved pennies in a jar under the bed. Alfred's financial nonchalance met with ongoing disapproval from his family. A year after he and O'Keeffe had begun to live together, brother Julius had pleaded with his older brother, "I hope that the inspiration and presence of Miss O'Keeffe will give you not only the artistic life . . . but also the strength and courage to take up the burden which life lays on any man assuming responsibilities."

But as he approached his sixtieth birthday, Alfred was not about to take up any new burdens in life. He told people O'Keeffe wanted to have a baby, but he was opposed to the idea on several grounds. For one, he believed he had failed as a father to Kitty. Kitty had refused to talk to Alfred ever since he had left her mother, and she would not speak to him again for some time to come. What was more, his own sister Flora had died in childbirth in 1890, and Alfred feared O'Keeffe would, too. Flora's death had made him, according to Sue Davidson Lowe, "unbearable about pregnancies in those whom he loved."

O'Keeffe's desire to have a baby appealed to Stieglitz's vanity, but he prohibited it from occurring—probably in the way most people kept from becoming pregnant before effective birth control: by judicious copulation. There may have been other factors as well in their birth control. Stieglitz talked about sex openly and embarrassed women by making lewd remarks, but there is no evidence to suggest he was particularly potent, and in fact, because of the way he expressed his sexuality with verbal taunts and aggressive flirtation, it may be that he suffered from periods of impotence. A few years later he silenced a woman who had said she did not appreciate the painting she was looking at by saying, "Madame, can you tell me this: why don't you give me an

erection when I look at you?" It may have been that he didn't get an erection when he looked at anybody.

Stieglitz convinced O'Keeffe that her paintings were her children—a point he believed strongly and that she came to believe herself. This typical late-Victorian characterization of the creative process was applied to the work of countless male as well as female writers and artists. It was, however, hardly a concession to a woman who wanted to have a baby. She explained to a friend that being a woman artist had forced her to choose between having children and having a career. She couldn't have both. O'Keeffe had come to accept Stieglitz's position on the matter, as she did on nearly every other count, having learned that it was futile to dispute him. "There was such a power when he spoke," O'Keeffe later marveled, "—people seemed to believe what he said, even when they knew it wasn't the truth."

Leaving his wife and taking a much younger lover boosted Alfred's stock with his cronies. His virility in the art world had been declining for some time, as had his fortune and his relations with his wife and family. In the final years of the 291 gallery, artist Francis Picabia drew a caricature of Alfred in which a camera's bellows were shaped like a limp penis. Another artist drew a tombstone with an epitaph and RIP by his name. Although he tried to convince people that it would, the world of modern art did not close down along with 291. In fact, trade was brisk, and the number of galleries dealing in modern art increased as a result of the growing acceptance of modern art. In some ways, being with O'Keeffe was a way of reasserting himself in the world of art. By promoting and developing her talent, by creating a portrait of her body, by hitching himself to her star, the art impresario reinvigorated himself, as O'Keeffe herself would one day attempt to do with a much younger man.

Which is not to say their relationship was always amicable. O'Keeffe was entirely opposed to the February 1921 exhibition of the portrait Stieglitz had made of her. Like so much else in her life with Stieglitz, it happened so quickly she barely had time to assert herself. When she did, it was

half-heartedly. In the late fall of 1920, Mitchell Kennerley, owner of the Anderson Galleries, approached Stieglitz with an invitation to show his work in February of the following year. Kennerley and Stieglitz had been friends for some time; in fact, when Stieglitz had closed 291, Kennerley gave him storage for the gallery's records and files in the basement of the Anderson Galleries' building at 489 Park Avenue. British-born Kennerley was a hard-drinking bachelor, most likely a homosexual, with one eye on fashion, style, and art, and the other on scandal.

The night before the opening, Stieglitz held a private showing of the O'Keeffe portrait series for family and friends—as well as selected members of the press. While the group examined the power of his portrait of the artist, O'Keeffe sat silently in a Louis Quatorze chair, wrapped in a black cape over a black dress. Just as Prohibition had ended the sale of alcohol in the United States in 1919, censorship of movies and books had become a companion in moral jurisdiction in 1921—forty-six states had enacted strict laws defining what was decent. After some debate over the artistic value of such work, Stieglitz withdrew the photographs that included views of O'Keeffe's genitalia. Although he would have relished a debate over the morality of such images, he finally conceded because he did not want to put O'Keeffe or Kennerley on the wrong side of the law.

On the night of the opening, Stieglitz basked in the pale light that the world of entertainment allows those making a comeback. Wearing a trimmed moustache and unchar-acteristically neat hair, a tweed suit and a four-in-hand tie, he was positioned prominently in front of the portrait. O'Keeffe was less secure. Having so many people look at her body embarrassed her. She moved around uncomfort-ably. It was a terrifying experience. She complained to Strand that she felt exposed—she wanted to flee from the people she felt were judging her. She fled from the gallery after she overheard several men ask Stieglitz to photograph their wives as seductively as he had her. Years later, after the shock had worn off, O'Keeffe mused ironically about the

incident. "If they had known what a close relationship Stieglitz would have needed to photograph their wives or girl-friends the way he photographed me—I think they wouldn't have been interested."

O'Keeffe was probably referring to the widespread speculation that some of the photographs had captured her expression as she achieved orgasm. Although that state was probably induced autoerotically, Stieglitz boasted to his cronies, like a vulgar sailor, of this feat of artistic engineering. Some women attending the exhibit were particularly upset by this. Men were, for the most part, aroused: "one of the profoundest records of woman's being which we possess," wrote critic Paul Rosenfeld, "her great painful and ecstatic climaxes make us at last to know something man has always wanted to know." A woman standing before one of the portraits felt the passion behind the creation of the works. She said with a sigh: "He loves her so."

Stieglitz refused to part with any of the O'Keeffe portraits for less than five thousand dollars, a considerable sum in 1921 dollars and an unheard-of price for a photograph, calculated to ensure that only dedicated (and very rich) people would invest in the work. For weeks after the show, the art world was abuzz over the existence of the secret photographs of O'Keeffe's genitalia, with a great deal of prurient interest in Stieglitz and O'Keeffe. He, dressed in a black cape and porkpie hat; she, in a black turban and long black dress—the two became a couple of bookends in the New York of personalities that went places and were seen. When he wrote, "I was born in Hoboken. I am an American. Photography is my passion. The search for Truth my obsession," she replied, "I have not been to Europe. I prefer to live in a room as bare as possible. I have been much photographed."

Stieglitz's photographs of O'Keeffe launched her as a personality before she was seriously regarded as an artist, a case of putting the cart before the horse. This situation would hamper her future reception in artistic circles by placing her work in a special category that the art world reserves for

phenomena. Why she allowed Stieglitz to exhibit the nudes has never been made clear. She was so afraid of exposure and of what other people would say about her that it seems like a case of subconscious fear being made real, of what Buddha meant when he stated that a person creates what they defend against. One of the signs of a victim of incest is their inability to accept their own body as their own property, primarily because they were invaded as infants who were unable to say no. For the most part, O'Keeffe maintained a wry detachment from the pictures. She seems to have viewed them as creations of Stieglitz's that had nothing to do with her—any more than the purified forms of her still lifes were about specific flowers. The artist rarely referred to the portraits, remaining mysteriously aloof from them. She felt the nude portraits always portrayed her with a cowlike expression.

PART TWO

.

1918–1946

Chapter 11

.

T he first major showing of the artwork of Georgia
O'Keeffe needed no introduction. People had been
talking about the artist and her sexually charged pic-
tures since Stieglitz unveiled her portrait two years earlier.
Again on the red velvet walls of the Anderson Galleries, on
January 20, 1923, exactly one hundred watercolors, draw-
ings, charcoals, and oil paintings were laid out for public
inspection. The invitation read, "Alfred Stieglitz Presents
Georgia O'Keeffe American," but the artist herself took up
a pen and in a rare excursion into self-pronouncement pro-
vided her followers with a brusquely worded statement of
intent. She said that she had discovered she could not live
where she wanted to live or say what she wanted to say. "I
decided I was a very stupid fool not to at least paint as I
wanted to and say what I wanted to when I painted as that
seemed to be the only thing I could do that didn't con-
cern anybody but myself—that was nobody's business but
my own."

What O'Keeffe painted soon became everybody's business
but her own, however. On the first day, five hundred people
crowded into the ornate gallery. There were no skulls or
bones or red hills or enlarged flower blooms or New York
skyscrapers—subjects for which the artist would become
known later. This show included simple, straightforward
still lifes that she might have completed in Chase's class
fifteen years earlier—a bowl of grapes or group of apples—
striking abstractions that continued the thread, begun in
Texas, of using a flat plain slit down the middle to contain

a feeling or an emotion. The show also featured views of
Lake George, including *Lake George with Crows,* a mystical
painting that would later draw people to her; an abstraction
of corn plants; autumn leaves; and a sensual watercolor of
a red canna lily in full bloom. "Flowers and fruits burn in
their conception of them," wrote the *New York Sun,* "with
deep, luminous colors that have no names in spoken or
written language."

On the whole, O'Keeffe's works echoed those of the other
modernists in her circle, particularly Marsden Hartley and
Arthur Dove. But hers departed from theirs in several dis-
tinctive ways, and since she was the only woman in the
group, people were eager to point out the feminine qualities
of her work. O'Keeffe used bright colors, like pink and
yellow, at a time when most palettes were subdued as dusk.
She proved that she could paint like "the men" by producing
The Shanty, which she humorously called a "low-toned, dis-
mal colored painting," and she pointed out that the men
thought she could paint because of its coloring. *The Shanty*
was later purchased by Duncan Phillips for the esteemed
Phillips Collection in Washington. She normally painted as
she wished, using luminous underpainting and vibrant
colors to bring out the essence of plant life and landscapes.
In her meticulously painted small canvases, a leaf or blossom
was enlarged to encompass a universe of sensation, while a
range of mountains was reduced to the size of a flower bud,
as if her sense of scale had come from the wrong side of a
camera lens. And in fact, she later admitted that she cropped
her paintings as if they were photographs, acknowledging
the debt she owed to Stieglitz. Her work was personal and
lyrical. It was vibrantly sexual. Nothing like it had been seen
before. O'Keeffe was a heretic. "Even many advanced art
lovers," wrote critic Henry McBride, "felt a distinct moral
shiver."

Awakened by the writings of Freud and encouraged by
the coaxings of Stieglitz, many critics looked only for the
sexual imagery in her work, responding salaciously to it as
if it were pornography: "What men have always wanted to

know, and women to hide, this girl sets forth," wrote critic Paul Rosenfeld. "Essense of womanhood impregnates color and mass." Writer Herbert Seligmann also connected O'Keeffe's work to her physical being: "Her body acknowledges its kindred shapes," he stated, referring obliquely to what others referred to graphically as the "vulval," "labial," and "clitoral" shapes found in the paintings by those who looked for them. Helen Appleton Read, a critic for the influential *Brooklyn Daily Eagle* and a former classmate of the artist's, was clearly upset by the showing: "the shameless naked statements are too veiled to be anything but rather disturbing . . . they seem to be a clear case of Freudian suppressed desires in paint. . . . Whether you like some of these very obvious symbols is a question of taste."

Other writers came closer to the true point of O'Keeffe's work when they wrote of the pantheistic world in her paintings. Some noted correctly that round shapes and protruding figures were also described in the Kandinsky book *Concerning the Spiritual in Art,* to which the artist referred almost every day, and that the cave forms in two of her paintings had been used by creative people as a metaphor for the mystical unknown ever since Plato. However, at times the critics elevated the artist to the status of goddess. One writer referred to the exhibit as "the shrine to St. Georgia," holding on to the Victorian belief that women are more spiritual than men, and again separating her work from the mainstream as that of a female oddity. "Georgia O'Keeffe," wrote Marsden Hartley, "has walked on fire and listened to the hissing of vapors round her person . . . is the Sphinxian sniffer at the value of a secret." "Something rare and significant in realm of spirit," Strand observed in an article, "has unfolded and flowered in the work of Georgia O'Keeffe. A woman soul is on the road, going toward the fulfillment of destiny."

The week after the opening—and for nearly every opening for the rest of her life—O'Keeffe took to her bed like a Victorian consumptive, suffering from what appears to have been an acute attack of shame. As many creative people

eventually find out, critics are free to write whatever they wish, even when they see what she had not intended. Still, she reported matter-of-factly to a friend from boarding school that she needed to have people talk about her work, even when she did not like what they said. Stieglitz had told her that "people buy pictures more through their ears than their eyes . . . and one must sell to live." What she objected to was not the commerce, but the people themselves—the "greasy" people who came to see the shows, who cheapened the experience and gave her a "queer feeling of being invaded." Nearly fifty years later, referring to what Hartley had written, the artist revealed to Grace Glueck of *The New York Times,* "I thought I could never face the world again."

At the time, she found comfort in the advice of Hutchins Hapgood, a Harvard-educated liberal journalist and author of *Spirit of the Ghetto,* a romanticized account of daily life on New York's Lower East Side. On finding her upset over one of the troublesome articles a year after the exhibition, Hapgood laughed at the distressed artist at first. But then he saw she was seriously upset and he told her she had nothing to worry about. The critics were not even really writing about her, he said—"They were only writing their own autobiography." For the rest of her life, the artist repeated what Hapgood had told her, concluding that she was powerless over the written word and serenely accepting others' opinions with a shrug: "So—what could i do about it—."

O'Keeffe found it was almost as hard to have people buy her art as it was to have people write about her. Having become a painter after years of toil, struggle, and doubt, she could not believe that she now had to part with what she had created—and in fact, she spent the later years of her life trying to buy back paintings she had sold. Approximately twenty works from the 1923 show found buyers—a fantastic occurrence at a time when John Marin and Arthur Dove found it hard to make a single sale. She brought home around three thousand dollars, more than many people earned that year.

She had to let go not only of what people said of her and of what she created, but of what people thought of her. Having emerged as a powerful woman at a time when many women were beginning to assert themselves in the marketplace, O'Keeffe found herself "besieged by her sisters for advice," according to Henry McBride. Becoming a role model for other women had not been O'Keeffe's goal, nor was it generally recommended as a sideline for artists who wanted to continue being artists. McBride advised her to "get herself to a nunnery."

O'Keeffe had already found her nunnery—in a manner of speaking. From the summer of 1920, a run-down outbuilding known affectionately as the Shanty—the subject of her dim 1921 painting—was her studio and home-away-from-home at The Hill on Lake George. Escaping the large Stieglitz family and all of their various rivalries, she lined up rows of paint jars on an unpainted wooden shelf and with her milk-glass palette turned out personal artworks, painting by herself in the nude. Outside the Shanty she had to contend with Stieglitz in his pontificating tirades, with his sisters and brothers, and their large broods, and with their infirm old mother, Hedwig, until her death in 1922. The Shanty was where she was safe from people, where O'Keeffe could be O'Keeffe. Only Alfred's beautiful thirteen-year-old niece, Georgia Engelhard—whom Alfred had nicknamed "the Kid"—was allowed in the Shanty to paint alongside her. Because they were often together, the family dubbed them Georgia Major and Georgia Minor, and in fact it was later revealed that the two were sexually intimate.

Each summer, O'Keeffe and Stieglitz ventured north to Lake George, traveling up the Hudson River by train or by night boat. Stieglitz, a creature of deeply ingrained habit, was as bound to the annual summer rite as he was to the six pieces of zwieback he devoured every morning and his afternoon nap. O'Keeffe said she would have preferred to live alone, but in spite of the many demands made on her by such a large family and many house guests, she enjoyed being at the lake. There she cultivated a large vegetable

garden in which she tended a large harvest of corn, squash, peas, lettuce, and herbs. She swam nude in the lake at night and remarked on the inky quality of night-water. She climbed towering Prospect Mountain, which rises from the center of quaint Lake George Village, taking in the view of the range of green mountains across the lake. Having sold the big house, Oaklawn, the family and their friends were crowded into the simple white frame farmhouse on The Hill and a few small outbuildings, often doing without the cooks or maids to which they had grown accustomed. O'Keeffe did more than her share of cooking and washing.

Being at the lake seems to have brought O'Keeffe full circle in her life, back to her days as a child on the farm in Sun Prairie. There was a rhythm to the land, of which she became a part, quietly enveloping herself in the birch woods and pine groves lining the cold northern lake, wishing each year to go to The Hill earlier in the season and remain past the first snowfall. The family found her quiet and enigmatic. "Her solitary walks," recalled Sue Lowe, "became deliberately longer" as the years passed. O'Keeffe walked quietly in canvas espadrilles through fields of sour grasses and wildflowers, looking for such specimens of "found art" as skeletal branches, weathered stones, or a feather, which she brought back to the farmhouse and put on display. When she brought bits of nature into the house, as she had carried a cottonwood branch into her room in Canyon, she aroused the suspicion of some of the hidebound family members who preferred fancy bibelots. The lake and the compound known as The Hill became the world from which the artist drew most of her inspiration in this period—as the plains of West Texas had been and deserts of New Mexico would be in later years. She spent hours crouched on her knees studying morning glories that bloomed in a clump at the base of a drain spout by the Shanty.

All was not bliss, however, on The Hill. There is something about a summer house that brings out discontent in family members, and this family was no exception. It was as if they stored their bile and rancor all winter long for

annual purgings in warm weather. O'Keeffe's ally in the family, Elizabeth Stieglitz Davidson, stopped coming to The Hill during the summers; she could not leave her fruit-growing business in Westchester. Meanwhile, Selma Stieglitz Schubart, Alfred's lusty younger sister, irritated O'Keeffe. A flamboyant woman who smoked cigarettes in public and wore elegant silk-printed Fortuny dresses on the farm, Selma carried her temperamental French bull terrier wherever she went. Named Prince Ricco, the dog had been a gift of the opera star Enrico Caruso, one of Selma's many suitors. Prince Ricco bit so many people that the family renamed him Rippy and took to leaving a bottle of iodine out on the dining-room table for the next victim of the vicious little dog to use. O'Keeffe refused to be in the same room alone with either the dog or its mistress.

When Alfred's brother Lee and his wife, Lizzie, arrived from East Sixty-fifth Street with their cook, O'Keeffe began concocting her own meals to avoid eating the salads Lizzie ordered. Lizzie's preferred salads were either tomato aspic or grapefruit sections and avocado, resting on a bed of lettuce and doused with what Sue Lowe remembered distastefully as "a gruel of anemic pink that [was] supposed to be French dressing." O'Keeffe took an empty bowl from the cook and tore fresh lettuce from her garden and watercress from the brook into it with her bare fingers. She added onions and garlic, foods strictly prohibited in Stieglitz households. "Then, in haughty silence, she [rose] to take her fragrantly polluted creation to the porch overlooking the lake" and ate by herself.

Each summer while they were at The Hill, Alfred and Georgia entertained house guests from New York. Their first guest was Paul Strand, who in 1919 returned from the army to visit them. In the time since they had parted at Penn Station in June 1918, Strand had become reconciled to losing O'Keeffe to Stieglitz. The young photographer remained a staunch supporter of O'Keeffe's work, talking about it with whomever he met. O'Keeffe tended to lump him in with the men who did not get it, however, and their relationship

never recovered its former passion. In the summer of 1922, Strand brought his bride, a painter by the name of Rebecca (Beck) Salsbury, for a visit. A strikingly handsome, large-featured, heavy-browed woman, Beck would soon clip her hair short like a man's and dress in baggy men's trousers and loose blouses. Beck became friends with Georgia at first sight. The two women swam nude at night and during the day painted side by side in the nude in the Shanty. One day, after some coaxing from Alfred, Paul and Beck went for a nude swim, too, only to be arrested by Lake George police enforcing a ban on public nudity. Stieglitz, who was watching from the shore, paid the fine, claiming "the crime" was his fault.

While Georgia worked diligently in the Shanty, completing twenty-five paintings by the end of that summer, Alfred engaged in what appears to have been a lighthearted flirtation with Beck. He teased her, made suggestive remarks to her, tickled her, and photographed her in the nude in the woods. Although Alfred was collaborating with Paul on a series in a new magazine, *MSS,* his attention toward Beck created some understandable friction. Having lost one woman to Alfred, Paul was no doubt apprehensive about what might happen to a second. Throughout 1923, Alfred wrote incredibly explicit letters to Beck. Since he claimed that they were intended for both Beck and Paul and their content was sexually charged, Alfred may have been infatuated with both Strands. But Alfred was not the only bisexual in the family. Georgia had already professed her love for Paul and seemed to share Alfred's infatuation with Beck. Beck was physically a mirror image of her, and according to one family member, "she could have been an understudy for Georgia."

Their relationship was definitely open to other alliances, but with few exceptions O'Keeffe trusted Stieglitz emphatically and does not seem to have been jealous of his wandering eyes and hands. Although Stieglitz, whom she would eventually marry, was wildly promiscuous, O'Keeffe told people she did not mind being disregarded from time to

time. It may have been that she enjoyed being relieved of the intense glare of Stieglitz's focus. During periods in the late fall, when they remained at the lake after the others had returned to New York, she had him all to herself: "My particular kind of vanity—doesn't mind not being noticed at all . . . and I dont even mind being called names—but I dont like to be second or third or fourth—I like being first—if Im noticed at all—thats why I get on with Stieglitz—with him I feel first—and when he is around—and there are others—he is the center and I dont count at all."

By now, Stieglitz had begun to photograph other people as often as he photographed O'Keeffe. These photographs document the various personalities who passed through The Hill, especially during the summer of 1922. One was Sherwood Anderson, a lyrical realist best known as author of *Winesburg, Ohio,* whom H. L. Mencken called "America's most distinctive novelist." The handsome, moody, square-jawed Anderson, a rival of Hemingway, was known as "the Rake" and dubbed a "matinee idol" by Gertrude Stein. Both Georgia and Alfred were enamored of Anderson's physical presence and his talent as a writer. The year after Stieglitz and Anderson met, in what Anderson's biographer referred to as "potentially embarrassing terms," Stieglitz wrote Anderson that he would never forget how he felt when they first met, using romantic language usually reserved for members of the opposite sex: "Strength and beauty. Or should I say simply Great Beauty for beauty is always strong." Anderson purchased a still life from O'Keeffe's exhibition and enjoyed talking with Stieglitz about her work, although O'Keeffe was miffed after she asked him to compose an introduction to her next exhibition catalogue and, several half-hearted promises later, Anderson replied that he could not write on command.

Another visitor was Charles Demuth. A dapper, Druidic-looking homosexual artist with electric eyes, a pencil-line moustache, and a gimpy walk, whose subjects included muscle-bound sailors, Demuth occupied a secret world of homosexuals that both attracted and repulsed Stieglitz. As

with many of their other joint friendships, Stieglitz and
O'Keeffe each seemed to stake out their own relationship
with Demuth. O'Keeffe and Demuth soon became close con-
fidants and drinking companions, and she defended him
vigorously: "He was a better friend with me than any of the
other artists." Demuth, a diabetic, was not supposed to drink
and O'Keeffe drank against the teetotaling Stieglitz's wishes,
but their bibulous alliance brought out a sardonic side in
her that was exposed whenever she was around those who
drank. A friend later recalled that the artist became "bitchy"
when she had a few drinks, while others noticed that she
often refused to drink at all, indicating alcohol made her
lose control.

Even Claudia O'Keeffe was photographed by Stieglitz
when she came to visit the lake from New Jersey. But because
Claudia was not interested in men, she found Alfred's flir-
tations overbearing and cut herself off during the summer,
resuming her close relationship with Georgia after Alfred
died in 1946.

Inspired by O'Keeffe's abstract works based on music, Stieg-
litz began to photograph cloud formations as seen from The
Hill, looking across the deep lake. He called these photo-
graphs *equivalents* and announced that he had successfully
made the photographic "equivalent" to music. Only a few
other people concurred with this pronouncement, but he
was thrilled to be working again, as he had, feverishly, when
he was younger. "The splendid cook remarked yesterday,"
he wrote Strand excitedly from The Hill, "seeing me chase
in & out—drying negatives over her stove, etc., etc.,—'Why
Mr. Alfred you are working & looking so hard, as if you
were trying to draw the last ounce out of the place!' "

Even before her first big show in 1923, O'Keeffe was
beginning to grudgingly accept that she was becoming a
famous person. *Vanity Fair,* the magazine of famous people,
had already written about her. Under the title "The Female
of the Species Achieves a New Deadliness," O'Keeffe was

described as "the very essence of woman as Life Giver." Stieglitz later confessed that he found it easier to promote O'Keeffe and her work than any of the other artists he had represented over the years. Marsden Hartley, for one, auctioned off all his work in 1922 to raise money to go to Europe, claiming that he was tired of struggling to make ends meet in America. It was almost impossible to separate O'Keeffe and Stieglitz's business relationship from their personal relationship. They had become so enmeshed in this period that it was often hard to separate one from the other. Relatives on The Hill remember that they always seemed to be conspiring to do something—no one could figure out what—whispering softly and laughing knowingly.

When Stieglitz's mother, Hedwig, died in November 1922, his bond with O'Keeffe became even tighter. For some time, he had been estranged from his mother, whom he had once worshiped and with whom he had walked and read novels in Saratoga as a child. Stieglitz clearly worshiped O'Keeffe in the same way he had once placed his mother on a pedestal. Much of what was written about O'Keeffe that bothered her was actually, inadvertently, generated by him. Stieglitz could not stop talking about O'Keeffe to people; in some ways, he practically canceled her out by explaining her constantly. He seems to have been more responsible for her reception than she wanted to admit. Guiding many of the critics through the show like an eager salesman, Stieglitz pointed out the sexual imagery in her work and continued to separate her from other artists because of her sex: "The woman," he maintained, "receives the World through her Womb. That is the seat of her deepest feeling."

O'Keeffe would have no part of Stieglitz's image of her—although, rather than disagree with him, she seems to have simply ignored most of what he said. She didn't want the responsibility of being a goddess for a group of addlepated male painters. She objected to the notion of her work as a cosmic expression of the ethereal woman. Nor did she want to be a ringleader for the emancipated woman. Or a femme fatale. Or a sphinx. Thinking of herself as a conventional

midwesterner who was trying to capture the true mystic light of nature in her paintings, O'Keeffe could not believe that people found so many things in her work that she herself did not. "They make me seem like some strange unearthly sort of creature," she wrote to a friend, with ironic exaggeration, "floating in the air—breathing in clouds for nourishment—when the truth is that I like beef steak—and I like it rare at that."

Chapter 12

.

On a cold and drizzly December 8, 1924, O'Keeffe, Stieglitz, and his brother-in-law, attorney George Engelhard, boarded the Weehawken ferry on the West Side of New York and crossed the Hudson River. They were met in New Jersey by slight, nervous John Marin. Marin wore his hair in bangs over his eyes, and he was sitting behind the wheel of a big Chandler roadster. Neither O'Keeffe nor Stieglitz knew how to drive a car at all, but Marin was not much better. As he was rounding a corner, he turned around to tell O'Keeffe a joke. The Chandler careened out of control, sideswiped a grocery truck, and hit an iron pole. No one was injured, but O'Keeffe later said she felt as if she had lost a limb.

Like nearly everything else the artist said, her comment had more than one meaning. For two days later, she and Stieglitz made the same trip from Manhattan to New Jersey, where they were joined by a justice of the peace in a hardware store as husband and wife. The bride, who refused to repeat the words "love, honor and obey," wore black. There was no reception, no honeymoon, no bouquet; no one threw rice for good luck. She was thirty-seven; he was sixty. Afterward, those who asked Stieglitz if he and O'Keeffe were married would be met with a shrug, followed by, "What do you think?" When asked why she consented to marrying him, O'Keeffe responded, "What does it matter? I just know I didn't want to."

Stieglitz had been pressuring O'Keeffe to marry him for some time. His relatives felt that he was concerned that she

would not inherit his estate unless they were married. What was more, in his heart of hearts, Stieglitz was of the bourgeois belief that a man and woman who shared the same address should be legally bound. But as with most people, his primary motivation throughout his life was fear, and it could be safe to say that he wanted to insure that O'Keeffe would feel beholden to him in the years to come. "Would he be able to hold her?" a relative imagined he was thinking. "The possessive impulse he deplored in others still lurked within [Alfred]."

O'Keeffe's reasons for avoiding marriage had been the same as Stieglitz's, only reversed. As O'Keeffe became self-sufficient from the proceeds from her exhibitions, she began to exercise more of her rights as an individual—and would soon begin to leave him as her mood dictated. She said she felt that if she married, she would lose a part of herself. The marriages she had witnessed had not been particularly positive ones. Her maternal grandfather, her namesake, had abandoned her grandmother before she was born. That event had repercussions through the family, affecting the behavior of unwed aunts and uncles who clung to their self-reliance. Her father had become a burden to her mother as he became unable to support even himself. Although O'Keeffe wanted to have a baby, she did not want a husband.

Working in her favor—strangely enough—was Stieglitz's estranged wife, Emmy. Embittered, Emmy had refused to grant Alfred a divorce for many years. Finally, in September 1924, she gave him a divorce, and the final decree freed Alfred to marry as long as the service took place outside the state of New York. The papers arrived in Lake George in the middle of September. Stieglitz immediately talked of driving an hour across the New York state line to Vermont, but since neither he nor O'Keeffe knew how to drive, the idea was put to rest. O'Keeffe said she saw no reason to rush to the altar; after all, they had lived together for five years without exchanging vows.

Adding fuel to Stieglitz's argument for marriage was the law in the city of New York prohibiting unrelated couples

from renting an apartment together. In the fall of 1924, for the first time since they had been living together, Stieglitz and O'Keeffe were compelled to find lodging on their own. Lee Stieglitz had sold his house on Sixty-fifth Street and moved to a small apartment that had no spare room for his brother and paramour. Stieglitz and O'Keeffe had lived with Lee and Lizzie for five years. During the summers they had taken separate rooms in the Lake George house along with many Stieglitz relatives. Now, once they were married, they moved into their first real place together, a small top-floor studio space on East Fifty-eighth Street.

Being married did not improve their relationship. Since O'Keeffe's big show in 1923, friction had been generated between them. After recovering from the depression that overtook her after the show opened, O'Keeffe discovered she could not paint at all, was incredibly self-conscious, wanted to escape, and was irritable—a condition she would find herself in after nearly every one of her annual exhibitions for the next twenty years. O'Keeffe blamed Stieglitz for the critics' reception of her exhibit and began to see him as an obstacle to her continued success.

Withdrawing from Stieglitz and those around her into the cool cocoon in which she would shroud herself from time to time, she sat silently through their ritual weekly dinners at a Chinese restaurant overlooking leafy Central Park from Columbus Circle. Stieglitz hosted a dinner each Saturday night for other artists and their friends, continuing a custom initiated during the years he had lived with Emmy. During these dinners, O'Keeffe was generally the only woman; either the men left their wives at home or, as in the case of Hartley and Demuth, they were homosexual. The only reason she agreed to go, it seems, was that she enjoyed Chinese food. So while the men spoke in detail about the "plastic" quality of paint and the importance of Cézanne, O'Keeffe serenely devoured beef with oyster sauce and shrimp cooked in garlic, saying absolutely nothing, looking to some of the men like a vixen in black. Her silence added fuel to the argument that she was an intuitive painter who

was merely documenting her body. Years later, she admitted she did not even know what the word *plastic* meant when applied to painting. On seeing Mont Sainte-Victoire, the mountain in the south of France that Cézanne repeatedly painted, she reflected ironically on the epic talks in the Chinese restaurant: "all those words," she thought to herself, "piled on top of that poor little mountain."

In the spring of 1923, O'Keeffe and Stieglitz learned they were to be alone in The Hill at Lake George that summer. Stieglitz's relatives—his two brothers and two sisters—had made other plans for the summer. Stieglitz panicked at the idea of spending the summer alone with O'Keeffe—as he would have with anyone else, the operative word being, it seems, *alone*. He began to book guests into the house like a "nervous innkeeper," inviting the Strands to spend the entire summer with them and even bringing in O'Keeffe's sister Ida for periods of time, as well as some of the artists with whom he had worked. O'Keeffe went along with the scheme, inviting Anita Pollitzer, her old friend and former co-conspirator, from whom she had become somewhat estranged over the years.

The day before he was to leave for Lake George, Stieglitz received news that cast a pall over not only the summer but the rest of his life. He had reconnected with Kitty when she married Milton Sprague Stearns and happily entered into a life of domestic bliss in White Plains, New York. Stieglitz had nervously followed the course of her pregnancy until she delivered a healthy baby boy, Milton Sprague Stearns, Jr., the first week of June 1923. Then Kitty slipped quickly into a postpartum depression from which she never recovered for the remainder of her life. For forty-eight years she was institutionalized in a sanatorium, suffering from fits of rage in which she attempted to mutilate her body—a condition found frequently among women who have been sexually abused as children. Stieglitz was at first despondent. Then the doctors decided that his presence would trigger one of her fits, and he alone was not allowed to visit Kitty. He became numb and did not even mention her condition

to any of his close friends. Emmy and Milton, as well as her uncles and aunts, were allowed to see her, but Alfred never saw her again. He received cards from her on his birthday and Father's Day. The cards were written in the hand of a seven-year-old.

In September 1923, O'Keeffe fled from Stieglitz, whose "nerves," she reported to Anderson, "seemed tied up so tight that they wouldnt unwind—," and she escaped to York Beach, Maine. Beginning a tradition of leaving Stieglitz unexpectedly, she stayed in a big brown shingled house that was owned by friends of Stieglitz's and walked alone on a deserted beach, collecting clam shells and gathering cranberries from the bog. Stieglitz had been particularly difficult that summer, with the bad news about Kitty weighing heavily on his mind. But O'Keeffe would not make excuses for people. She needed to take care of herself. Maine was the answer. A place she had first visited in the spring of 1920, the wild coastline of Maine appealed to a part in her that required open expanses of space and simple pleasures: "I loved running down the board walk to the ocean—watching the waves come in, spreading over the hard wet beach— the lighthouse steadily bright far over the waves in the evening when it was almost dark. This was one of the great events of the day."

Georgia returned to The Hill to discover Alfred and her friend, Beck, in each other's arms. Beck had written to Paul that Alfred came into her room at night and that she had wanted to "take him to my broad bosom." Alfred had been distraught and could not sleep, she said, because Georgia had gone to Maine. On Georgia's return, Beck and Georgia had a row—not because Beck had slept with Stieglitz but, oddly, because Georgia did not want Beck to wear trousers. Georgia, probably reflecting her own homophobia (lesbians had been referred to in newspaper accounts as "trousered puzzles" when she was growing up), had insisted that Beck wear skirts and dresses as she did. Georgia does not seem to have minded that Beck may have had sex with Alfred. What bothered her was that Beck dressed like a lesbian.

A few weeks later, Ida O'Keeffe arrived for a visit and took the place Beck had occupied in the Stieglitz–O'Keeffe ménage. Almost immediately, Alfred flirted openly with Ida, exchanging amorous glances, slapping her on the rump with a dish towel, and tickling her with a feather from a crow, which she found so amusing she began to call him "the Old Crow Feather." A few years younger than Georgia, Ida had grown from a pretty girl into a robust, large-boned woman, a coarser version of her famous sister. Now in her early thirties and still single, Ida worked as a gynecological nurse at Mt. Sinai Hospital in New York, created watercolors, told fortunes, and did horoscopes. Georgia wrote to a friend that Ida was one of the kindest people she knew—and she was. Ida went along with Stieglitz's lascivious banter, it seems, because she felt it was expected of her. Alfred reported to Sherwood Anderson that Georgia's sister was a quintessential virgin.

Ida and Alfred exchanged mock-passionate letters for some time, but in retrospect they do not seem as humorous as Stieglitz apparently meant them to be. Taken together, the letters appear mean-spirited, showing Stieglitz as a frustrated old lech working his depredations on a lonely nurse who was desperate for attention. He referred to himself as "the Old Crow Feather" and an "Ida-Iter." In a very thinly veiled come-on, he wrote about his "body filled with bursting maleward going." Of her "breasts that challenge God himself to do his duty by them—with a blackness that no pioneer has ever beheld but that many are passionately seeking—." Any resistance on her part only added to his enjoyment of the dalliance. For Alfred, being involved with his wife's sister seems to have been as much a part of his genetic makeup as the color of his eyes. He told people he believed that his father had conducted an open affair with his aunt.

Not only was Georgia, from all accounts, not jealous of her mate and her sister, she seems to have brushed their playfulness off as so much nonsense, even after Alfred claimed that Ida could have been as good an artist as Georgia

if only she had found Alfred first. Ida later attempted to put Alfred at bay by reminding him that he was planning to marry Georgia that fall. Before their wedding, Ida wrote, "I think after you get married this time you better settle down and not be making love to me or anyone else—You have put in a career along this line. . . . I'm just doomed to be an old maid all my life."

In October, Ida returned to Mt. Sinai and her bleak little room in the Central Club for Nurses in midtown Manhattan, and Georgia and Alfred went to work intently, continuing a pattern they had established that fall of concentrated activity for short periods of time. O'Keeffe painted a still life of autumn leaves, *Pattern of Leaves,* which Duncan Phillips later added to his Phillips Collection. She painted a flagpole in front of the white house where Stieglitz printed his photographs. Entitled *The Flagpole,* an arrow coyly points at a full white shaft in the surrealistic composition. *The Flagpole* was a phallic conceit on the prominent position of the man in her life, a man who continued to aim his camera to the sky and photograph patterns made by clouds. O'Keeffe felt she had something to say about men, and she was still stinging over the way "the men" had dismissed her. "I wonder if man has ever been written down the way he has written woman down," O'Keeffe wrote Sherwood Anderson. "—I rather feel that he hasn't been—that some woman still has the job to perform—and I wonder if she will ever get at it—."

In February 1924, O'Keeffe and Stieglitz showed their paintings and photographs in a joint exhibition at the Anderson Galleries. His sixty-one prints fell under the title "Songs of the Sky—Secrets of the Sky as Revealed by My Camera and Other Prints." It was not the media sensation the previous year's exhibition had been. In fact, it was probably a mistake to exhibit O'Keeffe's work alongside Stieglitz's. The critics connected O'Keeffe to her mentor, and their reviews reveal that she had been frozen in their minds as a byproduct of Stieglitz's ingenuity. "[O'Keeffe's] art was related to her femaleness . . . most specifically . . . her body,"

revisionist historian Barbara Buhler Lynes has recently ob-
served, "rather than ideas or concepts." O'Keeffe was the
naif, Stieglitz was the genius. Helen Appleton Read,
O'Keeffe's former classmate, again described her art as an
unwitting expression of what was in her womb, not on her
mind, in what seems today like a quaintly Freudian inter-
pretation—but that must have been devastating to the artist.
"Psychoanalysts tell us that fruit and flowers," Read wrote
speculatively, "when painted by women are unconscious
expressions of their desire for children. Perhaps they are
right."

Being a phenomenon did not hurt sales. The artist
brought home a few thousand dollars from the exhibition,
considerably more than Stieglitz netted from his show, which
went without a single sale. Photography in 1924 had a tiny
market. O'Keeffe invested some of her income in the stock
market through Paul Strand's father; saving money and
building for the future would characterize the shrewd artist
from then on. With her new income, she spoke of building
a house for herself and Alfred at Lake George. Their future
at the lake was being challenged as another season ap-
proached and again only a few Stieglitzes wanted to use the
place. Increasingly, Lake George was becoming a place for
middle-class people on two-week vacations staying in the
Wigwam cabins on the shoreline. Ice cream and taffy stores
were opening in the once-elegant little village. The rest of
the Stieglitz clan had the wherewithal to go to Europe,
Newport, or wherever fashion dictated. O'Keeffe and Stieg-
litz had neither the money nor the time to travel during the
summer. The Hill was where they produced most of their
artwork each year.

What was more, Alfred and Georgia were now in control
of who came and went at the lake, which gave them an
upper hand—and Stieglitz's relatives were uncomfortable
under their direction. O'Keeffe had become noted for her
foul temper and unpredictable moods, which she had no
doubt found kept Stieglitz relatives at bay. Stieglitz's niece
recalled painfully her first meeting with her famous aunt.

Sue Davidson Lowe was Georgia's great friend Elizabeth Stieglitz Davidson's daughter. Her grandparents Lizzie and Lee had coached her on what to say at her meeting with her famous aunt—they suggested a prim curtsy, followed by, "How do you do, Aunt Georgia." Georgia had lived with Lizzie and Lee for five years. Surely Georgia would be pleased to meet her friend's daughter. Surely Lizzie was attuned to her ways. Little could they have known that their granddaughter would be met with a slap squarely on the face, along with a stern injunction, "Don't ever call me aunt again!"

O'Keeffe's temper would soon become as well known as the flowers and bones in her paintings. The source of her aggravation probably was her stern mother, Ida, who demanded perfection of her children. Although there were no outward signs of corporal punishment in the O'Keeffe household, it may be safe to assume that it existed, particularly since Georgia was known to have slapped small children on the face on more than one occasion. Another source of her aggravation may have been her sexual frustration. Many repressed homosexuals, having harnessed their impulses, lose their patience with people who cannot. "I dont know why people disturb me so much—," O'Keeffe wrote. "They make me feel like a hobbled horse—."

With various relatives afraid that Georgia would behave abruptly or that Alfred might molest their daughters, it should come as no surprise that the family began to talk of selling The Hill before the summer of 1924. The Hill may have been where they had spent their childhoods, but it was not where they chose to grow old—except for Alfred. Alfred was as tied to the lake as he was to any image he had of himself. The problem was: Hedwig had granted Alfred control over the property, but she had not given him an income to support it. Alfred was hardly solvent. In the spring of 1924, he had actually given away a collection of photographs to the Boston Museum of Fine Arts, paying for them to be framed at his own expense. Defending the move, Alfred pointed out that it was a big step for a photography collection

to be accepted by a major museum—and it was. But it did not help pay for the bills, most of which were paid from O'Keeffe's account at Banker's Trust.

Nor was Alfred in any position to move from The Hill. His world was crumbling between his fingers as he lost not only his daughter's affection and love but his own health. In April 1924, he suffered from a major kidney attack that caused him excruciating pain. Like his father before him, Alfred began to suffer from a litany of digestive illnesses, one after another, some major, some minor—all subjects of lengthy and indiscreet discussion with whoever might be near. Visitors to the Stieglitz house were often disgusted to find enemas being discussed at the dinner table. Hedwig had upset many people with clinical reports on the state of her bladder and bowels, in German-accented English; Stieglitz complained to Sherwood Anderson that he felt he was weighed down by his life.

It was ironic that O'Keeffe married Stieglitz just when her income from sales of paintings was increasing to where she could be financially independent. In fact, he was becoming financially dependent on her. Of course, having supported her for some time in his own fashion, Stieglitz was in a position to enjoy her success, as the person who could claim he had laid the foundation for it. For the next twenty years, while O'Keeffe soared in her world, Stieglitz came crashing down to earth in his. The two artists battled good-naturedly over what each owed the other, how much they were willing to give, and how much they were willing to take. O'Keeffe told people she did not feel deserving of love; Stieglitz told people he loved O'Keeffe more than himself.

O'Keeffe and Stieglitz were never husband and wife in the conventional understanding of the concept. For one, they were always referred to by their last names, making them seem more like institutions than people. For another, O'Keeffe refused to be addressed as Mrs. Stieglitz, unless it somehow suited her needs. On one occasion, after he had died, a curator in the Metropolitan Museum of Art tried to convince her to allow the museum to frame Stieglitz's prints

a certain way on the grounds that they did the same thing with Rembrandt's. "Well," snorted O'Keeffe, "Mrs. Rembrandt is no longer around."

Being married only complicated things for the two artists. They never divorced, although they separated for long periods of time; and in fact, O'Keeffe did not believe in divorce, any more than she believed in marriage, and she was as surprised to learn that friends had divorced as she was to learn that they had married. After his marriage, Stieglitz told Anderson that his new wife would still be called Georgia O'Keeffe. They disagreed about everything, from the way O'Keeffe painted to how Stieglitz drove, from the way Stieglitz handled money to the way O'Keeffe spent money, from what was wrong with Stieglitz's health to why O'Keeffe needed to leave him so often—she spent almost entire years away from him in certain phases of their life together. Writers would later devote whole volumes dissecting their brief union, which lasted only four years as a full-time marriage. Theirs was clearly much more than a marriage—it was a partnership, a friendship, a spiritual bond. Long after Stieglitz died, O'Keeffe would cup her hands around a crystal ball he had left to her and talk to Stieglitz. It was odd, she once wrote, that people find it so difficult to get to know one another.

Chapter 13

.

For several days O'Keeffe stooped over a crude pine table in the kitchen in the farmhouse, pouring and measuring, straining and chopping. She was following formulae set out by the various medical specialists Stieglitz had consulted after an attack of angina in September 1928: they required that he be fed strained food like a baby five times a day and castor oil every fifteen minutes. She endured the routine without question—and with a great deal of humor— "until the girl who helped me grind and measure and rub the stuff through the 2 sieves actually got hysterical laughing about it—," she reported to a friend. "I recommend myself," she added, "to anyone who is ill—."

Like other women who marry older men, O'Keeffe discovered after a mere four years that her partnership would entail nursing an aged body. O'Keeffe loved Stieglitz, loved him as much as she had—or would—but she was not going to spend the rest of her life measuring, straining, and spoonfeeding him. "If it was a nuisance to her she wouldn't do anything for anybody else," recalled a friend. What was more, Stieglitz had years of experience being a patient. From the time he was a little boy, his mother and aunt had led him to believe that he was unwell. Even O'Keeffe was entranced by how helpless an "old man" could seem. Fortunately for her, her sister Ida was able to care for him—and she quickly gave over to her the tasks of ministering to the needs of Stieglitz's weakened heart—in addition to his kidneys, bowels, eyesight, and hearing—returning to her plain white easel in the Shanty.

Being a wife may not have been O'Keeffe's goal, but it worked out better than she had expected at first. She and Stieglitz continued their established routine of winters in New York and summers at Lake George. The only change was a new address in New York: from November 1925 they lived by themselves in a small suite of rooms on the twenty-eighth floor of the Shelton Hotel. Originally built as a residential hotel for men, the Shelton contained all the amenities of a top-flight luxury hotel. Not only was there an Olympic-size swimming pool, there was a steam room, a library, a billiards room, a bowling alley, and a topiary garden on the roof, as well as a solarium, a pharmacy, and a barber shop—and in the lobby a wooden Indian.

Although O'Keeffe wrote to Ida that "it isn't nice here—New York seems a queer place—and I wonder what business we have here—We seem like two funny little lost things," living in the Shelton made New York bearable. O'Keeffe marveled at the self-sufficiency of the hotel, taking breakfast and dinner in the cafeteria (which she spelled with two f 's), not needing to venture out of the building for days at a stretch. She swam in the heated pool and marveled at the view from the roof of the skyscrapers rising in every direction: the General Electric building, with its neon bolt of lightning aimed at midtown Manhattan like a modernist ode to Zeus, and the gothic towers of the elegant Waldorf-Astoria. Stieglitz praised the hot-water supply in the hotel and the firmness of the mattresses—they slept in separate beds—and wrote glowingly as if he had discovered a blissful state of detachment from his new lodgings: Comparing living high in the Shelton to being on an ocean liner in the middle of the sea, he marveled that the only sound was the wind.

Living in a big building suited O'Keeffe as well. Beginning in the summer of 1924, she took flower blooms from the garden at the lake and enlarged them in her world of paint to a fantastic size—as if they were seen through the close-up lens of a camera or the eye of a bumblebee. Like nothing else O'Keeffe had done before or would do afterward, the gigantic petunias, calla lilies, and zinnias were incredibly

luscious and magnificent. O'Keeffe credited her interest in flowers to Henri Fantin-Latour, a nineteenth-century French painter of floral bouquets as seen in bourgeois Parisian drawing rooms at the time of Marcel Proust. This was an odd reference for her to make since her magnified flowers owed nothing to Fantin-Latour's pretty arrangements. In fact, O'Keeffe's flowers probably sprang from her studies with William Merritt Chase.

Whatever the source of her inspiration, O'Keeffe's treatment of floral blooms was all her own. She made the flowers, she reported, "like the huge buildings going up," and added defiantly, once again pleased with herself for making a scene, "People will be startled—they'll *have* to look at them—and they did." Stieglitz certainly did. When he first saw what his wife had produced, he attacked the work mercilessly. "I don't know how you're going to get away with anything like that," he stated coldly after looking it over, then asking, "—you aren't planning to show it, are you?" Generally, Stieglitz encouraged even the most outlandish experiments O'Keeffe—or any other artist—came up with, but he had his likes and dislikes. By August 1924, O'Keeffe was "beside herself . . . weeping uncontrollably," according to Beck Strand, who consoled her friend when she learned that Stieglitz did not like her new work. O'Keeffe almost never cried in front of anyone else.

The flowers were redeemed, however, because they were all-American—loud, brash, and just a beat short of vulgar. Being American was particularly desirable at this time, and a great deal of print was expended on discussions about Hemingway and Fitzgerald's American novel, as well as the American movie, the American way of life, American jazz, and American poetry. Stieglitz was feverishly patriotic and loved anything American with the unbridled enthusiasm of the American-born first son of a self-made immigrant. And there was more going on in the flowers than their gigantic Americanism. By making the small large, O'Keeffe had followed the modernist theme that a universe of ideas could be contained in one single object. It was the American poet

William Carlos Williams, around this time, who described this new way of thinking when he wrote in "The Red Wheelbarrow":

> so much depends
> upon
>
> a red wheel
> barrow
>
> glazed with rain
> water
>
> beside the white
> chickens.

Echoing Williams, O'Keeffe observed a similar phenomenon: "When you take a flower in your hand and really look at it, it's your world for a moment."

Flowers being the sex organs of plants, O'Keeffe's flower paintings were viewed by some as a continuation of the hypersexuality in her earlier work. A painting of deep purple petunias, for example, contained a series of full-spirited penises in the petals of the flower. Stieglitz wrote that she was painting the petunias in the summer of 1925, saying he was astonished by her performances. Using a flower to represent a male sex organ posed even greater challenges to some minds than using it to represent the female. O'Keeffe and Stieglitz, who read James Joyce's Ulysses every summer at the lake, possibly connected her work to the passage in the twentieth-century odyssey where Leopold Bloom compares his own penis to "a languid floating flower."

And yet, some people were blocked by their own prurience. A few years later, a socially active woman in Kansas City hung one of O'Keeffe's shell paintings over a sofa in her living room. First she discovered a father teaching his son the facts of life from the painting. Then, after moving the picture into another room, one of her friends said, "Thank god you took that vagina off the wall." Many years

later, the artist Andy Warhol, after attending an exhibition of O'Keeffe's early works in a museum in New York, confided in his diary, "she does these flowers and slashes and all she does is paint vaginas."

On March 9, 1925, O'Keeffe's flowers made their debut in a group show that included the works of six other artists, titled "Alfred Stieglitz Presents Seven Americans" at the Anderson Galleries. The seven Americans were the stable of Stieglitz's new Intimate Gallery: O'Keeffe, Marin, Dove, Strand, Demuth, Stieglitz, and Hartley. In an effort to link the artists under a single heading, Stieglitz asked Sherwood Anderson and others to write essays connecting the artists' uniquely American transcendental viewpoints. Anderson asserted that these artists were more "alive" than other artists and concluded on a somewhat petulant note as if he were talking about the works of Boy Scouts: "this show is for me the distillation of the clean emotional life of seven real American artists."

Although the critics disliked the theme of the show, O'Keeffe's reviews were primarily positive. Writing in *The New Republic,* Edmund Wilson said he would compare her output with that of "the best women poets and novelists," adding with unbridled enthusiasm, "Her new paintings in Stieglitz's exhibition are astonishing." Wilson singled out her richly detailed study of a corn leaf: "Her 'corn' pictures have become so charged by her personality, current and fused by her personal heat that they have the aspect of some sort of dynamo of feeling constructed . . . to generate . . . an electric spark." Poet Marianne Moore, writing in *The Dial,* rhapsodized over the ethereal quality of O'Keeffe's flowers: "Her calla lilies, gladiolas, and alligator pears, have upon them, the luster of mosques, of lotus flowers, of cypress-bordered pools. They have the involute security of Central African, of Singhalese and Javanese experienced adornment." Writing in *The Nation,* Glenn Mullin found a pantheistic universe in the artist's flowers: "We intuitively feel and recognize the truth she has made," he wrote, " . . . of the essence of things."

O'Keeffe's general view of other women changed in this period. Once married, she became more relaxed around other women, wanted to know all there was to know about creative women, and reached out to women as she had when she was younger. At the behest of her old friend Anita Pollitzer she spoke at the National Woman's Party convention in 1925, even though she had little use for political women, preferring instead to know about women who made things and wrote. Although they never met, she inquired about Gertrude Stein in her letters to Sherwood Anderson, who told her to ask others what she was up to. Stein was more interested in men than women, however, and had actually taken an active interest in Anderson at one time. She was not, it seems, interested in O'Keeffe. Born in Oakland, California, the ample-girthed, cigar-smoking expatriate Stein lived in Paris with Alice B. Toklas and is best known for having promoted the works of Picasso and Matisse at a time when they were obscure, and for having forged a link between America and Europe when information moved slowly.

O'Keeffe did become a regular at a salon hosted by the Stettheimer sisters, a trio of incredibly exotic, sexually ambivalent women who lived on the remainder of a large family trust and produced various things of whimsy. The three sisters dressed in frills and bows like little girls even after they outgrew children's clothing. Ettie was a novelist whose lifework remained unpublished until after her death because she was shy. Florine was a painter who hung cellophane curtains on her windows and dressed entirely in white satin, including man-tailored trousers, sprayed calla lilies with silver paint, and used lace in her house and on her clothing unsparingly. Carrie was known for a dollhouse that included examples of modern art, echoing the famous salons the sisters hosted. It featured a figure of their friend O'Keeffe in a turban and black dress and Stieglitz looking dashing in his trademark loden cape. Gertrude Stein was also in the dollhouse, as was her good friend Carl Van Vechten, who is best known for his epic soirées in which he dressed in

drag and entertained a mixture of high society, bohemia, and black Harlem from an all-white apartment at 150 West Fifty-fifth Street. Van Vechten, "a man who had pushed his slender talent through many doors," chronicled his own life in novels like *Parties!*, in which jaded flappers in all-white apartments drank sidecars and pink squirrels, and in a book about Harlem with the improbable title of *Nigger Heaven*.

O'Keeffe, who assiduously avoided groups, seems to have enjoyed the Stettheimers' tea parties enormously and even occasionally attended Van Vechten's soirées. Stieglitz stayed home. Neither O'Keeffe nor Stieglitz were night people. They did not go to Harlem slumming with the demimonde of New York, nor to speakeasies or dinner parties. Most nights they were both in bed before ten. For several decades, O'Keeffe corresponded with the Stettheimers and wrote intimately to them, admitting that she was afraid to sleep alone or, on occasion, that she was tired of Stieglitz.

Her flower paintings drew the sisters to her, as they did hordes of other women who had an interest in their own sex. Beck Strand observed in a letter to Paul that O'Keeffe's 1925 exhibition was populated by a "funny mob" made up mostly of "old spinster gals, flappers—hawk-nosed student boys," this last referring somewhat pointedly to the large homosexual crowd that O'Keeffe's works drew. Having told Anderson that women needed to write about men, O'Keeffe now reached out to women she believed could write about women. Mabel Dodge Luhan, a patron of the arts from Buffalo, New York, who operated a salon of her own in Taos, New Mexico, attracted O'Keeffe's attention when she read a sympathetic article Luhan had written about novelist Katherine Cornell.

Born Mabel Ganson in Buffalo in 1879, Mabel Dodge Luhan, as she was known most of her life, was an heiress to a vast banking fortune established by her paternal grandfather, James Ganson. Although she was short, plump, and plain-looking, Mabel was as cultivated as a hothouse orchid, with what one admirer remembered as the sweetest female voice he ever heard and a hunger for culture and spirituality

so passionate that D. H. Lawrence observed with horror, "[her] bright candor of youth resolves into something dangerous as the headlights of the great machine coming full at you in the night." Mabel operated the first of her several salons for artists and intellectuals outside Florence, Italy; this was soon followed by a salon in an all-white town house on Fifth Avenue in Greenwich Village. Every night, supper was served at midnight. After a brief attempt at running a Dionysian commune in Croton-on-Hudson, from where she had followed journalist John Reed to interview Pancho Villa, Mabel had a dream in which the head of an American Indian was beckoning her to New Mexico.

In New Mexico, Mabel built a Florentine-style villa out of adobe bricks and native mud on the edge of the Taos Pueblo. She named her house Los Gallos for the majolica figures of chickens that lined the parapet of the flat-roofed adobe. She intended to establish a "cosmos," joining the old world of Europe with the new world of the American Indian, inviting artists from the East to come and stay with her in the West. Shortly after she arrived in 1918, Mabel met a tall, handsome Tewa-speaking Taos Pueblo Indian by the name of Anthony Lujan. Recognizing him as the face in the dream, Mabel wooed him, and he responded by pitching his tepee outside her house. Luhan, who anglicized the spelling of his name to please his new bride, would return from time to time to the pueblo and his former life, but the majority of his remaining years were spent with Mabel. He was her fourth and last husband.

Boldly, and at the same time somewhat hesitantly, O'Keeffe asked Mabel Luhan to write an article about her own artwork, particularly her flower paintings. "What I want written," she began, "—I do not know—I have no definite idea of what it should be—but a woman who has lived many things and who sees lines and colors as an expression of living—might say something that a man cant—I feel there is something unexplored about woman that only a woman can explore—Men have done all they can do about it.— Does that mean anything to you—or doesn't it?"

Luhan was jealous of the bond between O'Keeffe and Stieglitz. At a time when she, who had had many husbands and lovers, said she was attempting to move beyond her "primary" sexual urges, she found O'Keeffe's depictions of what appeared to be genitalia disgusting. Her attack surpassed that of any of the male critics of the time in ferocity. One "feels indelicate looking upon these canvases," she wrote, because they are "unconscious outpourings of the sexual juices" that "permit her to walk this earth with the cleansed, purgated look of fulfilled life!" But such art is the "negation of being." Stieglitz is the "showman" who uses "this filthy spectacle of frustration" to market his wife's work. O'Keeffe could not have known that Luhan was going through a rebellious stage in which she considered herself "a super-female and free of myself and everyone else thank heaven."

O'Keeffe seems to have been resilient to what Luhan wrote about her. Being snubbed by Gertrude Stein and pilloried by Mabel Dodge Luhan seems to have only made her stronger and more determined to forge her own way. Decades later, feminists were taken aback when the elderly artist declared, "Women never helped me. Only the men." Perhaps she was referring to women like Stein and Luhan who could have helped her formulate a woman's view of the world through her painting. Such rejection only seems to have drawn her closer to Stieglitz, who never flagged in his opinion that her work was a true expression of "a woman's feeling."

O'Keeffe made do with women who were attracted to her work and wanted to write about it. Blanche Coates Matthias did not have the clout of Mabel Dodge Luhan or Gertrude Stein and was primarily a rich (and openly bisexual) Chicago socialite—wife of a lumber baron—who dabbled in criticism from a luxurious suite of rooms in the Ambassador Hotel on Park Avenue in New York. But Matthias was enamored of O'Keeffe and her work—the first requirement the artist asked people to meet, beginning with Anita Pollitzer. First attracted to O'Keeffe because she liked the way

she looked in the Stieglitz nude portrait of 1921, Matthias soon became a leading fan of O'Keeffe. O'Keeffe and Matthias frequently had lunch together in the wealthy patron's suite, along with Matthias's women lovers.

And there were other women who responded positively to O'Keeffe's work. Stieglitz noticed them first in the gallery. These young women found in her paintings a channel for their own feelings, and he often reported occult happenings there—Stieglitz kept a crystal ball on display in the Intimate Gallery to remind people of the hidden forces at play in the universe. One woman actually vibrated ecstatically as she stood in front of a painting of yellow birch trees, as if she were in a frenzy of spiritual transformation. Stieglitz wrote to Sherwood Anderson of the woman, bolstering his story by stating that O'Keeffe saw her do the same thing. Although Stieglitz believed in mystical occurrences, his claim must have seemed far-fetched even to Anderson, who also believed in occult occurrences. Reporting the girl's face actually radiated as her body became enshrouded with a colored light, Stieglitz concluded that this couldn't have been an hallucination because O'Keeffe saw the transformation, too. He wondered if Anderson would see it as well.

Although neither was religious, both Stieglitz and O'Keeffe believed in the world of spirits, as many artists often come to do. Creating art requires a suspension of disbelief not unlike a spiritual experience—calling up forces from within to appear on paper or canvas—or, as O'Keeffe put it beautifully, "making your unknown known." In O'Keeffe's world of paint there was an energy field at work that was not altogether of this earth, and she was aware of it from an early time in her life. She told people she had wanted to capture how she felt standing outside the Shanty in a painting that appeared to most eyes a petunia blossom. Many of the sexual references to her work could also refer to spiritual symbols. When the artist stated that she did not see what others saw in her work, often she was not being coy. She said she regularly summoned the muses to what

she was doing and opened herself to the forces within. Stieglitz constantly referred to her in occult terms as the "whitest of the white."

At this writing, to many people the very words *occult* and *witchcraft* seem far-fetched. But beginning in the 1880s, when Stieglitz was a student in Berlin, and continuing until the close of World War II, unexplainable phenomena were widely accepted by the average person, as in the popular novels of H. G. Wells and Thomas Mann. Stieglitz's beliefs often gave him the aura of an oracle of modern art, and he was not shy about letting people know his beliefs. O'Keeffe was quieter in her beliefs, normally allowing her paintings to do her bidding. "She was very much against the canned mysticism of her day," recalled a friend. Every summer Stieglitz read aloud to his chief disciple passages from Johann Wolfgang von Goethe's *Faust,* an epic poem detailing a quest for power and immortality, considered an exemplar of Western man's struggle to reconcile spiritual power with human weakness, including hidden worlds of occultism. By referring to O'Keeffe as the whitest of the white, he was doubtless applauding the luminosity and vibrancy of her creative output, her conscious harmony with the worlds of white magic through her depictions of plant life and ordinary objects of the natural world.

Beginning in 1924, O'Keeffe and Stieglitz were introduced to the work of the oracle George Ivanovitch Gurdjieff—a Russian-born bald-headed spiritualist who operated the Institute for the Harmonious Development of Man at Fontainebleau, outside Paris, through two of his disciples, A. R. Orage and the Harlem Renaissance poet Jean Toomer. Stieglitz consulted Orage about the mystical realm in the cloud photographs he had begun producing at the lake. O'Keeffe fell under the spell of Toomer, author of the best-selling *Cane,* a dream-inspired account of slave life. A charismatic, Toomer was said to mesmerize women he was near. Although later denounced as a fraud because he believed in free sex and drinking massive amounts of calvados brandy to free the libido, Gurdjieff attracted a large and influential

following during the twenties and thirties. At his institute and through his courses taught in major cities in the United States, the master offered to awaken students through a course in living that was as simple as it was complicated; the Gurdjieff method led to total psychic harmony through mastery of the universal laws of "cosmic consciousness," by close contact with others on a similar path.

Toomer became a regular at O'Keeffe's annual exhibitions of art, as the flowers in her paintings unfolded into amazingly full and ripe creations. She also began to bring the same spiritual light to New York skyscrapers, including the Shelton Hotel with the word *Stieglitz* on a sign on the side of the building. And she painted calla lilies, popular hothouse blooms seen in florists all over New York that were commonly sent to the bereaved. And she painted red poppies in full luscious bloom, black irises opening revealingly, and clamshells collected on the shore of Lake George. In 1926, she turned out an amazing variety and number of paintings, producing a record eight pictures in five days.

O'Keeffe's 1927 annual exhibition catalogue began with an ode to color by her friend Charles Demuth and closed with an essay in *The New Republic* by Lewis Mumford comparing O'Keeffe's use of color favorably to that of the French master Henri Matisse: "Miss O'Keeffe's paintings and the recent retrospective showing of Matisse remind one that the pure artist is always more deeply in touch with life . . . she has discovered a beautiful language, with unsuspecting melodies and rhythms." A few weeks later, her new friend Blanche Matthias wrote a glowing paean to the artist's way of looking at things in the *Chicago Evening Post Magazine of the Art World*. Defending the artist against masculine misinterpretations, Matthias concluded that when looking at O'Keeffe's art, her critics had been "unprepared for direct contact with spirit art of woman" and thus "began frantically searching for the magic key which was to illumine their habit stunted minds."

In August, O'Keeffe was admitted to Mt. Sinai Hospital on Fifth Avenue in New York to have a lump removed from

her breast. As she was when confronting much other bad news in her life, she was remarkably detached from her feelings as she faced the operation. What she later recalled noticing was the anesthesia. When she was injected with a powerful knockout drug and asked to count backward, she remembered the way the light over the operating table appeared to shrink to the size of a head of a pin. After she recovered from the effects of the operation, she made what appeared to be an abstract painting of a black shape and a pin of white light.

Although the tumor was found to be benign, recovering from the operation took time, and O'Keeffe's work once again suffered. As 1928 approached, she realized that she did not care what she produced or even if she ever painted again, a state that would recur periodically throughout her life—sometimes entire years would pass without a single painting. She compared herself unfavorably with Stieglitz, who himself was hardly a vision of health: "I feel like a little plant that he has watered and weeded and dug around— and he seems to have been able to grow himself—without anyone watering or weeding or digging around him—." Not even a spring trip to Bermuda could raise her spirits.

Nor, it seems, did the news that four of her paintings had been sold to an anonymous "Frenchman," for the outstanding sum of $25,000 improve her disposition. Stieglitz was usually mum about the details of his transactions, but he began to tell people about the sale in March. Twenty-five thousand dollars was more than O'Keeffe had made in her entire career to date. It was enough, in 1928 dollars, to buy a mansion or a yacht. The news was spread through the newspapers—which only helped to establish O'Keeffe's name and reputation. "She painted the Lily and Got $25,000 and Fame for Doing it!" blared *The New York Evening Graphic*. Later it was revealed that the deal had been a hoax orchestrated by Stieglitz and Kennerley to boost the value of O'Keeffe's work. The calla lilies surfaced in Kennerley's private collection, where they had been all along. But O'Keeffe's work had needed a boost. The 1928 exhibition was met

with the cautionary words of Henry McBride: "An annual exhibition is a severe test upon any artist's powers, and, as a rule, is not to be recommended."

In August, the artist visited her birthplace in Wisconsin, the first time she had done so since 1901. Her aunt Ollie had returned to Madison from Chicago with her sister, Lola. Aunt Lola was ninety-eight, the age Georgia would reach at her death. The aunts marveled at their niece's success in a world they had only read about. She visited the family farm in Sun Prairie, as well as her sister Catherine and her baby daughter, Catherine, Jr., who lived in Portage. Georgia had written to Catherine to congratulate her on her successful delivery, commenting that her preference for wholesome Wisconsin life pleased her: "I like to feel that at least one member of the family lived what might be called a normal life." Alexius, his wife, Elizabeth, and their baby, Barbara June, were also living in Madison, where Alexius was an engineer. Her sister Anita had produced an offspring, Eleanor June, known as Cookie, in 1918. At forty, Georgia was an aunt to three nieces. Being an aunt seems to have been no consolation to the childless artist whatsoever. Perhaps she remembered her own wicked aunt or perhaps she realized the sad truth that her siblings' children were not her own, but she did not want to have anything to do with being an aunt and rarely kept up with her nieces.

Then one day Stieglitz clutched his chest and suffered what appeared to be a heart attack but was in fact an attack of angina, a precursor to a heart attack. Although he had always been sickly, O'Keeffe found that it was difficult to have her husband bedridden. The winter of 1929 was a struggle. Having been ill the winter before as well, she found it hard to face the future with such frailty—particularly when the future held only another summer at Lake George with Stieglitz's family. Her bond with Stieglitz was proving to be bad for her health. "Well, I know how it is," Ida wrote to her comfortingly, "if one of you cut your finger you are both sick."

Chapter 14

· · · · · · · · · · · ·

Stieglitz walked down the dirt lane connecting the farm-house with Bolton Road and hiked along the blue lake to the village of Lake George. He had taken the one-mile walk often over the years—only now, in the summer of 1929, things had changed, and it was not the peaceful walk it had once been for him. Cars whizzed by—cars he did not know how to operate, never having learned how to drive. Wild teenagers called out, "Hey, Pops!" to his anti-quated figure. O'Keeffe had left him alone at the lake and gone to New Mexico. He had filled his spare time by taking flying lessons and playing miniature golf—"the rage of the 1929 season"—becoming a local champion at the Tom Thumb Golf Course in the village. But he missed O'Keeffe terribly. In July, he began to ask her to come back.

Leaving Stieglitz to go to New Mexico, the artist main-tained, was the hardest thing she had ever done. Although she had gone to Maine without him, Maine was less than a one-day trip from the lake, and she never stayed there more than a few weeks. But this time she left Stieglitz for four months on a trip that took three days and nights aboard a train across the better part of America. To Stieglitz, who had never been farther west than New Jersey, America seemed a vast and dangerous place. He worried about her. She had been a part of his summers at Lake George since 1918. During that time, Stieglitz had buried his mother and lost his only daughter to a mental illness from which she would not recover. By the summer of 1929, he and O'Keeffe had been as closely aligned as hand and glove.

O'Keeffe would never have been able to detach from Stieglitz if a doctor had not prescribed that she break her routine. Stieglitz believed in doctors more than any other authority—and he felt forced to let her go if a doctor recommended it. The winter of 1929 had been hard on her. Her work had continued to get her down. She was an intuitive painter dependent on a compelling need to paint; flailing about for a new direction and a new source of inspiration, she found her work now too pretty. Suffering from low self-worth, the artist felt embarrassed to be canonized by her followers. She told people that she wished the women who wanted to talk to her about the flowers would abandon the mental shrines they had made for her. "I would like the next [show] to be so magnificently vulgar that all people who have liked what I have been doing would stop speaking to me—" she wrote a friend. Not even the news that the Museum of Modern Art wanted to include five of her paintings in a group show cheered her up. She worried that she would not have five pieces of art worth showing in the prestigious new institution, and she called what she had turned out "dead on me." Finally, her doctor recommended a change in landscape as a cure for what was ailing her. Europe was considered, but dismissed—O'Keeffe was intimidated by high culture and realized she had nothing to gain from the place except more low self-esteem. "The others went to Europe," she later said airily. "I went to America."

The trip to New Mexico happened so quickly that O'Keeffe barely had time to plan what she would do once she got there. In the winter of 1928 and 1929, Mabel Dodge Luhan and her companion, Lady Dorothy Brett, had stayed in the Shelton for an extended visit. Luhan, an old acquaintance, had decided that Stieglitz should exhibit Brett's paintings of Taos Indians. Not shy, Luhan came to New York to deliver the pictures to him without first contacting him. After Stieglitz kindly pointed out what Brett needed to do to improve her paintings, Luhan and Brett had remained in New York. They attended showings at the Intimate Gallery and lectures on the Gurdjieff method of self-actualization.

Luhan spoke to everyone she met about the high country in Taos: "Taos," she reported she had been told by a leading New York occultist, "is the beating heart of the world." In a 1925 magazine article she explained that in Pueblo Indian cultures, "the mysteries of propagation and of the fiery energies of the human soul and its transformable power have blended and fused into the pattern of existence that is at the same time both life and art. For with the Indians life is art." Since this was a belief O'Keeffe had held since her days as a student of Alon Bement in Virginia, reading Luhan's article must have excited her interest.

Luhan and Brett must have been quite a pair. Lady Dorothy Eugenie Brett was the daughter of the second Viscount Escher, and with her weak chin, buck teeth, watery blue eyes, and brass hearing horn named Toby (she was partially deaf), she appealed to the sympathy of others. More than forty years later, Brett was still a local curiosity in Taos. Wearing yellow miniskirts and driving a run-down Ford van decorated with flowers without regard for signs or speed limits, she was known as "Lady Brett—the first hippie." During their stay at the Shelton, Luhan, Brett, Stieglitz, O'Keeffe, and a friend would gather in front of the fireplace in the cafeteria on the sixteenth floor of the hotel each morning for breakfast. Lady Brett ate a bowl of prunes, Stieglitz had six pieces of zwieback and cocoa, and O'Keeffe had dry toast and tea. In time, conversation would turn to the subject of Taos and Luhan's home, Los Gallos. These conversations attracted the attention of everyone else in the room, for in order for Lady Brett to hear what they were saying, they had to speak loudly.

When Luhan invited Stieglitz and O'Keeffe to come west, Stieglitz declined immediately. Although he had traveled extensively in Europe as a young man, since the First World War Stieglitz had not gone anywhere except Lake George. He told Mabel he did not like to travel (possibly because he could no longer afford first class, possibly because he no longer needed the stimulus or escape that travel provided). Still, Taos would have been a logical destination for him.

Writing in *The New York Times Book Review*, Elida Sims reported that Taos was "the garden of Allah in the New World; an oasis of twentieth-century culture in a vast desert of primitive nature." But Stieglitz was afraid there would not be a doctor in Taos who could meet his needs.

Remembering the day she had spent in Santa Fe on her 1917 vacation with Claudia, O'Keeffe could not wait to return and told Luhan to "kiss the sky for me." For several years she had reminisced about the West with everyone she met, watching enviously when Sherwood Anderson left for Nevada and when the Paul Strands (and many others) went to New Mexico. The West was in her blood. The year before, she had painted from memory a landscape reminiscent of the red hills of West Texas. The problem for her was Stieglitz. Not only did the art impresario refuse to go west, he was reluctant to let her go by herself. It seems hard to believe of a woman who later came to represent independence, but according to family accounts, O'Keeffe had to secure Stieglitz's permission the year before in order to visit her family in Wisconsin.

To assuage Stieglitz's fear, O'Keeffe convinced Beck Strand to go with her. He relented under the condition that Beck supply him with regular written reports on O'Keeffe's status. Beck, eager to escape her problematic marriage to Paul, agreed. In the first week of May 1929, the two artists arrived in Santa Fe, where they stayed like tourists in La Posada de Santa Fe (The Inn of Santa Fe), an old Victorian adobe house that had a series of guest cottages nestled in a wooded grove near the historic plaza. Beck and Georgia were quite a couple. Paul had convinced his wife to dress in black like O'Keeffe some years earlier—never, it seems, having fully gotten over her rejection. Beck had cut her prematurely gray hair as short as a man's and preferred trousers to Georgia's skirts and dresses. With her pale skin, brilliant blue eyes, and shapely figure, she was a complement to O'Keeffe's dark skin, green-brown eyes, and black hair.

To some, they doubtless appeared to be lesbian lovers. Santa Fe had become a mecca for women who wanted to

live openly with other women—and it was not uncommon
to see women paired with women there. During the 1920s
and 1930s, Santa Fe and Taos were to American lesbians
what Capri was to British homosexuals at the same time—
a place away from the constraints of organized society, which
discouraged homosexual unions. For many years on Canyon
Road, a bar for women operated under the unlikely name
of Claude's. Claude was a woman, rumored to be a scion
of an old New York family, sent west with a small income
to pursue her style of life away from the disapproving glare
of her family's social circle. Men were allowed in Claude's
only by a special arrangement when a white flag was raised
outside the adobe house. In Broadway crowds at this time
a woman who had switched her sexual preference was said
to have "gone Santa Fe." For some time, the leading Santa
Fe social figures were Eleanor Brownell and Alice Howland,
a lesbian couple.

On the first day, Beck and Georgia joined a Fred Harvey
bus tour to the San Felipe Indian reservation, south of Santa
Fe, to attend a ritual corn dance. In this ancient dance the
Indians moved in formation to the beat of a drum while
chanting in the Tewa language to summon rain for the crop
of corn that had been planted in the dry hard earth. It was
O'Keeffe's first Indian dance, and she was taken by the pulse
of the beat, which was neither rhythmic nor melodic but
persistent. Even D. H. Lawrence had found writing about
the dance difficult. "Bit by bit," he wrote, "you take it in.
You cannot get a whole impression. You realize the long
lines of dancers, and a solid cluster of men singing near the
drum. You realize the intermittent black-and-white fantasy
of the hopping Koshare, the jesters, the Delight-Makers. You
become aware of the ripple of bells on the knee-garters of
the dancers, a continual pulsing ripple of little bells; and of
the sudden wild, whooping yells from near the drum. Then
you become aware of the seed-like shudder of the gourd-
rattles, as the dance changes, and the swaying of the tufts
of green pine-twigs stuck behind the arms of all the dancing
men, in the broad green arm-bands."

Georgia's enjoyment of the dance was marred by an incident at the entrance. Leaning out of the window of the bus, she had recognized massive Tony Luhan driving a big open Cadillac touring car onto the reservation, his long braids entwined with colored ribbons, his fingers, hands, and arms covered with turquoise and gold jewelry. Tony and Mabel greeted the two women and invited them to sit with them on one of the flat roofs overlooking the ceremonial plaza. After the dance, Mabel instructed them to return to Taos with them. When Georgia protested, Mabel pointed out that it was too late to object—Tony had shipped their trunks from La Posada to Los Gallos on the way to the dance that morning.

Georgia and Beck slowly relaxed as they drove north to Taos in the Cadillac through spectacular rugged high desert scenery. Although they were in New Mexico ostensibly at Mabel's invitation, the two women wanted some time for themselves. They traveled through several Indian reservations made up of squat adobe mud dwellings with flat roofs and pole ladders running up the sides along the banks of the Rio Grande; then the party made its way up a precarious road strewn with boulders, through a dark narrow gorge that rose several thousand feet to a vast plain of sagebrush. It was paradise. Sharp mountains rose to heights of fourteen thousand feet. Although it was warm in the sun, there was snow on the peaks. O'Keeffe was enraptured. "A sea of sage," she recalled, "the likes of which you have never seen."

Mabel may have been manipulative, but she had arranged a world that was as accessible as it was exotic. Beck and Georgia were immediately installed in a pair of adjoining bedrooms, from which they were free to move about as they pleased. Los Gallos was approached over a rustic wooden footbridge over a life-giving irrigation ditch known as *acequia madre* (mother stream), whose cool snow-fed water flowed by the house from early spring to late summer. The sound of running water provided a soothing contrast to the desert heat, as did a complex of dovecotes housing cooing pigeons. The house was decorated like a Tuscan villa, with

majolica tiles and magenta and emerald pillows lining French and Italian sofas. Stark geometric-designed Indian blankets hanging against the chalk white walls were the only concession to native folk arts. The various sitting rooms and the dining room were arranged at different levels to accommodate the hostess's need for staged entrances. Later, Mabel received visitors from an ornate dais she had installed in her living room. Mabel's bedroom, dominated by a large fourposter bed, was in a tower, from which she could see the sunrise over sacred Taos Mountain and the sunset over the Rio Grande gorge and sagebrush plain—as well as whoever arrived at or departed from Los Gallos.

"Brett remembered those . . . days as wonderful," noted Luhan's biographer, Lois Rudnick, "with . . . Mabel full of 'keen perspections' and 'vigor.' " She was continually arranging joyous occasions for her guests' benefit: charades, hot baths in mountain springs, picnics, and horseback rides into the high mountain forests. Mabel and Tony delighted their friends with Indian dances and often gave them at home. The large dining room would be cleared, "the drum suddenly throb, the singers softly sing," and through the kitchen door came the feathered Indians dancing to the ever-strengthening beat of the drum, "fantastic, gorgeous figures" in the low light. On midsummer evenings, they were spellbound outdoors by "the wild beauty of the songs, the unbearable rhythm of the drum, the bells and light swish of the feet of the dancers."

As charming as Mabel was, Georgia was not at all happy to find herself in another group in Taos. Soon, Ansel Adams arrived. Adams, who had been studying to become a musical composer, switched his interest to photography while he was staying at Los Gallos. "The skies and land are so enormous and the detail so precise and exquisite," he exclaimed, "that wherever you are, you are isolated in a glowing world between the macro and the micro—where everything is sidewise under you and over you, and the clocks stopped long ago." As had been her reclusive custom at The Hill, O'Keeffe often skipped dinner. She preferred to ride out

onto the plain to see the spectacular New Mexico sunset by herself on horseback. She purchased a Ford, finally learning how to coordinate the clutch and gas pedal after smashing a window. It came back to her—the brilliant light, magical air, sweet smell of wet sage after a terrific thunderstorm. Once again she felt as one with the landscape, as she had in Texas so many years before.

Although Mabel had promised Georgia her own little house and adjacent studio, for the first couple of weeks the dominating heiress had kept her near her in the main house. Georgia turned a shady spot under an ample cottonwood tree into an alfresco studio. The Pink House that Mabel had promised Georgia had been built in 1922 for D. H. Lawrence. Mabel had brought Lawrence and his wife, Frieda (née von Richthofen), to New Mexico so he could write about her place and immortalize it for her. *Wilful Woman,* the book about Mabel and New Mexico, never materialized. During one of their many horrific fights, Lawrence beat her with his bare fists. On another occasion, Mabel sobbed uncontrollably for several hours outside the door of the Pink House. Lawrence stubbornly refused to admit her—attracting a crowd that included some Indian dancers and Spanish-speaking servants, who gathered to witness their imperious boss's distress. They had never seen Mabel cry before. The Pink House stood across a field of alfalfa—"a saucer of alfalfa," as O'Keeffe remembered it years later—from the main house.

O'Keeffe never met Lawrence—the writer was in Europe the summer she arrived in New Mexico, and he would not return. He died the following spring. His ashes were brought back to New Mexico by his widow, who was assisted at customs in New York by Stieglitz. Frieda Lawrence, a plump German aristocrat, was beaten by Lawrence as well. She told people he beat her after he made love to her because, he said, he was disgusted by her soft flesh.

Mabel's worship of Lawrence was perhaps even more masochistic. Even after he beat her, and left the Pink House hurtling a volley of abuse at her, she gave him her son's

ranch north of Taos on the side of Mount Lobo in exchange
for the autographed manuscript of *Sons and Lovers*.

O'Keeffe was influenced by Lawrence's view of sexuality,
as much as the other women in his orbit were. She read few
books, but she read nearly all of his. In spite of his misogyny
O'Keeffe thought he alone had expressed modern sexuality
in words, particularly in *Lady Chatterley's Lover,* which was
banned in the United States because of its heightened sexual
content. Copies wrapped in plain brown paper were none-
theless passed clandestinely from reader to reader. The year
before she traveled to New Mexico, O'Keeffe had defended
Lady Chatterley's Lover to her friend Ettie Stettheimer. Stett-
heimer had objected to it on the grounds that the sex was
too graphic. The novel gets under way when the grounds-
keeper of a large estate contemplates "the stirring restlessness
of his penis." O'Keeffe recommended a second reading for
Stettheimer. She felt her friend would truly come to appre-
ciate the beauty of Lawrence. She was probably moved by
his psycho-sexual landscape, particularly his veiled homo-
sexual longings, which cast a melancholy light on all of his
work.

Much to Georgia's initial surprise, she and Mabel got
along so well at first that Beck began to feel left out and
isolated. Mabel and Georgia even shared Mabel's fourposter
bed when Tony went on an overnight trip to Santa Fe. Beck
slept in Tony's bed in the room next door. Sleeping with
Mabel apparently came naturally and effortlessly to Georgia.
Mabel was a woman who had created a world Georgia had
longed to inhabit—and in fact, the walled fortress in Abiquiu
over which Georgia would come to preside owed a great
deal to Mabel's cosmos.

Mabel seems to have regarded Georgia as a conquest—
and a convert. For years to come, the spiritually precocious
Mabel would take full credit for introducing Georgia to New
Mexico, in a series of pronouncements that indicated the
powerful position she assumed over those who came near
to her. "Take an exquisite sensitive mortal like Georgia
O'Keeffe," she wrote in a disclosure of her seduction, "and

suddenly lift her from sea level to the higher vibrations of a place such as Taos and you will have the extraordinary picture of her whoopee."

Mabel and Georgia's union was interrupted that summer, when the heiress returned to Buffalo for a radical hysterectomy. Although she had already had children, the removal of her womb upset Mabel, who feared it would take her sex away. To make things worse, a few days before the operation, helpless on her back in a hospital two thousand miles away, she learned that Tony had returned to Taos Pueblo and was sleeping with his Indian wife. In Mabel's mind, free sex extended no farther than the confines of her own bed. To make matters still worse were the communiqués Mabel received from her conquest Georgia. Georgia took dictation for Tony, who could not write or read in English. As soon as Mabel left, Georgia and Tony had become great friends, once again leaving Beck, whom other accounts report became a fill-in bedmate of Georgia's in Mabel's absence. (Beck and Georgia sunbathed nude together, danced in a bar together, and even washed Georgia's car in the nude together. Paul Strand believed the two women had sex as well. Pleading family obligations, Beck returned east at the end of June.)

Mabel had suspected O'Keeffe had strong sex urges, probably because of their own tryst. Since she was under the impression that Georgia did not have sex with Alfred, Mabel believed she would want to seduce Tony. She was doubly distressed to discover that Georgia and Tony had camped out at Lawrence ranch together, where they had slept under the tall ponderosa pine trees that would later inspire one of O'Keeffe's best known pictures. They had been chaperoned by Brett, who was living in the Lawrence house while Frieda and Lawrence were in Italy. Georgia and Tony spent nearly all their days together in Mabel's absence.

Georgia was extremely lucky to have fallen into the hands of Tony Luhan—and she knew it. Tony was a link with the ancient world of the native people of Taos. He lived in the realm of the spirit and understood what Georgia meant when she said that something looked the way she felt. Few people

besides Alfred could understand what she meant when she compared feelings with vision: "the surface doings of the days are only important," she wrote to Mabel, "in so far as they do some things for an undercurrent that seems to be running very strong in me—." Mabel wanted to experience what Georgia meant when she referred to mystical occurrences in these terms. Mabel wrote: "I must die—or be reborn—or converted. . . . I long to live in that free, disembodied,—carefree—functioning way. . . . Georgia has a great faculty for living this way. How she enjoys herself!"

When O'Keeffe wrote to Mabel that, aside from Alfred, she had "found nothing finer than your Tony" and that "Even if he goes out and sleeps with someone else it is a little thing—," she may have been referring to his sleeping with his Pueblo wife, Candelario Lujan, after Mabel left for Buffalo. But Mabel concluded that Georgia and Tony were having sex in her absence and became enraged. She summoned her destructive forces to quell Georgia: Firing off a missive to Alfred, she informed him that his wife was having sex with her husband. Whether Georgia was actually having sexual relations with Tony was never made clear. It is possible that Georgia had not believed that Mabel would suspect her of having sex with her husband after she had sex with her. It is also possible that Georgia, who did not believe in marriage, attempted to live each day as if it were a universe and attached herself to whomever she was with at the time.

Poor Alfred had been despondent, walking alone into town to play miniature golf and celebrate with an ice cream cone at Flint's pharmacy. And now this. He was not particularly happy about what Mabel had told him, and he did not know what to do about it. Like Mabel, Alfred believed that sexual freedom extended only to people he did not want to possess. Having never been monogamous himself, he could not exactly point the finger of shame at Georgia. Finally he devised a plan to get back at Georgia. He wrote to Mabel that he had found a nurse to accompany her back to Taos, someone who could take care of her every need, who would not mind what went on out there, and who

would bring joy to her life. Although other accounts have Georgia making the arrangement, further research has disclosed that it was Alfred who arranged for Ida O'Keeffe to accompany Mabel to Taos. "Do take a bit of care of Georgia," Stieglitz advised Ida, refusing to believe Beck Strand's accounts of Georgia's health and vigor. "She needs it more than Mabel Luhan.—I just know it—."

When Georgia learned that Mabel and Ida were returning to Taos together, she made a whirlwind car trip of the sights of the Southwest, then packed her bags and left Los Gallos for the relative quiet of The Hill and Stieglitz, who had been begging her to return over the phone. Realizing that she was departing without saying good-bye to her hostess, she penned a thank-you letter to Mabel, saying she wished she could explain more about what had happened in the summer and asked contritely: "May I kiss you goodby—very tenderly—for I am thanking you for much—much more than hours in your house—." Like many people who go west looking for escape, she discovered that although she could leave what had been bothering her at home, she could not flee herself.

Mabel responded angrily that she felt Georgia experimented with people. Georgia replied that she disagreed, that she was not smart enough to do such a thing. Georgia once again attempted to control what others thought of her, to deny others their experience of her, and to stonewall any dialogue between them. Seen in the harshest light, Georgia was an insensitive clod. "I mostly when I think of Georgia," recalled a friend, "I see a block of wood. She had a terrific talent along one mind, but with people . . . she just walked right past them. She was very insensitive to other people." Years later, recalled another friend, she embarrassed some children by asking them persistent questions about their parents' individual motives in an unpleasant divorce.

Georgia was not dumb, but she played dumb when it suited her. Acting like the innocent victim of the machinations of her husband and his friends—which, in a way, she was—she was actually as much a part of their schemes as

they were; she simply refused to admit her own part in her behavior toward others. It was Georgia who attempted to explain Tony Luhan's behavior to Mabel when she could have simply relayed the information to her. It was Georgia who chose to go first with Beck, then with Mabel, then with Beck, then with Tony, as the opportunities arose. She wallowed in self-pity: "I just feel Im bound to seem all wrong most of the time—," and she acted self-righteous, "so there is nothing to do but walk ahead and make the best of it—," once again refusing to examine her own behavior and admit her faults.

Although Georgia could not escape herself, Taos had nonetheless been an eye-opening experience for her. There she could see part of herself operating on a plane of freedom. She would never be the same after the summer of 1929: "I have frozen in the mountains in rain and hail—and slept out under the stars—and cooked and burned on the desert." New Mexico was in her blood. "It has been like the wind and the sun," she wrote Ettie Stettheimer, "—there doesnt seem to have been a crack of the waking day or night that wasnt full—." Back in the damp, green East, she closed her eyes—as she had in South Carolina, when she first began to create what she truly believed—and remembered what it had felt like when she looked up at the stars under the ponderosas on the Lawrence ranch or how she felt when she witnessed a sunset behind a *Penitente* cross next to a *morada* on the hill in Taos—a cross "large enough to crucify a man."

O'Keeffe told people she would not have returned east had it not been for Stieglitz. New Mexico was now her place, and she longed to go back as soon as she unpacked her bags. "If you ever go to New Mexico," O'Keeffe told a friend, "it will itch you for the rest of your life." Stieglitz, glad to have her at the lake, his uxorial pride temporarily restored, confessed that it had been a bad summer without her. But "All the summers at the lake were bad," O'Keeffe confided to a friend. Her life with Stieglitz would never be the same. One foot would always be in New Mexico. Part of her would

always belong to other women. Writing affectionately to Mabel shortly after she returned east, she told her that she even enjoyed their disagreements—the "heat" in them appealed to her. Mabel became her link with a world she wished to inhabit. "I wish I could give you a feeling of completeness that I have," she wrote her new friend, "about Taos."

Chapter 15

· · · · · · · · · · · ·

First she could not sleep. Then she could not breathe. She lost her appetite. She could not stop crying. Her eyesight became strained. Her legs would not work. Severe headaches crippled her with pain. Noise bothered her. She became phobic of water. Four days before Christmas 1932, O'Keeffe left Stieglitz and the Shelton and moved to the guest room of her sister and brother-in-law, Anita and Robert Young, in their spacious Park Avenue apartment. Her condition did not improve. On February 1, 1933, she was admitted to Doctors Hospital, where she was diagnosed a psychoneurotic. Although she exhibited many symptoms, there was no discernible physiological cause of them. The problem was in her mind.

Recovery came slowly. Over the course of seven weeks, the artist learned how to walk again, one step at a time, how to sleep again—and eat again. At first, only Anita was allowed to visit her. After a few weeks, garbed in a loose-fitting black dress and turban, with her sister on her arm, the artist ventured out onto East Eighty-seventh Street and walked around the block. New York streets filled her with terror. Her world had shrunk to a hospital room with a view of the East River across quiet, leafy East End Avenue. During the last few weeks, Stieglitz had been permitted to visit only once a week for exactly ten minutes at a time. As with Kitty, the doctors felt his presence would hinder Georgia's recovery. Stieglitz was despondent. He cried to friends, "First Kitty, now Georgia," claiming full responsibility for O'Keeffe's mental state. It seems he felt he had the power

to drive the women who were close to him insane. O'Keeffe would never say it had been his fault that she had a nervous breakdown. But when she was released from the hospital, the frail artist returned briefly to her sister's, then sailed with her friend Marjorie Content for an extended rest in Bermuda. Months passed before she saw Stieglitz again.

Life had been going so smoothly that it was hard to see the breakdown coming. During the fall of 1929, fresh from her trip to Taos, O'Keeffe had exhibited the paintings she had conjured from the West in Stieglitz's new gallery, An American Place. An American Place was around the corner from the Shelton on Madison Avenue at Fifty-third. Like the Intimate Gallery and the Room, An American Place was an experimental lab for Stieglitz's theories about art, underwritten by a wealthy friend—in this case, a beautiful young woman, Dorothy Norman. Norman (née Stecker), heir to a Philadelphia clothing manufacturing fortune and wife of Edward Norman, heir to Sears Roebuck mail-order millions, signed the checks for the new gallery and managed the business. Mitchell Kennerley had suffered major setbacks in the crash of 1929 and no longer had the funds to foot Stieglitz's bills.

The 1929 American Place exhibition reestablished O'Keeffe's name as a leading painter of the period and produced a few big sales. It included a view from underneath a towering ponderosa pine, *Lawrence Tree,* in addition to several famous portrayals of the thick-walled St. Francis d'Assisi church at Ranchos de Taos and a number of paintings of crosses. In New Mexico, large crosses appear along roadsides and on treeless knolls, as well as in the churchyards of the small adobe settlements. The crosses O'Keeffe portrayed caused quite a stir. Some people felt they were as hackneyed and sentimental as travel posters, while others agreed with O'Keeffe that they symbolized the mystery of Catholicism in the Spanish-speaking section of the American Southwest. "Anyone who doesn't feel the crosses," the artist announced defiantly, "doesn't get that country." Critic Henry McBride called the cross "a chef-d'oeuvre of mysticism" and

pronounced to readers of his popular newspaper column that "Georgia O'Keeffe got religion" in New Mexico.

O'Keeffe had been grappling with the spiritual in art ever since she read Kandinsky's book on the subject in 1914, and McBride's assessment was more than she needed to continue on her path. Not only had he comprehended the deeply personal impressions of the mystical West in her work, he had seen the double-edged humor in her paintings. In a rare burst of self-confidence, O'Keeffe herself had already recognized that the paintings were great. She had even told herself, as she reported to Beck, "guess you've won again." So much of the artist's work depended on her enthusiasm for the subject. O'Keeffe was not an artist's artist. Her strength lay in the passion she was able to convey of her vision, not in her ability to handle paint.

In the opinion of many formally trained critics, O'Keeffe's work would never measure up to rigorous standards. Appreciation of her work was a subjective experience. When critics saw things her way, she tended to grease the wheel of their support. She offered tickets to a concert to critic Blanche Matthias. She cultivated Henry McBride's friendship over the years, even sending him an unsolicited check for two hundred dollars after he complained to her of being broke. McBride was invited to private little suppers in the Shelton for exclusive viewings, as well. O'Keeffe often chuckled over what he wrote, as she no doubt did when she read: "I should like Mae West to see [the cross painting]. It can only be properly understood, one feels, by someone who knows life thoroughly."

O'Keeffe was moving again. With her inspiration back, she was eager to go west and repeat the experience she had had there before. The heat her work generated was clearly on her mind as she wrote to Matthias, in what appears to be a double entendre, that she needed to know that the center of the earth was "burning hot." She continued work on a series of paintings of the interior of the jack-in-the-pulpit flower, which she said had interested her since the day in a high-school classroom in Madison when the teacher

(1) "The barn is a very important part of me," Georgia O'Keeffe once said, referring to the six-hundred-acre Wisconsin dairy farm where she was born on November 15, 1887.

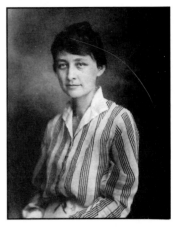

(2) This rare early portrait, probably commissioned by Arthur Macmahon, Georgia's beau during the summer of 1915, depicts the artist at a time when she was struggling to find her identity.

(3) O'Keeffe received first prize in William Merritt Chase's still-life class at the Art Students League in 1908. Chase made a lasting impression on the artist: "There was something fresh and energetic and fierce and exacting about him that made him fun."

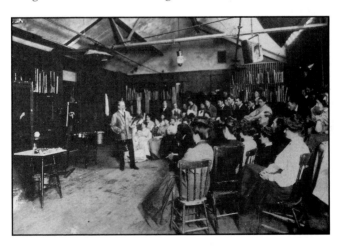

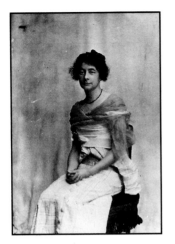
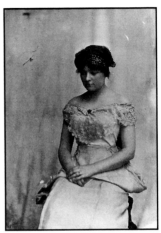

(4) *Left:* Ida and (5) *right,* Anita O'Keeffe were not only Georgia's younger sisters, but in the summer of 1912, after
she had abandoned art to help her family, they were her only friends.

(6) Before Georgia's mother, Ida, died in 1916, she asked her eldest daughter to care for her youngest, Claudia. The following year, Claudia enrolled in the education program at West Texas State Normal College, where Georgia was teaching and where this picture was taken for the yearbook. Commenting on her elder sister's aloofness, Claudia remarked that walking with Georgia was "just like being alone."

(7) *Abstraction IX,* a c.1919 charcoal drawing, most likely depicts friend and fellow classmate Dorothy True. O'Keeffe, moved by True's beauty, said, in an unusual romantic confession, that she wanted to "pick her up and…take her away from it all for always."

(8) The identity of the subject of *Seated Nude No. II,* a watercolor drawing, has been revealed as Leah Harris, a lecturer in home economics and Georgia's lover. "I've been looking for Georgia," Harris told Paul Strand, "all of my life."

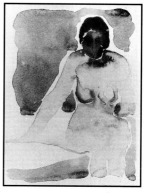

(9) From their first meeting, O'Keeffe idolized photographer and art impresario Alfred Stieglitz, who for thirty years guided her through a Faustian maze of sensations. "There was such a power when he spoke [that] people seemed to believe what he said, even when they knew it wasn't true…. It was as if something hot, dark and destructive was hitched to the highest, brightest star."

(10) The cross-fertilization between the works of O'Keeffe and Stieglitz began almost immediately, seen here in O'Keeffe's watercolor drawing, *above left, Train at Night in the Desert,* which was inspired by Stieglitz's 1902 photograph (11), *above right, The Hand of Man.*

(12) O'Keeffe provided Stieglitz with his greatest subject—herself. Comprised of more than one thousand images taken over several decades, Stieglitz's portrait of O'Keeffe has no equal in the history of photography. *Below left: Torso* and (13), *below right, Breast and Hands,* were both taken in 1919.

(14) The Texas flatlands inspired the artist even after she had left Texas and settled in New York. *Rising from the Plains* was painted in 1919 from memory.

(15) Mountainous Lake George and the compound known as The Hill became the source of most of the artist's material during the 1920s.

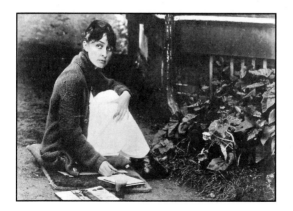

(16) The artist spent hours studying morning glories that bloomed in a clump at the base of a drainspout.

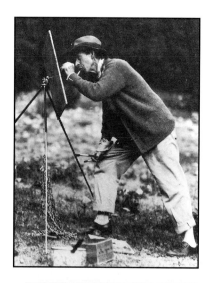

(17) O'Keeffe once remarked that "the men were always more interesting." The men in her circle included fellow painters John Marin, *left,* whose serenity impressed the artist; (18) *below left:* Marsden Hartley—she called his paintings "a brass band in a small closet"; (19) *below right:* writer Sherwood Anderson—his lyrical tales of a midwestern childhood reminded the artist of her own; (20) *opposite near right:* photographer Paul Strand—the artist wrote him passionate love letters; and (21) *opposite right,* Charles Demuth, whose paintings of flowers influenced O'Keeffe.

(22) In one of her epic fits of temper, Georgia once slapped
Frank Prosser, *below,* the son of the Stieglitzes' housekeeper,
Margaret Prosser. "I don't know why people bother me so,"
the artist declared around that time. "They make me feel like
a hobbled horse."

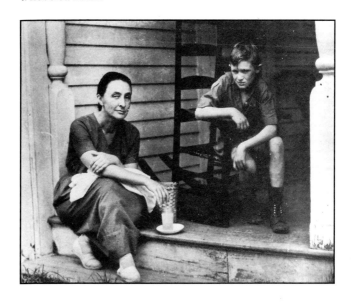

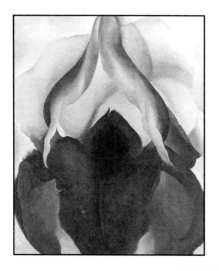

(23) "Making your unknown known is the important thing," O'Keeffe wrote Sherwood Anderson in 1926 after she painted *Black Iris*—and in many ways she succeeded with this painting, which combines spiritual and sensual experience in a lush union.

(24) Having emerged as a powerful woman at a time when many women were beginning to assert themselves, O'Keeffe found herself "besieged by her sisters for advice," according to art critic Henry McBride. The artist is seen here with Mrs. Chester Dale, a wealthy art patron.

d back the jack to show her students what was
th the hood on the flower. In fact, a similar scene
D. H. Lawrence's *Women in Love,* a novel the artist
ore than once; and the event may have been sub-
usly transposed in her mind. The abstract paintings
roduced now were as passionate and sensual as they
cold and clinical. In some minds, they were anthro-
orphized female genitalia; to others, the dark center of
jack was a reference to the mystical unknown. As with
the artist's other flower paintings, the jack-in-the-pulpits
attracted a number of lesbians to the gallery. Around this
time, Frida Kahlo, the exotic Mexican painter, flirted with
O'Keeffe openly in the gallery. Like O'Keeffe, Kahlo docu-
mented her own body in her work, and also like O'Keeffe,
she was married to a famous artist—muralist Diego Rivera.
Rivera approved of his wife's lesbian lovers and could not
feel threatened by her bisexuality. Women's sex, he main-
tained, unlike men's, "was all over the body, and therefore
two women together would have a much more extraordinary
experience." Rivera believed O'Keeffe and Kahlo had been
sexually intimate. Like many of the artist's liaisons, her affair
with Kahlo does not seem to have lasted.

Although she had a long way to go before she could
couple with another woman, the artist was beginning to
accept her bisexuality. Her sister Claudia had become in-
volved with other women sexually. After several protracted
long-distance affairs with unavailable men, her sister Ida
remained single, although she had been with women. Fifty
years later, there were women in Taos who remembered Ida
as one of Mabel's sexual conquests. According to several
accounts, the heiress boasted that Georgia had sent her sister
to her when she left New Mexico. On her return to New
York, Georgia did not continue her affair with Beck Strand,
leaving her behind like an old shoe that had lost its shine.
She preferred variety over stability. Several women at this
writing told me they knew of other women who had been
intimate surreptitiously with the artist in New Mexico.

Georgia was eager to go west. She took Alfred to Lake

George in April 1930, opened the house for th
spent a week alone on the Maine coastline, then
New Mexico on the train. A friend drove her Mod
to Taos. Once again she stayed in the Pink House and
in the studio. Nothing was the same, however. Still s
from the betrayal of the summer before, Mabel was
cordial to O'Keeffe. Appearing formidable and brusque
treated Georgia as she would a lodger—which, in a
she was, since she paid the heiress for the use of her spacia
quarters. A day after she arrived, Georgia asked Tony ou.
for a ride with her. Mabel stopped her cold: "lay off Tony
this summer," she said. "[I am] well now & able to do things
with him myself." Mabel told Brett that Georgia had a "most
unpleasant habit" of "grabbing" people.

O'Keeffe also knew how to avoid people, having learned
how to stay away from her cold mother and bossy aunt as
a child. She carefully made her way around Mabel for the
rest of the summer. But things got so bad, she finally moved
to the Sagebrush Inn, an old adobe fortress on the edge of
Taos with a stone fireplace, large enough to walk into, in
the lobby. On one occasion Tony stayed with her in her
room after she had been snubbed by Mabel, who would not
invite her to a party for the peyote singers at Los Gallos.
Like other Native Americans, Pueblo Indians ingested psy-
chedelic peyote as a ritual to join with the cosmic forces of
the universe. Although many artists and writers also took
peyote to gain insight, O'Keeffe did not experiment with
drugs, by all accounts.

O'Keeffe took her meals of green chili stew and blue corn
tortillas at the café in town, or she ate with friends like
Dorothy Brett and Frieda Lawrence. Both Brett and Frieda
had taken her side in the feud with Mabel. Georgia was not
the only person Mabel had been bothering. Mabel had be-
come persona non grata to both of her other friends as well.
D. H. Lawrence had died of tuberculosis in March in Italy.
Returning to New Mexico, Frieda had had her husband's
ashes shipped from Italy, enlisting Stieglitz in a customs
battle in New York. When she arrived in Taos with the urn,

Mabel attempted to steal Lawrence's remains and keep them for herself. Frieda retrieved the ashes, then embedded the urn in a mound of unmovable cement, around which she erected a chapel, on the grounds of the Lawrence ranch.

Mabel's battle for Lawrence's remains was a fitting finale to her experience with the writer, although surprising given how Lawrence viewed the heiress in his private letters: Mabel is "a culture-carrier," he wrote to his mother-in-law, "little-loved, very intelligent as a woman, likes to play the patron-ess, hates the white world . . . loves the Indian out of hate, is very 'generous,' wants to be 'good,' and is very wicked, has a terrible will-to-power, you know—she wants to be a witch and at the same time a Mary of Bethany at Jesus's feet—a big, white crow, a cooing raven of ill-omen, a little buffalo."

Mabel's ostracism of Georgia must have pained her greatly, for Georgia began to make disparaging remarks about the woman for whom she had expressed love only the year before. Georgia was desperate for peers. Mabel seems to have been someone with whom she felt she could be on a par. Being denied the friendship of someone one admires is possibly the most painful ordeal in life. Referring to Taos as "Mabeltown," she dismissed the social life there as "poisonous." Fifty years later Georgia continued to nurse her grudge, when she put down artistic life in Taos on a television talk show. "When Georgia hated," recalled a friend, "it was with a purple passion. She could be vindictive! Nothing she could say could be bad enough if she disliked a person."

O'Keeffe ventured far afield in New Mexico that sum-mer—at considerable risk. Most of the roads she traveled were rugged dirt roads that dipped and turned with the contours of the land. Each afternoon the summer rains washed away roads and stranded motorists. Axles broke. Cars sank in the mud. What was more, the terrain was full of bobcats and rattlesnakes, desperado outlaws and un-known perils. O'Keeffe was not afraid of people she did not know or of perils she could not fathom. Fortunately, the

summer of 1930 was incredibly dry, and a drought baked the already-hard earth; afternoon thunderstorms were few. The drought caused widespread starvation, and the desert plains were littered with rotting carcasses and bones: deer, antelope, cows, horses, coyote, and red fox. The sky was full of huge black ravens and vultures in search of carrion on which to feast. O'Keeffe loved the experience of so much death, the shapes of the bones and their smooth white surfaces. She began collecting them, forming a bone pile outside the inn.

When she got ready to leave New Mexico, she realized she had not created anything as new as she had the summer before—"the country had been so wonderful that by comparison what I had done with it looked very poor to me—." Casting about for souvenirs that would bring the place back to her once she got home, her eyes fell to her bone pile. She promptly packed it into a barrel to ship back to Lake George. Arriving at the lake a few days before her parcel, she was present to see Stieglitz's eyes widen—as did those of his conventional relations—as she opened the barrel and pulled the bones from the bright flowered Mexican funerary paper in which she had wrapped them. Stieglitz "raged" at her for spending sixteen dollars to ship the bones. At the time, that sum could have fed a family for a week. There were rib bones, pelvis bones, skulls, and shoulder bones, as well as antlers and complete deer racks. The variety was staggering. One day, passing a large horse skull that had been left out on a table, the artist decided on a whim to put a pink cloth rose in its eye socket. "The rose in the eye looked mighty fine," she remarked years later—so fine, she painted the skull with the rose in the eye. O'Keeffe had taken the idea of using artificial flowers from Beck Strand, who had been using them as subjects for her quaint reverse glass paintings. Local Spanish-speaking people decorated graves with artificial flowers in arid New Mexico.

Critical reaction to O'Keeffe's bone paintings was not positive. Henry McBride joked that she had gone to the other side, entitling his review of her show "Mourning Be-

comes Georgia." Nearly all the other responses reported that
O'Keeffe was meditating on the theme of death. As when
people saw only female genitalia in her paintings of flowers,
O'Keeffe was upset that they saw something in these paint-
ings that she did not—death. Why couldn't they understand
what she was doing? Why couldn't they see bones as beau-
tiful shapes that "cut to the center of something *alive* in the
desert," she wrote, echoing Kandinsky, who had written,
"Even dead matter has spirit." What was wrong with the
critical establishment? It was infuriating for her to have one
thing in mind and have another come out—at least, in the
public's eye. Her reaction was to return to the extreme fear
of exposure she had felt earlier. The reviews "make me feel
like crawling far far into a dark—dark hole," she wrote a
friend, "and staying there a long long time—."

Perhaps O'Keeffe had indeed been meditating on death
without knowing it—the death of her relationship with
Stieglitz. While the artist was away in New Mexico pursuing
crosses, sunsets, and bones, her husband had been at home
with a new subject as well—a human subject, a new model,
and—so it seemed, since both parties were married—a new
paramour. She was Dorothy Norman, the sponsor of An
American Place. Like Mabel Dodge Luhan and other women
with inherited wealth, Norman had the same energy her
forebears had applied to amassing fortunes, but only the
lives of men as objects of her enthusiasm. Norman's tastes
were eclectic, and she supported different men at different
times. After Stieglitz died, she became a companion for
Jawaharlal Nehru and helped the photographer Henri Car-
tier-Bresson. She even assisted the composer John Cage. It
was Norman's self-appointed role to erect scaffolding under
already important men. Norman and Stieglitz met in the
mid-twenties; by 1930, they had become great friends and,
in fact, were exchanging rather passionate love letters. He
photographed her as he had O'Keeffe. Doe-eyed, with
smooth skin and a curvaceous shape, Norman was the first
serious model he had taken since O'Keeffe, a situation that
presented a major threat to their relationship. "Whenever I

photograph," Stieglitz had told people pointedly, "I make love."

O'Keeffe was not at all happy about the situation. For the first time in their relationship, she was visibly jealous of someone else in Stieglitz's life—and nearly everyone in the small, incestuous, and gossipy world they occupied knew how she felt. Only adding to her feelings of abandonment, she admitted in rare moments of objective clarity that Norman was clearly what Stieglitz needed, however much she may have disliked her. Norman was only in her mid-twenties in 1930—so young she could have been Stieglitz's granddaughter, and in many ways, she treated him like a beloved grandfather, and he treated her like the granddaughter he had not otherwise known. It must have been difficult. While O'Keeffe had to leave Stieglitz when she went west, she did not want anyone to take her place. While she wanted Stieglitz to be happy, she did not want his happiness to include other women, like Dorothy Norman.

Norman, for her part, worshipped Stieglitz. She made him feel good about himself at a time when his wife and the rest of the world were moving away from him—literally. He had abandoned flying as quickly as he took it up. He had never learned to drive, giving it up completely after he smashed a car into a tree on The Hill. There was a cruel symmetry at work: After he had photographed O'Keeffe driving off into the sunset behind the wheel of her Ford, he was now photographing young Dorothy Norman in the nude. Stieglitz no longer photographed O'Keeffe in the nude. Although she maintained what one friend later referred to as a "perfect physique," her once-firm body had lost its tautness, and what was more, the years had not been kind to her face, which began to look weathered for someone only in her early forties.

O'Keeffe was relieved to return to New Mexico in the spring of 1931 and leave her concerns over Stieglitz and Norman behind. This time she avoided Los Gallos and Taos altogether and stayed at the H & M ranch in Alcalde, an old Spanish mission town adjacent San Juan Pueblo on the

fertile banks of the Rio Grande, midway between Santa Fe and Taos. Lying under the sheltering arms of old cottonwood trees, H & M was owned by a Radcliffe-educated Bostonian poet named Marie Garland and her fourth husband, Henwar Rodakiewicsz. A Polish-American experimental filmmaker and photographer, Rodakiewicsz would later show his movies, at O'Keeffe's instigation, in An American Place. It was at H & M that O'Keeffe became friendly with many of the people who would remain close to her throughout her New Mexico life: Witter Bynner, a rich Harvard-educated poet and translator of Chinese who introduced the artist to haiku poetry and Chinese paintings, and his lover, Willard "Spud" Johnson, founder, editor, and producer—on a hand-operated press—of Laughing Horse, a local literary magazine. One night at a party for Cake, Bynner's searing satire about the poisonous Mabel, Beck Strand, who was also visiting for the summer, started a brawl. The next day, O'Keeffe reported, the floor was littered with broken glass.

Eccentrics abounded. Mary Cabot Wheelwright, a Boston brahmin who was a direct descendant of the well-known Cabot, operated a ranch on adjacent property. Like Mabel, Mary had established her own cosmos, employing primarily female cowhands to run her property. She kept a Navajo medicine man and sand painter by the name of Hosteen Klah for spiritual guidance. Klah was a hermaphrodite, chosen by Navajos in his tribe to maintain the secrets of the ancestors because of his special body. Like other Native Americans, Navajos in this area believed that homosexuals and hermaphrodites, because they combined both sexes in one body, possessed special powers and unusual mental capacity. Klah had abandoned his tribal rights when he left his people to live with Wheelwright, where he became something of a consort. Wheelwright even took him on a trip to her family's summer home in exclusive Northeast Harbor, Maine. Klah became a favorite on the summer tea-party circuit. He found it amusing, he observed wryly, that white women in Maine, unlike Pueblo people, drank tea with no special healing purpose in mind.

For the most part, however, O'Keeffe kept to herself. She traveled in her car across the river on a one-lane bridge—so narrow, the local story went, that only angels could pass easily—into the badlands of Abiquiu to the west. Years later, one of Georgia's companions Dorthy Fredericks remembered going with her father to pull the artist's car out of a deep arroyo after it got stuck in the sand. "Georgia," she said, recalling the incident with humor, "went into the most unusual places in that car." O'Keeffe loved the badlands. There, incredible sandstone formations rose from the ground. The earth was as white as chalk in some places, poured like sand into cone-shaped mounds. In others it was purple; in others, striated red, orange, and yellow. The deeper she ventured into the badlands, the stranger things got. O'Keeffe had heard about a ranch way out in the badlands, and she longed to find it because she wanted to be as far away as she could. "I hate being under a roof—" she wrote McBride.

One day O'Keeffe opened an envelope from Stieglitz to discover that he had mistakenly sent her a love letter intended for Dorothy Norman. (Other accounts place this occurrence in 1935, but research indicates it also took place in 1931.) O'Keeffe returned to The Hill as fast as she could, determined to fix things with her husband. She arrived at Lake George to discover that Stieglitz had ventured away to visit Norman at her summer house in Woods Hole, Massachusetts. For Stieglitz to leave the lake during the summer was news in itself. The fact that he had gone to visit Norman was a scandal. In the past, O'Keeffe had not been able to get him to budge. She had asked him to go to New Mexico with her. He had refused on the grounds that his heart would not survive a trip to high elevations. Now, when Stieglitz returned to Lake George, they fought. She left for three weeks at York Beach in Maine; after she returned, he left for another week in Woods Hole. She became despondent: "Everything is so soft here—I do not work—When the sun shines I want to be out in it and when it is grey I think it too dark to work."

O'Keeffe's despair was underscored by the presence of

little children on The Hill—the same little children she had avoided unsuccessfully for many years. "One suffocatingly hot day," Sue Davidson Lowe recalled in her family memoir, "a tribe of four little squaws aged four to ten, dressed in fringed chintz buckskins of Lizzie's devising, dared the ultimate hazardous mission into forbidden territory: scouting Georgia's Shanty. Peering through the window, we were dumbfounded to find her naked at her easel, a tableau for which nothing in our essentially prudish upbringings had prepared us. Georgia's momentary shock turned to immediate rage. Shrieking—and still naked—she flew out, brandishing a paintbrush, to chase us away. To her, we were prurient little horrors. To us (or at least to me) she was as magnificent and awesome as a goddess." Later, O'Keeffe often recounted this incident when asked why she had left Lake George.

For some time the artist had wanted to paint a mural or a room in a building, and she had asked Blanche Matthias about the possibility of a commission for one of the pavilions in the 1929 Chicago World's Fair. Then the Museum of Modern Art invited her and sixty-four other artists to submit a drawing for a prospective mural for the interior of the new Radio City Music Hall. The drawings were to be displayed at the museum's inaugural exhibit at its new headquarters in a Rockefeller mansion on Fifty-third Street. O'Keeffe seized the opportunity without checking with her business manager first. Stieglitz was aghast when he heard of it. First, he was against the Museum of Modern Art, which had overlooked modern American art in favor of modern European art and in his opinion had been corrupted by conservative Baptist Rockefeller money. Second, he opposed artists receiving commissions from businesses to paint their interiors. Third, he detested murals under any circumstances, but especially at this time, when they were generally politically motivated. He called them "a . . . Mexican disease," since the best-known mural artist of the period was Diego Rivera, a Mexican.

Titled variously *Skyscrapers* and *Manhattan,* the O'Keeffe

drawing for the Music Hall mural depicted fanciful buildings in a dreamy landscape—not unlike her lesser-known paintings of New York skyscrapers—with a pair of camellias floating on the top. Her design won first place, and she was selected by Donald Deskey, interior designer of the Music Hall, to paint her mural in the second-mezzanine powder room. Stieglitz was so upset that he tried to block her commission, her fifteen-hundred-dollar fee only adding to his ire. At this time, the prices of O'Keeffe paintings ranged from four to six thousand dollars, and Stieglitz had worked hard, he claimed, to keep those prices during the Depression. Stieglitz did not care that O'Keeffe had aspired to paint a mural. He did not like murals, and she shouldn't, either. He even suggested sarcastically that if she wanted to paint a room, why didn't she paint the kitchen in the farmhouse?

Throughout 1932, O'Keeffe waited for the room for her mural to be completed. The mural and the room became her albatross. She did not go west. Instead, changing her mind at the last minute, she went to Lake George with Stieglitz for the first time in four years, waiting for a go-ahead from the contractors. Living with Stieglitz that summer was difficult. In those four years, he had pulled away from her and grown used to the company of primarily small children during the summer. "I am divided between my man and a life with him—," she wrote a friend in New Mexico, "and some thing of the outdoors—of your world—that is in my blood—and that I know I will never get rid of—I have to get along with my divided self the best way I can." O'Keeffe got along with her divided self at Lake George by drinking bootleg whiskey and becoming moody and joining forces with Stieglitz's niece, Georgia Engelhard, in her campaign against him and his opposition to what she wanted to do. Over and over again, compulsively, she cranked up the Victrola and let Marlene Dietrich's dusky rendition of "Johnny" create a mood of discontent in the farmhouse. Engelhard, an attractive, breasty single woman in her mid-thirties, had dropped out of Vassar to paint in a style that echoed O'Keeffe's and take photographs in a style

similar to Stieglitz's. According to her mother, Agnes Stieglitz Engelhard, Alfred's sister, Alfred and Georgia "blighted the young woman's chances for a normal life. They had both played with her," she insisted disapprovingly years later, strongly suggesting that her daughter had been a sex object for both Stieglitz and O'Keeffe from an early age. When she was still a teenager, Georgia Engelhard had painted next to the older Georgia in the Shanty, and she seems to have adored her exotic aunt. Now, the two Georgias drove a few hours north to Montreal to purchase more whiskey, which was sold legally in Canada, Prohibition still being in force in America, only to have their booze seized at the border. In August, they went to the windswept Gaspé Peninsula in Canada on a painting trip. O'Keeffe was again influenced by the sight of crosses along the road. She painted the French Canadian crosses for her next show and a series of barns that a critic later compared favorably to Picasso's work.

In November 1932, O'Keeffe finally began work on her mural. The mural was harder than she imagined it would be to complete. The walls of the rest room were punctuated by seven large round mirrors, around which she had to paint, and she was charged with continuing the theme on the ceiling, which involved a completely different perspective. O'Keeffe was overwhelmed by the task. While she was looking at the mural one day with Donald Deskey, a section of the canvas bubbled and began to peel away. An artist who was normally meticulous to the point of distraction, painting detailed studies of enlarged flowers in tiny brush strokes, finishing the seams on her dresses as tightly as a machine, O'Keeffe had been unable to maintain her rigid standards on such a large work. The peeling canvas caused her to become unglued herself. "O'Keeffe," Deskey remembered, "became hysterical and left in tears."

The next day, Stieglitz called Deskey to say that O'Keeffe would be unable to complete the mural, because she had suffered a nervous breakdown. This was in November. By December she was no better. "As I remember myself," she reflected, "it seems that there was a spring in me—now I

feel more like just a dead weight—." Four days before Christmas, she left Stieglitz and moved in with her sister and brother-in-law. She told people she had a bad heart. Lee Stieglitz, Alfred's doctor brother, diagnosed her case as "shock." She stayed at Doctors Hospital, which at this time was where rich people went to dry out and recover from the excesses of life. She did not receive advanced medical care in the place. No one examined the effects of incest. No one studied her repression or rages. What she got was time. While she slowly recovered, the artist had time to reflect on her life: where it had been and where it was going. As the only woman of her generation to compete successfully with men in the field of art, O'Keeffe enjoyed a special place in a world of personalities. She had in fact become more famous than the men against whom she competed. Hers was a household name; not so with Arthur Dove, John Marin, or Marsden Hartley. But now, in the thirties, a new generation of women was coming into their majority, and there were other women against whom she must compete. Although no female artist ever supplanted O'Keeffe, around this time she felt the presence of other females, who exhibited their work together in group shows.

Even one of her own sisters seemed to be competing against her. While she was recovering from her illness, she learned that Catherine O'Keeffe Klenert had exhibited almost identical likenesses of her flower paintings in a New York gallery, capitalizing on her famous sister's fame. *The New York Times* declared, "Another O'Keeffe," and Georgia was furious. The flower paintings had been remarkably easy to copy—a number of imitations had been found floating around New York. Advertisers used likenesses to sell cigarettes and automobiles. Catherine's were so good, few people could tell the difference between the two. The older artist threatened to cut her sister's pictures to ribbons and ceased contact with her. Traumatized, Catherine stopped painting at Georgia's request. They did not speak to or see each other for four years.

Anita was Georgia's only link to her family at this time.

Ida was wandering around the country, bouncing from job to job, writing letters extolling the virtues of Springfield, Missouri, as was Claudia, whose letters were often unanswered by Georgia. Neither sister seems to have fared well during the Depression. Ida would end up working in a munitions factory in southern California during the Second World War. Francis had moved to Cuba. Alexius, her favorite brother, had died suddenly in 1930, leaving a pregnant widow, Betty, and their two-year-old daughter, Barbara June. Georgia was not particularly generous to her brother's widow: "I felt [your marriage] would make trouble for you," she wrote heartlessly to her distraught sister-in-law.

As with most cases of nervous exhaustion, the exact causes of Georgia's illness no doubt date back to early childhood and to unresolved conflicts with her shadowy father and cold mother—and it was interesting that she had so little contact with her sisters and brothers at this time. The rigidity to which the artist fell prey and the rages that seized her would plague her for the rest of her life. The summer before, she had slapped the cook's son on the face with such force that his cheek was still stinging a week later. There is little doubt that Stieglitz had a hand in her condition—if he had not, he would not have been barred from seeing her in the hospital. What really caused her collapse is lost, however, for O'Keeffe never discussed the matter in detail, nor did she continue in the therapy the hospital provided for her. Years later, she confided in a friend that she felt Stieglitz had put a hex on the mural project—an indication not only of the artist's superstition but of how much sway she allowed Stieglitz to have over her and how truly dependent she was on his nod. Psychiatrists would have said she was in denial, but analysis was not for her. Reflecting the forward-looking strain of American thought, O'Keeffe believed the solution to her trouble was found in the future, not in the past. "I seem to be one of the few people I know," she said airily around this time, "to have no complaints about my first twelve years." If only she had had a few.

Chapter 16

.

The ranch was so isolated that most people, when they finally arrived, stayed for months. It was seventeen miles from a crumbling adobe post office in the tiny village of Abiquiu, reached by a dirt road of red clay that turned slick as oil when wet. The last few miles were nothing but a pair of faint tracks in the dust. In Spanish times, outlaws had driven rustled cattle into the remote oasis. The ranch was named Ghost Ranch because an early settler had shot his brother during a dispute in the middle of the night. From time to time superstitious people heard the voice of a woman wailing—the ghost of the bereaved widow. People who appreciated red rock and cacti, deep blue sky and wide plains of golden grass said it was the most beautiful place on earth.

The more O'Keeffe heard about Ghost Ranch, the more she wanted to know it firsthand. Being hard to find was something O'Keeffe sought passionately in the summer of 1934. Having already tried unsuccessfully to find the place the summer of 1931, the last time she was in New Mexico, she reasoned that once she arrived, no one would be able to find her, either. Before, she had missed the turnoff. Hard as it may seem to believe, she had driven past the twenty-thousand-acre spread and into the wilds of Rio Arriba County, where natives, descendants of cattle rustlers, and lawless renegades spoke no English and often used their gun as a calling card. "Santa Fe friends told us we could not live safely in this wild and dangerous country," recalled

one settler around this time, "—the native people hated all Anglos."

One day in June, after she and two of her friends had arrived in New Mexico for the summer, she spotted a wood-paneled station wagon in the parking lot of the Farmway feed store in Española. The initials GR were painted on one of the doors. O'Keeffe asked the driver if he had come from Ghost Ranch. She wanted to know how she could get there. He told her to follow the road forty miles into the desert and turn where a cow skull was propped against a rock. That was the entrance to the ranch. The main buildings were several miles off the road down an incredibly steep hill, across a creek on a narrow log bridge. The driver warned her that she might not find the entrance. The skull was often stolen by desperadoes who did not like the dude ranchers at Ghost Ranch. Ghost Ranch was a dude ranch operated by Arthur Pack, an easterner—son of the founder of Cleveland Trust Company—for his rich friends. Pack had put in an airstrip at the ranch to accommodate his friends' Fairchilds and Douglas DC-2's.

The problem was there was no room for her at the ranch after she finally found the place. Pack told her she was free to come out during the day and paint, but she could not stay overnight.

Ghost Ranch was ideal for the tired artist. Situated on a broad plain at the end of the Chama River Valley, the ranch enjoyed an unobstructed view across miles of open land to the Pedernal, a flat-topped mountain shaped like a pyramid with its top cut off. Odd shapes of land rose out of the desert floor in all directions. Herds of wild antelope, deer, horses, and burros roamed the plain freely. The sky seemed bigger at the ranch, ineluctable as a dinosaur. "I wish you could see what I see out the window," the artist would later write to Arthur Dove and his wife, Reds; "the earth pink and yellow cliffs to the north—the full pale moon about to go down in an early morning lavender sky behind a very long beautiful tree covered mesa to the west—pink and

purple hills in front and the scrubby fine dull green cedars—
and a feeling of much space—."

O'Keeffe's world had changed dramatically after her
breakdown. As anyone who has experienced the crippling
effects of a nervous collapse will attest, life takes on new
resolve afterward—and O'Keeffe's was no exception. For
her, this meant pursuing her own life in the desert away
from her husband and his circle of artists. She was willing
to stand up to Stieglitz and go her own way—even if going
her own way cost eighty dollars a week, as room and board
at Ghost Ranch did, making the ranch prohibitive to all but
a handful of millionaires. (At the time, for instance, a room
in the Plaza Hotel ran seven dollars a night.)

Recovering from the breakdown took time. Most of the
past two years had been spent regaining her balance and
learning how to operate in the world again. "I really have
to move myself mostly with my head," she confided in Beck.
During the spring of 1933, after she was discharged from
the hospital, she visited Bermuda with her friend Marjorie
Content. A vivacious divorcée who favored full-pleated Mex-
ican peasant skirts and gold hoop earrings, Content was a
poet and a publisher of avant-garde writing who operated
a salon from a house on Tenth Street in Greenwich Village,
as well as a bookstore, SunWise Turn, with a friend, poet
Lola Ridge. The two women may have met in New Mexico,
where Content had been photographing Pueblo life for the
Bureau of Indian Affairs. O'Keeffe felt comforted by her
friend and shared her insecurities: "I feel more or less like
a reed blown about by the wind of my habit," she wrote to
her. In Bermuda, Content gave the artist free rein to come
and go as she wished. O'Keeffe spent hours walking on the
pink sand beach, swimming in the turquoise sea, collecting
seashells, and gathering pieces of gnarled old wood.

Populated primarily by golfing businessmen who wore
pink shorts and stayed in pink cottages, Bermuda, O'Keeffe
admitted, was boring. In addition to rest, Bermuda also
offered privacy and miles of paths where she could exercise
her passion for walking great distances. She even took up

bicycling and rock climbing, although after a fall she had to be confined to bed for three days.

Arriving back in New York in May 1933, O'Keeffe went almost immediately to Lake George, where she opened the house for the summer before Stieglitz joined her there in June. As Marjorie Content had in Bermuda, Stieglitz gave O'Keeffe plenty of room on The Hill. It was the first time they had been together for any length of time since she had moved out of the Shelton in December of the previous year. Stieglitz was surprised to discover how slowly she had recovered. Still shaky and prone to bouts of tears, she was terrified even to drive her car. She was at a loss to explain exactly what had taken place. Stieglitz told people that her condition was his fault, as with Kitty. He excused her from their annual photography session and even allowed her to keep a white kitten she had been feeding. Stieglitz disliked cats, but he discovered to his dismay that O'Keeffe cried when he attempted to have it removed. Long Tail was the artist's first pet as an adult.

Stieglitz kept his relatives away from O'Keeffe during the summer. No one visited The Hill except for a brief period in August, when Elizabeth and Donald Davidson arrived. Elizabeth and Donald were permitted to visit because they had been such good friends of the artist when she moved to New York from Texas; their company soothed her. She did not paint. She could not read or sew or cook, activities that had normally kept her occupied in the past. O'Keeffe swam in the lake every day, rested often, listened to recordings of Beethoven piano sonatas on the wind-up Victrola, and kept Stieglitz from overwhelming her with his lengthy diatribes: "—the not talking seems to give a real quiet that seems to make the whole house feel good."

The housekeeping and cooking were taken care of by Margaret Prosser, a dour Canadian widow who took long walks in the pine woods and birch groves with the artist. O'Keeffe became closer to Prosser than most people became with servants at that time—a familiarity that seems to have led later to inevitable contempt. Frank Prosser, her son, was

not taken in by his mother's friend: "I always felt that she was different than the Stieglitzes. I remember them for their . . . well, I shouldn't say gentleness . . . but I mean, class, maybe. . . . Refinement, maybe. And I don't feel that she was that way. I feel that she was a very forceful type person . . . and very opinionated. . . . I think she had her own ideas and that she was going to stick by them."

Stieglitz now suffered from the tyranny of health. When his mother, Hedwig, had suffered from a debilitating stroke, he refused to go near her and gave her up as dead. Finally, after she wailed that his absence was, in fact, killing her, he had relented and seen her. He prided himself on looking after artists, but he was a terrible nurse, with no bedside manner whatsoever, tending to talk nervously at the patient, unable to soothe or calm. So it was that at the end of September, instead of remaining together at the lake as they normally did, Stieglitz left O'Keeffe in Prosser's care. "I see no light for the autumn or winter," he wrote a friend of her condition, "as far as she is concerned." He later returned with Paul Rosenfeld and other friends to spend Christmas with O'Keeffe.

After Christmas, O'Keeffe remained at the lake with an old friend of Stieglitz's and hers, novelist Jean Toomer. A light-skinned black with small features, tiny tortoiseshell eyeglasses, a moustache, and elegant long fingers with which he often stroked his chin sagely, he had what one observer described as a "feminine intimacy" that engendered a closeness with his subjects. Toomer was a welcome addition to the artist's convalescence. Unlike Stieglitz, he was naturally quiet and self-contained. O'Keeffe missed Stieglitz's seventieth birthday on January 1, while remaining at The Hill with Toomer—Stieglitz celebrated his birthday in town with Dorothy Norman and other friends. Norman presented him with a copy of *America and Alfred Stieglitz*, a book of essays she had organized with the help of various contributors. O'Keeffe's name was a glaring omission. Toomer and O'Keeffe went for long walks on the frozen lake, marveling at the vast stretch of whiteness in the north woods. They

talked at length about life and death. Toomer's wife Margery (née Latimer) had recently died in childbirth. Margery had been a beautiful and talented poet who moved restlessly back and forth between men and women; she had been lovers at one time with O'Keeffe's ardent supporter Blanche Matthias, as well as with writer Zona Gale. "Reading over your list of paintings," Latimer had written O'Keeffe, "made me suddenly taste your world in my throat." What was more, the previous fall O'Keeffe and Prosser had come across a pregnant woman who had just severed an artery in her foot while chopping wood with an ax. O'Keeffe applied expert first aid while Prosser went for help. O'Keeffe had saved her life, the woman later told people. Toomer talked to O'Keeffe about the after-life, and discussions of occult occurrences seeped into their conversations. One night, he beat out an Indian rhythm on the bottom of a tray. O'Keeffe wrote Content that the experience made her shiver all over.

Jean Toomer rekindled a passion in the artist that she had not expressed in many years. She wrote him fifteen letters in a few months. As in her letters to Paul Strand, she revealed how she wanted to feel after their time together, using their correspondence as an outlet for her pent-up longings: "I wish so hotly to feel you hold me very tight— . . . All your being here was very perfect for me." As with Stieglitz, O'Keeffe felt a spiritual bond with Toomer and appreciated what must have been his incredibly gentle touch with women: "The center of you seems to me to be built with your mind—clear—beautiful—relentless—with a deep warm humanness that I think I can see and understand but have not—so maybe I neither see nor understand even tho I think I do—I understand enough to feel I do not wish to touch it unless I can accept it completely because it is so humanly beautiful. . . . I like knowing the feel of your maleness."

O'Keeffe wrote to Toomer that he gave her something that made her "more able to stand up alone—and I would like to be able to stand up alone before I put out my hand to any one. . . . I want you—sometimes terribly—but I like

it that I am quite apart from you. . . . I need it that way."
O'Keeffe recognized that her need for him was greater than
it would otherwise have been because she was cold and
lonely living at The Hill. She wanted to lie in the hot sun
and "be loved and laugh—and not think—be just a
woman—I rather imagine just a woman doesn't have to
think much—it is this dull business of being a person that
gets one out of shape." She advised him to find a woman
who was just a woman: "The sort of thing I am is of no use
to you." She concluded that she dreamt that he went to bed
with another woman: "I was neither surprised nor hurt."

After another prolonged rest in Bermuda for several
months, this time by herself, O'Keeffe returned to New York,
where she took a room of her own in the Shelton. She
discovered that Toomer had heeded her advice and found
a woman who was of use to him—her good friend Marjorie
Content. This relationship complicated matters. O'Keeffe
and Content had already made plans for the summer of
1934 to drive out to New Mexico together in her Model A
Ford and stay in an adobe at H & M Ranch in Alcalde—
which they did anyway, with Toomer joining them after
they were settled. Once again the artist found herself part
of an incestuous triangle, with herself the outside point. The
twice-divorced Marjorie Content was madly in love with
Toomer. O'Keeffe was in love with him, and she may have
been in love with Content, too. But O'Keeffe had no desire
to navigate around Marjorie and Jean as she had navigated
in previous summers around Mabel and Tony. She wrote to
Beck, "I must be someplace where the people do not run
me crazy."

It took about two hours to get from H & M Ranch to
Ghost Ranch—that is, if the road did not wash out in an
afternoon thunderstorm or if a herd of cattle was not block-
ing the way, both of which happened to O'Keeffe the first
summer. Having finally found the place, O'Keeffe returned
there to paint the next day. When she arrived, Pack had
good news for her. During the night one of the children of
a family staying for the summer had been rushed to the

hospital for an emergency appendectomy. Their place was now vacant. Was O'Keeffe still interested in a small adobe for the summer? O'Keeffe seized the opportunity like a hound on the scent of a hare. She moved into a small adobe redoubt known as Ghost Garden Cottage with a dirt floor and beehive fireplace. It was rustic. There were kerosene lamps for lighting. An outhouse and a pitcher and a bowl were the extent of the plumbing.

Ghost Ranch was as self-sufficient and isolated as the O'Keeffe farm in Sun Prairie had been. Using water from a spring in the hills, Arthur Pack irrigated a strip of land upon which he grew squash, corn, melons, and other produce. Meat was supplied by cattle and sheep raised on the land and slaughtered in one of the outbuildings. Since cattle and sheep people had been at war over grazing lands in this part of the West for some time and the help were cattle people, Pack found he had to get his wife to cook a leg of lamb. The cook would not even stay in the room when lamb was being prepared. Fresh trout came from nearby mountain streams. Mail came from Abiquiu in a wagon pulled by a team of horses. Telegraphs came forty miles on bad roads from Española. There was no telephone.

Arthur Pack, a quiet, conservative Christian who quoted from Scripture in everyday conversation, was not at all like O'Keeffe's previous New Mexico hosts. He did not keep an Indian for a spiritual guide. Rather, he employed Indians to clean up in the kitchen and complained about their inability to handle money. Nor had he read contraband copies of *Lady Chatterley's Lover* or *Ulysses*. When he wasn't studying the Bible, he spent his spare time reading articles in *Nature* and writing a book, an autobiographical account of life with an unearned income entitled *The Challenge of Leisure*. Pack had heard of Georgia O'Keeffe, but he was no more interested in her than he was in David Rockefeller, Robert Wood Johnson, Charles Lindbergh, or John Wayne, other guests of the ranch.

Ghost Ranch was nirvana to O'Keeffe. She walked for miles along dusty roads in battered Mexican *juarachi* sandals,

taking in the majesty of the place in a state of detached awe. She carefully "wished," in the observation of Henry McBride, this feeling onto the canvas of her best paintings over the years. Ghost Ranch reaffirmed her vision of the world as a place of brilliant light, fantastic form, and pure color. Over the next rise of a cliff or across a plain of sagebrush, there was a place of spiritual unity. It was out there, almost within reach. Like a person who has not been able to drink for some time, O'Keeffe soaked up the sunlight in Ghost Ranch, sitting for hours in the intense light of the high desert without a hat to shade her or sunglasses to block the rays. People were worried about the effects of the sun on her brain: "Georgia," Pack remembered people saying, "why don't you come in out of the heat."

Arthur Pack later remembered O'Keeffe for the kindness she had extended to him. Earlier in the year, his wife had left with their children to live in Santa Fe with the children's tutor, a handsome archaeologist from Princeton. Pack was so despondent, he had even begun to believe that Ghost Ranch was plagued by a curse. One day, O'Keeffe presented him with a crisp rendering of one of the cow skulls that was used to mark the entrance to the ranch. She told him he could do whatever he wished with the drawing. Pack adopted it as the insignia for Ghost Ranch letterhead. "She tried to be a friend," Pack later observed of the famous artist, who was not particularly noted for her generosity of spirit or for extending her friendship to people she did not know well.

O'Keeffe was not at all like the other guests at the ranch. Most of them were rich easterners, and some of them had chosen this remote vacation spot because they were afraid their children would be kidnapped, as Charles Lindbergh's baby had been a few years before. O'Keeffe did not dress like them, talk like them, or least of all, act like them. To people who drank martinis promptly at five, she appeared blunt and coarse and unsocialized. "We were all intrigued by Georgia," one of the women guests recalled; "there was something witchy about her. We thought she was a witch.

Those long dresses. And the bones. She was always carrying a bone with her. She seemed to know something we did not. Yes, everyone assumed she was a lesbian. Wasn't she? The husband was her business manager. Wasn't he? We never heard a thing about him. Not a word. We assumed it was a marriage of convenience." Like many other rich women who were attracted to the artist, this one seems to have viewed her as a stylish mystic, a situation that would only obscure the artist's true identity in years to come.

Having experienced in Taos the pain of being around people who were like her, however, O'Keeffe seems to have preferred being the odd duck in a flock of swans. At least these people would not expect anything of her, would leave her alone, and would allow her to go her own way by herself, painting what she wished and doing what she wanted. She may not have found her people, but she had found her place.

She called it "The Faraway."

Chapter 17

.

In the summer of 1940, having come to think of the U-shaped hacienda that Pack had given her to stay in the summers as her own, O'Keeffe was surprised to discover he had given it to someone else this time. She had arrived unexpectedly, without writing or phoning, driving out from New York in a new Buick convertible with a friend, "a piece of humanity" by the fantastic name of Narcissa Swift, who was an heir to a Chicago meatpacking fortune. It had not occurred to her that the Packs would give the house to anyone else. It suited her perfectly, mostly because it was isolated—about two miles from the main buildings at Ghost Ranch.

The hacienda, known as Rancho de los Burros after the herds of wild burros that grazed in the area, had enabled the artist to be self-contained for the first time in her life. With several bedrooms, the house contained a large open room with a wide plank pine floor and a huge stone fireplace for a studio. O'Keeffe housed a friend in a bedroom next to hers known as the companion's room—a succession of women occupied it. On occasion, with the help of a maid and a cook, she entertained guests from Taos and Santa Fe for lunches and dinners outside, under the shade of the covered portal. Jean Toomer and Marjorie Content visited in 1934. So did Beck Strand, who as the married wife of a wealthy and portly cattle rancher by the name of William James, had changed her name to Becky. From the patio, the hacienda enjoyed a magnificent view of the open plain and the flat-topped Pedernal. From the roof, which was reached

by a crude pole ladder up the side of the house, the wide world of New Mexico's spectacular desert came into full view. O'Keeffe could not live without it. "It is like a love affair one knows better than to try to be free of," the artist said of the hacienda, "—each time I come back to it . . . I think it more wonderful."

Because she was assertive and blunt, people often forgot that O'Keeffe spoke softly, in almost girlish tones, in a rich and distinctive voice that was not unpleasant to listen to. Arthur Pack had not heard from her in over a year, but as she called to him now, he knew her voice at once. She often left the hacienda without a word and then returned, expecting things to remain frozen as she had left them. Both Arthur and his second wife, Phoebe, had come to expect such behavior from her. And although Arthur acted at times as if she were an imposition on his time, Phoebe had grown to like Georgia enormously and accepted her for who she was. She had become not only her closest neighbor and landlady but her confidante. A handsome and direct woman who curled her hair in tight little ringlets in what was known as a Poodle-do and wore round tortoiseshell glasses, no makeup, and no jewelry, Phoebe had grown up in a family of naturalists in Oregon on a large farm in which her father had cultivated nearly every type of fruit tree known to man. She had married Arthur impulsively when they met at Ghost Ranch during the summer of 1935. Arthur and her father had been friends.

Phoebe never forgot her first meeting with the famous artist. "Georgia came up, and Arthur said, 'I want you to meet Miss O'Keeffe.' Georgia stood there looking at me with little wonder in her eyes. I, typical of me, I said, 'Hi, Georgia!' She was so surprised. I think I shocked her to death. She said, 'Hi, Phoebe.' She never called me anything after but that, and I called her nothing else. It was one of those things. . . . I think I surprised her out of her wits. Because I think what she expected was to see—I was twenty-nine— was to see a young girl come up and fall down in front of her, you know. Well, I didn't. I didn't fall down in front of

anybody, and I took her as a human being, just as she was. Well, she'd never been treated that way, apparently."

Phoebe respected the artist's courage and honesty, but she spoke to her in a tone that one generally reserves for problem children. In many ways, although Phoebe was young enough to be Georgia's daughter, it was Phoebe who mothered Georgia. Being the official hostess of a dude ranch that was summer home to people accustomed to solicitous care, Phoebe was mother to more than just Georgia. Georgia, however, became one of her closest friends and she relied on Phoebe for advice even as an old woman.

So when Georgia demanded to know why there was someone in her house, even though she had not contacted the Packs in advance to tell them she was coming, Phoebe said—after a long sigh meant to indicate that she did not feel she needed to explain what had happened—"We rented the house to someone else. After all, we didn't know you were coming. We can't just ask them to leave. It is not your house, you know. The house belongs to us."

"Why don't you sell it to me then?" O'Keeffe demanded. "I'll ask them to leave. Imagine! Someone in my house!"

During the years since O'Keeffe had discovered Ghost Ranch, she had focused her energy on moving west permanently. During some years in this period, she had arrived when the snow was still on the ground and left after the first snowfall. She began collecting as much money as she could from the highest bidders for her work to finance her Shangri-La, selling out to commercial enterprises, of which Stieglitz disapproved. She tried to devise ways to trick Stieglitz into moving out west with her. Alas, although he was not at all interested in the West, his bad heart gave him the excuse he needed to stay on The Hill and wave good-bye to his part-time wife. Deprived of sufficient oxygen, people with weak hearts often suffer fatally at six thousand feet above sea level, the average elevation of the area around Ghost Ranch. Had he even wanted to go west, his doctor would not have recommended it.

Going into their tenth year of separation, O'Keeffe none-

theless still found it hard to leave Stieglitz. His affair with Dorothy Norman had cooled down, and he was now alone. An old man in his mid-seventies, he wore heavy wool clothes even in the middle of the summer and complained constantly of drafts, of the decline of American standards, of Franklin Roosevelt—"A patrician dilettante"—of George Eastman and his mass-market cameras; and of artists—like his wife—who sold out and produced art for money. Sue Lowe recalled that Stieglitz also complained frequently of the "sexual inconsistencies of women," doubtless a reference to O'Keeffe's growing preference for women as sexual partners, as well as to the general increase in the number of open lesbian couples in New York circles. Around this time, a genteel southern woman who was visiting An American Place for the first time was shocked when Stieglitz asked her if she was a lesbian. She said she did not even know what the word meant, "but from the context I had an idea what he was driving at." Stieglitz spent increasingly large amounts of time inveighing against the world from the front porch of the farmhouse to an audience of little children. In 1937, through the Davidsons, Georgia met Swami Nikhilananda, a popular Hindu guru, who told her and Alfred that contentment in later life rests on the ability to disengage emotionally: "It was exactly what [Georgia] was trying to communicate to Alfred," observed Lowe.

O'Keeffe had already disengaged from Stieglitz. No longer was she a member of the avant-garde crowd of artists, writers, and mystics. Now she was a friend of the exclusive New York Social Register rich who vacationed in the West. David McAlpin, a grandnephew of John D. Rockefeller and an early supporter of the Sierra Club's efforts to save Yosemite, had abandoned his career as a stockbroker to establish the first department of photography at the Museum of Modern Art. Through McAlpin, O'Keeffe met Margaret Bok, a ravishingly beautiful Philadelphia socialite who had recently been divorced from Edward Bok, heir to a publishing fortune. Peggy Bok, whose shoulder-length blond hair, smooth skin, delicate features, and tinkling, easy laughter made her an object

of admiration to those who were near her, became one of Georgia's closest friends.

In the summer of 1935, O'Keeffe invited Peggy Bok and her three children to spend part of the summer with her in her house at Ghost Ranch. The Bok children became a part of the small group of children whom the artist let into her world. It was a testament to her affection for Peggy that she allowed her children to visit at all. "Georgia liked children," remarked a friend, "if they could go home after she was done with them." She became particularly close to young Derek, who would one day become president of Harvard. Henwar Rodakiewicsz, who had been divorced from Georgia's former landlady, Marie Garland, fell in love with Peggy Bok on first sight. Henwar and Peggy were married in New Mexico that summer. Georgia held a small reception for the couple at Rancho de los Burros. Although Phoebe Pack maintained that Georgia did not have any real friends, she observed over the years that she was particularly close to Peggy Bok: "I think you could say that she and Peggy were friends, although there was a gap of more than twenty years between them." Peggy said she and Georgia "clicked" on first meeting.

In April 1936, O'Keeffe received a commission from Elizabeth Arden to paint a mural of flower blooms for her Fifth Avenue New York salon. Arden, a fashionable taste-maker, operated a beauty salon for the richest and most fashionable women in the world. Georgia probably met Elizabeth through her sister Anita, whose social-climbing feats would soon include a friendship with the Duke and Duchess of Windsor. Arden knew exactly what she wanted when she approached the artist with the concept for the mural: flowers in full bloom, as the customers of her salon were to feel after their makeovers were completed. She had already purchased an O'Keeffe painting of an orchid for her home. For the mural, money was no object. She paid the ten-thousand-dollar asking price without question, at a time when most of the artists in Stieglitz's circle were lucky to get a thousand dollars from a sale. Stieglitz had probably set the high price, as he said he did in the past, to discourage philistines.

Painting a mural in a prominent location was a plum assignment for the competitive artist, having failed to complete the mural for Radio City in 1933. She selected a design of jimsonweed blooms for the salon, convincing the beauty magnate that although they were called weeds, they were incredibly beautiful when they bloomed at night in the deserts of the Southwest. "When I think of the delicate fragrance of the [jimsonweed] flowers," O'Keeffe said, "I almost feel the coolness and sweetness of the evening." She did not know it at the time, but jimsonweed flowers are similar to night-blooming cereus, which are deadly poison when ingested in large quantities and hallucinogenic when taken in small quantities, as the Yaqui Indians in Mexico do for ceremonial rituals. To those who recognized the similarity, it was ironic to see what looked like poisonous flowers decorating a beauty salon. "The flowers," the artist remarked poetically, "die in the heat of the day."

O'Keeffe even allowed herself to be made over by Arden. The artist was one of the rare people in New York in 1936 who were able to enjoy a rich material life in the depths of the Depression. O'Keeffe was concerned about those who suffered during the economic downturn, many of whom—like Arthur Dove and John Marin—were artists, and she attempted to help them. But she herself actually prospered during the thirties, as did most of her friends. Which does not mean she wanted to look prosperous. The artist refused to go anywhere with her new makeover until she inspected it in her own mirror in the privacy of her room at the Shelton. When she saw what she looked like with a Betty Grable hairdo and a painted face, she washed them down the drain. She never wore makeup again. The only piece of jewelry the artist wore with regularity was a brooch Alexander Calder had cast in brass with the letters O.K. A writer at this time observed that O'Keeffe's appearance had reached a stage where it had to be called "aboriginal."

When O'Keeffe and Stieglitz arrived the following night at Arden's Fifth Avenue mansion for a party celebrating the completion of the mural, they were dressed as they had

dressed for two decades. But in the late 1930s New York high society of shoulderless evening dresses and white tie and tails, they seemed like extras from a historical drama. O'Keeffe wore her trademark long black silk dress, no makeup, no jewelry, hair trained into a bun on the nape of her neck; Stieglitz wore a porkpie hat and a black loden cape. As the elegant hostess greeted her artist friends in her white marble town house—one wall of which was covered with white peacock feathers—the butler looked disapprovingly at Stieglitz's cape and hat. "Sorry," the once-impeccable dandy said sheepishly, "it is all I own." For a long time, the memory of the evening stayed with O'Keeffe, who admired the control Arden exerted over others. "She was the queen of all those people. Wherever she settled down, the others moved in behind her."

In New Mexico, O'Keeffe was the queen of a group of people as well, as she had been as a girl in Wisconsin and at Chatham. Her consorts now were rich and beautiful young women. In addition to Peggy Bok—who maintained a special place in the artist's inner circle because she was also close to Stieglitz at this time as well—O'Keeffe befriended a few of the women who came to stay at Ghost Ranch and their friends. For one, in the summer of 1936, she met Margaret (Maggie) Johnson, wife of Robert Wood Johnson, the enormously rich chairman of the board and principal heir, with his brother Seward, of the Johnson & Johnson pharmaceutical fortune. Maggie Johnson was an exuberant and attractive woman who had worked modeling clothes at Bergdorf Goodman and as an assistant to photographer Edward Weston before marrying Johnson. She and Bob shared a large New York apartment and a horse farm outside Princeton, New Jersey. Maggie Johnson had not been born rich. She enjoyed all the trappings of the life into which she had come like someone who had not known things could be so grand—with childlike enthusiasm, as well as spoiled petulance. She and O'Keeffe became great friends, and O'Keeffe took her side in the epic battles she and Bob had during the summer in New Mexico. Bob was a hard-drinking fox

hunter and champion sailboat racer who had met his match in Maggie. Once at Ghost Ranch during an altercation with Bob, Maggie knocked a martini glass out of Phoebe's hand and sent it flying across the room.

Georgia took Maggie with her on painting trips into the desert, a privilege only a few of her closest friends enjoyed. Phoebe noticed that Maggie spent her spare time at Georgia's, while Georgia never entered the house Bob had built on the grounds of Ghost Ranch. When Phoebe asked her friend why, Georgia replied matter-of-factly that she "hated Bob." Georgia's friendship with Maggie puzzled Phoebe. "Georgia was apt to pick up someone who was . . . there was nothing unique about Maggie . . . the daughter of a barge captain with a grammar school education. Maggie couldn't talk with her. They had no communication whatsoever." Phoebe Pack suggested that Georgia's interest in Maggie was probably visceral.

Stieglitz wanted nothing to do with either Maggie or Bob Johnson. In New York, when the rich couple went to An American Place to see him about buying an O'Keeffe flower painting, he made sport out of them, as he often did with bourgeois couples who tried to buy art as if it were just another tangible commodity. Being spiritually motivated himself, he was deeply offended by the crass materialism that some people applied to artworks. To photographer Eliot Porter, Stieglitz later explained, "I make no attempt to sell anything at all at the Place, but do let people acquire some things if they should want anything. The distinction is not understood." Maggie Johnson knew what she wanted when she and her husband came to An American Place that day: a painting of a morning glory for her bedroom at the ranch. O'Keeffe had already painted one and named it for her new friend.

Acting clairvoyant when he was probably relying on information Georgia had passed to him, Alfred placed Bob in a chair facing a lightfilled window. "I know what you and your wife want more than anything else in the world," he began softly, as if receiving messages from the other world.

"You want a baby! You cannot have one—I know these
things. But you can have an O'Keeffe painting. For this, you
will give her two years of creative life, which will need fifteen
thousand dollars." Fifteen thousand dollars was more than
double the usual price for an O'Keeffe, and although it was
not an inaccessible figure for someone as rich as Johnson,
it was more than others paid for similar paintings. Johnson
did not want to be conned. Later, he wrote back to say that
he and Maggie had decided to adopt a child instead of buying
an O'Keeffe painting.

O'Keeffe, for her part, could be as difficult as Stieglitz.
In the summer of 1937, she had planned a camping trip to
Indian country with Ansel Adams, David McAlpin, and Or-
ville Cox, a wrangler at Ghost Ranch. Adams had become
a name in western scene art; O'Keeffe had met him in Taos
in 1929, and Stieglitz had exhibited his penetrating land-
scapes in 1936 at An American Place. McAlpin had organized
a hallmark exhibition of photography at the Museum of
Modern Art that year. That David McAlpin was an important
figure in the art world did not impress O'Keeffe. She felt he
had made the mistake of failing to consult her first when
he invited a woman friend to accompany them on their
camping trip.

Phoebe Pack remembers the incident vividly: "I couldn't
figure what in the world was the matter at first. But it was
obvious that Georgia was simply fit to be tied about some-
thing. And it came right out, and she started right in on
David McAlpin. I thought Georgia would blow up. She
ripped him up one side and down the other. 'Why did you
dare ask anyone to go on this trip without asking me first?
And of all things on earth, another woman? And I don't like
her and she has no brains.' I had seen her mad once or twice
before, but not that mad. I thought there was a delicious
vindictiveness that ran all through the thing. She could say
anything bad about that woman, and about Dave for asking
her."

The group nonetheless set out in a caravan of wood-
paneled station wagons for the Navajo and Hopi country in

Arizona and Colorado. One day, while he was out walking on a barren mesa, Adams came across O'Keeffe mugging with Cox. Fortunately, he had brought his camera, and the pictures he took captured the usually stonefaced artist smiling coyly at the young guide. For this reason, the portrait of Georgia O'Keeffe and Orville Cox remains a unique document of a softer side of the artist. Adams later remarked, when asked about the portrait, "When Georgia O'Keeffe smiled, the entire earth cracked open." Because of her smile, people thought perhaps she and Cox were lovers—a notion Phoebe Pack, who believes Georgia was only interested in women sexually, firmly dismisses.

Stieglitz stopped taking photographs in 1937 altogether. He no longer had the motivation. The Place was his only consolation. He spent hours each day in the gallery, taking a nap on a cot next to a vault where he kept only O'Keeffe's paintings. Occasionally, he still got excited by the work he showed in his gallery. Writer Henry Miller remembered going in one day to find Stieglitz, "an old man with a bad cough," enraptured by the work of John Marin. He insisted that Miller go to New Jersey to meet the artist. Miller was a regular at exhibitions at An American Place. Like Stieglitz, the writer found inspiration for his work in complex sexual arrangements, including with his bisexual wife, June Smith. Henry Miller had taken up painting at this time in his life.

Henry Miller considered O'Keeffe's work to be possibly the only contemporary American art of value, so he was surprised to find that Stieglitz did not particularly share his enthusiasm for her work. Stieglitz did not need to be excited about O'Keeffe's work. It sold itself, and it had done so for some time, as he admitted to those who asked about it. In the winter of 1938, he exhibited O'Keeffe paintings of grievously decayed bones floating in a southwestern landscape, and tiny paintings of shells, and one particularly fine little still life of a shark's egg case. The paintings were displayed elegantly in narrow silver and copper-leaf frames. She included in the catalogue a selection of letters she had written from the desert to Stieglitz, telling Arthur Dove jokingly that

she had done so because "so many thought . . . I couldnt read or write at all—." The following year, she wrote in the catalogue again, defending her choice of desert subjects. "A red hill," she wrote, explaining her landscapes of barren red hills found around Ghost Ranch, "doesn't touch everyone's heart as it does mine and I suppose there's no reason why it should."

In April 1938, Stieglitz was stricken by a serious heart attack. He was recovering from it when, to make matters worse, he came down with a bad case of pneumonia. He convalesced through July. Instead of going to Lake George, he remained in New York, sleeping during the day on the terrace wrapped in Indian blankets in the middle of a summer heat wave. He stopped taking photographs altogether and would not resume again for the rest of his life. O'Keeffe proceeded as if she did not have a sick husband. She left New York at the end of May for Williamsburg, her first trip to what had once been her home in years—the scene of the dank cement-block house and her parents' travails. As Ida and Claudia O'Keeffe and Anita O'Keeffe Young looked on, Georgia received an honorary degree from the College of William and Mary. Wearing a plain skirt, a blouse, and simple flat shoes, she refused to give a speech. The honorary degree was an occasion for a reunion of the sisters and for viewing the Rockefeller restoration of the colonial capital in which the women had grown up. Williamsburg had been restored to its eighteenth-century splendor, although the memory of what it had been like when the O'Keeffes lived there seems to have disturbed Georgia. "She seemed strangely hostile to the honor," recalled one official of the university, "and not moved by it. She seemed to be in some other world."

After she left New York, Stieglitz remained home in the penthouse apartment that O'Keeffe had rented in 1936. Although the penthouse at 405 East Fifty-fourth Street enjoyed a panoramic view of the East River and Queensboro Bridge, Stieglitz hated it and called it "O'Keeffe's apartment." He said it was inconvenient, and he missed the hustle and bustle

of the Shelton, from which he could walk to An American Place, to restaurants, and to movie theaters. Living in the new apartment meant taking cabs, which were expensive, as the apartment itself was. He also found it drafty and cold. He began wearing both an overcoat and a cape indoors. At first he refused to go onto the terrace—which was bordered by a privet hedge and a white picket fence—out of fear he would fall off. O'Keeffe bore his complaints with resolute silence. She did not argue, nor did she ever remind him that she was paying for both the cabs and the apartment. Nineteen thirty-seven was the first year O'Keeffe was listed in the Manhattan telephone directory. She turned fifty in November of that year.

Four-oh-five East Fifty-fourth Street was what was known as a "show business" building, which meant that the owners rented apartments to entertainers and artists—often known homosexuals; Noël Coward, Hermione Gingold, and Lotte Lenya were residents. Many New York apartment houses, particularly on the East Side, tended to prohibit "show business" people, who were not viewed as good neighbors. O'Keeffe and Stieglitz were "show business" people, as their photograph in a 1938 issue of *Life* attested. Under the caption "Artists Look Like This," Stieglitz stood frozen in his loden cape while O'Keeffe looked stolid in all black. The Saturday-night Chinese restaurant group having disbanded as Stieglitz's artists drifted away, he and O'Keeffe entertained new groups at home on Saturday nights. She laid out a spread of imported cheeses and bread and fruit on a table made from a sealed plywood board on a sawhorse. Among her friends who came on Saturdays were Frances Farmer and Zelda Fitzgerald, both of whom, like O'Keeffe, had been institutionalized for psychoneurotic conditions. Zelda, herself a painter as well as a writer, used to leave the sanatorium to which she had been committed by her husband, F. Scott Fitzgerald, to see O'Keeffe's exhibitions: "I loved the rhythmic white trees winding in visceral choreography about the deeper green ones," she wrote of the O'Keeffe paintings. "And I loved the voluptuous columnar tree trunk

with a very pathetic blue flame-shaped flower growing arbitrarily beneath it . . . the cosmic oysters. . . . [The pictures] are magnificent and excited me so that I felt quite sick afterwards."

In February 1939, an advertising company that represented the Dole Pineapple Company commissioned O'Keeffe to paint a pineapple flower. Stieglitz was opposed to the N. W. Ayers assignment, but O'Keeffe overruled him again. The commission included an extended trip to Hawaii, courtesy of the pineapple company. O'Keeffe wanted to travel to exotic and warm places during cold weather. For several winters she had enjoyed Bermuda, and in the winter of 1937 she had spent a few weeks with her sister Anita and her husband at their mansion in Palm Beach, Florida. Having amassed a fortune in the stock market crash of 1929 by selling short and trading in worthless paper, Robert Young had quickly become one of the richest men in America. In addition to their large Park Avenue apartment, the Youngs maintained a mansion in Palm Beach and a large estate, Fairholme, in Newport, Rhode Island. Anita, herself a licensed stockbroker in New York City, assisted her cunning husband. The Youngs also collected Georgia's flower paintings. Anita eventually decorated a part of her Palm Beach house by extending the flower theme to cover the drapes, the upholstery, and even the accessories. O'Keeffe, however, found her sister's life too elegant. After returning from her 1937 visit to Palm Beach, she told Phoebe Pack that she would not go back to visit: "never again. Never again. I can't live the way she does." The Youngs dressed for dinner and ate seven-course meals with footmen in attendance. Their daughter Eleanor, known as Cookie, was debutante of the year in New York in 1938.

O'Keeffe enjoyed Hawaii more than any other tropical place she had visited. Looking back a few years later, she remembered the "soft fuzz on Diamond Head—and the big green leaves—and feel the soft warm air on your face—particularly when you look up into the palms at night—or the ocean seems high in the air—." She traveled from island

to island and stayed in first-class accommodations, compliments of Dole. With a new friend, Richard Pritzlaff, whom she had met at the elegant Kona Inn, she visited plantation owners on the then-remote island of Maui. A wealthy, eccentric Arabian horse breeder from Milwaukee, Pritzlaff had settled in a ranch on the verdant eastern slope of New Mexico's Sangre de Cristo Mountains, about two hours' drive from Ghost Ranch. Pritzlaff introduced O'Keeffe to a side of Hawaiian life she would not otherwise have known—he had gotten to know the local gentry over the years he had been traveling to the islands.

O'Keeffe returned to New York from Hawaii energized by the natural beauty of the islands. She recalled seething volcanoes and lush fields of sugar cane—"bare lava land more wicked than the desert—." A few weeks after she returned, however, the piper came to call: Representatives from Dole arrived to collect the pineapple flower she had been commissioned to draw. O'Keeffe had failed to complete her commission—in fact, she had not even begun it. Dole then ordered a pineapple in full bloom to be shipped to 405 East Fifty-fourth via overnight air express. When it arrived, O'Keeffe drew what she felt about the flower and remarked that she was surprised by its beauty. Unfortunately for consumers of canned pineapple, who would have benefited from such beauty in the market, O'Keeffe's pineapple drawings were not used for the labels. Many of her Hawaiian paintings were included in her next exhibit at An American Place, however, and two were subsequently purchased by Dole.

O'Keeffe was riding high. There was no limit to the value of her commissions, and she was receiving the honors society reserves for great figures and personalities. She designed a bowl with a jimsonweed etched on the bottom for Steuben glass. She received a high fee for this and was seriously considering other commercial art jobs when Stieglitz intervened. The art impresario reminded his famous wife that she was jeopardizing her place as a serious artist, whose work was written about and studied by scholars, when she

accepted such jobs. Her place, he reminded her, was behind an easel painting from her soul—not for her purse.

In April 1939, O'Keeffe was selected by the New York World's Fair commission as one of twelve outstanding women of the past fifty years, along with Helen Keller and Eleanor Roosevelt. The honor seems to have gone to her head. A month later, she collapsed from the strain of another nervous breakdown. She told people, "As far as I can make out there isn't much the matter with me except that I was tired and had been too tired too long—." Because the doctors felt an increase in altitude would not help her condition, O'Keeffe did not go to New Mexico until late in the summer. (Although some accounts place her in New York all summer, her niece Catherine Klenert Krueger, who visited her in New Mexico in late summer 1939, insists that she was in New Mexico by the end of the summer.) She remained on the terrace of her apartment, venturing in midsummer to Lake George with Stieglitz. There she draped the furniture with Indian blankets and decorated the shelves with rocks and bones, in an effort to create the look of New Mexico. When some new friends of Stieglitz's visited the couple, O'Keeffe appeared cold and dictatorial. The group decided to visit the World's Fair, but when one man said he wanted to bring his wife along, O'Keeffe told him not to bother. She wanted to be the only woman. But this time she did not get her way, and the man, Beaumont Newhall, did bring his wife, Nancy, along when they made the trip. Newhall was David McAlpin's protégé at the Museum of Modern Art. He never forgot how poorly O'Keeffe treated both him and Nancy on that trip. When he later attempted to write a biography of Stieglitz—whom he had gotten to know quite well during the years O'Keeffe was away in New Mexico—O'Keeffe blocked his efforts: "You," she said, "did not know him."

Georgia contacted her sister Catherine Klenert around this time and ended the freeze that she had initiated after Catherine exhibited her work in New York in 1933. Georgia invited Catherine and her daughter, Catherine, Jr., to New Mexico for a visit during the summer of 1939. Catherine,

Jr., who was sixteen, came by herself. Georgia had never been what might be called a dutiful aunt. She consistently forgot her three nieces and one nephew on their birthdays, at Christmas, and on other holidays that an aunt, particularly a childless one, might have remembered. Now she attempted to forge communication between herself and Catherine, Jr. A conservative Catholic girl from Portage, Wisconsin, who wore a large cross around her neck and plain sweaters and skirts, Catherine, Jr., was a shy young woman. She was upset when her aunt yelled at her for driving on the grass but pleasantly surprised to find that life in New Mexico differed from life in Wisconsin. Georgia instructed her niece matter-of-factly to take off all her clothes and sunbathe nude the first day she was in New Mexico. At night, they slept on the roof in sleeping bags. Catherine, Jr., treasured her memory of the trip the rest of her life: "You know the air is so clear down there, and in summertime the stars are beautiful at night. . . . It's like you could almost reach up and grab one."

According to Catherine, Georgia drove at ninety miles an hour in her car, and whenever Catherine took over the driving, Georgia told her to go faster, to stay on the road, to look out for that rock. They drove along the Rio Grande to Taos, where they stayed overnight with Becky James and her husband, Bill. They visited Frieda Lawrence and her new husband, Angelino Ravagli, as well as Dorothy Brett. "I had no idea *who* these people were," Catherine recalled years later. She was wide-eyed and easily impressed. On one occasion, she was embarrassed by her own provincialism. "I never realized, I'd never been told that Stieglitz was Jewish. Now, I come from a small town, Portage, where there is, I think, one Jewish family. And I'm sure they were lovely people, but they were kind of looked down on. And I never knew he was Jewish, and I made some comment about Jewish people, and she said, 'Well, Stieglitz is Jewish.' I was so embarrassed. But I'd never been told, and of course I had strange feelings about Jewish people. Now I think they're great."

In spring 1940, Georgia went to Nassau with Maggie and Bob Johnson for a month-long sailing trip. When the trip was over, she stayed on in exclusive Paradise Isle with the Johnsons, who introduced her to Seward Johnson, Bob's eccentric younger brother. Seward spent the majority of his life sailing around the world, while his second wife, Esther (née Underwood), waited at home for him to return from his trips. Esther, one of three beautiful sisters from a conservative old Boston family, became one of Georgia's closest friends. Small and elegant, Esther wore suits tailored in a military style by Mr. John, flat Belgian loafers, hats by Lily Dache, and no makeup. During the sixties, she drove a Bentley convertible.

Like Georgia, Esther believed in walking great distances and eating fresh foods that she had grown herself on her own property. At home in Oldwick, New Jersey, Esther walked for hours around her three-thousand-acre Cedar Lane Farm in a pair of old Keds sneakers. She and Seward bred prize-winning Holsteins from two herds—"Milk" and "Honey." A voracious reader whose library included first editions of Joyce as well as the complete works of Proust, Esther once confessed that she could not comprehend the greatness of Norman Mailer. In the Bahamas, when she and Georgia first met, Esther wore large straw hats and big sunglasses—which, in 1940, looked "so glamorous," according to her daughter, Jennifer Duke. The two women walked for miles on the open beaches of the then-private island. (This was before gambling was introduced and Nassau was popularized.)

"Mom used to say that she would meet Georgia," recalls Duke, "and they would go on these really long walks, and then, that they really liked each other. And they felt like they had something in common. And then they would say to each other after they did . . . I don't know what they did there but . . . they would say, 'Well, now we've done that.' I don't know. That just seemed funny. I think what they had in common was that neither of them wanted to be poor, but they didn't want to live like millionaires. They wanted

that lovely life where things look so simple, but perhaps they aren't. I think they both have that."

By the time O'Keeffe returned to Ghost Ranch in June 1940, she was ready for that lovely life. As she entered her sixth decade, she was only beginning to learn how to live. Having been sick so frequently, she had slowly learned what she needed to keep herself from going over the edge one more time. What she needed was the company of a good friend who would not make serious demands on her; sunshine; quiet; and days with long walks both at the beginning and at the end. She needed Ghost Ranch, "—a dry open space all by myself—." So when she learned that the Packs had rented her house to someone else that summer, small wonder that she panicked and convinced them to move the others out so she could have her house.

O'Keeffe was just beginning to enjoy the life she had found in New Mexico: the long walks into the sunset, the camping trips into Indian country, the bones and rocks and petrified wood she found. Becoming one with the land and being confused for a native New Mexican because she was tanned and garbed in loose garments—this was what the artist sought in her mystical splendor, fixing the image of Georgia O'Keeffe in many minds. "A lot of people would say," Phoebe Pack recalls, " 'is she Indian?' And she looked like one." Stieglitz was increasingly becoming a burden for her; she had already found a new world for herself that did not include him. "I see Alfred as an old man that I am very fond of—," she wrote Henry McBride, "growing older—."

Chapter 18

.

On a clear, warm, starlit spring night, May 15, 1946, O'Keeffe stood in the sculpture garden of the Museum of Modern Art in New York in the distinguished company of Picasso's *Shebang*. It was one of the few times she had appeared at an exhibition of her own work, and she did so without Stieglitz. Stieglitz was at home, a few blocks away—too weak to go out at night, he told people, even to a celebration of the first woman artist to be honored with a major showing at the museum. While the other women milled about in the sculpture garden wearing off-the-shoulder evening dresses, O'Keeffe, who said she did not believe in occasions that required new clothes, appeared in the long black silk dress she had worn so often over the years—giving her the look of a nineteenth-century-style eccentric who studied flowers, skyscrapers, and bones with a twentieth-century eye. Henry McBride compared her success to a Broadway star's: "O'Keeffe's name is up in lights!"

The retrospective was a hollow victory for the artist, however. Instead of heralding the pinnacle of her success, the show of fifty-seven of her artworks spanning thirty years actually heralded her downfall. For months before the exhibition, Stieglitz had pleaded with her to cancel the show. He felt the museum had become compromised by Rockefeller money, and he disapproved of its policies and direction. None of his objections swayed her. She went ahead with the show, over the protests of her elderly patron, husband, and friend. But in a way, Stieglitz was right. The direction of modern art had shifted during the war. Even

the terminology had changed: Instead of *modern*, the word used to refer to new art would become *contemporary*. Rejecting the intuitive approach to art that O'Keeffe had developed over a lifetime of work, the new art favored a cool, rational, and scientific approach. It was as different as night from day. O'Keeffe's mystical work was deemed as out of step with the times as a medieval manuscript. Writing in *The Nation,* Clement Greenberg, a leading critic of the new abstract art movement that would grow in popularity over the next thirty years, denounced her achievement categorically: "Her art," he declared, "has very little inherent value." In a reference to its mystical content, he compared it to objects of "private worship," and, referring to its homoeroticism, he said that the result was the "embellishment of private fetishes with secret and arbitrary meanings." Greenberg was particularly upset by the mystical content of her work. Because the underpinnings of Nazism were mystical, many intellectuals at this time rejected the study of inexplicable phenomena in favor of those that can be explained.

The day before she left for New Mexico in June 1946, O'Keeffe escorted Stieglitz through the exhibition. At eighty-two, Stieglitz was still overwhelmingly proprietary toward O'Keeffe's work. He had fired off a missive to Greenberg the day after his scathing review appeared in *The Nation.* Seeing O'Keeffe's works in the beautiful, glass-walled modern museum, nonetheless, brought him a burst of pride. Even though he despised the policies of the place (and was upset that the museum had not bought an O'Keeffe, as he insisted, or allowed her to oversee the hanging of the exhibition), he was moved by the work he felt he had nurtured over the years. "Oh, Georgia—," he wrote, "—we are a team—yes, a team." She received this letter, along with three others, including one in which he lamented her departure, when she arrived in New Mexico a few days later. "Can't believe you are to leave," he continued, "and that you are reading this in your country."

It had been her country since October 30, 1940, when she had given Arthur Pack a check for $2,500 (although

other accounts report the sum as $6,000, Phoebe Pack said it was $2,500) drawn on her own account at Banker's Trust on Water Street in New York. They drove up the hill on a dirt road to the tiny Rio Arriba County Courthouse in Tierra Amarilla and recorded the transaction. But for most of the summer it was assumed that the house was already O'Keeffe's. It was more than a sale; in some ways, it was a truce. The Packs had agreed to everything Georgia requested of them, freeing her to live in peace two miles down a private road from the main buildings of Ghost Ranch, agreeing to steer people away from her—telling them, "*No*—they cannot see her or meet her." The only thing they requested of O'Keeffe in return was that she stop raiding their vegetable garden. Phoebe Pack recalls that Georgia had an annoying habit of taking the only ripe cantaloupe or all the ripe lettuce, as if the garden were hers.

What O'Keeffe missed in her new house was a vegetable garden. Although the Packs gave her leftover produce after they had fed their guests, she wanted her own supply of fresh greens and vegetables. Often the heads of lettuce she purchased in Española were wilted and brown by the time she got home after driving an hour and a half through the summer heat of the desert. For Georgia, growing her own food in summer was a part of the rhythm of her life, having been raised on a farm in Wisconsin and having spent her summers tending a garden at Lake George. The water from the deep well operated by an electric pump that supplied the house would not have sustained the daily irrigation required of gardens in the desert. (The Packs' water came from a mountain spring.) What was more, the soil was sandy and inhospitable to anything but sagebrush, cactus, piñon, Indian paintbrush, and other hearty plants.

The desert terrain may not have been hospitable to lettuce or melons, but it was to O'Keeffe, who regained her health and her composure there in the summer of 1940. She wrote glowingly to Richard Pritzlaff, the friend she had made in Hawaii in 1938, that she had never felt better in her life. She spoke of long walks into the sunset and of rare beefsteak

cooked over the stone fireplace in the great room, and sleep-
ing under the stars on the flat-topped roof in a dark green
army surplus sleeping bag. She gained weight. She drank
Tiger's Milk, took vitamins C and B, exercised her eyes using
the Bates method, and each morning followed a regime
prescribed by Ida Rolf, a pioneer in the field of body work.
The summers of gloom, the breakdowns, the pressures of
the marketplace, her barren beginnings—all vanished like
yesterday's news. She had learned to live in the moment, to
live for the way the sun hit a rock on her patio at a certain
time of the day in a certain time of the year, casting a long
deep shadow, a shadow only found in the clear air of the
high desert. Day after day during her first summer as mistress
of four acres of badland, the sun beat down on her with a
healing power unmatched by anything else in her life.

Her paintings had become quiet meditations on bleached
white pelvis bones held up against a deep blue sky, a stark
contrast of white and blue that appealed to the Surrealists.
Although she was never aligned with that movement, one
of her pelvis paintings found its way to the cover of *View*,
a journal of Surrealism. The big events of her life were
ordinary and domestic. She told Pritzlaff that her only con-
nection with the outside world came from a three-week-old
issue of *Time* that the girl who took care of her brought
from the post office in Abiquiu. Pritzlaff gave her a kitten,
which she took on walks into the badlands. She said the
cat "trotted along the road like a dog."

O'Keeffe did not operate her world by herself. She enlisted
the help of a Spanish-speaking maid from a local family, a
cook who learned that her employer's tastes were more
refined than others', and a companion, a horsewoman by
the name of Maria Chabot. Chabot was a big-boned, earthy,
Chaucerian woman with close-cropped hair (one acquain-
tance uncharitably said her hairdo looked as if she cut it
with a blunt knife) who was originally from Texas. Before
she came to live with O'Keeffe, she had lived with Mary
Cabot Wheelwright at Los Luceros, a ranch in Alcalde near
H & M Ranch. Arthur Pack was under the impression that

Chabot had been Wheelwright's housekeeper, but she adamantly insists that she was not. She had been staying with Wheelwright, a patron of Indian arts who had once supported the hermaphrodite witch doctor Hosteen Klah, while she completed a study of Indians for the Indian Association. Self-taught, enterprising, and deeply spiritual, Chabot felt such deep affection for O'Keeffe that decades later she was still stinging from the treatment she ultimately received from her. After ten minutes of conversation, it appeared that Maria was describing a very deep relationship with the artist. When I asked her if they had been lovers, she responded angrily by calling the question "stinking" and the topic "disgusting."

One day, Pritzlaff had suffered through an uncomfortable lunch at the ranch because Maria was rude to him. The artist later explained Chabot's role in her life. She said Maria was always odd about the food when anyone came. It was as if she could only cook for the two of them. Maria was only there doing things for her because she liked Georgia and liked Ghost Ranch. "She is a great girl," O'Keeffe told Pritzlaff, "so healthy that I believe it is contagious for me, as I am feeling unusually fine." O'Keeffe painted a flower, a penstemon, for her new companion and titled it *Maria Goes to a Party*. When I asked Chabot what had prompted O'Keeffe to paint a flower for her, she again responded angrily that it was private information and she would not tell me.

Chabot had good reason to be touchy on the subject of O'Keeffe. O'Keeffe once referred to Chabot, when speaking to Pritzlaff, as her "slave." Another friend observed that Maria was the only person who could boss Georgia around. The relationship the two women enjoyed was as deep as any relationship the artist would ever have during her lifetime. When a male friend drove for hours during the gas-starved war era to visit Maria, Georgia turned the friend away and told Maria that she could not have guests. Maria told people that she did not work for Georgia, although she admitted that she got her spending money from the food allowance Georgia gave her. Maria did the food shopping for the two

women. Over the next ten years, Georgia would periodically let Maria go, only to ask her back.

Around this time, O'Keeffe began to appear brusque herself. Once more her admirable attempts to assert the way she felt became aggressive, as they had over the years, beginning in Canyon when she had said she "made hash" of the faculty. It is possible that she admired in Chabot the very qualities that others found hard to bear. Once at the main house in Ghost Ranch, a guest approached O'Keeffe and attempted to introduce her to a friend from the East. The friend was an artist, too. O'Keeffe scowled. First she looked at one of the women. Then she looked at the other woman. "You," she said calmly, with a detectable undercurrent of irritation, "are bothering me." After overhearing such exchanges, Phoebe Pack warned her guests about O'Keeffe before she attacked them like an untrained dog. "I had to stay right there and see that she didn't kill someone. She hated strangers." On the southern edge of Ghost Ranch was another ranch owned by a family from Chicago. Because they were her only neighbors, O'Keeffe visited them once with the Packs. When they invited O'Keeffe to "come back any time," she scowled at them, too. "I wouldn't dream," the artist said grandiloquently, "of visiting people I don't know."

Although O'Keeffe went camping with Orville Cox and some of the other cowboys on the ranch, it was Chabot who really made her camping life possible. Chabot loaded the car, drove to the campsite, set up camp, and cooked, while O'Keeffe was responsible only for her Siamese cat and her art equipment. The two women drove into the badland to the north of Ghost Ranch, where on the other side of Navajo country they discovered the Black Place. The Black Place, to which O'Keeffe would return over and over for inspiration, was a barren section of black lava deposits in rows of hills, the debris from a volcanic eruption. O'Keeffe wrote about the mounds in her autobiography, comparing the way the hills looked to "a mile of elephants." She and Chabot camped in the barren hills under a lone cedar tree. Chabot

taught O'Keeffe to warm her place for the night in the cool desert by keeping a fire going all day over where she wanted to sleep, then dousing it at night, so that when the temperature dropped after the sun went down, the ground under her bed stayed warm. O'Keeffe and Chabot cooked venison over an open cedar fire, holding a piece of meat wrapped in bacon on a long-handled toaster. They sat on rush children's chairs that Chabot had purchased for the trip. At night, the women hung the leftover venison from a tree by a rope so that bears would not get it. Chabot read aloud from *Taras Bulba* and *Siddhartha*, Hermann Hesse's story of the life of Buddha. O'Keeffe had enjoyed having people read to her, ever since she was a little girl and her mother had read aloud from *The Leatherstocking Tales* and *The Life of Billy the Kid*.

On one trip, the weather turned on them, as it is apt to do in the high desert. They awoke during the night to mayhem: wind had ripped the tent from its stakes, collapsing it on one side; rain was coming down in sheets. O'Keeffe moved her cat to the safety of the car. It was scary. A part of the tent had collapsed on her head. In the morning, the wind blew the coffee right out of their cups. O'Keeffe and Chabot drove more than a hundred miles home in the rain, slipping and sliding from stern to bow on the wet road. But O'Keeffe was not to be deterred. She would return to the Black Place many times over the years, using its bleak landscape for several paintings. Once something inspired her, it remained an inspiration forever. For her, it was "such a beautiful, untouched, lonely-feeling place—."

Midway through the summer of 1940, after Chabot had left after a spat, O'Keeffe noticed that her maid was getting heavy around the middle. When she asked her what had caused this condition, the maid, a single Hispanic woman who was also named Maria, denied that she was pregnant. The artist was proprietary toward those who worked for her and wanted to know what she could do to help. Although the maid seems to have been afraid O'Keeffe would disapprove of her condition, she discovered that the artist was

actually probably a little envious of her, having wanted to bear children herself. As the weeks passed, the maid continued her charade, pretending that she was not pregnant. Finally, when she could not work any longer, having revealed herself as unmistakably pregnant, O'Keeffe drove her to St. Vincent's Hospital in Santa Fe, where Maria awaited delivery, a common practice in rural New Mexico in those days.

A few weeks passed. One day the hospital called O'Keeffe to say that her maid was ready to come back home. She had delivered a healthy baby boy. When the artist arrived to pick her up, the maid appeared without her baby.

"But where's your baby?" O'Keeffe asked.

"I gave him for adoption," Maria explained.

"But don't you want your baby?" the artist demanded.

"Yes," she said without hesitation, adding quickly, "but I am going back to work."

O'Keeffe did not want the mother to give up her child. "Then we'll get the baby and take it home," she instructed her.

O'Keeffe returned to the ranch with the mother and the baby. They hid the infant from others. The mother was unwed and the Catholic church that she and most of the natives of Abiquiu attended disapproved of unmarried mothers. Phoebe and Arthur Pack, who knew about the baby, began to refer to it as "their" baby, meaning Georgia's and the maid's. Although she had wanted a baby when she was younger, at fifty-two O'Keeffe soon realized what caring for a young child was about. Having been raised by Auntie, as were her younger siblings, she had been spared the work that rearing an infant entails, particularly in the first months when babies wake up frequently during the night. When she got ready to return to New York in the fall, she drove to a logging camp in the mountains, where she found the father and took him to the mother. Then she organized a wedding and invited her relatives. O'Keeffe's generosity exceeded her capabilities—and it soon became clear that she knew even less about throwing a wedding party than she

did about rearing infants. As she had in the past, she appealed to her friend and neighbor Phoebe Pack for help.

"Georgia came over one day and I had just finished a huge cake for . . . maybe twenty people . . . [staying at the ranch]," says Phoebe. "And Georgia came in and she said, 'Hmmmm! I smell cake.' And I said, 'Yes, I just finished one for dinner tonight for the guests. I want to decorate it.' And Georgia said, 'Oh, Phoebe! You've saved my life. My little Spanish girl is getting married, and I have to give her a cake.' She was apparently getting married at Georgia's. I don't know. But it sounded like it. She said, 'You make another cake, and I'll take this cake to her for the wedding.' I nearly dropped dead. I had spent all day making and decorating the darned thing. And I said, 'No, Georgia. You can't have the cake. This is the dessert for twenty people for dinner tonight.' Georgia said, 'Why can't I have it?' I said, 'Well, what will I give them?' And she said, 'Oh, you can make another one.' I said, 'Well, I haven't got time, for one thing. And I'm tired, for another.' And she said, 'Well, I can't help it. I have to have that cake.' And I said, 'No, you don't have to have the cake. There's the door!' Boy, was I furious. She turned around and gave me a dirty look, which I expected, and I stared right back at her. She turned her back and said, 'Now I suppose you'll talk about me behind my back.' I looked at her and said, 'Probably.' "

O'Keeffe did not return to New York and Stieglitz until November 1940—she remained with Chabot at the ranch after all the other guests had left. In October, the day after she paid the Packs for the house, Stieglitz had suffered another attack of angina, and she had returned to help him recover from it. New York was grim during the war years. Lights were dimmed at night, gas rationing slowed cab service, and reports of constant loss of life upset the daily flow of activity, reminding everyone of the impermanence of human existence. It did not affect O'Keeffe, however, as the First World War had. Over the years, she had grown into a world where there was no war. She marveled at her detachment. "With all the earth being rearranged as it is these

days I sometimes wonder if I am crazy to walk off and leave it," she wrote Ettie Stettheimer.

O'Keeffe lived the life of a famous person. In the spring of 1942, she received an honorary doctor of letters degree from the University of Wisconsin in Madison. As her aged Aunt Ollie and sister Catherine looked on, America's favorite woman artist once again refused to speak and was miffed when one of the officials referred to her as "poor little Georgia O'Keeffe." O'Keeffe had become a regular on the honorary degree circuit. Years later, at Bryn Mawr College, outside Philadelphia, she told a class of graduating women that she found it "embarrassing" to be called great. She was also on the schedule now for retrospective exhibitions, the first of which took place in Chicago at the Art Institute in January 1943.

O'Keeffe traveled to Chicago by train with Maria Chabot. The two women stayed in the same room in the hotel. Chabot later explained it was "so we could fight better." Stieglitz had agreed to the exhibition because the museum had met all of his conditions: O'Keeffe could oversee and help hang the show, the walls would be painted white, and the museum agreed to purchase one of her paintings for its collection. The show was organized by Daniel Catton Rich, a curator with a special interest in southwestern art whom O'Keeffe had met in the summer of 1929 in Taos. On the evening of the opening, as snow piled in drifts around her hotel, she said she had come down with the grippe and stayed in with Chabot. Stieglitz called on the phone.

In general, at this time in her life O'Keeffe's health was excellent. She no longer suffered from breakdowns as she had when she was younger. She no longer had prolonged colds or recurrent bouts of flu, either. As she approached her sixtieth year, a time when many people feel their bodies slowing down, the artist was actually as sound as she had ever been. Living in the Southwest, she had been born again—in a manner of speaking. She had found her stride and more or less accepted who she was. In the summer of 1945, her old friend Anita Pollitzer came to visit her in New

Mexico. Pollitzer had assumed the position of chairwoman of the National Woman's Party in Washington. Traveling with a Woman's Party friend, Margaret Williams, Pollitzer stayed for several weeks, during which time O'Keeffe showed them around like an old native, taking them to the Black Place, on hikes into old adobe Indian ruins and up deep arroyos. On her return east, Pollitzer visited Stieglitz and told him how wonderfully O'Keeffe functioned in New Mexico. He did not want to hear about it. He had been convinced that she did not do well, being "so frail a person."

O'Keeffe had resigned herself to Stieglitz's condition and worked around him. She gave up her airy penthouse because he wanted to be able to walk to the gallery. Although she preferred to stay out west, the artist returned to New York each fall, staying in a small apartment at 59 East Fifty-fourth Street, where it was hard for her to work, so she could be near Stieglitz. She put up with his opposition to the way she was handling her career and to the war, and even with his support of Germany. In spite of mounting evidence that Hitler was exterminating massive numbers of Jews, homosexuals, artists, and gypsies, Stieglitz continued to support his parents' homeland. Stieglitz was an old man, a martyr who suffered quietly while his wife went off to live in the desert—this was the line, it seems from all accounts, echoed in the recollections of friends of Stieglitz's. "You got the sense," recalls photographer Eliot Porter, "from the way she talked about him . . . it wasn't as though she didn't know him . . . it was as though she didn't have a very intimate relation with him . . . she had an aloof attitude toward him."

Sue Lowe visited Stieglitz at the lake shortly after the war had ended in 1945. Her husband, Pete Geiger, had been killed in the war, and although it seems preposterous, she had been asked by her Uncle Lee to spare Stieglitz the bad news. The family was attempting to shield him from things that might upset his weakened heart: "Moments after our greeting, however, he paused to peer at me over his glasses. 'Your Peter. Yes, I know; nobody had to tell me. I'm sorry,

child. I don't know what to say.' He reached for my hand and looked toward the barns.

" '*You* are alive,' he went on. 'That matters. Alive and young.' Another pause. He sighed, and closed his eyes. 'Why do I linger? What for? Old as The Hill, with nothing to do but sit here. And wait. What for? And so what?' A silence so long I thought he had dozed off; carefully, I extricated my hand.

" 'Going?' He seemed to welcome the possibility. 'Here, give me a kiss and go to your mother. She's a fine woman, Elizabeth.' Leaning back in his chair, he fumbled with the top buttons of his exposed underwear, rested his hand on his heart, closed his eyes again, winced, and hissed an indrawn breath. I had to smile; the pantomime was so familiar. On cue, he whispered, 'It's nothing. I'll be all right. Run along.' "

The following summer, Stieglitz never made it to the lake. On July 6, 1946, Beaumont and Nancy Newhall brought a chocolate ice cream cone, his favorite, to An American Place on their way to Long Island for the weekend. O'Keeffe had left for New Mexico a month earlier. Two days later, the doctor wired her to ask her to return to New York. Stieglitz was much worse. O'Keeffe ignored the wire—Stieglitz was always worse. What was more, she was expecting a visit from Peggy Bok. In another two days, she learned from a telegraph operator in Española that her husband had suffered a massive stroke. Without bothering to notify Bok, O'Keeffe sped to Santa Fe to catch a plane east, leaving a cloud of dust a mile long as her big Buick bumped along the dirt roads. Benny Goodman was playing the clarinet on the radio. By the time the DC-3 plane had taken off from the small airport in Santa Fe, Stieglitz had slipped into a coma from which he would never recover. He died two days after the artist returned to New York, on July 13, 1946. He was eighty-two; she was fifty-eight. *The New York Times* identified him in its obituary as "husband of Georgia O'Keeffe."

PART THREE

· · · · · · · · · · · · · ·

1946–1986

Chapter 19

.

In the summer of 1951, Georgia O'Keeffe fetched her old friend Anita Pollitzer from the airport in Santa Fe. It had been a long trip from New York, and the small plane had made several stops along the way; moreover, there was the added difficulty of breathing at six thousand feet. The strange desert scenery was both exotic and scary. The night after they arrived, Pollitzer and her husband, Elie Charlier Edson, were sleeping soundly when, at four-thirty in the morning, they heard a knock on the door. O'Keeffe was standing before them in a white kimono and Mexican sandals; her long black hair, which was generally pulled in a bun, flowed across her shoulders and down her back loosely.

"Come quickly," she implored her tired guests. "You mustn't miss the dawn. It will never be just like this again."

O'Keeffe led her blurry-eyed friends through the interior of the calm adobe house and into a patio where jimsonweeds bloomed enticingly in the cool dark air. They passed through a narrow doorway in an adobe garden wall leading to a strip overlooking the Chama River valley and the spectacular land formations of Abiquiu. The threesome stared in awe at the same spectacular light show that had inspired O'Keeffe more than thirty years earlier in Canyon—it had prompted the drawings, rolled up in newsprint, that Pollitzer took to Stieglitz. Now Pollitzer could see what had moved her friend to create a new type of personal art—and she was impressed. The sky, she wrote, was "flaming orange and cerise."

O'Keeffe stood in her white kimono drinking the dawn, as she had for thirty years and would do for more than thirty

years more, never tiring of the sight. By her side was a dog, a black standard poodle named Chino, and a Siamese cat named Yellow. She was proud of what she had discovered; at times she even considered the sunrise, sunset, and land-scape to be oddly hers alone, as if she had swallowed the strange scenery and breathed it onto her canvases.

"Isn't it worth coming to New Mexico to see this?"

O'Keeffe was entertaining Pollitzer in a new house in the pueblo of Abiquiu, sixteen miles from the ranch, which she had acquired as a base for year-round living in New Mexico. She had found the house years before while climbing a hill that rose sharply a hundred feet from the road. What had once been the main hacienda of the tiny village, occupied by a grandee named Chavez, had become a run-down un-occupied pile of adobes. The roof had been caved in. Chick-ens ran in and out of the old house. Pigs were kept in a side yard, through which ran a life-giving irrigation ditch—*acequia* in this Spanish-speaking part of the world. Several fruit trees—apple, peach, plum, apricot—were gnarled and neglected in the walled yard. It had been romantic and eerie to poke around in the old house, and the artist had returned from time to time to see what she could find. She became obsessed by the house, could not get it out of her mind. What stood out was an old wooden door with handmade iron hinges on one of the patio walls. The way the door was placed in the wall impressed the artist greatly: "That wall with a door in it was something I had to have."

When O'Keeffe had to have something, she latched onto it and would not let go, as a bulldog holds on to a rope. She located the members of the Chavez family who still owned the property and asked them to sell it to her. The Spanish-speaking people of Abiquiu were suspicious of out-siders like O'Keeffe. (The only other non-Hispanic was a German by the name of Carl Bode, who owned the store.) As property was generally kept in the family, passed from father to son, or mother to daughter (the previous owners traded a couple of burros and a serape for it), O'Keeffe found herself excluded from any sale. She later told people that

the owners had wanted too much money for the house, but it seems that she had not even been considered as a buyer. In the forties, coming in from the outside and buying a piece of property in an isolated village like Abiquiu was almost unheard of. Those who did often had their houses lit on fire at night by vigilantes, illuminating the darkness to scare off the unknown. After turning O'Keeffe down, the Chavez family gave the property to the Catholic Church. The Church controlled the social, political, and economic life in the village. At one end of the village was a sanctuary dedicated to San Tomas on a small dirt square. A few blocks away on the other end of the village was a coffin-shaped building known as a *morada*. A morada was where a group of village elders, or Penitente, carried on medieval practices of self-flagellation and mock crucifixion. The Penitente formed an extralegal brotherhood, not unlike the Sicilian mafia, that settled disputes, took care of the needs of the people, and gave religious life a sinister dimension in this part of the world. Outside the morada were three black crosses, each large enough to crucify a man.

For years to come, O'Keeffe regaled visitors to her walled fortress with the story of how she had finally come to own the house. She was particularly proud of herself for having acquired the property from the Church because she felt that she had outfoxed the village elders and had been able to assert herself as a shrewd person of business. Phoebe Pack later recalled that she had been annoyed with Arthur for letting Georgia acquire the Ghost Ranch property for only twenty-five hundred dollars, particularly when Georgia told people whom she wanted to impress that she had paid more; it is possible that the Catholic Church felt the same way about its deal with the canny artist. Her business sense had already stood her in good stead and would continue to be one reason she succeeded as an artist while so many around her failed. "Georgia," Maria Chabot recalls fondly, "was tough as nails. Tough as nails."

Jerry Richardson, now a Santa Fe tax attorney, worked for the artist as a student during the late 1970s. One day

he was helping clean out her garden, and while she was watching him work, she began to talk about the property: " 'Do you know how I got this house?' she asked me. 'No, Georgia,' I said. 'How did you get this house?' She said she'd gone down to the bank in Española one day. In the lobby of the bank there was a table set up, and people from the Red Cross were asking for money to help support the humanitarian stuff they did in connection with the war, and they had asked her for money. She wouldn't give them a penny, and she told them exactly what she thought of the Red Cross, because the Red Cross had been very involved in promoting the draft during the First World War. She had seen all these naïve young men being sent off to the trenches in the war, and so few of them had come back. She could never forgive the Red Cross for selling these naïve, young, beautiful men the line about patriotic duty and glory and all that bullshit. And so she lectured the people sitting at the Red Cross table about it.

"And on the way back driving to Abiquiu, the idea occurred to her—I guess in the connection of charitable giving—that she could make a nice big contribution to the Catholic Church and shame them into giving her that house. And so she made an appointment to meet with the priest, and she said, 'I'm a successful artist, and as you know, I get my inspiration from this beautiful area around here, and I feel very connected to this land, and I feel that I see so much poverty around me and so many people that have so much less than me, and I'd like to do something to help out the village of Abiquiu. What can I do for you?' After Georgia made a large contribution to build a community center, the priest asked her what the village could do in exchange for her. She told him to give her the house."

Maria Chabot oversaw the construction of the house. The entire place had to be rebuilt. Although the two women had fought for some time and Chabot often left for weeks at a stretch after their blowouts, the artist realized that she needed her and, according to Chabot, gave her "carte blanche to do what I wanted" with the house. The house

O'Keeffe envisioned was a simple, clean Japanese-inspired modern building that would follow the original lines of the ruin, with an additional building on the cliff overlooking the Chama River valley for a studio and bedroom for the artist to work and live in. The studio was long and narrow. The bedroom was tiny, with a single bed overlooking the valley through a window, the same size as the tiny bedroom she had had as a student at Columbia. A tiny fireplace that Chabot had seen in a book on Mayan architecture was squeezed into a corner. The ascetic side of O'Keeffe loved spare quarters, like the cells monastic people occupied in medieval times. In both her houses, the beds were narrow and single. She did not have double beds, and she never slept with anyone else in the same bed or room after Stieglitz died. Her friends slept in adjacent rooms in their own beds.

Following the fashion of the forties, the artist used large plate-glass windows to bring the outside in. The studio overlooked the valley and red cliffs through its glass walls. In the living room, plate-glass windows presented a cool, dark walled-in garden in which she would grow vegetables and exotic poppies and irises and jack-in-the-pulpits and mariposa lilies and bamboo and red raspberries and other flora—as well as peach, pear, apple, and plum trees. The garden covered more than an acre within the bounds of a high wall. In the heat of the desert summer, the shady garden was an oasis of comfort and sensuality; the sound of water rushing through the *acequia* and flooding the beds added to the sensation. A friend compared her garden to a Persian miniature.

Chabot hired women to do most of the construction work. Construction of adobe houses had been woman's work historically, and most of the men in the area were just returning from the war or off in the cities looking for work. They laid the mud bricks section by section in the hot sun of the summer and hoisted the unfinished timbers known as *vigas* with pulleys to support the flat roof. For years afterward, the artist would run her hands along the rough walls and point out that the finish had been applied entirely

by women's hands. Each room had a different color of mud plaster. In the artist's tiny bedroom, the wall was coated with a finish the consistency and color of gray pig suede. She had found this mud in a river bed on Richard Pritzlaff's property.

It took several years to complete the house and garden. New Mexicans, like many Latin people, follow a sense of time that does not depend on rushing to complete something but instead savors the experience of doing it. At this time, things moved even slower than usual. During the war, a secret government installation had been built at Los Alamos, a former boys' camp in the mountains about twenty miles from Abiquiu. All the available construction materials went to construct what would eventually be the birthplace of the atom bomb. O'Keeffe's house had to wait for nails and boards and other ordinary building supplies.

One Sunday in May, the water to her *acequia* was finally released, as Georgia and Maria looked over the proceedings with friends and neighbors. The stone-walled irrigation ditch flooded her desert garden with precious water that would support life on the dry edge of the world. O'Keeffe was given water on a Sunday because she was the only person on the system, which ran from a spring in the hillside, who did not go to church. A few months later, she wrote to Henry McBride in wonder of her garden: "I have a garden this year. The vegetables are really surprising—There are lots of startling poppies along beside the lettuce—all different every morning—so delicate—and gay—My onion patch is round and about 15 feet across—a rose in the middle of it—Oh—my garden would surprise you and I think you would like it very much—I don't know how I ever got anything so good."

And what of Stieglitz? Did she miss him?

O'Keeffe did not cry at Stieglitz's funeral. She stood in the chapel of the Frank Campbell Mortuary on Madison Avenue and Eightieth Street and greeted his old friends and hers, as well as his family, with what many remembered as

a cold dignity. O'Keeffe had handled all the arrangements. Having searched all over New York for a plain pine coffin, she finally located one in the Hasidic Jewish community of Williamsburg in Brooklyn—only it was lined in pink satin. To the bemusement of the mortuary workers, who let her stay behind after they closed, she ripped out the pink satin and stayed up all night sewing in a plain white linen lining. (Some accounts refute this often-told story, quoting O'Keeffe as having later confessed to a friend that she did not really stay up all night or replace the lining. However, the idea that O'Keeffe would use her hands to assuage her grief seems entirely in character, as does her staying up all night.) Even though the coffin was sealed and draped with a black cloth, O'Keeffe felt that Stieglitz would have wanted to be laid out in white, not pink.

There was no music at Stieglitz's funeral. No one spoke. No spiritual passages were read. Everyone stood in silent mourning around the coffin. An old friend of Stieglitz's, photographer Edward Steichen, with whom he had been recently reunited after several decades of separation, charged the atmosphere when he laid a bough of pine over the coffin. The bough was from a tree in his yard that he had been given by the art impresario—the Stieglitz tree. O'Keeffe rode alone with the body to the crematorium in Long Island. A month later, she took a canister containing Stieglitz's ashes and mixed them with the earth on the shore of Lake George.

The day after the funeral, O'Keeffe called Dorothy Norman on the telephone. She told her to remove every sign of herself from An American Place and never appear there again. She was taking over the gallery, as Alfred would have wanted, and there was no place for two proprietors. When Norman protested, O'Keeffe released twenty years of pent-up rage on her husband's paramour. O'Keeffe told Norman that her relationship with Stieglitz had been "absolutely disgusting" and reiterated that she wanted her out of the gallery and her life. Norman, who had been helping support the gallery, was surprised by O'Keeffe's outburst, as were count-

less others. Referring to her display as a "malignant whip-
ping," Ansel Adams concluded that O'Keeffe was
"psychopathic."

O'Keeffe barely had time to miss Stieglitz. Settling his
affairs involved constant contact with his work—and as she
later remarked, she much preferred the work to the person.
Sorting through thousands upon thousands of letters and
images and negatives and prints and paraphernalia that her
late husband had accumulated over more than seventy years,
she stopped painting. She told people she had no time for
both the work of an administrator and the work of a painter.
Periodically, the art impresario had attempted to simplify
his life by burning his possessions in fits of despair. For the
most part, however, he had been an unregenerate hoarder.
From an office set up in the Fifty-fourth Street apartment,
with the assistance of a young woman by the name of Doris
Bry, O'Keeffe sorted through Stieglitz's things and decided
what to do with them. Most of his possessions had little or
no monetary value—certainly not the huge value that they
would later come to have. As executrix, O'Keeffe did not
want to sell his things, anyway, realizing that he would not
have wanted her to. What she did with them was left to her
discretion. Stieglitz had not specified any gift or donation,
leaving the entire dispersal to her, as she herself would one
day leave her own possessions to Juan Hamilton.

Some of Stieglitz's relatives contested the will. As his wife
and only significant heir since he had lost contact with his
only child, however, O'Keeffe was in a good position to win
the contest—and she fought back. The relatives maintained
that she had not been a dutiful wife, that she had left him
repeatedly to go where she wanted to go and do what she
wanted to do. The fact that she had not taken his name was
brought up. The fact that she had been in New Mexico when
he succumbed to the fatal stroke was mentioned as well.
There was not very much money involved—O'Keeffe had
supported Stieglitz over the years—but there was a family
trust valued at around $130,000, over which O'Keeffe had
inherited control. O'Keeffe was not a favored Stieglitz in-

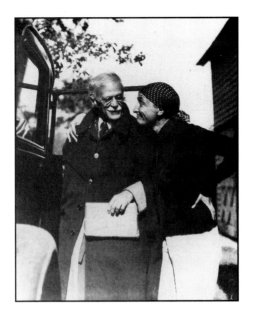

(25) *Above:* In an unusually candid portrait, O'Keeffe mugs for the camera as she bids Alfred good-bye. (26) *Below:* Georgia poses with Beck Strand in Taos in 1929.

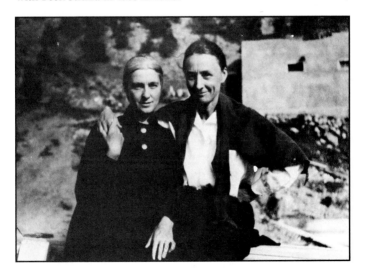

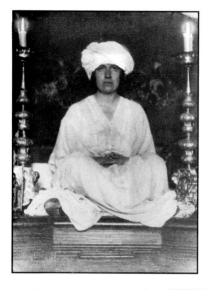

(27) Mabel Dodge Luhan, Georgia's host in New Mexico during the summer of 1929, was a wealthy spiritual seeker whose Taos salon influenced the work of Ansel Adams and D. H. Lawrence as well as O'Keeffe. "I wish I could give you a feeling of completeness that I have about Taos," Georgia wrote Mabel after her visit.

(28) A Tewa-speaking Taos Pueblo Indian, Anthony (Tony) Luhan was Mabel's fourth—and last—husband. Georgia was drawn to Tony during her first summer in Taos, much to the distress of Mabel, who was jealous of the spiritual bond between them.

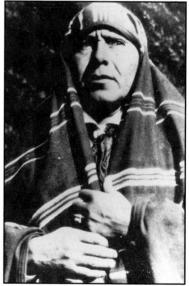

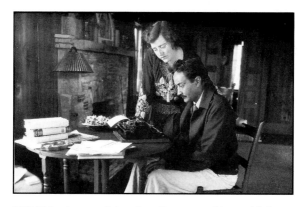

(29) This picture of poet Jean Toomer and his publisher wife, Marjorie, was taken after the couple were married in Taos. O'Keeffe, who often found herself in triangles, had been intimate with Jean and a close friend of Marjorie.

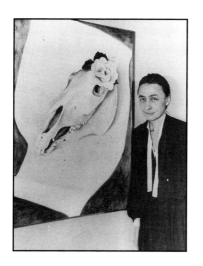

(30) O'Keeffe poses next to *Horse's Skull with White Rose,* which she completed in 1931. The artist's skulls and bones prompted critics to speculate that she had become macabre, but she maintained that they were wrong: "Bones cut to something *alive* in the desert."

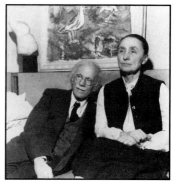

(31) O'Keeffe poses with Stieglitz for a late 1930s photograph. The artist traveled to New York grudgingly at this time. Only in New Mexico, she said, could she relax.

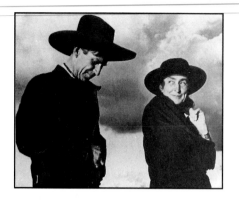

(32) This Ansel Adams photograph shows the artist mugging with wrangler Orville Cox on a camping trip. When O'Keeffe smiled, Adams noted, "the entire earth cracked open."

(33) In the 1940s, O'Keeffe's painting of white pelvis bones against a deep blue sky appealed to the Surrealists. Although she was never aligned with the Surrealist—or any other—movement, one of her pelvis paintings found its way onto the cover of *View,* a journal of Surrealism.

View

Summer 1944
fifty cents

(34) Stieglitz poses against the image of a birth canal in one of O'Keeffe's pelvis paintings in a gesture symbolic of the bond between the two artists. "I see Alfred as an old man that I am very fond of—" the artist wrote, "growing older—"

(35) O'Keeffe holds Stieglitz's crystal ball,
which he gave her on his death in 1946,
and which she referred to for the rest of
her life as a source of spiritual comfort.

(36) When guests arrived at Ghost
Ranch, O'Keeffe often led them up a
crude pole ladder to the flat roof, where
they could take in the majesty of the red
rock desert. She called it "The Faraway."

(37) Intuitive and direct,
Phoebe Pack was Georgia's
neighbor and confidante for
more than thirty years. She
was one of the few people
Georgia contacted for advice.

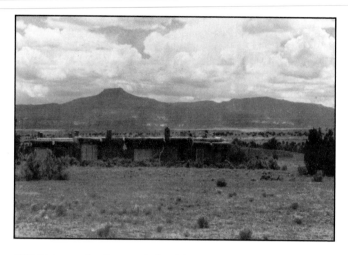

(38) Rising in the distance behind her house at Ghost Ranch was the flat-topped Pedernal mountain, home of the mythical "changing women." The artist maintained that God told her she could have the peak if she painted it enough times.

(39) O'Keeffe said she wanted to purchase the house in Abiquiu because of the way a door was placed in a wall. A traditional New Mexico adobe that the artist renovated with her friend Maria Chabot, the interior of the Abiquiu hacienda contained a number of inviting doorways.

(40) Measuring eight by twenty-four feet, *Sky Above Clouds IV* depicts the view of a bank of clouds the artist enjoyed from the window of a plane. Completed in 1965, it was her largest painting and the cornerstone of the 1970 Whitney Museum of American Art retrospective.

(41) Juan Hamilton told people that he had been beckoned to care for Georgia O'Keeffe by the spirit of Alfred Stieglitz, a claim furthered by the close physical resemblance between the two men, seen here nearly one hundred years apart.

(42) "Juan was sent to me," Georgia would tell people who questioned the powerful role sculptor Juan Hamilton assumed in her life as she grew old and feeble. Almost all believed her.

(43) As her eyesight failed and she could no longer see to paint, O'Keeffe found an outlet for her energy in pottery, which she created under the aegis of her companion, Juan Hamilton. A perfectionist to the end, O'Keeffe told people she was not satisfied with the results of her efforts.

law. Since she had taken over the farmhouse and upset some of the relatives she did not like, she had become persona non grata. She won the contest, however, by settling to accept the income from the trust for life—and according to Hamilton, thirty years later, she laughed when she realized she had outlived those who had made a claim on the trust in the first place.

With Bry's assistance, O'Keeffe catalogued thousands of Stieglitz's artworks. Adopting a method of generosity that had boomerang benefits for herself (as when she gave the Catholic Church a contribution), she made a master copy of the finest works and gave them to leading institutions: the Metropolitan Museum of Art, the Museum of Modern Art, the Philadelphia Museum of Art, the Boston Museum of Fine Arts, the Cleveland Museum of Art, and the Art Institute of Chicago. Stieglitz's reputation and the value of his work benefited greatly from being housed in these institutions. Bry was a dutiful assistant; as an undergraduate at Wellesley College, she had developed an interest in photography through the Stieglitz collection in the Boston Museum of Fine Arts. Nearly everything was recorded and deposited in storage in New York. Stieglitz's correspondence was donated to the Yale Collection of American Letters in the Beinecke Rare Book and Manuscript Library, where it entered collections of letters of Gertrude Stein and Mabel Dodge Luhan. Prompted by her good friend Jean Toomer, who had donated his own papers to the institution, O'Keeffe also made a sizable bequest to Fisk University, a college for blacks in Nashville, Tennessee, where they entered the collection of the Carl Van Vechten Gallery of Fine Arts.

O'Keeffe drove to Nashville with Doris Bry to install an exhibition of Stieglitz's photographs at Fisk in the spring of 1949. O'Keeffe and Bry made the drive on their way to New Mexico, where Bry would begin working as O'Keeffe's secretary and administrative assistant, dividing her time between New York and New Mexico for the next thirty years as the artist's factotum. A thin, tailored woman who wore sensible flat shoes, neat suits, and a frown of perpetual

discontent, Bry devoted her life to working for the artist. She soon became accustomed to O'Keeffe's temper, which flared up in Nashville, as it would over the years. O'Keeffe marveled at the scale of the large gymnasium where the exhibition was held, but she soon regretted having gotten involved in the show and said she did not want to install an exhibit again. The lighting was terrible. The backdrop was not what she had envisioned. Two days before the show opened, the artist appealed to a friend who specialized in lighting to fly in from New York. "The inertia of the south," she wrote, "was like a mountain."

On the day of the opening, the artist was confronted by a black student who asked why she associated the idea of purity with "white and not with black." O'Keeffe was not what was considered a socially responsible artist; like Stieglitz, she had rejected the then-popular social realism during the Depression in favor of a type of art that was intimate and personal. Nor had she spoken or written on the subject of race. She had spoken and written about the rights of women and in 1944 had petitioned Eleanor Roosevelt to support an early version of the Equal Rights Amendment. She was a registered Democrat in New Mexico, and in the election of 1952 she supported the Progressive party candidate. O'Keeffe was later investigated by the FBI because she employed a Chinese cook, espoused liberal views, and lived close to classified research at Los Alamos. But she was not prepared to answer any questions about her views of racial matters: "I had no idea before of the many things color of the skin can mean and do—it is sad—That black girl had something that made me discount the color of her skin as I never have with any other colored person—." When Mildred Hudson, one of the few whites who attended the opening of the exhibition and a trustee of the segregated Memphis Art Museum, asked O'Keeffe why she had given the collection to Fisk, the artist snapped, "If we gave it to you people, *they* wouldn't be able to see it."

O'Keeffe was conscious of the gap between the amount of money she had and that of people around her, but she

may have exploited that situation when she acquired her property. Her generosity, like most of her traits, followed her own logic. She gave money to support certain students in Abiquiu who wanted to go to college, and she withdrew funds when she was disappointed with their performance. Later, she volunteered to build a gymnasium, only to stop before it was completed because she had feuded with the contractor. Arthur Pack picked up the balance on the project. In Abiquiu she did not just own a house; she was considered a patron of the pueblo. For some time, she was also the only resident with an automobile and indoor plumbing. Outhouses were still in use when she moved there; there was no telephone, and unpredictable electric service was provided by a rural co-op. Fuel wood was brought down from the mountain timberlands on the backs of burros. In many ways life in the pueblo was feudal; people like O'Keeffe were considered overlords. With her property and stature, had she been Hispanic, she would have been called *doña*. As it was, she was always called *Miss* O'Keeffe.

By the time Anita Pollitzer and her husband arrived in Abiquiu in the summer of 1951, O'Keeffe had become adjusted to her new life. After another feud with Maria Chabot, the two women had parted once again. "Maria, who really built this house," she later told a visiting writer, "became attached to me and as a result, was very jealous. I told her eventually she'd have to leave and not come back." Chabot told people that she had left O'Keeffe because she had been given Los Luceros to ranch, and she raised prize-winning Black Angus cattle on the Wheelwright place for the next ten years. O'Keeffe subsequently made do with various people to help her. It was a desolate life. Moving back and forth between Ghost Ranch and her walled fortress in the pueblo of Abiquiu, the artist had made friends with some of the local teenage boys. O'Keeffe liked teenage boys. They appealed to a side of her which was adolescent and ornery.

She made friends with a local tough by the name of Jackie Suazo. A handsome, talented boy, Suazo became O'Keeffe's first protégé—she taught him how to paint, and he produced

capable likenesses of her paintings of bones. They went camping together. He sent her a Mother's Day card one year. She loaned him and his friends her station wagon so they could play basketball games against other schools. Eventually, Suazo's life turned on him, and for a time he was in and out of jail. O'Keeffe visited him there, although her friends were worried that she could be hurt. As with most people who got close to her, O'Keeffe lost her patience with him, too, but on her death, she left him thirty thousand dollars—more than anyone but Juan Hamilton.

Her first show after Stieglitz's death was the last show at An American Place. The gallery closed after the 1949–1950 season—and there was little reason to keep it open. Being a generation younger than most of Stieglitz's group, O'Keeffe now found herself left alone. Many of the other artists had either died or stopped painting. Symbolic of the dissolution of the old group, in 1950 a destitute Mitchell Kennerley hanged himself by his own belt strap from a light fixture in a room in the Shelton Hotel. Sherwood Anderson had died a few years earlier when he swallowed a toothpick after an epic bout of martini drinking aboard a Europe-bound ocean liner.

O'Keeffe began working again with a series of paintings of the patio door in Abiquiu and a study of cottonwood trees along the banks of the Chama River in Abiquiu. With these, she returned to the simple, childlike composition that Arthur Dow had espoused and that had originally attracted Stieglitz to her work. Freed of the demands of annual exhibits and a hungry press (she was ignored now), the artist again produced bold, original work. She showed it primarily through the Downtown Gallery (which was, curiously, located in midtown Manhattan). The Downtown Gallery was operated by Edith Halpert, a Russian-born, ample-girthed art dealer who showed exclusively American art. The gallery was not a showcase for avant-garde art; along with Ben Shahn political drawings, there were duck decoys, whirligigs, and other examples of American folk art, which had become a specialty for certain collectors. It may not have

been An American Place, but it was where Arthur Dove and John Marin continued to show their work after Stieglitz's death.

O'Keeffe increasingly inhabited a world of women. Her dealer, her secretary, and even her doctor—Constance Friess—were all women at this time in her life. On Stieglitz's death, she became reunited with her sister Claudia, who had moved to Beverly Hills in 1939 with her friend and companion, Hildah Hohane. Georgia loaned Claudia money when she and Hildah opened a kindergarten on Olympic Boulevard. Reflecting the endemic snobbery of Beverly Hills parents to which they were trying to appeal, the school was billed as "an exclusive school for particular parents"—which aroused the ire of the prosaic Georgia. "Sounds a bit snooty to me," she wrote back to Claudia.

O'Keeffe made herself available to her family in ways she had not before. In the summer of 1946, for the first time, she entertained her niece, Barbara June O'Keeffe, in New York. June was her beloved brother Alexius's daughter, but for unknown reasons, Georgia had had little previous contact with her. They had met earlier in Beverly Hills, where June grew up, on one of Georgia's trips to California to visit Claudia, without establishing rapport. June visited Georgia in New York on her way to enroll in Vassar College as a freshman.

June felt that her aunt was something of an eccentric. Georgia's plywood table impressed her because she had never seen anything like it before. Georgia was June's first introduction to Tiger's Milk and other health foods, which were unusual in 1946. They walked across the Brooklyn Bridge together. Georgia had been particularly kind to her, pointing out one day over a breakfast of wheat germ and yogurt a family resemblance. "When I look at you," she said, "I see your father looking back."

O'Keeffe became the subject of a biography, an honor usually reserved for people who have completed their careers. Before departing New Mexico, Anita Pollitzer asked the artist if she could become her Boswell. O'Keeffe agreed.

Over the next few years, the two women communicated about the project. Pollitzer traveled to Wisconsin and Virginia to interview people the artist had known when she was growing up. She talked to many people, put in hours of work, and tried to piece together the life of a woman who kept big parts of herself secret and scorned those who got too close.

Before they left, O'Keeffe took Pollitzer and her husband to Santo Domingo Pueblo to watch the Corn Dance. The Corn Dance, whose beating of ancient rhythms vibrated the hard earth, was similar to a dance that Georgia had attended when she and Beck Strand had met Tony and Mabel Luhan in the summer of 1929, her first in New Mexico. That was the summer O'Keeffe had found a mystical union with the land and discovered that living in New Mexico could make her feel a river running through her—as she now felt all summer, as the *acequia* in her walled garden opened and precious water made the desert bloom like Eden. So much had happened to O'Keeffe in the years since. So much would still happen to her in the next years to come. Although a part of her life had ended when she buried Stieglitz, in some ways her life was just beginning.

Chapter 20

· · · · · · · · · · · · ·

In 1957, O'Keeffe joined old silent film stars and deposed Eastern European monarchs in "Where are they now?" a *Newsweek* column. More than ten years after Stieglitz's death, the artist who had once shocked New York with her nude body and had been voted one of the outstanding women of the century had disappeared from the public eye. She celebrated her seventieth birthday on November 15, 1957, with a pair of Chinese chow dogs. She communicated with Stieglitz through his crystal ball, but she did not see or talk to many people at this time. "She didn't have many friends," observes photographer Eliot Porter, "because of the kind of personality she was."

O'Keeffe told people her dogs were the "center of everything around here." Her favorite was the Beau, a black Chinese chow that the artist had received from Richard Pritzlaff for Christmas in 1952. The first of many chow dogs the artist would own over the years, the Beau was her favorite. Fierce and loyal, the Beau protected O'Keeffe from whatever she imagined she needed protection from out in the desert. And he took his job seriously. Once he tore the ligaments of the leg of a woman who had unfortunately entered O'Keeffe's domain without knocking first. O'Keeffe blamed the woman—she said it happened because she had not followed her instructions when she entered the yard. "Those dogs bite," she told people. "I've seen plenty of shoes fill with blood."

Phoebe Pack was terrified of O'Keeffe's dogs. "It was just like Georgia," she says, "to have man-eating dogs!" One day

she was walking across the artist's property with a pan of meat to feed a pet mountain lion that she and Arthur kept in a zoo in another part of the ranch when the chows charged her. Suddenly "I heard 'Phoebe! Phoebe!' And all the ways away came Georgia. She was walking with her usual cane, her homemade cane or whatever it was. She was coming from her walk. Ahead of her galloped two chows. I had one look at them, and I thought, 'You'd better get rid of the meat, Phoebe.' They were pretty well upon me then. But I didn't pay any attention, I just threw it, and they turned and went right for the meat. Georgia came up, and I said, 'Your dogs ate paper and all.' And she said, 'Well, that's all right. That won't hurt them.' Typical of Georgia. Here I was—they could have torn me to pieces."

The dogs, always in pairs, were indeed the center of O'Keeffe's world—as odd as the artist herself recognized that sounded. She buried a length of screen in the earth to keep rattlesnakes away from the Beau and his mate, Chia. Rattlesnakes were native to Ghost Ranch, and her dogs, like most dogs, were unaware of the lethal power of a snakebite. The dogs went with their mistress on rides in her convertible Buick. The Beau rested his arm on the armrest, like a person, gazing regally into the world. The two fuzzy black dogs and the old artist dressed in black became a local sight, as much a part of her persona as the cane she had begun to carry as an affectation and the long black dresses she had donned since she was a young girl. She joined a society of chow dog owners. The Beau, she told people proudly, was "top dog of the town."

During the summer of 1956 the Beau was hit by a car on the Chama Highway. He dragged himself home on his front legs. His back was broken, and he had no use of his hind legs. O'Keeffe rushed him by car to a vet in Española. He would be reduced to a cripple who could no longer move on his own, so the vet recommended putting him to sleep. The Beau's death tore the artist apart. For three days, she said, she could not speak to anyone. When the shock finally wore off, she told Pritzlaff what had happened. "The

Beau is gone," he remembered her saying. She asked him not to come because she said she knew she would cry. "I almost died with him," she explained. "It seems I never felt worse about anything."

The effects of losing Stieglitz seem to have played themselves out over years rather than months. At first, O'Keeffe felt great relief, as people often do on the passing of someone who has tempted the Reaper for so long. But what followed was a period of mourning that stretched on without definition or form, bringing on a three-day catatonic state upon the death of a pet she had known only a few years. Replacing Stieglitz was impossible. When, years later, Juan Hamilton compared himself to Stieglitz, O'Keeffe supported his comparison even though Juan Hamilton was not Alfred Stieglitz.

When Peggy Bok—now Kiskadden, having married for a third time—visited Georgia in 1950, she helped Georgia go over Alfred's letters and photographs in a room in the ranch. When she left, Georgia wrote to say how moved she had been by the experience: addressing her beloved friend as Peggie, as she had over the years (it is not clear whether Peggy corrected Georgia on her spelling or accepted the spelling of her name as a part of her older friend's quaint personality). Recalling the time they spent looking over Alfred's work, Georgia allowed how his presence was always felt at the ranch: "I wrote to him from this table so many times—so he is always here—and when you were in Abiquiu he seemed vaguely present—as you drove out the gate—it was as if that thing he had been in my life for so long was going again—driving off into the dawn."

O'Keeffe found some of the qualities of Stieglitz in other people around her. Richard Pritzlaff, for one, autocratic and Germanic, loved horses, as Stieglitz had. Born in 1902 into a family of wealthy industrialists in Milwaukee, Pritzlaff had bought his ranch in New Mexico in 1937. He had fallen in love with New Mexico as a boy, when he was sent west as a cure for hay fever. His ranch, Rancho Ignacio, covers four square miles in the eastern foothills of the Sangre de Cristo Mountains. The spare, low-slung ranch house and buildings

are tucked into a hollow at the junction of two valleys. There are several large Alpine meadows—green most of the summer—for grazing his herds of Arabian horses. His is a glittering world: Peacocks have the run of the portal and lawn in front of the houses, fanning and spreading their brilliant feathers; an array of silvery rocks are lined up on a wall, as are a collection of nearly life-size portraits of Chinese noblemen with crushed precious stone. Pritzlaff once gave O'Keeffe one of his Chinese paintings. A few weeks later she returned the picture, explaining that she was a "working girl" who had no use for such luxury in her life.

Pritzlaff was best known in the rarefied world of horse breeding for having introduced Blunt Egyptian Arab horses into America. Over the years, he has won awards and set record prices for flesh from his stock. He speaks with authority of his horses, calling them "the best blood in the world," admiring their flesh like a doting parent: "perfect head, perfect body, perfect croup." There were those in the Arabian horse community who claimed that he had overbred his horses and that he had failed to keep good records. In response, Pritzlaff denounced the world and the horse community as "crooks who are money crazy." A constant refrain on several occasions when I spoke with him at his ranch was: "The whole world has gone to hell!"

Among a socially active set in Santa Fe, visits to Pritzlaff's ranch were as de rigueur as opening night at the opera. He entertained lavishly in an ample adobe house decorated with six-foot-high pairs of Chinese ancestral portraits. Skins of rare snow leopards covered the floor. In the dining room, four-foot-tall cloisonné candelabra illuminated rare Chinese landscape paintings and a pair of T'ang dynasty ceramic horses. The walls were chocolate-brown mud with flecks of straw. A trio of six-foot pine trees, cut regularly from the forests on his land, graced a nook. The overall effect of the elegant trappings in the primitive dark dwelling was awesome. His dinner parties for ten or twelve were often served by tall, handsome cowboys wearing tight blue jeans and silver belt buckles.

Stories about Richard Pritzlaff generally involve his quick temper and his horses. He was apt to command people to leave the ranch who said or did something he did not approve of. On one occasion, a visitor for lunch told him when he arrived that he had to leave at three to return to Santa Fe for a cocktail party and dinner before the opera. "In that case you'll have to leave right now," he instructed the dumbfounded guest. "Get off my ranch. I have no use for people who go to cocktail parties in the afternoon, and less use for people who go to the opera. Leave my property immediately." Guests were often surprised to discover that his lengthy diatribes about breeding included not only horses but people. "Lazy Natives!" he barked at the locals who worked for him.

O'Keeffe spoke highly of Pritzlaff. She considered him an "old, old friend," probably one of her few close friends in New Mexico. Her letters and reminiscences from this period are full of praise for him. She loved looking at his horses and often attempted to use them as subjects for her paintings. They shared an interest in Chinese art and Chinese cooking. She once lured a Chinese cook away from Pritzlaff by offering to double his salary. (The cook stayed with the artist only for a year.) They shared an interest in Hawaii and in traveling to exotic places. They were both single, and there was a gap of only a little more than ten years in their ages. They both disliked so many other people that it seemed to some that they were stuck with each other.

But O'Keeffe enjoyed other male friends as well. She liked being around men, and she tended to prefer sensitive homosexual men who would not make any aggressive demands on her and would allow her to take the lead in the relationship. Around this time she took a long driving trip to Mexico with the poet Spud Johnson, who, along with his male lover, Witter Bynner, had been her friend for some time. She had been planning the trip with Johnson since the Pan American Highway into Mexico was opened. Johnson was a thin, fey man who wore white T-shirts and blue jeans and had filled his tiny adobe house in Taos with tin

toys. He had driven O'Keeffe back east during the forties.

When Spud suggested that they join his good friend Eliot Porter and his wife, Aline, Georgia consented only grudgingly. Georgia had known Eliot since the 1930s, when she had helped Alfred curate a show of his nature photographs at An American Place. (A former chemist and the brother of famous American landscape painter Fairfield Porter, Eliot took up photography under the tutelage of Ansel Adams.) The problem was that Aline and Georgia did not mix well. Aline was also a painter and would later exhibit her work in Betty Parsons's gallery in New York. A sophisticated Bostonian, her precise diction and easy culture probably unnerved the rusticated artist.

They traveled in a caravan of station wagons. The Porters led the way, and O'Keeffe and Johnson followed in her wood-paneled Ford. The first day on the road, trouble began. The Porters pulled over promptly at five for an evening's liquid libation that lasted until seven. Then they set up a tent camp along the road, since there were few lodgings on the newly opened Pan American Highway. O'Keeffe was not drinking at this time, and being self-centered, she did not want to watch other people do so. She said how she felt. Johnson wanted to drink with his pal after driving all day (he did the driving, while O'Keeffe looked out the window) and insisted that they stop when the Porters did. She and Johnson rowed, and Georgia became testy around Aline. By the time they reached Mexico City, the car caravan had separated and was not reunited for the rest of the trip.

O'Keeffe was enraptured by the power of the ancient cultures of Mexico and by the seething undercurrent of violence in the new nation. She and Johnson visited Diego Rivera and Frida Kahlo for lunch one day. She stayed with Miguel Covarrubias, one of the premier Mexican artists, and his wife, Rose—they were friends from New York. Visiting the Mayan ruins south of Mexico City and touring the famous murals by Mexican artists to whom she referred as "the boys," O'Keeffe was deeply impressed by the personal approach to art in Mexico. "A feeling of violence and rev-

olution—They are all that way," she wrote of Mexican art. "You feel it as part of their lives."

Although they did not see each other for some time after they returned from Mexico, the Porters eventually invited O'Keeffe for Thanksgiving dinner at their house in Tesuque, a pueblo in a wooded canyon outside Santa Fe. Eliot recalls that he invited Georgia to dinner because he felt indebted to Stieglitz for getting him started in photography and because he felt sorry for her that no one else invited her to their house on holidays. Georgia and Aline eventually established a working peace, but Georgia remained closer to Eliot. Eliot and Georgia later joined friends for a rafting trip down the Colorado River. One night, after the group pulled the rafts onto shore for the evening, they hunted for rocks and fossils. Porter found a magnificent smooth river rock. O'Keeffe, who collected rocks, admired his find. Not being shy, she asked Eliot to give her the rock.

"I wouldn't give it to her. I said it was for my wife. And then she came to our house for Thanksgiving, and my son Steve and I thought we would play a trick on her. So we put the stone on the middle of a black marble table in the living room without anything else on it to see if she would spot it. And she did right away, and when she thought we weren't looking, she put it in her pocket. I eventually confronted her with that, and she gave it back—not at all embarrassed. After talking it over, my wife and I decided to give it to her when we next went up to Abiquiu. So we gave her the stone."

O'Keeffe's misanthropic behavior underscored her isolation. Life without Stieglitz seems to have been lonely, and she floundered without an anchor for some time. In 1953 she even built a bomb shelter behind her studio in Abiquiu, reflecting her fears as well as her preoccupation with her own individual needs. She hired a deaf housekeeper, she told people, so she would not have to speak to anyone. With the exception of her nephew William Schubart, who managed her investments, the artist had little contact with the Stieglitz family. After the death of Claudia's companion Hil-

dah in 1958, Claudia's summer visits turned into lengthy
stays. Phoebe Pack is under the impression that Claudia
lived with Georgia at this time.

Claudia was Georgia's companion for the rest of her life
and probably her closest relative. Although they would fight
"like cats and dogs," the two sisters, who had shared a
halcyon summer on the Texas Panhandle in 1917, were very
much alike, a fact that Georgia never would have acknowl-
edged. "Oh, she said the meanest things to her," said a friend.
Georgia surprised people by making fun of her sister because
she had chosen to live with another woman. Claudia had
been freed of the burden of having to work when oil was
discovered on her property in Los Angeles, and she set out
for New Mexico each spring in a Lincoln sedan with a pair
of lhasa apsos and a Filipino maid named Fita. Claudia
eventually took on the vegetable garden; her older sister
beamed with pride when she grew a five-pound tomato one
summer. To keep a semblance of peace, the two sisters
divided Georgia's property. Claudia stayed in Abiquiu, while
Georgia stayed at Ghost Ranch. They visited each other for
meals.

Georgia had little contact with the rest of her family. After
the particularly painful visit with Anita and Bob in Palm
Beach, she stopped visiting them altogether. Anita never
visited Georgia in New Mexico—her family felt it was be-
cause it was too dry and too primitive for her. When Cath-
erine came to visit in the fall, Georgia often put her with
Claudia in the Abiquiu house and remained by herself at
the ranch. She did not spend holidays with her sisters. She
spent one Christmas in Old Wick, New Jersey, with Esther
and Seward Johnson and their two children, Jennifer and
James. O'Keeffe enjoyed both Esther and Seward—an un-
usual situation for the artist, who did not tend to like both
members of a couple. Essie was her walking companion,
whom she had met in Nassau in 1940. The two women now
took long hikes on the Johnsons' three-thousand-acre farm
with Esther's standard poodles. Esther loved dogs almost as
much as Georgia did. Georgia later told Esther's daughter-

in-law Gretchen that Esther used to stand on silk uphol-
stered furniture and throw her dogs greasy bones—a dis-
regard for finery that the elderly artist applauded. Esther
recalls that O'Keeffe insisted that they string cranberries for
the tree—she said it was "good for the soul to use the hands."
Although James Johnson, known as Jimmy, seems to have
been afraid of his mother's severe-looking friend, he was
impressed that O'Keeffe knew what he wanted as a present—
she bought him a toy model of a Cadillac sedan that was
popular at the time.

Eventually, O'Keeffe stayed at home on holidays. The
local people in the village of Abiquiu had adopted her as
one of their own and took her in. On Christmas they fed
her bowls of *posole,* hominy stew with pork and hot green
chili, hot chocolate, and *biscochitos*—thin cinnamon-coated
wafers. The artist wrote to a friend, "Christmas is very pretty
here with many candles in paper sacks outlining roofs and
walls—and luminaries—fires of pitch wood that flares very
brightly in front of all the houses where people can afford
it—each one has 9 or 12 fires in a row—it makes the little
village very pretty and smell very good as the pitch wood
burns."

Easter was the most exciting holiday in deeply Catholic,
Hispanic Abiquiu. While the seasonal spring winds blew
fiercely from the west, the local people reenacted the biblical
twelve stations of the cross around the morada and sang
low and mournful *alabados* grieving the death of Christ, often
accompanied by a mock crucifixion. A few of the locals
insist that occasionally a man was actually crucified, using
silver nails to prevent lead poisoning from iron nails.
O'Keeffe loved the violence and mystery of the secret proces-
sion. She hid behind her wall as the Penitentes passed on
their way to the morada. She wrote: "I have never experi-
enced anything like this week—the church overpowers the
little group of houses—and there is so much praying—so
much parading—with sad doleful singing—tunes that seem
to come from a long long experience—every day feels like
Sunday—I've just been up on the roof listening—The old

fellows who were important handed down the word that they should sing so that the hills would ring back the song— the songs are short and get their strength from being repeated again and again as the procession comes down from the hills and goes to the church—then after a time leaves the church and goes back up the hills—It is oddly moving with the faintest touch of green just coming—and the long dark mesa back of it all—."

O'Keeffe did not paint either the Penitentes or their *morada,* one of the most beautiful buildings in northern New Mexico. She told people she respected the tradition of their ways and the privacy of the people. The Abiquiuians were an indigenous people at risk of being subjugated, and for some time they had been ridiculed for their primitive customs. She restricted her Abiquiu paintings to the landscape and the door on her patio wall.

O'Keeffe's painting style became simpler and simpler as the years passed. She began to see the world as a minimalist painter, with less emotion and greater intellect. She did not employ the energy and bravado of the popular abstract painters of the fifties, however. She had no use for Jackson Pollock. She said she thought his work was a big mess. Pollock's big "drip" paintings were frantic compared to her own work, which was quiet and calm. It had no place in the brash fifties. For the most part, it consisted of compositions of rectangles, like *Patio with Black Door* of 1955. She returned to the themes she had begun in Canyon forty years earlier— of zigzags across the sky at night. She began to try to imitate the style of simple Chinese brush paintings and read haikus, short poems in which a thought is contained in a breath, to train her mind. In 1946, on the death of Stieglitz, she had painted a single black bird crossing a field of white shapes—symbolic, in occult circles, of death.

O'Keeffe showed her work in group shows at the Downtown Gallery. Sales were slow. The market for her work did not disappear, as it did for works by Arthur Dove and Marsden Hartley, but nor was it robust. When she was in New York, she spent time with Doris Bry, Spud Johnson, and a

few other old friends. She ate beef with oyster sauce and garlic shrimp at Chinese restaurants on Third Avenue. She stayed in a plain room in the genteel Stanhope Hotel, across Fifth Avenue from the Metropolitan Museum of Art. Dressed in black, she haunted the Chinese art collection at the Met.

She became obsessed by a woman who ran a bookstore. Frances Steloff, a single woman, owned the Gotham Book Mart, a popular literary gathering place where authors like James Joyce and T. S. Eliot had launched their books. Copies of contraband D. H. Lawrence books were sold there, and O'Keeffe deposited back issues of *Camera Work* for its shelves. Steloff was an attractive, curvaceous woman, most likely a lesbian, who dressed like a girl in dirndl skirts and a pony tail, although she was in her early sixties. She had had close friendships with writer Anaïs Nin and other women over the years. O'Keeffe became as obsessed with Steloff as she had been with the house with the door; as Mabel Dodge Luhan had noted more than twenty years earlier, when O'Keeffe liked someone, she grabbed them. She wrote to Steloff, pleading with her to come to New Mexico. An occultist who followed the stars in her astrological chart, Steloff replied that she never left the Gotham, invoking a spiritual source as her guide in this matter: "The Gotham Book Mart," she said, "is not mine to do with as I wish."

For several years in the early fifties, O'Keeffe pursued Frances Steloff with steely determination. She ordered books on housekeeping from her, on Chinese art, and on Incan civilization in preparation for a trip to Peru, and brown-paper-wrapped copies of *Ulysses* and *Lady Chatterley's Lover* to be sent to Mrs. Seward Johnson in New Jersey. O'Keeffe kept contact with the Gotham Book Mart from Abiquiu. "I know you will come!" she wrote. She sent Doris Bry to the Gotham to clerk after Steloff complained of being short-handed, as if Bry were hers to do with as she pleased. One day in the fall of 1953, O'Keeffe visited the store and reissued her invitation to Steloff to come to New Mexico. She suggested Thanksgiving. Again the devoted bibliophile said she

could not leave the store. (Steloff lived in a couple of rooms above the store until she died in 1988 at the age of 101.) She said she had no one to run it for her in her absence. O'Keeffe seized the matter and turned to the young man who was her assistant. "You," she said, pointing to the man, "you can run the store, can't you?" He looked at O'Keeffe and at Steloff. He said yes he could. Steloff boarded a train for New Mexico at the end of November 1953.

O'Keeffe met Steloff at the tiny adobe train depot in Lamy, south of Santa Fe, and drove her through the same spectacular scenery up the Rio Grande and through the desert badlands that she had enjoyed ever since 1929, when she first took the trip north in Mabel Dodge Luhan's big Cadillac. She was thrilled to have her friend in New Mexico. She drove Steloff to Taos to visit Luhan, Frieda Lawrence, and Dorothy Brett. Steloff had already met them in her store in New York and now wanted to see them in New Mexico. She later remembered that Mabel asked her to stay one night with her. O'Keeffe then drove them along the ridge of the Sangre de Cristo Mountains to Richard Pritzlaff's ranch in Sapello. After a few days with Pritzlaff, O'Keeffe and Steloff headed back for Ghost Ranch over a steep mountain pass that descended thousands of feet to the desert, where Abiquiu was located. O'Keeffe was eager to impress her friend. She had planned activities for her so she would not be bored, although Steloff later recalled she would have been happier staying at O'Keeffe's, where she slept on the artist's narrow bed and watched the sun rise in the morning over the badland. O'Keeffe even planned vegetarian meals for her friend, an extreme sacrifice on the part of the artist, who generally ate red meat at nearly every meal.

Steloff recalled, too, that O'Keeffe was a terrible driver. She drove fast and recklessly. As they sped over the mountain pass on their way home in a big Ford station wagon, Steloff was frightened. It had begun to snow as they drove into the mountains, and the snow was sticking on the dirt road. O'Keeffe bore down on the car and squinted to see where she was going. Suddenly the car swerved and stopped.

They were stuck. Steloff, who did not know how to drive, got out of the car, intending to push them out of the snow. As she climbed out, she slipped on the ice and landed with a thump. She had broken her arm. It was incredibly painful. The next day she left New Mexico and never went back. For some time, O'Keeffe wrote to her, apologizing repeatedly for what happened, telling her it hurt her more than it did her. Steloff did not seem to hold it against O'Keeffe. Years later, in a conversation with this writer, she referred to the visit fondly as if it were a divine respite from her life in the bookshop. Their correspondence was thereafter reduced to a few cordial lines. O'Keeffe ordered books, and occasionally she asked Steloff how her arm was.

In the fall of 1953, O'Keeffe went to Europe for the first time in her life, at the age of sixty-six. She went with Mary Callery, a friend and artist who had traveled extensively in Europe and knew her way around. In the months before the trip, she had confessed to Pritzlaff that she was afraid to go abroad. She said that she had traveled all over "this country when I was young and that did not scare me. But foreign countries are another matter. I don't think I can do it." Callery took O'Keeffe on a whirlwind trip of European capitals. Like Evan Connell's Mrs. Bridge—the Kansas City matron who confessed after returning from Europe that she preferred Kansas—O'Keeffe was particular about her likes and dislikes and held most places in lofty disregard. She dismissed Rome as vulgar. She felt uncomfortable in France. She did feel at home in Spain—which was not too surprising, since she also felt at home in the Spanish-speaking parts of America and had been comfortable in Mexico. She became intrigued by bullfights, and in both Seville and Madrid she attended one every day, insisting on sitting right over the chute so she could watch the bulls charge onto the ring from above. She made some sketches of bullfights, but they never materialized into finished artworks. She visited the Prado in Madrid, where she was enthralled with the brutality of El Greco's tortured figures and the serenity of Goya's portraits. Because the Prado was a dark museum where the

paintings—although masterworks—were badly in need of
repair, O'Keeffe later reflected that there "must be something
wrong with me . . . [because] I was very excited about the
Prado."

In France, Callery asked her if she would like to meet
Picasso. O'Keeffe said no—"I don't speak French," she
pointed out reasonably, "and he doesn't speak my language."
O'Keeffe was probably aware that Picasso had been besieged
by admirers at La Californie who sought an audience with
him even though they did not speak Spanish, Catalan, or
French. In London, because she wore a turban, she was
mistaken for Edith Sitwell. In Paris, walking into a museum
one day, she noticed the Rumanian sculptor Constantin
Brancusi, whose work Stieglitz had first exhibited at 291.
"Georgia O'Keeffe!" the artist exclaimed on remembering
who she was. "But I thought you were dead."

Chapter 21

.

In 1964, O'Keeffe was driving from Ghost Ranch on a brilliantly sunny day when she experienced the shock of her life. As her Buick convertible rounded a curve in the road and the valley narrowed to a patch of greenery along the river, her vision was obscured. It felt, she said later, as if a cloud had entered her eyeballs—and, in a way, it had. She called a friend on the phone. "My world is blurred!" the artist cried into the receiver. For years, only those very close to the artist knew about her problem.

Although some days were clearer than others, her eyesight grew progressively worse in the years thereafter. She said she knew this would be the case even before she consulted her medical doctor. She saw Dr. Friess in New York in the fall of 1964. Friess told her she was suffering from what was known as macular degeneration, a disease that would progressively erode her central vision. The actual date of the onset of O'Keeffe's blindness differs in various accounts. Although many people put it at 1971, when she stopped painting, it is now clear that there was a problem as early as 1964, when she consulted Friess. In the spring of 1967, O'Keeffe told Pritzlaff that she could not come to visit because the sun hurt her eyes, saying, "I best not go out in it."

Being unable to see was nothing new for the artist. As a young woman, following a case of measles, she had temporarily lost her eyesight for several months. From Canyon, Texas, she had written to Paul Strand that she felt blinded after a bout of nervous exhaustion. This time, however, at

the age of seventy-six, the artist feared her condition was permanent—and she was right. There was no cure for the disease. Eventually, she would be able to see only out of the sides of her eyes, by turning her head like a horse. She would die in complete darkness.

It was a tragedy of epic proportions. Never again would the artist clearly see the red rocks and sharp edges of her beloved Ghost Ranch. Her view of the flat-topped Pedernal under a blanket of snow was gone forever. The White Place. The Black Place. The patio wall. The apricot trees in bloom. Her rich visual world had diminished and would continue to diminish. Of all the indignities old age presented to her— and there were many—this was the hardest for her to swallow. There were times when she told people she wished she were dead. A friend recalls that she sometimes covered her eyes with her hands and moaned.

O'Keeffe's world changed rapidly at this time. The world she had tried so earnestly to build was eroding, as a sand castle dissolves into the sea. Nothing seemed to go her way. Even Ghost Ranch was different. She had been aware that it was going to change for some time, but because it was painful, she denied it would. The change was put in motion in 1955, when the Packs donated the ranch to the Presbyterian Church. Phoebe and Arthur had decided to leave Ghost Ranch and move to Tucson. Breathing the thin air at the altitude of the ranch bothered Phoebe's weakened heart, and moreover, they found it difficult to run a dude ranch after the war ended. The appeal of Ghost Ranch as an isolated place was lessened once the road was paved and phone lines were installed. It was several years before the Presbyterians completed the changeover of the ranch into a religious retreat center for its members, but by the early sixties the transformation was complete. Where once there had been a handful of rich dude ranchers, there were now as many as several hundred Presbyterians on religious retreats.

O'Keeffe negotiated her way around the intruders. She kept away from the ranch lands where they might be found. She used a separate drive from the highway to her house.

"No trespassing" signs appeared around her house. Eventually, she grew close to her neighbor, Jim Hall, who ran the center, but in the early years of the retreat, she told people she had no use for the Presbyterians. Her resistance was fortified by one of the church members who addressed her as "girlie." In fact, when she learned that the Packs had given "her" ranch to the Church, she drove over to their house immediately. Without bothering even to close the door, she got out of her Buick and burst into the house, confronting her friends once again. By now, the Packs were accustomed to her fits of anger. But the officials from the Church were not. In the presence of several officials, she told the Packs how she felt, as Phoebe recalls vividly.

" 'Well, of all the things I have ever heard of in my life,' Georgia said, 'why did you give [the ranch] to a church?' Arthur said, 'That seemed the likely thing to do because they run the valley, the schools, all the big or little stores, down there.' And she said, 'Well, why didn't you give it to me?' And Arthur was taken aback completely for a moment—he didn't know what to say. And I popped off and said, 'Oh, Georgia, you couldn't possibly handle this whole thing. And it would cost a fortune.' And she said, 'Well, you could have done better than giving it to a church. I was next best, anyway.' And then she turned, the bishops stood there with their mouths open, and Arthur was embarrassed, but she turned her back and walked off and got in the car and revved it up and in a whole cloud of dust drove off. And she made one remark I forgot—she said to one of the bishops, 'I suppose this place will be creeping with churchy people from now on. Well, you can tell them to stay away from my house!' "

Phoebe was right: Georgia could not have managed the ranch. In fact, she could not even manage her own life. She once said she wished she lived in a tent and could open both sides and let the wind blow through, taking all her possessions with it. Like other artists, she found that the business of life interfered with the production of art. O'Keeffe was rare among artists in that her art became her life and

her life became her art—the line between the way she arranged colors in her paintings and the way she arranged a vase of flowers or organized a collection of rocks on a shelf was faint. In spite of the myth of her rugged self-sufficiency in the desert, O'Keeffe needed people to help her with this life. Between her two houses she had seventeen fireplaces that needed to be supplied with wood and cleaned regularly. Apart from Doris Bry, who worked full time for her in New York, O'Keeffe employed anywhere from two to five people as cooks, maids, gardeners, drivers, and companions.

O'Keeffe was never without a companion now—a stream of women flowed in and out of her house. These were generally women who, like Maria Chabot, were single, and they followed the artist everywhere she went, even on long trips abroad. She did not treat them well. During the fifties, she wrote to Pritzlaff and told him she was going to bring her "slave"—she had also referred to Chabot this way—with her when she visited for the weekend. Some of them, like Dorthy Fredericks, a local cowgirl who rode in rodeos, idolized O'Keeffe. At this time in the West, Fredericks points out, O'Keeffe stood out as strong and self-reliant: "She was my champion." Unfortunately, strong and self-reliant were hard characteristics to work under. One day, after O'Keeffe demanded without advance notice that Fredericks prepare a meal for a large group, she threw a pack on her horse and said good-bye. "You can't quit me," O'Keeffe said. "No one quits me!"

Plenty of people quit her. According to Phoebe Pack, O'Keeffe seemed to have a new companion all the time. Some women were never introduced to Phoebe. Others had only a first name. The one known only as "Betty," who was in fact Elizabeth Pilkington, the daughter of a local mechanic, Georgia had coaxed into working for her. Pilkington, probably because she viewed her work as a job, was able to strike a balance between the servile and the obsequious that pleased the artist. She worked for O'Keeffe for several years during the fifties.

O'Keeffe had known Dorthy Fredericks at Ghost Ranch

in the thirties. Fredericks, born in El Rito, New Mexico, with polio, told people proudly that she rode a horse before she could walk. But she was twelve before she could walk. Because Maggie Johnson felt sorry for her, she arranged for a plane to fly Fredericks back east, where she was operated on, enabling her to walk with a pronounced limp. O'Keeffe hired Fredericks when she ran into her one day at a shop in Española: "I drove, cooked, did whatever had to be done—you knew that if you knew O'Keeffe." Fredericks felt she and O'Keeffe got along because they were both independent women: "I can't stand beauty parlors. I can't stand gossip and women. I marched into a barber shop and said, 'I want a decent, short haircut. Now!' O'Keeffe and I had that in common. We both hated makeup." The local Spanish-speaking people who cooked, cleaned, and gardened for her tended to stay in her employ longer than the English-speaking people she hired. They were able to circumvent her tirades because for the most part they could not understand what she was saying.

Finding good help seems to have been O'Keeffe's only problem at this time. Now she even had time for other people's problems. In January 1958, when Georgia learned that a crisis had befallen her sister Anita, she was able to help her out. She learned of it from storekeeper Carl Bode. For although a telephone line had finally passed through Abiquiu, O'Keeffe refused to have a phone installed in her house. She resisted this sign of progress in her area and called it an intrusion (an irony, since she herself had boasted as a child that her father had invented the telephone). The crisis was that Anita's husband, Bob Young, had committed suicide. After taking breakfast in Palm Beach, he put the barrel of a twenty-two-gauge shotgun into his mouth and pulled the trigger. Anita and a maid had found his body in a pool of blood. In spite of her enormous wealth, Anita's life had been characterized by recurrent misfortunes. Her only child—a daughter, Eleanor—had died in a plane crash in 1941. And now this.

Georgia met Anita in New York and stayed with her for

several weeks at the apartment the Youngs kept in the Waldorf Towers, a deluxe wing of the Waldorf-Astoria Hotel, a block away from the Shelton. It was the first time the artist had been in New York in several years. Georgia took Anita shopping at Tiffany and Van Cleef & Arpel. She took her to the opera, to museums and concerts, and for lunch at 21. She did what Anita wanted to do. She was a dutiful older sister, a role into which she seems to have slipped with increasing grace throughout her life. She wrote to Marjorie Content Toomer, who was living with Jean on a farm in Pennsylvania, that she was at the disposal of her sister. Georgia took Anita back to Florida and made sure she was settled before returning to New Mexico.

Later, she took Anita to Europe to see the Lippizan stallions in Vienna and the bullfights in Spain. The sisters were escorted by Richard Pritzlaff, who had visited the Spanish Riding School frequently over the years and had many close friends in Vienna. Because Georgia was accompanied by someone Pritzlaff viewed as "her million-dollar sister, who liked the elegant life," he arranged deluxe accommodations for them in the Imperial Hotel. He took Georgia to the Spanish Riding School each day. Georgia told the director of the school that she had left her opera glasses at home and hoped he could provide her with a good seat where she could see, doubtless an early sign of her eye trouble. There, in the first tier of spectators, behind colonnaded boxes, they watched the formal exercises of the horses. Blue and white banners encircled the ring. The riders were dressed in scarlet cutaway coats with gold epaulettes, tricornered hats, white gloves, and white riding breeches tucked into shiny black boots. The catalogue promised "Horse and rider . . . the harmonious picture of the perfect unison of two living creatures." Anita spent her time touring elegant palaces in the area. Fascinated by eighteenth-century style and decoration, she bought entire rooms of gilt gold furnishings for her houses in Newport and Palm Beach. Georgia wore a black hood that looked like a nun's habit. Pritzlaff called it "her black outfit."

In Spain, Pritzlaff and O'Keeffe drifted aimlessly from bullfight to bullfight, like a couple of blood-crazed Americans out of an Ernest Hemingway novel. Although she said she was not a creature of habit, she seems to have been at times incredibly single-minded, listening to a recording of the same Beethoven piano sonata over and over, going to bullfights over and over, wearing the same clothes over and over. One day they visited a small nearby chapel where the matador's family eagerly awaited his return. As Georgia entered dressed in her black hood, the mother of the matador fainted—she thought the artist was a nun who had come to tell them the matador had been killed and would not return.

Anita did not act as if she needed her sister's comfort. Seizing hold of her late husband's empire, she fought with the shareholders of his railroad and blocked a suit by his relatives to stop her inheritance. Young had died only days before he was to be indicted on charges of skimming cash from Pennsylvania Railroad and other malfeasance. Although an exact figure has never been placed on her wealth, some have said it was as high as a hundred million dollars in cash, an enormous amount of money in 1958—enough to make her one of the richest women in the world. One of the relatives who sued her was Robert McKinney, publisher of the Santa Fe *New Mexican* and husband of Georgia's great friend Louise Trigg. After McKinney and the other relatives lost their suit, Georgia was apologetic about Anita's tough behavior during the contest. She said, "I am not at all like Anita"—an error in self-perception, since Georgia herself was getting tough these days.

O'Keeffe had had to watch as the demand for her work dropped noticeably in the late fifties. Now she began to search for ways to improve her sales. Although she was not rich, she had a manageable income from her investments and needed little. She suffered from a fear typical of many people who live on fixed incomes—that they will lose their capital and not be able to recover it. She blamed her dealer, Edith Halpert, for her sales decline. Although Halpert was

noted as a successful salesperson who was willing to sell pictures to anyone with the money, O'Keeffe claimed that the Downtown Gallery displayed her work poorly and was not aggressive in promoting it. In the early 1960s she removed her paintings and drawings from the gallery and stored them at Manhattan Storage Company on Third Avenue and Eightieth Street. Then she gave over the responsibility of representing her work to Doris Bry, who handled it exclusively from an apartment in a mansion off Fifth Avenue.

Bry worked in a quiet and effective way with O'Keeffe's work. Bry took her job seriously and shielded O'Keeffe by telling people that the artist could only be reached in a complicated arrangement that involved phoning a person five hundred miles away in Tucson, who would relay the message to O'Keeffe in Abiquiu. When people inquired about buying an O'Keeffe painting, Bry grilled them about their motives as Stieglitz had earlier. One buyer said she felt Bry was trying to make it difficult for them to acquire an O'Keeffe: "She wanted to know who I was . . . why I wanted to see them . . . whether or not I would be prepared to buy them. And she asked specifically what kind of picture I want. In other words—she didn't make it easy, let's put it that way."

O'Keeffe and Bry related to each other very well for some time. When they eventually fought, as nearly everyone close to the artist did, they fought emotionally and bitterly. Some observers felt that their relationship resembled that of mother and daughter; "The role that Doris took was unusual," says Betsy Miller, who along with her husband, Robert, operated the Robert Miller Gallery in New York. Bry was in many ways like the Totto women with whom O'Keeffe had grown up: arch, supercilious, and stern—just a beat short of pretentious. She spent a portion of each summer in Abiquiu with Georgia and Claudia and became like family.

Bry was in New Mexico in the summer of 1960, when four of the O'Keeffe sisters—Claudia, Georgia, Catherine, and Ida—met in Abiquiu for a final reunion. (Ida died of

a stroke in 1961 at the age of seventy-one, an event that passed through Georgia's life with no show of emotion on her part. Georgia had had little contact with Ida at the end of her life. The kind sister with whom Stieglitz had flirted and who took care of Mabel Dodge Luhan had drifted away as the years passed: "In some odd ways," Georgia wrote Claudia of Ida after her death, "it is a wasted life.") When she was in New York, O'Keeffe naturally spent a great deal of time with Bry. Bry became indispensable: She knew where every painting was and was responsible for all of O'Keeffe's sales.

During the thirty years she worked for O'Keeffe, however, Bry made few contributions to furthering understanding of O'Keeffe's work: she wrote an affectionate profile of her employer for the *American Association of University Women* magazine, produced a slim volume of drawings, and was listed as guest curator of a museum exhibition. An officer of a major New York museum was under the impression that Bry's abilities were not what impressed the mercurial artist. "O'Keeffe kept her around because she liked having her around."

O'Keeffe was not entirely dependent on Bry for emotional support, however. When she discovered her eyesight had failed, one of the first people the artist called was Peggy Kiskadden. O'Keeffe had first met Peggy in the late 1930s. Peggy had been divorced from Philadelphia publishing heir Curtis Bok. After she moved to Beverly Hills to be with her third husband, William Kiskadden, Peggy became a frequent visitor to Ghost Ranch—leaving her husband at home when she went for a couple of weeks to New Mexico. "Georgia called and she said, 'Peggy, my world is blurred!' It was a cry of utter agony. I rushed to be with her. A tragedy. A real tragedy."

Like many of the artist's close friends, when asked about her relationship with O'Keeffe, Kiskadden described an intensely private and exclusive bond, in the precise diction of the Main Line of Philadelphia, which she characterized as mother-daughter, "You understand: It was always a one-on-

one relationship and you didn't think of her as part of a group. Georgia separated her friends very neatly." Kiskadden and O'Keeffe would take long walks together, collecting rocks and old wood which they found along the way. Kiskadden was never introduced to the artist's many other friends. She met Claudia only once and later allowed that she felt the artist's sister was "suspicious" of her friendship with Georgia—possibly because Georgia seems to have made an effort to keep the two women from getting to know each other despite the fact that they both visited Ghost Ranch during the summers and both lived in Beverly Hills. Kiskadden recalled that she and O'Keeffe spent hours discussing "all sorts of things," including the relationship of Buddhism to the modern world and the political situation in the Nixon White House. "She had an active intellectual life. That's what the paintings were about."

Kiskadden looked up to the elderly artist because she was like no one she had ever known before. Raised in a conservative, "very, very limited" circle, Kiskadden had found life difficult in the 1930s as a divorcee in Philadelphia—and she was drawn to O'Keeffe, a strong, independent woman, who was at that time living alone in New Mexico. "Somehow we immediately clicked," she recalls. "[Georgia] said, 'You come back to visit me.' In about a few months I telephoned and said, 'Do you think I could come?' After that she took the initiative. When I hadn't been to stay with her for a while, I would get a telephone call: 'When are you coming?' I would say, 'In a few weeks.' She would say, 'See that you do.' She just counted on me, I think. She knew that I loved her very much. And that I was not after anything." After O'Keeffe began losing her eyesight, Kiskadden went to New Mexico several times a year.

Kiskadden also felt that the elderly artist loved her as well. She said that O'Keeffe just liked to know that she was there. One evening at the ranch she went to bed early, complaining of a sour stomach. At two in the morning she awoke to discover O'Keeffe sitting in a chair next to her bed, watching her sleep, "quite quietly. I said, 'What are you

doing?' She said, 'Just looking.' She really cared that I was
ill. Which was so extraordinary. I mean I could get over it
by myself."

Kiskadden was not the only rich woman to be involved
with the artist in her later years. O'Keeffe was also a partic-
ipant in a closed social circle of rich, conservative New
Mexican women who lived in and around Santa Fe in the
1950s and 1960s; Santa Fe had become a second home for
rich Texans and New Yorkers who enjoyed the healthful
benefits of its dry climate. Louise Trigg was a full-spirited,
handsome Texan who presented herself, like many of
O'Keeffe's friends, simply, with no makeup or jewelry, ex-
cept perhaps a turquoise and silver bracelet. She was orig-
inally from a prominent ranching family in West Texas. The
Trigg Ranch was one of the largest in West Texas, but the
source of most of her wealth was her husband, Robert
McKinney, who as a New York stockbroker had amassed a
large fortune during the forties. Trigg and O'Keeffe fre-
quently had lunch together tête-à-tête. These lunches often
took place without advance notice, at O'Keeffe's behest. Ac-
cording to Trigg, O'Keeffe would call and invite her out to
Ghost Ranch. Trigg lived an hour's drive away at Rancho
Acequia in Nambé. "Louise! What are you doin'?" she re-
members her asking every day she wanted to have lunch.
If Trigg said she was busy and could not come out to the
ranch, O'Keeffe would often invite herself over to Trigg's:
"Well, then, I'll come over there." Trigg points out that
O'Keeffe was her only friend who operated in this way. But
she did not mind—she even canceled dates to have lunch
with her famous friend. O'Keeffe had the brash habit, Trigg
recalls fondly, of going into the kitchen to see what the cook
had prepared to eat before she greeted her hostess. It was
generally felt around Santa Fe that people allowed Georgia
O'Keeffe to behave however she wanted because she was
famous—although some hostesses felt she was gauche.

Along with common garden herbs, O'Keeffe seasoned
some of her foods with lovage, an herb worn by women in
the Middle Ages to attract lovers. Although Trigg did not

recall being particularly impressed by O'Keeffe's kitchen, other guests remembered lunches at Ghost Ranch because the food was fresh and prepared simply to enhance its natural flavors. One guest recalled having been served fried flowers.

Trigg was an amateur artist herself who produced competent watercolors and amassed a collection of *retablos*—brightly decorated native New Mexican religious carvings. She never bought an O'Keeffe painting, and the artist never gave her one, as Trigg often pointed out. Trigg felt they were too expensive for her, even though she was one of the richest people in New Mexico and paid nearly as much for a head of the prize-winning Black Angus cattle she raised at Rancho Acequia as she would have paid for a picture. Years later, she remembered the way O'Keeffe often said, "Isn't that pretty?" pointing to a view or a flower. There was a lot of pretty in Trigg's world. Because it was located in an oasis below a series of springs, Rancho Acequia was as green as Ireland from May through September. From the terrace of the sprawling ranch house, a magnificent view opened across lush lawns through hundred-year-old cottonwood trees to the red-rock desert and the snow-capped Sangre de Cristo range.

Trigg was a witty hostess and a good sport whose humor often centered on herself. She named her daughter Robin, she said, because when she was delivering her, "I just pulled her out, like a worm." At one time, she and a friend, Winnabelle Beasley, rode from Nambé to Santa Fe at night on Beasley's motorcycle (Trigg rode in the sidecar) on a vigilante mission. Armed with an ax, the two women chopped down advertising signs because they felt the offensive signs detracted from the desert scenery. Trigg and Beasley also flew over friends' ranches in Beasley's plane. They threw notes tied to rocks out of the plane as they buzzed close to the ground. The notes said, "Hello!"

Sometimes months passed before Trigg would hear from her famous friend. It was hard for her to get O'Keeffe to visit when she wanted to see her—O'Keeffe did the inviting.

Occasionally, she could lure O'Keeffe with the promise of an introduction to someone she wanted to know. J. Robert Oppenheimer, for instance, the man credited with inventing the atom bomb, was a regular guest at Rancho Acequia when McKinney was U.S. representative to the International Atomic Energy Agency. After Trigg named one of her prized peacocks Oppie, people asked if she had named him after Oppenheimer. "Oh, no!" she said with a laugh, then suggested the name carried two meanings: "His name stands for opportunist."

During her absences, when no one saw the artist, she was generally in her mystic's cave at Ghost Ranch. In her eighth decade, O'Keeffe arose at dawn, as she had in her first. She exercised every day and walked several miles with her dogs. She paid attention to what she ate, exchanged recipes for health foods with Phoebe Pack, drank iced mint tea and ate homemade bread, and lay on a chaise longue in the bright desert sun—"the sun that burns through your bones."

As her eyesight began to fail and her body slowed down in her seventies, O'Keeffe turned increasingly to spiritual sources for guidance. As early as 1956, the artist journeyed to Peru in search of Incan secrets to other worlds. Although she did not exhibit the results, she painted several views of the mountain Machu Picchu, the sacred apex of Inca civilization. She and her companion, Pilkington, traveled for several months on their own through dangerous mountain terrain in the volatile country. In 1958, she painted *Ladder to the Moon,* an obviously spiritual picture of a homemade ladder stretching in the sky toward the moon. The flat-topped Pedernal Mountain, which she also painted repeatedly, was home to the mythical Changing Woman and was O'Keeffe's sacred apex. "It's my private mountain," she joked, "it belongs to me. God told me if I painted it enough I could have it." Some of her friends laughed when they heard her say this. They said it was just like Georgia to try to make a pact with God.

In the early 1960s, on a trip around the world, she spent

seven weeks in India. She returned, she said jokingly, because she wanted to find one of the rusted can openers she had seen littering the Hindu temples, but she was struck by the sights of the subcontinent, later recalling to Pritzlaff that the men sleeping in the streets looked like bundles of rags. Later she took several trips to Japan. She continued to read books about Buddhism and four volumes of Oswald Siren's *History of Early Chinese Painting*. She bought a bronze hand in a shop in Hong Kong. It was called *abhaya mudra*, which roughly translates to "fear-not." She hung the hand by her bed, where she could see it every day. She talked about religions to people and had staff read to her from Basho's *Narrow Road to the Deep North*, a book of haiku poems. She never attended a Presbyterian service, but when a Benedictine monastery was built near Ghost Ranch in a secluded canyon along the Chama River, O'Keeffe began to go to mass there. It was a modern mass, conducted in English, in which the congregation would circle around a stone altar, Greek Orthodox style, and chant psalms. She began to tell people that she could convert them to Catholicism (probably since so many priests over the years had tried to convert her) but that she preferred to remain independent religiously. It is possible that she realized Carl Jung's observation that organized religion is for people who do not want a spiritual experience. She told one visitor, "My mother was Episcopalian. My father was Catholic. An aunt who lived with us was Congregational. That got me thinking." After her eyes failed, one of her maids swore she saw the artist kneel in front of a blank canvas before she painted. It seemed the artist was praying.

Chapter 22

· · · · · · · · · · · · · ·

Once again the artist stood by herself at an opening of an exhibition of her art. She was in the concrete Whitney Museum of American Art on Madison Avenue in New York, watching a crowd young enough to be her grandchildren, or even great-grandchildren. Even at eighty-two, O'Keeffe still disliked attending her own openings. To make sure things looked right, she had worked nights, driving the curators at the museum crazy with her demands. "Working with Georgia O'Keeffe is easy," one curator said, "as long as you do everything her way."

Having already received several retrospective exhibitions, O'Keeffe was rare among artists to live to see the highlights of her career laid out once again. At that time, retrospectives normally occurred at the end of an artist's career—often posthumously. Although many of the familiar images—cow skulls, jack-in-the-pulpits, barns, skyscapes, and pelvic bones—had already been seen in the other exhibitions, there were also images that had been created in the period since Stieglitz died that were exhibited here. Leaving behind the doldrums the artist had entered after the war, she was once again considered a vital force in the art world, turning out amazingly contemporary—contemporary being 1970— works for such an old modernist. When she told people, as she increasingly did, that she had died many times after looking over her work, they tended to believe her. It was indeed the work of many lifetimes.

She looked like a grandmother's grandmother. Her face and hands and body had caught up with the antiquated

garb she had been wearing since the teens, and she acquired
the eternal beauty of the very old. Her peers had left her
behind, and she faced a future of disability by herself. Doris
Bry, who had curated the exhibition along with the Whit-
ney's Lloyd Goodrich, was one of the few faces she recog-
nized in the large crowd. Otherwise, the crowd was a blur
of faces due to her diminished eyesight. Suddenly in front
of her was someone out of the distant past. "Georgia," the
face said, "it's Ted Reid." It was the boy from Canyon, the
student who had caused a commotion when he came to her
room. He looked old. She remembered him when he was
young. She said, "My, you look old."

O'Keeffe had once been famous for living out of wedlock
with Stieglitz, for painting flowers that looked like genitalia,
for being the only woman artist in her generation to achieve
a degree of success, for a unique sense of fashion, and for
bravery in settling in a remote part of the country by herself.
Now she was famous for being female and old. O'Keeffe,
who had never fully comprehended the other reasons for
her fame, maintained a sardonic detachment from her new
role as a famous old woman. Although she enjoyed the
attention, having almost forgotten in the years since Stieglitz
died what it was like to be noticed, she acted as if it were
no big deal. At the same time, although she said she was
unaware of it, she had played a part in her own revival. By
extolling the virtues of her isolated rugged life in the desert,
she had brought herself to people's attention. Hers was a
modern dilemma—she wanted celebrity, and she wanted
privacy. As Stieglitz had taught her, "People buy art through
their ears and not their eyes: one must be talked about to
sell and sell to live."

The world was catching up to Georgia Totto O'Keeffe.
The road from Española to Ghost Ranch had been paved
with blacktop, and a telephone with an unlisted number
had finally been installed in her Abiquiu house and later in
the ranch house. People began to recognize, as O'Keeffe had
most of her life, that eating well was a key to good life.
Although by no means a fanatic—the artist ate red meat

nearly every day and loved mashed potatoes with gravy, apple pie, and homemade sausage—she used the Adelle Davis method of beginning the day with a huge breakfast, followed by a large lunch, and ending with a tiny dinner. The theory is that people eat too much at night because they have starved themselves all day; going to sleep on a full stomach, they gain weight. She ate her last meal of each day around five-thirty, retiring for the night when the sun went down.

O'Keeffe's artworks appealed to people in the 1960s. Psychedelic colors had been the first new hues introduced into artists' palettes since the Renaissance, and art was undergoing a revolution of styles. O'Keeffe's use of bright pinks seemed in step with the times, even though she had been ridiculed for using these colors in the 1920s. The references to a mystical world in nearly all her works also appealed to a period when Eastern religions and spiritual books by Hermann Hesse and Thomas Mann were undergoing a revival of interest. O'Keeffe's life and work spoke to a generation of men and women looking for another way of life. Her self-sufficient life in the desert took on an almost biblical importance. Her choice of feminine colors and her documentation of a woman's response to the world of botany and the landscape of the Southwest appealed to growing ranks of feminists, who attempted to enlist her in their movement—without much success. Artist Judy Chicago made O'Keeffe the center point of her tribute to women artists, *The Dinner Party,* by lauding the elderly artist for having depicted female genitalia—exactly the interpretation O'Keeffe had attempted to avoid. The frail woman who had opposed war in 1918 seemed in step with antiwar marches in 1970.

The renewed interest in her work had been touched off by an exhibition in the Metropolitan Museum of Art in 1958. In "Fourteen American Masters," which surveyed American art, O'Keeffe's work was given its own room. It was the first important show of her work in twelve years. In the fall of 1960, in the Worcester Art Museum in Massachusetts, her

old friend and ardent supporter, Daniel Catton Rich—who had put together the 1943 retrospective in Chicago—presented a one-woman show of her art. Since then, O'Keeffe's work had been exhibited primarily in group shows in regional museums in backwaters in Ohio and Indiana. Clement Greenberg's 1946 denunciation had left a wide wake, and new interest in her work had been slow to develop.

What had fascinated observers of the 1960 Worcester exhibit was the way her work kept pace with the times. *White Patio with Red Door* (1960) and *It Was Blue and Green* (1960) were as contemporaneous as paintings by Mark Rothko or Clyfford Still, who were heralded as the young geniuses of their generation. Even O'Keeffe's early work was so contemporary-looking that, until they looked at the dates, some people thought she was aping what was fashionable. O'Keeffe resisted being called an abstract painter, as she had resisted all other labels during her lifetime—including *woman* artist. She said her paintings were actually realistic views of the way she saw rivers from the window of an airplane thirty thousand feet above the ground: "There's nothing abstract about those pictures; they are what I saw—and very realistic to me. I must say I changed the color to suit myself, but after all, you can see any color you want when you look out the window" of a plane.

After the advent of jet travel made the trip easier, O'Keeffe had traveled around the world. What she depicted afterward was not the temples or the mountains or the deserts she visited. She depicted the view out the window of the plane. The view from a plane window was so exciting to the artist that it inspired her to embark on the largest painting she would ever create. *Sky Above Clouds IV*, as the title indicates, was her fourth—and largest—depiction of the view looking down on a bank of white clouds from a plane window. As in most of her work, the artist continued to explore one theme in different formats.

Measuring eight feet by twenty-four feet, *Sky Above Clouds IV* was not the crowning glory for which the artist seems to have hoped in her largest painting. Although it was the

cornerstone of the 1970 Whitney exhibition and has been included in other exhibits since that time, it is generally viewed as a curiosity rather than as an integral part of the artist's oeuvre. Painting such a huge canvas posed a challenge to an artist who was most proficient in a small format of nine by twelve inches. The last time she had attempted to make a picture as big as a room—in 1932 in New York—she had collapsed under nervous strain. Since her vision had become blurred the year before, the undertaking acquired a heated urgency. She wanted another chance at painting a big canvas before her eyesight failed altogether.

There was not enough room in the studio at Ghost Ranch for the painting—she had to rig a studio in the garage. She became obsessed by the painting. Working from six in the morning until nightfall, she stopped only for meals. It was a race against time. She felt she had to finish the picture before winter arrived because the garage was unheated. She mixed the paint in a Mixmaster in the kitchen and carried it out to the garage in pails. A local girl came to the ranch and lived with her while she was painting. She even allowed the "little girl" to care for her "in her way, as I didn't have time to teach her mine."

After she had completed her canvas, O'Keeffe invited Phoebe and Arthur Pack over for an unveiling and supper. She cooked a steak in a pan on her stove, which she served simply along with a salad and homemade whole wheat bread. Before they ate, she took them to the garage to view her new picture. The sunset glowed red and orange and yellow in the desert beyond. The painting, by contrast, was a cool composition of white shapes against a blue background. O'Keeffe asked the Packs what they thought of the painting. Phoebe was not altogether comfortable with pictures "that did not look like what they were." But she saw something: "I looked at it, and to me it was a bowl of bubbles. I mean it was sort of a round shape and it hadn't been framed, and in the whole picture was nothing but round things like disks. Like bubbles, was what I thought. And she said, 'Most people wouldn't understand this, would

they?' And I said, 'Gee whiz, I must be dumb, Georgia, no, I don't.' Arthur says, 'I do.' He says, 'You were in the plane looking down upon clouds.' Just like that. She said, 'That's right. You're the only person who thought that.' But clouds aren't round to me. I never saw a perfectly round-circled cloud in my life. But then, I never saw a ladder in the sky either."

O'Keeffe was on a roll. As she approached her eightieth birthday in 1967, she seemed as energetic as she had been in decades. Completing the big painting boosted her confidence and gave her strength to go on to new work. Finding new energy in her spiritual life that would grow with the years, she talked excitedly about Zen Buddhism and years later would send copies of *Zen and the Art of Motorcycle Maintenance* to friends. In 1966, her work was once again the focus of a retrospective exhibition. This time the show was near her home, in the Southwest. It traveled from the Amon Carter Museum of Western Art in Fort Worth to the Museum of Fine Arts in Houston, then completed its run at the University Art Museum in Albuquerque, a little more than one hour's drive from Ghost Ranch. Although the artist had lived in New Mexico for almost forty years, it was the first major showing of her work in her home state. At each stop in the schedule, O'Keeffe was present, along with Doris Bry, to make sure the show was exhibited to meet her specifications. Officials at Amon Carter recall that she became irritable over the way they handled her work.

O'Keeffe's image was boosted in November 1967, her eightieth birthday, when *Vogue* devoted pages of its premiere fall fashion issue to her rugged western style of life. Dolled in a quilted paisley turban, her spare aesthetic was given a shot of New York glamour. O'Keeffe in reality never looked as dressy as she did in *Vogue,* but the extensive coverage pleased her enormously. "I thought it was rather grand," she wrote to a friend. What was remarkable was the way O'Keeffe's face suddenly looked: At a time when most models seemed to be thirteen-year-old starvation cases, her face

looked as old as time—as weathered as one of her bones—etched with more than a thousand lines.

O'Keeffe was becoming more famous than she had imagined she would ever become. But being famous as a woman artist was one thing—being famous as a woman who aged well was another. She could not have been prepared for the onslaught of the next twenty years. After the Whitney show, her popularity skyrocketed. She received crank calls and bags of fan mail. In the St. Louis airport, where she was changing planes en route from New Mexico to New York one day, she was confronted by one of her new fans. "Are you Georgia O'Keeffe?" the admirer wanted to know. The artist, unable to see where she was going, was confused and upset by the sudden confrontation. She said, *"No!"*

Friends and relatives suddenly appeared to visit her. Whereas during the 1950s people thought she had died, now they wanted to take up all her time. Her plain Wisconsin sister, Catherine Klenert, visited as she had before, now bringing along not only her daughter Catherine Klenert Krueger but her grandson Raymond and her granddaughter Georgia. Catherine Krueger, her shy niece who had visited her in the thirties, had kept in touch through her mother, who was a frequent visitor to Abiquiu. Catherine Krueger named her daughter Georgia after the artist.

Catherine Krueger's visit, like many of the visits Georgia endured over the years from her far-flung relatives, was characterized by misfortune. Young Raymond Krueger asked why she had a plywood table and looked in awe at the "raw" meat his aunt served him. A few days after they arrived, Georgia Krueger was driving her great-aunt's Volkswagen van when she rounded a corner going too fast. The van rolled over. Luckily, no one was hurt in the accident. A few days later, however, young Raymond Krueger slipped on some rocks hiking at Bandelier National Monument in nearby Pojoaque. He broke his wrist. Georgia liked her relatives and wanted to help them out, but the gap between them was sometimes enormous. She sent money to Georgia

Krueger to attend the University of Arizona, continuing a
legacy that began when her aunts had sent her to school.
She offered to finance Ray's education if he attended Har-
vard, but Ray selected the University of Wisconsin and paid
his own way.

Then a niece she had not seen in twenty years appeared
with her two children: June O'Keeffe Sebring, Alexius's
daughter. Georgia had entertained her in New York in 1946,
when June was on her way to Vassar; she had been married
and widowed since she last saw her famous aunt. June Se-
bring, as she was now known, had not visited her aunt for
some time because, she explained, she had been busy raising
a family and following her husband's career in electrical
engineering, which took them all over the country. On her
visit now, O'Keeffe showed her niece and her children where
to hunt for rocks in special places. At night, they polished
their finds on a machine that the artist had bought specif-
ically for that purpose.

Not all of June Sebring's memories of her only visit to
her famous aunt were pleasant. For one thing, there was a
problem with the food. O'Keeffe served Sebring's children
ground beef heavily spiced with garlic for breakfast one day.
They left most of it uneaten. The artist reheated the leftovers
and served it to them for lunch—then dinner. Sebring felt
this was cruel. She said reheating food that her children
clearly did not like over and over was pointless. She com-
pared her aunt somewhat jokingly to *Mommie Dearest*, the
book and movie about the extreme cruelty that actress Joan
Crawford inflicted on her children. O'Keeffe and Sebring
had little contact after the visit. Juan Hamilton later allowed
that he did not even know that she was related to the artist.
He thought she was simply a friend of Claudia's.

Anita Pollitzer no longer visited O'Keeffe in the summer.
She had devoted nearly fifteen years to researching and
writing a biography of her friend, and she was doubtless
crushed when O'Keeffe withdrew her permission for her to
publish her findings. Pollitzer's biography was eventually
published in 1988. It was not objective or thorough, but it

was a loving memoir by an adored friend. O'Keeffe offered to pay her for her time. "You have written your dream picture of me—," she wrote, "and that is what it is. It is a very sentimental way you like to imagine me—and I am not that way at all. We are such different kinds of people that it reads as if we spoke different languages and didn't understand one another at all."

Heartless as it sounds coming from a friend of fifty years, O'Keeffe seems to have been motivated once again by the overwhelming fear of exposure that had dogged her throughout her life and that would continue to bother her. Pollitzer was not a professional biographer; nor did she even consider herself a writer. Her touching efforts to write down her recollections of O'Keeffe in the early days of the artist's career have proven to be an invaluable source for later biographers. But because they did not jibe with the artist's self-perception, they were summarily dismissed as worthless. O'Keeffe's phobia served her poorly in this case, as it would again as she pushed away writers and scholars who could have loaned a fresh eye to her life and work with the determination of a miser hoarding a pot of gold. A few years later, when the young writer who would write the first published biography of the artist approached O'Keeffe, she refused to help her and told others not to talk to her.

O'Keeffe's best friends were often her newest. Now that she had become famous again, she was besieged by visitors all summer long. She picked and chose who would be allowed to stay from those who came near her. One woman waited outside in her car all day until Claudia finally let her in. Another showed up uninvited one day. Marilyn Thuma, a young artist from Chicago, stayed for the summer and returned the following summer. O'Keeffe sent her money to help her continue with her painting, exhibiting a generosity that followed her own logic. When Thuma was pressed for details about her friendship with the artist, she became withdrawn and said it was private. One day in the summer of 1968, a writer for a newspaper in Amarillo showed up unexpectedly. O'Keeffe answered the back door at Ghost Ranch

wearing a sapphire-blue house dress. The writer, Vivian Robinson, was surprised to see O'Keeffe wearing a garment that was not black or white. She admired the artist's silver concha belt. Robinson had made her way into O'Keeffe's life by calling Eliot Porter on the phone on the recommendation of a friend. "She's no friend of mine," said Aline, who had answered the phone. "She's a friend of my husband's." Aline had told Vivian how to get to O'Keeffe's house.

"Wrong day!" O'Keeffe announced through the fly screen in the door— after Robinson explained who she was. It was hot and still. Robinson had driven for over an hour from Sante Fe to see the artist. She told her this and explained she would only be in town for a few days. Finally, she informed her that she had brought some drawings to show her. A friend in Amarillo had found them in the schoolroom in Canyon where the artist had taught. She wanted to know: Were the drawings hers? Robinson held up the drawings so O'Keeffe could see them. They were of a female head and bust—most likely, her old friend Leah Harris. The artist was surprised. She opened the door and grabbed the drawings from Robinson's hand. Though possession is nine-tenths of ownership, she considered them hers. She did not want anyone else to see them or have them. She said she was going to tear them up. The two women sparred.

"She looked at them and said, 'Well, two of them are mine, the other one isn't.' And she slammed the door and went back into her house with them, and so I said, 'I'm not going to leave without those pictures.' And she said, 'Well then, you better be prepared to wait a long time because snakes come out at night.' I said, 'Well you just pray that they hit me in a vital spot because I'm not leaving here without those pictures.' I wouldn't follow her on in the house—I knew that would be illegal—so I just stayed outside. Said, 'I'm gonna call the police.' And she said, 'There isn't any telephone here.' I knew there was, because I could hear it in the background. It was a 'ding-a-ling-a-ling,' you know, it was an old country telephone. She said, 'I'll sic my dogs on you!' And I said, 'You just better pray again that

they hit me in a vital spot, because I'm not leaving here without those pictures!' We had quite a little conversation about that, about the pictures. Then finally she came out, and I asked her some questions I'd prepared myself a little bit here and there."

O'Keeffe finally let Robinson inside the house. She guided her through the studio, which was in disarray, and onto the flagstone patio in the cool center of the hacienda. A view of the flat-topped Pedernal rising several miles away opened up. The artist was still clutching the watercolor drawings. It had long been hard for her to part with her work. Seeing it exhibited in 291 had driven her to bed. Having people buy it and hang it on their walls and "pin their associations on it" incensed her. Now someone wanted her to verify that she had produced something no longer in her possession. She ran up the crude pole ladder to the flat roof. Robinson followed her, amazed that someone O'Keeffe's age could climb a ladder so effortlessly. "Like an opossum," she recalls. The artist attempted to impress her visitor with the desert view, but all Robinson could think about was how she would get back down the ladder.

For about six hours O'Keeffe talked to Robinson about her life in Canyon and Amarillo. It had been fifty years since she had left Texas, but the memories were as fresh as if it had been yesterday: the flat plains, the wide open sky, the wind that howled incessantly, the war, the small-minded people, the madness. The artist wanted to correct historical accounts of her life. She told Robinson that she had not been fired from her job at West Texas State Normal College—she had quit. It was important for O'Keeffe to be able to talk to someone about this. What had happened in the past had become extremely important to her. Reading Anita Pollitzer's manuscript had aroused her latent fears. Seeing the drawings had triggered a torrent of emotions. Finally, she gave them back to Robinson and invited her to return for lunch the next day.

Vivian Robinson returned to O'Keeffe's Ghost Ranch house a little before noon on the following day. O'Keeffe

liked to eat promptly at noon and had instructed her guest
to be on time. (One of her closest friends recalls that she
always arrived early at O'Keeffe's: "Georgia had a fit if I was
late.") O'Keeffe also extended her hospitality to David Ro-
binson, Vivian's son. Mother and son were studies in con-
trast. Vivian was a robust, outspoken person whose
stentorian tones were emitted in a thick southern accent.
David was a shy, sensitive boy who spoke in the halting,
hesitant tones of a person accustomed to opposition. David
was a junior at Southern Methodist University in Dallas,
majoring in art.

"She is the most remarkable person," David recalls. "She's
the one who taught me what garlic was. She had this servant
girl peeling off what I thought were small onions. And I was
hungry. She goes in for salads—wooden bowls, like that,
that she stacks up—never washes. And she said, 'I'm going
to show you how to make a salad.' It was a ritual. We're
Roman Catholics and she said she was sort of inclined that
way because of the ritual. And she rubbed the inside of the
bowl with garlic. And I thought, 'Well, that's kind of neat.'
So I just grabbed one of them and ate it. And she just smiled
and said, 'You want another one?'"

The next day, David Robinson returned to the Ghost
Ranch house without his mother—O'Keeffe had invited him
to come back by himself. When he arrived at the house,
she greeted him warmly and led him inside. As they sat in
the shade under a wide portal, the artist told him things
she told no one else. She told him she had died several
times. She told him she communicated with Stieglitz, who
had died twenty years earlier. She asked him to come and
live with her. She said she needed someone to take care of
her.

Twenty years later, David Robinson was still living at
home with his mother. When people asked him about Geor-
gia O'Keeffe, he said he wished he had gone to live with
her—it had been a brief moment of glory for him. But he
did not accept her offer because he was afraid that if he left
school he would lose his student deferment and be drafted.

But she gave him a present anyway: a human skull. When he returned to SMU in the fall of 1968, David Robinson learned that Georgia O'Keeffe had called the dean's office to inquire about him.

O'Keeffe was particularly impressed that David Robinson spoke Spanish. She did not, although over the years she had developed a shorthand "Spanglish" for ordering her help around. Around this time, radical Spanish-speaking insurgents took over the Rio Arriba County Courthouse at nearby Tierra Amarilla. For a day, they also occupied Ghost Ranch. O'Keeffe told people she was not afraid of the radicals. But around this time she began to fall, and her neighbors worried about her living by herself. After one fall, her neighbor, Jim Hall, found her stranded on the floor. He told her she needed help: "She wouldn't know me till I spoke to her if I were ten feet away," he recalls. "She had some peripheral vision, but not directly. She actually shared with me that time the frustration, just very casually, that it was intolerable."

Chapter 23

· · · · · · · · · · · ·

Thomas Kirby, Virginia Christianson, and their children were not like others who had lived in the old adobe along the Chama River in Abiquiu. Though they dressed in brightly colored clothes made out of fabric woven by Indians, slept on hammocks, and ate beans and rice, the Kirby–Christianson clan was not from Abiquiu or even from New Mexico. They were Californian, and like many of the people who settled in rural New Mexico in the 1970s, Kirby and Christianson were proud of renouncing earthly ways to exist in what Christianson called "a life of splendid poverty." Their meager income from sales of Kirby's paintings was supplemented by Christianson's earnings as paid companion to Georgia O'Keeffe.

Christianson met the artist by accident. One day she, Kirby, and a friend were walking in the pueblo of Abiquiu. Outside O'Keeffe's walled fortress, they discovered an opening in the wall that led to a parking area from which they could gaze across the village below to high sandstone cliffs of many shades of red and yellow. They were in the world from which O'Keeffe drew inspiration for her many landscape paintings. Suddenly a gate opened, and an old woman in a long white silk kimono appeared. With her white hair, narrow eyes, and brown skin, she looked oriental. She stood quietly and glanced at the intruders quizzically. Christianson felt embarrassed. "Oh, my," she said. "We've invaded your space. We'll leave right away."

O'Keeffe peered at her with curiosity. "Well," she said in a manner that indicated she almost expected them to come

that night, "since you're here, why don't you stay for tea." The group passed by a bed of flowers that bloom only at night into the cool, dark interior of the hacienda, ending their passage in a sitting room whose large picture window overlooked a flower garden. Inserted in glass under a table were the vertebrae of a rattlesnake. The walls were white and the floors were deep chocolate brown, covered by richly hued Navajo rugs. The furniture was simple, designed primarily by prominent modern architects: Mies van der Rohe, Le Corbusier, and Marcel Breuer. The pieces' sharp lines and light forms were amplified by either black or white slipcovers. A selection of rocks and bones decorated the tops of tables. The walls were bare except for one painting: a rectangular canvas of a black pear-shaped rock against a white background, the artist's most recent, completed two years earlier, in 1971.

O'Keeffe served a pot of chamomile tea and cookies and in a scratchy falsetto regaled her guests with conversation about herself; about the large jade plants she grew indoors in big pots, and how she liked them because they did not need much care or water; about how she was able to grow raspberries in New Mexico, a horticultural achievement in an arid climate, and how she did it by spreading manure around the plants, soaking them each night in water. Kirby complimented O'Keeffe on her painting of the rock and told her he used the same technique—painting several layers of color under a top layer of white. The result of this underpainting was a faint luminosity that brings about what alchemists refer to as a ring of fire when the painting is seen in certain light. Kirby and O'Keeffe discussed the paintings of Mark Rothko, an Abstract Expressionist painter whose work they both enjoyed. Rothko had killed himself a few years earlier. He had also used the underpainting technique employed by Kirby and O'Keeffe.

On their way out, O'Keeffe motioned for Christianson, who had barely spoken a word, to stay behind. After learning that Christianson, a psychologist, was studying dreams, O'Keeffe asked her if she would come the next day and talk

about working for her. O'Keeffe did not specify what she wanted her to do; nor did she say how long she wanted her to work, or during what hours, or on what days. Work was hard to find in Abiquiu, and Christianson was weary raising a family on beans and rice. So Christianson agreed to come, although she had some reservations, thinking, as she later said, "It was really kind of unreal" that she offered her a job, because they barely knew each other.

O'Keeffe offered her a position very much like that of a standard paid companion for an elderly person. She described trips they would take together, and she talked as though they were going to be attached to each other like hand and glove. When Christianson reminded O'Keeffe that she had a husband and three small boys in her care, the artist acted as if that were an insignificant detail. The next day, Christianson arrived at dawn to wake the artist up. O'Keeffe raised herself and sat against the metal headboard. "Sit there," she said, directing Christianson to a place on the edge of the narrow bed. She stared at her sideways like a bird for what seemed a long time. Christianson felt inspected, like an object of some hidden desire. "I think," she said later, "her attachment to me was physiological—she liked the way I looked."

Christianson drove O'Keeffe to the eye doctor's in Santa Fe several times a week. The artist was losing her eyesight rapidly. Each time she received treatment, she would become despondent. "She would just put her head in her hands and go into a state where she had left her body," her companion recalls. O'Keeffe never talked about it, and Christianson never asked her what was wrong. She realized it was a situation graver than words could express. Christianson was one of the few to witness O'Keeffe's anguish. The artist accepted her comfort passively.

Christianson was as close to the eighty-five-year-old artist as anyone at that time. Each morning at dawn she brought her tea in bed, helped her get dressed, talked to her about what was going on outside, collected her mail at the post office, answered her correspondence, drove her places either

in the big Lincoln sedan the artist had purchased at Claudia's urging or in the VW van—in general, she says, she "did what needed to be done," which included "running interference" against people she felt the artist did not want to see. Christianson considered herself the eyes, ears, and legs of the elderly artist, as well as her judge and guide. "I don't think you could find one word," she said, "for what I did for Georgia."

Working for O'Keeffe was not easy. The prestige of running the affairs of one of the great figures of an era was little compensation for what Christianson felt was "a power struggle." Fortunately for O'Keeffe, Christianson—an attractive, small-boned, fine-featured, slow-speaking woman—is not as frail as she appears, although sometimes she seems to have the detached look of someone not of this world.

One day O'Keeffe instructed Virginia Christianson to drive her from her main house to her ranch house on the grounds of Ghost Ranch. This was a ritual O'Keeffe practiced as often as possible, since she preferred the ranch. If she had been able to find people who would stay with her overnight, she would have lived there. But the local people who cared for her were afraid of Ghost Ranch. A housekeeper she had employed in this period came and went. Now from the U-shaped patio of the hacienda O'Keeffe looked across a wide plain to the Pedernal. "Oh, look," Christianson said, pointing to what appeared to be a pyramid with its apex chopped off, "there's my mesa!"

"*Virginia*," the artist said patronizingly, "that can't be *your* mesa if it is *my* mesa."

Then O'Keeffe simply disappeared. Christianson scoured the house and grounds looking for her until finally she sighted her standing on the flat roof of the ranch house, gazing across miles of badland, taking in the majesty of the barren landscape of rocks and cacti. Christianson was frightened—she thought O'Keeffe would fall and hurt herself. "How did you get up there?" she asked, only to answer her own question: Leaning against a side of the ranch house was the crude pole ladder. The question was not how she got

up there, but why. The artist stood in silent awe in the midst of the land from which she had drawn so much inspiration for her work and life. Although she could not see the Pedernal very clearly anymore, she told people she took comfort in knowing it was there.

Christianson climbed the pole ladder to the roof, then breathed deeply as her eyes expanded to enjoy the view. She instructed the artist to climb down after her, thinking that if O'Keeffe fell, her own body might break her fall and keep her from hurting herself. O'Keeffe acknowledged her concern and followed her companion dutifully. Then the van got stuck in mud driving on the dirt road from the ranch. O'Keeffe jumped out, and before Christianson could object, she started pushing on the back of the vehicle, as if she were half her age and twice her size. "Okay!" she yelled in a voice that seemed to strain her vocal cords. "I'll push us out of here." A fight over who would push and who would drive began. O'Keeffe won.

Christianson and O'Keeffe coexisted in a state of perpetual disagreement, a tension that was both exhilarating and exhausting for the companion. They fought for months over how best to preserve ginger. O'Keeffe preferred freezing chunks of fresh ginger, while Christianson dried the ginger in warm air on a rack. The ginger fight went back and forth long after it was clear that neither woman would cede to the other's will. She was not going to give up the elaborate rituals for daily routines she had developed over the years. Not only did she have a special way of preserving ginger, she had a special way of folding a blouse, of arranging a bouquet of wildflowers, and of preparing tea (by first warming the pot with hot water, then letting the brew steep until it acquired an aroma of fine perfume). "She was deeply involved in other worlds," said Christianson, "as was I." Christianson noticed, as others had, that O'Keeffe was also secretive. The artist once said to Christianson, "I am going to tell you something. But you must promise not to tell anyone or write about it until I am dead."

"Well then, don't tell me," Christianson replied.

O'Keeffe was crestfallen. She turned around and walked out of the room. She had wanted to draw her companion closer; the only method she knew was to offer her an exclusive piece of information. Secrets create tension that binds relationships like strands of nearly transparent wire. As a schoolgirl, O'Keeffe had admonished her friends not to speak about her to others, and she had whispered secrets to them in the dark at night. As a grown woman, she wrote friends imploring them never to repeat to others what she was going to tell them.

"Virginia," O'Keeffe asked one day, "you're not afraid of anything, are you?"

"No," she replied, securely.

"Well, that's why we get along," O'Keeffe concluded rhetorically, "and that's why we don't get along."

Christianson soon learned more about O'Keeffe than most people knew. To the world outside Abiquiu, the artist symbolized robust old age. On the occasion of her eightieth birthday, several magazines and newspapers ran pictures of her standing out on a windswept plain and devoted page after page to her rugged western way of life. *Look* called her a "timeless beauty." *Life* pointed out that she was "still vigorous in her 81st year." As she had since the 1920s, O'Keeffe made good copy for the media. She gave tips on longevity in the articles, telling readers how she had lived, so it seemed, gracefully and in good health through her eighth decade—all the while finding the experience ironic. Of the November 1967 article in *Vogue,* she said, "It was their spring fashion issue, and you turned page after page of beautiful young things leaping through the hay before coming to eight pages—eight pages! of this old face." (The article actually included three pages of photographs.)

None of the articles mentioned that she was partially blind, or that she had been complaining about her eyesight since 1964, or that she periodically suffered from both hysterical and physical blindness. Many of her close friends were surprised to learn later that she had had eye trouble for years. She refused to wear eyeglasses or, even in the

harshest sun, dark glasses. In 1971, a blood vessel burst in
her right eye, and for the first time she could not see to find
her way through a room. She stopped painting altogether
and began to struggle through life, acquiring the grace that
comes with handicaps: "when you get so that you can't see,
you come to it gradually. And if you didn't come to it
gradually, I guess you'd just kill yourself when you couldn't
see."

She grew increasingly superstitious. She believed in one
god, but she also believed that god spoke in many ways
through many things. She could sense things in the wind
that howled and in the smell at night of piñon wood, burning
a richness of burnt cinnamon. She said that the wind talked
to her, telling her what the weather was going to be, when
people would come, and when they would go. She spoke
to Christianson in metaphors, referring to her as a bird: "I
know you. You're like me. You can't stay put. One day you
will fly."

O'Keeffe believed she could communicate with the dead,
and she told Christianson—as she had Robinson—that she
herself had died several times during her lifetime. She looked
for signals as a native looks for talismans. Cupping her hands
around a crystal ball that Stieglitz had left her, she felt his
presence. She saw things she had never seen before. She
may have been blind, but her inner eye was still intact. "You
would come—I knew that," she said to a friend who had
driven some distance to see her without calling.

One day Christianson noticed something unusual about
the painting of the pear-shaped rock against a white back-
ground that hung in the sitting room. In the daylight under
the bright sun of the desert, there was a ring of fire around
the rock, glowing like the aurora borealis. The picture looked
familiar to her for the first time. She said nothing to the
artist. That night she researched what she had seen in a
book on alchemy: "This is the black bird that flies through
the night without wings," she found written next to some-
thing that looked like the glow around O'Keeffe's painting.
She wrote it down on a piece of paper, and the following

day she presented her findings to the artist. O'Keeffe looked at the paper and started to cry. It was such an unexpected response that Christianson was startled. She did not know what to do. O'Keeffe ran across a patio and sought privacy in her bedroom. She did not come out for about twenty minutes. "She couldn't stand it. It just really got to her."

Because Christianson was a perceptive listener, O'Keeffe had begun to confide in her. One day, while they were discussing families, O'Keeffe indicated that she had been molested as a child by her father and brother. Like many victims of incest, O'Keeffe was plagued by nightmares; Christianson's work with dreams made her a providential companion. In Christianson's opinion, O'Keeffe was trying to recapture in her work what she had lost because she had been molested: "I used to say, 'Georgia, that's so pure,' looking at her paintings. She liked that. I even once said, 'It is so virginal.' She liked that too."

As soon as Christianson began to see that O'Keeffe wanted to dominate her, she quit. O'Keeffe cried the day she told her she was leaving.

In the fall of 1973, shortly before Virginia Christianson left, a dark-haired young man with a moustache appeared outside the adobe house where Christianson was living with her family. "I hear you take people in," he said. A note of desperation in his voice gave Christianson the chills. She pulled on her hair and said nothing, but she thought, "That's a hell of a reputation to have." But the man truly did need help, judging from the way he looked, and people at the end of the earth generally do help one another. He put his head into his hands and began to sob "in fits that shook his entire body." Over the next hour and a half, he told Christianson the story of how his wife had thrown him out of the house he had built with his own hands. Although a young man, not yet thirty, he felt his life had ended that moment.

Christianson invited Juan Hamilton to stay with her family. She gave him a hammock and told him to string it on

the porch. Hamilton did not tell Christianson about his mission to help O'Keeffe; nor did he even tell her he knew that she worked for the artist. One day she mentioned she was going to O'Keeffe's house to work. Hamilton said he would like to meet O'Keeffe and work for her, too. He did not tell Christianson he had already tried to meet the artist— by this time, on two occasions. She advised him simply to go to the artist's house at dawn and wait for her to come outside.

The first time Juan Hamilton met Georgia O'Keeffe, he had been doing odd jobs at the Presbyterian Conference Center at Ghost Ranch. He had found work in the center through a friend of his father's, Allen Hamilton, an executive at the headquarters of the Presbyterian Church in New York. Jim Hall, O'Keeffe's neighbor, recalls that he first heard of Juan Hamilton through a mutual friend: "He called me about Juan, about how Juan's life was in disarray, and said that he used to live in a place like New Mexico [i.e., South America]. I said I could sure provide a place. And that summer [1973] he worked in the kitchen to earn wages. He had been raised in Venezuela and spoke beautiful Spanish, and he just got along beautifully with the ladies in the kitchen, most of whom were Spanish speakers."

Juan's life was in disarray because he had chosen to express himself as an artist. At twenty-six, few artists have developed the vocabulary that such expression requires, and young artists often wander from place to place looking for inspiration. Hamilton had graduated from Hastings College in Hastings, Nebraska, with a degree in studio art in 1968. Hastings was a conservative school where drinking was prohibited—the yearbook displayed "Coke dates and family meals." After a year of graduate study in sculpture at Claremont College in California, he studied ceramic techniques in Japan. Because he was attracted to the same oriental sense of light and space as O'Keeffe, the young artist had a strong premonition that he would find a place in her life. Now he hoped O'Keeffe would give his life direction, an indication of the artist's success: In O'Keeffe's day, young female artists

had attached themselves to better-known males. Now, at least in her case, the pattern was reversed.

The first time the two had met, when Hamilton tagged along on the service call to fix the plumbing, O'Keeffe had ignored Hamilton. The second time, she sort of spoke to him. She had again called Ghost Ranch headquarters and asked for someone to help: She had purchased a wood-burning stove for her studio and needed someone to lift it from the trunk of her car and install it. Ray McCall, who was the head of maintenance, once again asked Hamilton if he wanted to go with him. This time Hamilton primed McCall. He told him he wanted to meet the artist and said he had something in common with her—he had used antique wood stoves to heat his house in Vermont.

The result was not what he had hoped for. The artist was standing outside as the two men pulled up next to her hacienda. They climbed down from an orange pickup and approached the artist deferentially. The maintenance head was shy and blurted out his words: "Miss O'Keeffe," he said, "this is Juan Hamilton. He is an artist, and he used to heat his house in Vermont with antique stoves like this one."

O'Keeffe narrowed her eyes to an intense squint, like an animal about to pounce on its prey. Looking Druidic, she glared first at the maintenance man, then at Hamilton. She pointed to the stove with a long slender finger. "This," she said irately, tapping the side of the stove, "is not an antique."

Chapter 24

.

Barbara Rose was a fine-featured, slight woman of immense drive. Her 1967 survey, *American Art Since 1900*, positioned Georgia O'Keeffe where she belonged in the history of art for the first time. Acknowledging the mystical nature of her art as well as its painfully revealing intimacy, Rose described O'Keeffe's work as a "private world" in which natural forms became "lyric visions." In O'Keeffe's work, Rose wrote, "Nature is imbued with a pantheistic, transcendental life of its own." The artist's landscapes were "quivering." Fifty years after she had first exhibited her work, O'Keeffe had found a new ally. As she had in the past with favorable critics, she wrote Rose to thank her and extended an invitation to visit her at Ghost Ranch for the summer of 1974. Rose accepted. One day during the summer, O'Keeffe summoned her aside for a private conference. She enjoyed private conferences and was looking forward to finding out what her new friend thought.

The artist had come to trust Rose's opinion and now sought her advice in many matters. Although she was young enough to be her granddaughter or even great-granddaughter, Rose was a New Yorker whose mind was honed to operate effectively in situations that required quick judgments and snap decisions. Going on the assumption that intelligence is not always well matched with beauty, she sometimes referred to other attractive and intelligent women as bimbos. O'Keeffe sometimes felt the same way. She knew she would get a response from her friend when she asked:

"What do you think of that boy, Barbara Rose?" (O'Keeffe always addressed Rose by both her first and last names.)

"He seems okay," she said. "Certainly brighter than most."

"That boy" had been working for O'Keeffe since the previous fall. Rose was right: He was brighter than most, if by "most" she meant the hippies who had come to live in rural communes around Abiquiu in the 1960s and 1970s. It would take a bright person to do what Hamilton had done— penetrate one of the most heavily fortified households in northern New Mexico. O'Keeffe did not usually let people into her life. Since the mid-1960s, when the elderly artist had been rediscovered, it had been she who did the beckoning. Hamilton had been the first to enter her life without an invitation—and she was still not sure what to make of him, almost a year after she had first let him into her life.

Hamilton had finally made his way into O'Keeffe's world by following Christianson's instructions: He had gone to the back door of her house at dawn. O'Keeffe hired him as handyman that day, and he had become part of her life, as he had desired since driving by Lake George the summer before. Christianson had not only been trying to help Hamilton. She had also been trying to help O'Keeffe. She knew of the artist's need to be cared for, and she had sensed Hamilton's desperation to care for someone—so she felt they were evenly matched and would be good for each other. "I took one look at Juan," she says, "and thought, 'This is exactly what Georgia needs.'"

Hamilton was exactly what O'Keeffe needed. A robust, stubborn, and willful artist whose vision of light and space was similar to hers, Hamilton had the strength to keep up with his new employer and the stamina to withstand her abusive tirades. He spoke Spanish fluently, better than the natives of Abiquiu, with whom he could communicate as a superior. Physically, he resembled a young Alfred Stieglitz, and that he had been born the year Stieglitz died was an appealing coincidence, since the artist was superstitious and believed in omens. Ever since Stieglitz died, O'Keeffe had

not found anyone who could energize her the way he had been able to. Now she began to tell people, "Juan was sent to me."

A few months after O'Keeffe hired Hamilton, she took him on an extended vacation to Morocco and North Africa. O'Keeffe liked to travel, but since 1971, when her eyesight had decisively worsened, she had been afraid to go by herself. She had attempted to interest Christianson in traveling with her, to no avail. Hamilton was an experienced traveler—he had moved around in South America as a boy when his father was a missionary for the Presbyterian Church in Venezuela and Colombia. But he had never traveled first class, as he did now. The elderly artist and her young friend accompanied Alexander and Susan Girrard, a distinguished Santa Fe architect and his wife. Hamilton, although bright and well-spoken, was considerably younger and less worldly than his companions. He felt odd one day when they were discussing how roast pigeon had been prepared at a restaurant in France: "They were off in another country," he reminisced, "talking about pigeons."

By the time the group arrived at the first hotel in Morocco, O'Keeffe and Hamilton had already begun to fight. The strain of traveling had aggravated her eye condition. She found it hard to see and harder still to be entirely dependent on Hamilton. According to Hamilton, after they fought, "She went off and walked up some steps, and she went into someone else's room instead of her own room. And she said, 'You got mad at me, and I left, and I went alone up the steps, and I went in this door, and there was a man with a big red beard shaving, and he scared me.'" O'Keeffe had achieved a new level of intimacy with Hamilton: She admitted she was scared.

Juan Hamilton was as volatile as the artist herself was, a situation that was sometimes aggravated by his drinking habits. On their return from Morocco, O'Keeffe's housekeeper, Jerri Newsom, quit because, among other things, she later said, she did not want to pick up Hamilton's beer cans, which he left around the house. Jim Hall noticed that

Hamilton had begun to drink with the locals at Angie's Bar on the plaza in Abiquiu and that he sometimes got truculent: "So they had a little ill will down there . . . and they beat him up and broke the windows in his car. This upset O'Keeffe terribly."

Hamilton's personal struggles did not interfere with his professional life. He worked long hours for the elderly O'Keeffe. Arriving at breakfast early in the morning, he stayed until after supper, when a girl from the village arrived to sleep overnight in a room next to the artist's. O'Keeffe found it difficult to be alone at night. She had asked Hamilton to stay with her in her house, but he had refused. He took over Christianson's adobe house along the river when she moved out. In the spring of 1974, he purchased an old adobe on the apex of a hill in the neighboring village of La Barranca. Hamilton drove O'Keeffe places in her white Lincoln sedan. He drove as fast as she had, speeding, according to one witness, "like a hot dog." He typed and answered correspondence for her. He fetched her mail from the post office in Abiquiu. He determined who among those who wanted to see her would be granted their wish.

Soon, some of the artist's friends and relations began to feel stonewalled by Hamilton. When they called, they were told she was unavailable. Both Claudia and Catherine were suspicious of him. It had been one thing for the artist to select women companions. It was another for her to select a handsome—and penniless—man. In the minds of some of her friends and relatives, Hamilton was a figure out of literature like Christopher Flanders in Tennessee Williams's play *The Milk Train Doesn't Stop Here Any More*—a poet and self-appointed "angel of death" who travels from rich old woman to rich old woman on the Amalfi coast of Italy. The first time Catherine O'Keeffe Klenert, Georgia's Wisconsin sister, saw Hamilton, he was covered with grease from working on the plumbing in Georgia's Ghost Ranch house. The impression was indelible. Klenert recalled that he was "nothing but a tramp." Claudia called him "a gigolo" to his face.

Barbara Rose saw another side of Juan Hamilton. From

her own work, Rose was accustomed to knowing young, misdirected, but talented artists. An energetic person who had worked as a freelance critic and curator in various capacities, Rose charged whatever she undertook with electricity. She spoke in short, clipped sentences and wrote the same way. Having been involved with many artists—including a marriage to painter Frank Stella in a loft in downtown Manhattan—she believed she was an expert on the artistic personality. She observed of Hamilton, "Typical artist—obsessed by his work, sees everything in relation to his art—can be charming, witty and generous—can be moody, temperamental, cantankerous. Typical artist."

Rose had come to stay with O'Keeffe on her invitation, but she, too, had an agenda. She wanted to organize an exhibition of what she called O'Keeffe's abstract painting. Even though O'Keeffe had never considered herself an abstract painter, she went along with Rose's scheme because she believed in her vision. An exhibit of abstract art would not have been her idea—in fact, O'Keeffe often said that she did not see any difference between abstract and realist painting. In her career, she had clearly moved back and forth between both twentieth-century currents with considerable ease.

Rose had grown up in the fifties in New York looking at abstract painting and had been married to an abstract painter. When she saw that O'Keeffe had done a great deal of what could be called abstract painting, she wanted to get it all together in one room and write about it coherently—which she could have done well. The room she had in mind was the Guggenheim Museum in New York, a spiral-shaped building designed by Frank Lloyd Wright. O'Keeffe, a champion of Wright's work, told Rose that Wright had once asked her to marry him—her first and only reference to the remote possibility of this unlikely union. Wright and O'Keeffe had met only once; since both were Wisconsin natives, he asked her why she didn't spend more time in her home state. "I don't see you spending much time there yourself," she replied correctly.

O'Keeffe wanted something from Rose, too: to help her sort out her life. Since 1971, when she had stopped painting altogether, O'Keeffe had begun to look backward instead of forward. She did not want to do this alone. By working with a writer named Virginia Robertson, who encouraged the artist to put down what she remembered, and with Christianson, who encouraged her to respect her dreams, O'Keeffe had become more reflective. She had drawers of old letters in a storeroom in Abiquiu, boxes of clippings and exhibition announcements. There were stacks of old paintings and drawings that she had kept over the years—some, because she liked them; some, because no one else liked them. In the vault of the Beinecke Library at Yale University, among O'Keeffe's and Stieglitz's correspondences, are more than three thousand letters that she and Stieglitz had exchanged. On Stieglitz's death, those letters had been donated to the library, on the condition that they be withheld from the public until twenty-five years after O'Keeffe's death. O'Keeffe had copies of the letters; she asked Rose to edit a selection of the correspondence so she could publish it in a book.

O'Keeffe was a challenge to Rose—and Rose liked challenges, thrived on them. She recalled that the artist "tested" her "mettle" in different ways. First, O'Keeffe had told her that the chow dogs were vicious—which they were—to see if she was afraid of them. Then she had reminded her that Ghost Ranch was home to nests of rattlesnakes that could crawl into her room at night. Being reassured that Rose was not frightened of either dogs or snakes, she put her to another test. When she learned that Rose had a photographic memory, she instructed her to go into a small dank cell and read the letters between herself and Stieglitz. Knowing that Rose did not have a pen or pencil or paper with her, she closed the door and told her to come out when she heard the bell for lunch. It was now ten o'clock; lunch was at noon. This became routine. Rose felt O'Keeffe was "entertained by the idea of me frantically speedreading every morning."

O'Keeffe began to confide in Rose her problems in grow-

ing old alone out in the desert. She complained of all of the details of running two households. She said she had a hard time finding people to work for her, calling those who did "foot draggers." She said she had no use for such people— "Foot draggers. All of them!" One reason she was interested to know what Rose thought of Hamilton was that she felt that maybe he was an exception. She told Rose that Doris Bry was "the biggest foot dragger of them all." She apparently felt, as she had about Edith Halpert, that Bry was not doing enough to promote her or to raise the prices for her work. O'Keeffe's work was benefitting from a renewed interest generated by a shift in fashion back to personal, hermetic art. The artist wanted more than she felt Bry was capable of producing for her. As she once again basked in the lime-light of recognition, she needed a different person in her life. What was more, she felt that Bry had begun to exercise too much authority. She said Bry insisted on ". . . dealing with my paintings as though they were her own."

Chapter 25

.

On Christmas Day 1977, O'Keeffe awoke to greet the dawn, as she had for ninety years. She said hello to the young helper who was lighting the piñon wood fire in the beehive fireplace in her room and sat down to a breakfast of whole grain cereal at a table by herself. After her helper left, she heard banging on the gate. As she had been doing since she could no longer see well, she pretended she was not home and did not ask who it was. Although she would not have admitted it to most people, at ninety, she was afraid and lonely a great deal of the time.

Juan Hamilton was visiting his family in Costa Rica for the holidays. On their retirement, his parents had moved from New Jersey to Costa Rica, where they lived in a luxurious hacienda. After four years of working for O'Keeffe, he had found that he needed a break from her and her world from time to time. He did not abandon her, however—in his absence, he had arranged for three friends to cook Christmas dinner for her and keep her company. Taking care of the elderly artist had evolved into a full-time around-the-clock job. What she did on Christmas Day had become his concern. There was no family to take care of her on holidays; nor were there friends to look in on her. If he had not made arrangements for her care, she would have spent the day by herself, as she doubtless had in the past.

Glen Myers, Walter Pickette, and Jerry Richardson arrived in midmorning with a turkey stuffed with rice and nuts and homemade pies. O'Keeffe had always liked being the only woman in a gathering of men, and today was no exception.

As they organized the meal, she instructed them to boil whole white onions in a large pot—her contribution to the meal. She had met the three men only the previous year, when she had visited their house in nearby El Rito to tour their garden, but she had grown to like them enormously. Pickette and Myers ran a small café in El Rito catering to local artists; Richardson was a young law student at the University of New Mexico. While she talked about her early days in Abiquiu, the men hunted for a bottle of wine in her wine cellar. It was clear that she was not a drinker—most of the wines in the dusty cellar room were no longer fit to drink. They finally found a bottle of sweet sauterne to go with their pies.

After dinner, O'Keeffe insisted they stay until her companion returned for the night. She said she was afraid: Someone had tried to enter the compound earlier in the day, when she had been alone, and she did not want to be alone in case they returned; on Thanksgiving Day an uninvited woman had walked in through the gate. They played a recording of Handel's *Messiah* on the stereo, and O'Keeffe told them a story about Stieglitz. During a lull, she asked Jerry Richardson to dial a number for her on the phone. It was Esther Johnson in Old Wick, New Jersey. There was no one home on the other end. No one called her on the phone. No one else came to call. She said sadly to Richardson, "You can live here all your life, but you will never really be accepted by these people."

In four years, Juan Hamilton had revitalized O'Keeffe's life and given her a new outlet for her enormous energy. She had published an autobiography with his assistance and learned how to produce a clay pot on a wheel. She had made new friends and traveled to new places with him. She had even briefly returned to producing paintings under his direction. Whatever suspicions she may have harbored of him had been allayed, and she had become his most vocal supporter. Giving up control was not easy for the elderly artist. Not even her late husband, who sometimes gave people the impression he told her what to do, ever exerted the

kind of control Hamilton had come to exert. Periodically, she would unleash a fury of frustration in his direction, but he could take it and give it back to her. No one had been able to do that before. Hamilton had come into her life at a time when she had no choice but to give up some control. Not only could she not see well, she suffered from periodic deafness and loss of balance.

The turning point in their relationship had taken place on Christmas Day in 1974. For most of that year, Hamilton had fulfilled the duties a person known as "my boy" would. He drove to Santa Fe and fetched meat from a butcher in Tesuque and greens from a grocer on Old Santa Fe Trail; he opened mail and answered phone calls. He spent Christmas Day with the artist, and she surprised him with a gift of a small drawing. He said he was sorry he did not have a gift for her. She said that was all right because she had a favor to ask of him. During the night when she could not sleep—she suffered from insomnia in this period—she had been writing her story. Would Hamilton read what she had written? She said she had decided to write her own book "because such odd things have been done about me with words."

Hamilton became O'Keeffe's eyes and fingers. Each day through most of 1975, she gave her friend fresh copy that she had written the night before in large cursive characters with a fountain pen. He read what she had to say and typed it up for editing. As the artist was losing her eyesight, she wrote: "My first memory is of brightness of light—light all around." Her friend made comments, and she listened attentively. No one else was told about their project. It was a secret, and they liked it that way. Hamilton was as secretive and complicitous as O'Keeffe. (When I first got to know him, he was always trying to tell me who to talk to and who not to talk to.) They selected pictures of her paintings to illustrate the autobiography. They shopped for a publisher in New York through friends, eventually placing it at Viking Press.

Hamilton also became the artist's legs. He assisted David

Bell, the Senior Editor at Viking Press who worked on the book, in selecting the color plates. It was the first time a large body of her work had been reproduced in color. According to Barbara Rose, who had worked with hundreds of difficult artists over the years, "nobody was as particular about reproductions as Georgia O'Keeffe." Hamilton learned to be as particular as she was, rejecting color proofs until the fidelity was nearly perfect, pushing the book over budget. Bell refused to comment to me on the project, his silence suggesting that he had nothing positive to say about the experience. Hamilton learned to do nearly everything as O'Keeffe would have done it herself. When he didn't, he soon discovered, she became irate and gave him what he called "the old snakebite."

In New York, people learned that working with Juan Hamilton could be a trying experience. Robert Miller, who had met O'Keeffe through Esther Johnson, found he had to work with Hamilton, too. Although he came to appreciate Hamilton's artwork and exhibited it in his gallery, Miller indicated that he was not always happy to work with him. Miller's sister-in-law, Gretchen Johnson (who was married to James Johnson, Esther's son), observed that Hamilton was "the kind of person that doesn't let you alone. [He's] going to jostle you one way or another, so if you want to just suit yourself and be removed, then you are going to have a hard time dealing with it."

Gretchen and James Johnson met Juan Hamilton in December 1975, when along with Robert Miller they visited Georgia in New Mexico. They arrived after a light snowfall and telephoned O'Keeffe from Bode's General Merchandise in Abiquiu. "Oh," she said after they first talked to Juan, "don't come. It's just snowed." According to Gretchen, Juan convinced Georgia to tell them not to come to tease them, a characteristic for which Juan would become known. However, Gretchen immediately noticed when they arrived that Juan was not in control; Georgia nagged him to get to work and even criticized his table manners. She latched onto Gretchen, a fair-haired, smooth-featured woman with a

poet's depth of character, to the exclusion of both James and Robert. "She kept wanting to brush my hair," Gretchen recalls, still somewhat incredulous, years later. "So this was an odd situation. I'm sitting on the floor and she's sitting in her chair brushing my hair. So that's pretty much how we spent the evening, with her brushing my hair and telling me things. . . . I should be brushing it more. . . . The fact that she was in contact is pretty unusual. That made everybody nervous in our group. And it made me sort of weirdly relaxed, so it was really nice for me in a way."

Before long, O'Keeffe purchased an expensive kiln and had it installed in the garage at Ghost Ranch. This was a symbolic move: The artist gave over to her friend the space she had used to create the large painting of clouds. The day the kiln arrived, Hamilton and O'Keeffe watched a large crane lift the heavy gas oven from the back of a flatbed truck. O'Keeffe was standing directly under it as the cable sagged—it nearly dropped on her head. At night, sleeping at the ranch, the roar of the gas jets in the kiln frightened her, she said.

As Stieglitz had once found his way back to work through O'Keeffe, now O'Keeffe was finding her way back to work through Hamilton. He taught her how to throw a pot on a wheel—a perfect alternative, since she did not need eyes to do it. Being a perfectionist, however, she was frustrated by her efforts. They were not as fine as Hamilton's smooth-walled vessels. O'Keeffe loved holding wet clay in her hands and then running her fingers over the walls of the finished products. She wrote that Hamilton could make the clay "speak" and called him "one of our great talents," echoing the way Stieglitz had described her abilities sixty years earlier.

In January 1976, the artist and her friend celebrated their achievements with a tropical holiday on the island of Antigua. She walked on the smooth white-sand beaches and swam in the calm, turquoise-colored sea. As she had in Bermuda forty years earlier, she collected seashells and gnarled pieces of bleached wood. One day she surprised her

young companion by presenting him with a series of small drawings. They were sketches, done in felt-tip pen on a napkin—the first she had produced in five years. The sketches expressed the way she felt when she saw the shadows that the tall slender palms cast on the white sand.

In October 1976, they traveled to Washington, D.C., where they met with curators at the National Gallery of Art to discuss an exhibition of Stieglitz's photographs. After this work was completed, they stayed through Columbus Day to enjoy the sights of Washington. "It was a wide blue sky and the green grass," Hamilton recalls poetically, "and we walked along slowly down from one end of the mall to the other most of the afternoon. We ended up at the Lincoln Memorial. She wondered what Lincoln would think of himself sitting up there so big. We had a hard time getting a taxi; she sat on the sidewalk curb waiting till we got a ride. Anyway though, she could see the Washington Monument clearly against the sky, and it was exciting for her. She knew it was tall and it went way up into the sky. And she could see the gradations of light in the column. And I would hold her so she wouldn't lose her balance. She would look up at it, and it was something very simple, something like perhaps a patio door. And again, perhaps, in some oriental way, the simplicity attracted her. And she got an idea from it, and once she got an idea, her inspiration would build."

The fall of 1976 was a golden period for O'Keeffe. For the first time since 1971, she was back in her studio working. Barbara Rose had noticed that O'Keeffe "became quite miserable when she wasn't working." While Hamilton was in New York overseeing the publication of her autobiography, she once again took out her milk-glass palette and went to work with the help of a studio assistant who mixed the paint and prepared the surface. Then the artist began to expand on two themes she had previously begun. The first was the palm trees she had sketched in Antigua. The second was the way the Washington Monument rose into the blue sky. She called the second painting *A Day with Juan*. It was the

fifth time in her life she had included one of her friends' names in a painting. The first was Stieglitz, whose name appeared in a sign on the side of a 1927 skyscraper painting; the second was Maggie Johnson; the third was Maria Chabot, the inspiration behind the 1942 flower painting *Maria Goes to a Party*; the fourth was Narcissa Swift, whose friendship moved the artist to paint an orchid.

When she wasn't working, the artist enjoyed her garden in Abiquiu for the first time in years. The lush growth of plants along footpaths covered an irrigated acre within a high adobe wall, and in thirty years the garden had reached its maturity. As O'Keeffe's central vision failed, however, walking in the garden became a perilous ordeal. She could no longer enjoy the beds of irises and oriental poppies that she had planted over the years. No matter how many times she asked her gardener to prune the branches of the fruit trees, he would not do so, and she ran into the low branches on her walks. Under Hamilton's direction, the garden was finally cleared of its overgrowth.

While he was in New York during the summer of 1976, O'Keeffe entertained visitors. Jane Weinberg was a Chicagoan whose husband had given her *Green-Grey Abstraction* (1931) for an anniversary present. She contacted O'Keeffe because the painting needed cleaning, and she wanted the artist to recommend a qualified person for the delicate job. O'Keeffe replied promptly with the name of a restorer she used in New York. She also invited Weinberg to visit her in Abiquiu. She said she had always been curious about who had bought that picture.

Weinberg's visit started strangely. In her letter, O'Keeffe had instructed her to stay at the conference center at Ghost Ranch and to be at her house on the ranch at a certain time. When Weinberg arrived, however, the artist was not home. She telephoned her from the conference center and explained what had happened. O'Keeffe mistook her for a companion who was late for work. Much to the discomfort of her visitor, the artist then upbraided her over the phone.

After Weinberg explained who she was, the artist told her to drive to Abiquiu. She was not in Ghost Ranch that day, she said in an exasperated tone.

O'Keeffe finally greeted her guest in the courtyard wearing a crisp white kimono. She served a tall glass of raspberry juice that had been extracted through a juicer from berries she grew in her garden. O'Keeffe chided the maid for leaving out the garnish of fresh mint leaf. She explained to Weinberg that the contrast between the two colors was particularly pleasing to her eyes. Weinberg, knowing that the artist liked Chinese music, had brought a recording of Chinese opera. "A friend who knows what he is talking about," the artist said as she put the record aside, "told me there are no good recordings of Chinese opera."

The artist showed her visitor the proof sheets from the upcoming autobiography, explaining that Hamilton was in New York overseeing its production. She noted that he had complained to her about New York and would have preferred to stay at home in New Mexico. "The trouble with young artists," O'Keeffe said pointedly, "is that they don't want to work." O'Keeffe suddenly warmed to her new friend. She asked a lot of personal questions about her husband, her children, and her work. Concluding the interview, she surprised her visitor by asking her to stay and live with her. Weinberg protested that she did not know what she could do for her. Noticing that the books were in disarray, she said she could organize her books. But, reconsidering, she concluded that she really could not stay. "It's all right," O'Keeffe said as she walked her to her car. "I'm not sure I'd want another person around."

While Hamilton was in New York overseeing the production of *Georgia O'Keeffe,* the artist reveled in her newfound life in New Mexico. She had her garden back, she had her studio back, and she even was able to entertain visitors, as she once had, by herself. After nearly five years of downward spiraling, she was productive again. She owed a great deal of her success to Hamilton's care of her, and she told people around her that this was the case—even

though she sometimes complained good-naturedly about him as well. "Juan," a friend noticed, "was the son she never had, the man she might have been. She loved him like her own."

Before he left, Juan had hired a studio assistant to help her complete her paintings. Painters have used studio assistants since the Renaissance. Generally, as in O'Keeffe's case, the artist designs the work, and the assistants execute it. Jon Poling, the assistant Juan hired for Georgia, produced *A Day with Juan,* the painting inspired by the day they spent at the Washington Monument. When Hamilton returned from New York, the two men had a disagreement, and Poling, who left in a huff, told Hope Aldrich of the Santa Fe *Reporter* that he had painted O'Keeffe's paintings. When Aldrich called and relayed what Poling had said, O'Keeffe bristled. "Why," the artist said, "he was nothing more than a palette knife." And when an old friend wrote to say that Hamilton was "crow in carrion," she replied by correcting her friend's choice of words. She said she may be old, she may even be unwell, but she had not yet died, nor had her flesh begun to rot. She felt her friends were jealous of her relationship with Hamilton—and they should have been. Hamilton had become her sole source of support and comfort. The old artist and young man went everywhere. He even took her as a date to a friend's house for dinner on his birthday.

"We had told him that we wanted to have him to dinner for his birthday, and he could invite whoever he wanted," recalls Jerry Richardson, who along with Glen Myers and Walter Pickette hosted a dinner for Juan's thirtieth birthday. "And so he invited Georgia. That was the first time that she had come to our house for a meal. Juan liked to get nice custom-made clothes from time to time—he had wonderful taste in clothes. Anyway I had gotten this idea of giving him some handmade silver buttons. It wasn't like there was a lot that he needed or anything, but I thought he could have them sewn on one of his shirts or a coat or something like that. I'd come across them down in Santa Fe one day.

They were big, silver buttons made from hammered-out silver fifty-cent pieces. All the fifty-cent-piece design was hammered out, and they'd done some kind of Indian stampings on them, but you knew they were from fifty-cent pieces by the little ridges on the edges. . . .

"I'd given him those buttons, and she saw them, and she could see the glint of the silver, and she knew they were silver buttons. Juan was raving about how beautiful they were. And she grabbed them: 'Let me see those.' When he asked for them back, she said, 'No, these are mine.' And he said, 'No, those are not yours, Georgia.' And she went into this real childish thing, like a little five-year-old saying, 'I want these. I want these.' Anyway, he said, almost patronizingly, 'No, Georgia, those are mine. This is my birthday, and Jerry gave me those for my gift.' She said, 'Well, you took those shoes of mine with silver buckles into the repair shop, and I never got the silver buckles back, so I'm going to keep these instead.' He said 'What?' So they had this big argument.

"At first when this started to happen, I thought that she was just giving him a hard time. I didn't think they were serious. But as the voices started to be raised, I realized it wasn't a game. Finally Juan grabbed her hand, and of course he was much stronger than she. He pried open her clenched fist and grabbed his buttons back. After this humiliating defeat, she turned to Glen very calmly and said, 'Will you drive me home?' Glen drove her home. It was upsetting for all of us. This had been a really fun party. We'd all been carrying on and telling stories, drinking—and it ended on that very abrupt and negative note. Juan was upset, and he ended up staying over that night. I don't think he was concerned for her—he was pissed off that she would do this. She couldn't let him be the center of attention for one night. Juan likes to be the center of attention, too. He's always trying to make wisecracks, to the point where he can be obnoxious."

O'Keeffe celebrated her ninetieth birthday with Hamilton and a few close friends at Esther Johnson's Cedar Lane Farm.

To many, she seemed to have actually gotten younger in the previous decade. Reporters who came to New Mexico were impressed by the many projects she was undertaking with Hamilton's help, as was she herself: "It can be like a New York office building here at times," she told *Newsweek*. "But I wake early every morning and begin painting." Having been introduced to pottery by Hamilton, the artist was prompted to pull out her 1917 sculpture *Bending Figure*, the tribute to her mother, and another piece of sculpture she had made in the thirties, *Spiral*.

A few days before her birthday, she visited the Johnson Atelier, a foundry in Princeton, New Jersey, with Juan. He had arranged for her work to be cast there in ten-foot molds of polished bronze. She told *Newsweek* she had been inspired by large outdoor sculptures that she had seen on a recent trip to Milwaukee. "I have a lot of unfinished business," she said.

Chapter 26

.

Like many people who were drawn to O'Keeffe at the end of her life, the popular singer Joni Mitchell wanted to meet the artist because she had come to feel they were spiritually linked. "When I was in my twenties I had a house in Laurel Canyon, and it was full of assorted things," she says. "One day I was hanging a blanket in a doorway when a friend came over and—I don't know what the association was, maybe it was this blanket hanging in the doorway of a house that was very rustic—he said I reminded him of a young Georgia O'Keeffe. This was the first I had heard her name. There were no books or anything available on her at this time. I remember asking who she was, and he told me and it didn't mean that much. I heard her name again and again and a bit of her story over and over again."

There was a similarity between the two women artists. A blond soprano whose trademark was a black felt beret, Mitchell attracted a large number of followers during the seventies who felt that they knew her because of her music. But Mitchell was not content with popular acclaim. As her songs—particularly "Both Sides Now" and "Woodstock"— came to define a lyrical aspect of the youth movement and were performed over and over by other musicians, she strove to create something more sophisticated. Her search led her to bring in a complex range of musical roots to her recording sessions, abandoning the folk style for a free-floating jazz sound. From the very beginning, Mitchell was a multi-media artist. She painted pictures for the covers of her record albums and wrote the lyrics of the songs she performed.

By the mid-seventies, however, Mitchell suffered from something of a breakdown. Her 1975 record album *Hissing of Summer Lawns* was panned by critics. *Rolling Stone* called it the worst album of the year. Fleeing Los Angeles and the world of music, she settled in a cabin on the coast of Vancouver. For several years she worked on her own compositions. She painted and walked on the beach. Living the life of a recluse as Georgia O'Keeffe was doing in New Mexico, Mitchell had developed an appreciation for the artist and her work.

In the fall of 1977, Mitchell decided to visit O'Keeffe. She didn't have an invitation or introduction, but since O'Keeffe had been an inspiration to her, she wanted to stop and leave her a gift on a driving trip from California to Texas: a limited edition book of her drawings and a copy of her latest record album, *Hejira*. "Hejira" is an Arabic word that refers specifically to the forced journey of Mohammed from Mecca to Medina in A.D. 622 and generally to any journey made for the sake of safety or escape. Mitchell chose the name because she had fled from Los Angeles to Vancouver and she felt the gift was appropriate for O'Keeffe because the artist had fled from New York to New Mexico.

"So we got to her place in Abiquiu. It's easy to spot—a hamlet, you know. We drove up. There was no doorbell. There's a fence. The dogs came and were making quite a commotion.

"The irony of this is that I spent time by myself in [Vancouver]. And I was constantly besieged by people paying homage to me, camped on my property waiting for me to come out. So having gone to such a degree and now having people seeking you out was something I sympathized with. When no one came to the door, I slipped the book and the record under the gate and got back into this van. My boyfriend said, 'Go and take it to her, there's a break in the fence—there's a storm coming. It will all get wet.' So reluctantly I went through this gap between the gate and the wall and around to the side of her house. In her bedroom, which had no curtains, I saw that we had the same luggage,

from a little store on Madison Avenue in New York. I'd never seen it anywhere else in the carousels of the world. I thought, that's interesting, Georgia and I have the same luggage."

When Hamilton returned from Costa Rica, O'Keeffe showed him the record album and the book of drawings. Like many other people of his generation, Hamilton felt an affinity with Mitchell because of her confessional style of music and her sophisticated range. In fact, in a rare, open moment, he told me that he had a "crush" on the singer and wanted to get to know her better after he discovered she had visited O'Keeffe. Being associated with O'Keeffe, her assistant had discovered, gave him entree into the lives of worldly and famous people. Earlier that year, Hamilton and O'Keeffe had entertained Andy Warhol at Hamilton's behest. Warhol arrived at Ghost Ranch decked out in turquoise and silver jewelry he had purchased in Santa Fe. So Hamilton sent Mitchell an invitation to come to New Mexico and visit O'Keeffe.

At this time in her life, because of her popularity, Mitchell received sacks of mail every day—and she only looked at it periodically, she recalled. Months after Hamilton had sent her the invitation, Mitchell started to discover items relating to Georgia O'Keeffe. The first was a cover story in *Artnews*. She felt this was particularly prophetic because it related directly to her. " . . . In the enlarged print it said something to the effect, 'So I asked Miss O'Keeffe, if you were to come back in another life what would you come back as?' And without skipping a beat Miss O'Keeffe replied, 'I would come back as a blond soprano who could sing high clear notes without fear.' "

Mitchell, of course, was a blond soprano who could sing high, clear notes without fear. She was also particularly superstitious—"omenistic" was how she described herself. "So I got this strange feeling looking at this thing. And I began to sift down through this pile of mail and, oh, I would say about six months down in it I found a postcard, 'Lake George with Crows.' I flipped it over and it said, 'Have we offended you in some way?' And I dug down and there were

odds and ends of correspondence, including a formal invitation to come and visit, signed Juan Hamilton, on their behalf, with a phone number." Hamilton maintained that he contacted Mitchell through a mutual friend in Los Angeles and denied having sent her the card. In fact, he complained that the singer exaggerated her importance to them.

"I mean," he said plaintively, "she acted like me and O'Keeffe were these country bumpkins waiting for her to come and liven up our lives."

Mitchell was slow to respond to Hamilton's invitation. It wasn't until late summer, 1978, that she actually called O'Keeffe on the phone, using the private, unlisted number Hamilton had sent to her. Mitchell's response focused on the article in the magazine that linked her talent with the artist's. "You know you kind of learn to trust to a certain degree in signs, especially in the arts. I think in a way synchronistic events and auspicious things mean a great deal. And the more you trust them and the more you work with them, the more spectacular the display they seem to put up. For a long time, that's been the color in my life and kind of my guidepost, and Georgia's too, I've learned over the years."

By the time Mitchell finally arrived at O'Keeffe's, it was late September. When she called the artist to accept the invitation, she told her she would be visiting after a three-day trip to Mexico to see the jazz musician Charles Mingus. She had collaborated with Mingus on an album. "Oh, you won't be getting out of there in three days," O'Keeffe told her knowingly over the phone. Seven days later, Mitchell phoned again to say that she was right. She had gotten sick. O'Keeffe asked her to come as soon as she could. Referring to Hamilton, she said that "a young friend" was going to New York on business. He would be disappointed, she said, if Mitchell visited when he was away.

Mitchell flew from Mexico City to Albuquerque, at that time, the closest airport to Abiquiu. Rather than drive the two hours to O'Keeffe's, she checked into a hotel at the airport and stayed overnight. The next day, she called to

say she was not sure when she would be able to get to Abiquiu. O'Keeffe again stated that "it would be good" if she could make it as soon as possible. Mitchell ambled an hour north to Santa Fe and went shopping at the Fenn Gallery, where she bought a pair of Haida Indian rattles and matching ankle bells. The entire day passed by, and she still had not even begun to venture to Abiquiu. As night approached, she still could not decide whether she should spend the night in a hotel or go on to O'Keeffe's.

"Just as I was debating whether to go to Georgia's the following day or that night, a crow flew across my path. Crows are talking birds—a crow is materialistic, it likes shiny things. I've thought I must have been a crow in my last life—there's something about these birds that I relate to. And this crow flew across my windshield—very tight in—with a mouse that looked like a road hit. And I looked at the numbers on my mileage gauge, and they were eights all the way across, including the fast-moving one. The bird made me see it—the auspiciousness of that number—I took that to be a signal to go on."

Mitchell arrived at O'Keeffe's as the sun was setting behind the hills in back of her Abiquiu house. The sky was flaming orange and purple. "I knocked on the door. She opened it and as she pulled the door back, she turned her body away from me and called into the room, 'Juan, did you see when she arrived?' I don't know what she saw—perhaps it was the sun setting behind me—somehow or another, for her my timing was auspicious."

O'Keeffe guided Mitchell through a maze of buildings, looking for a place for her to sleep. The artist made the search seem ceremonial. At the first room, "she opened the door and she said, 'You could stay here.' She opened the door and closed it, really quickly. I got a chance to see that it had a Navajo rug, and it didn't look as if she had decorated it. It might have been Juan's room, for all I know. Then she took me to her studio, where her painting was on the easel, and there was a cot in there. And she said, 'Or, you could stay here.' And she held the door open a long time. So she

made it apparent where she wanted me to stay, and I thought that was fine with me because it was a pleasure to sleep in her studio, you know.

"So, that night we sat down to a lovely meal. She grew all her own vegetables, and she had a grape vine that produced the most spectacular green grapes, just fantastic. Some kind of clipping that she'd brought back from South America. A sweet, bright green grape, not a chartreuse green, almost a blue green, like a turquoise green. Very wholesome bread, and a nice soup. Very light and nourishing, every course. I thought, it's no wonder she's so spry. It was very nutritional tasting, delicious food."

Mitchell began to feel uncomfortable during dinner. "I only remember two points of her dinner conversation that night. The first one was: 'Well, Warhol was here. He wasn't much.' I wasn't sure why I was there. It was a bit testy. I think there is always a certain amount of testing that goes on among artists . . . mettle testing, let the wars begin, da-dumdadum. How would you like to sit down for a dinner, you're the guest, and the first thing that comes up is a discussion on how boring the last guest was. That's a bit of a trial. And there were others like that. It was a pretty colorful visit.

"The following day we went to Juan's house. It was a brisk day. I took some pictures of Juan and Georgia, and we wandered around. Juan picked her up in the kitchen, and he threw her into a green plastic garbage can. And he said, 'Oh, Georgia, you're nothing but an old bag of bones!' And he dropped her in the garbage can. She let out a shriek that had so much vitality in it, like a sixteen-year-old girl, and then a series of giggles. She just loved it. He didn't throw her—he just kind of dropped her into this plastic bucket so her legs came out one side so she had to be helped out of it.

"Then we took a walk in the country. . . . I felt a bit like a fifth wheel, and there were moments of great discomfort there and she would say things to me like, 'Of course, she doesn't *see* like we do, does she, Juan?' And I'd say, 'Wait

a minute, wait a minute—I can see perfectly fine.' Georgia
was supposed to be blind at that time, and in fact her eyes
were gray in the center like an old dog's. But her peripheral
vision was excellent, and she'd cock her head like a bird at
the ground and say, 'Well, then, do you see that bug crawling
over there?' I'd have to look, and there would be this bug,
crawling.

"That day we went to the Ghost Ranch, and we took a
long walk there. And I'm chain smoking along through the
wilderness, and Georgia suddenly turned—it was almost
like that shot that Juan took of her leaning on her cane, you
know with the dogs from behind—like that one where she
turned around and she was in the black dress over the white,
winter garb. And she said, 'YOU should stop smoking!' And
Juan said, 'That's not like you, Georgia, you know, to stick
your nose in other people's business.' And she'd been par-
ticularly hard on me that day, and she said, with her arm
out at an angle and leaning on her cane, 'Well, *SHE* should
live.' I thought, I guess she likes me. She'd just decreed that
I should live, whatever the reason. . . .

"But there were still more trials to come. That night I
decided to leave as it got dark, and she said, 'Oh, you can't
go now. It's dark.' So I stayed another day, which stretched
into five days. Every morning—I sleep in late as a rule and
stay up late—I'd wake up in the morning with her hovering
over me like a hawk: '*TIME TO GET UP.*' Wonderful little
breakfast and then I'd do my yoga out in the square where
the square flagstone and double black doors are—very aus-
tere little Zen, raked garden. And it was lovely, beginning
the day with this wonderful little nutritious meal and then
the exercise and the climate—the blue saturated skies."

But because Mitchell wanted to sleep late and O'Keeffe
arose at dawn, the singer eventually moved to Hamilton's
house.

"Then—let's just say the trials continued. I would go
over to visit her if she was in her studio bedroom. And I'd
be standing at the screen door and she'd say, 'Zoni, is that
you?' She called me Zoni. I'd just say, 'It's Zoni here,' after

a while. But once I called myself Zoni she stopped. She was very much a woman, and she was terribly fond of Juan. It was interesting to see that a woman at ninety-one is very much a woman. There was a sense of competition in that he liked my music and he liked her art. And if that was a threat to her on any level, then by god, she wasn't going to make it easy for me. But over a few days I got kind of anesthetized about the stuff and found my humor about it and played into it. And I became fond of her as craggy as she was."

Before long, it became clear that Mitchell was not the primary cause of the friction between her hosts, who were in fact working their depredations on her because they were embroiled in arguments about O'Keeffe's will. For the first time since she had hired Juan, Georgia was amending her will to name him as executor. She also gave him power of attorney to sign in her name in the event she became incapacitated. Hamilton had supplanted Doris Bry in O'Keeffe's life. Because the wills were eventually challenged, Hamilton has refused to discuss them or their execution. But Mitchell, who witnessed the signing of the 1978 will, observed that he was not able to sway O'Keeffe as some of his detractors have since maintained.

"It was quite a dynamic five days because the signing of the will was coming up. It had been discussed that Georgia's previous secretary [Bry] was furious with Juan, whom she felt was an opportunist and had taken over Georgia's life and hoodwinked her. I didn't want to get caught up in this, but it came up for discussion. Georgia talked to Juan with regard to it, and Juan talked back. He had made a request that he wanted all the mail to come through him. She'd done some withholding with regard to this will. I didn't really read the will—I just signed it, witnessed it. But there seemed to be some kind of dispute. Juan had one of my ears and Georgia had the other. It came to kind of a showdown where Juan said to me, 'You have to be friends with one of us or the other. You can't be friends with both.' I'd only been there several days, and I said, 'That's ridiculous.

First of all it takes longer than that to make a friend. I'm dealing with a certain amount of animosity here and testiness. I'm not sure either one of you are my friend. I'm just here to see what happens in a way.' "

Hamilton continued to turn on Mitchell. "Georgia had a lot of paintings stored behind the double black doors. There was one painting, that I really liked the longer I stayed there. Because she's a painter who sells her work, one day I asked if it was for sale. And Juan flipped out! He said, 'We thought you were different. You've just come after something.'

"It was cranky around this time, anyway. Juan was yelling at Georgia that she'd been disobedient in some way. It had to do with the will. Letters were supposed to come through him. She'd done something covert. And I think it was that she had put him in the will and he was saying he didn't want to be in the will. And Georgia was saying, 'Isn't he funny? He's so strange.' Juan is very aesthetic, you know, to a finicky degree. Georgia came out one day and there was a rattler curled up in a large sagebrush. So she had the gardener chop the big bush down. And Juan flipped out because 'she'd destroyed the aesthetics of her environment.' [Georgia] tells me this story and looks at him fondly and laughs: 'Isn't he strange?' "

Years later, one scene of her visit with Hamilton and O'Keeffe particularly stood out in her memory. "I had these two Haida Indian rattles and these ankle bells, which were harness bells that had been put on leather straps, to dance—Indian dancing ankle bells. It might have been a form of escape, but [during dinner] I excused myself and went to the room to try these things out. So I tied on the ankle bells and the two rattles in one hand. And Georgia came into the room and found me leaping and hopping around the room. And she stood there with one hand on her hip and her other hand on her cane looking at me kind of with a curiosity and keenness but no real expression. Well, in that room was, if not her last painting, one of her last, which was a wedge of white going up the middle and two triangles of turquoise coming down the side. She told me that it was of

the Washington Monument (*A Day with Juan*). We stood there looking at it. This was interesting to me, because she denies the sensuality of her paintings. She'll say, 'Oh, people will see in it what they want.' We're looking at this painting, and she suddenly says to me, 'It looks like a man's pair of pants.' And I thought, 'You know, you old fox, you see everything. . . .' "

Chapter 27

.

In 1978, the Robert Miller Gallery was a fashionable venue for an eclectic array of art that reflected the distinct personalities of its creators. Located on the top floor of a trim Beaux-Arts building on a fashionable stretch of Fifth Avenue, the gallery was a small, all-white (even the floors were white) space in which such artists as Lee Krasner, the widow of Jackson Pollock, and photographer Robert Mapplethorpe would show their works. On a crisp November night in 1978, the sculptures of Juan Hamilton were previewed for the first time ever. Taken primarily from the black rock shapes in the 1971 paintings of his mentor, Georgia O'Keeffe, Hamilton's sculptures were a personal expression of his relationship to the famous artist. They were bronze, finished with a smooth shiny black lacquer. O'Keeffe said she liked to run her hand over the surface. She told many people to buy one—and they did.

Few contemporary artists have received as sensational an opening. While Andy Warhol talked with Joni Mitchell and Charles Mingus in the back room, photographers from *People* magazine took pictures of the crowd of art enthusiasts that jammed the rooms. At the same time, an official from the marshal's office of the County of New York delivered a legal suit to John Bruce Hamilton. O'Keeffe's former assistant, Doris Bry, had brought a case against him.

Rarely is a person as old as O'Keeffe introduced to as much excitement as she was during the last years of her life. As she entered her nineties and left her productive years

behind, she was as famous as she had ever been in her long life. Part of her fame was now due to the notoriety Hamilton had brought to her. In large part, however, she was famous because people liked who she was and responded to the searching gaze she had applied to nearly everything she touched. At last, her fans now had a chance to find out who she thought she was through her book, *Georgia O'Keeffe*. A documentary movie featuring her inside her private world in New Mexico was also produced around this time. A movie was a natural vehicle for an artist whose life had become her art. It presented the entire world she had created—her paintings, her landscape, her houses—to the world. The documentary, produced and directed by Perry Miller Adato, an award-winning filmmaker, remains one of the greatest single contributions to the myth of Georgia O'Keeffe.

In Adato's movie, eighty-nine-year-old O'Keeffe walks effortlessly across her magnificent desert countryside. Her life is shown as a series of struggles and conquests. Her present situation is idyllic. Nowhere in the movie does the facade crack. No one needed to know that the artist rehearsed climbing the ladder to the roof of her Ghost Ranch house for weeks before the film crew arrived. The crude pole ladder up which she had scurried in the past to show guests the magnificent view was no longer accessible to her. The sad truth was that, because her central vision had completely eroded, she could no longer know when she had arrived at the top of the ladder. To prepare for the movie, she learned to count the ladder's rungs so she would know when she was at the top.

What a great movie could also have been made if O'Keeffe had been depicted as a scared blind person who still made her way courageously into the world, as she appeared to those who got close to her. Yet, in spite of her fears, her sense of humor always remained intact. On the occasion of her ninety-first birthday, the artist was fêted in the home of Robert and Betsy Miller. Miller had invited some of her old friends, as well as a few people she did not know. One man

exclaimed after shaking her hand that "I will not wash the hand that touched the famous O'Keeffe ever again." "You," the artist said with a laugh, "are full of baloney!"

More projects followed.

Weston Naef, a young and ambitious curator at the Metropolitan Museum of Art, suggested that O'Keeffe open the Stieglitz archive and exhibit her portrait. O'Keeffe had not even looked at the photographs her late husband had taken of her since she had deposited them in the museum in 1947. As she looked through them now, she could see them only out of the corner of her eyes, but she could remember what they looked like. Going over the nude photographs of her young body brought back wave after wave of memory. "I was photographed with a kind of heat and excitement and in a way wondered what it was all about," she recalled in an essay she wrote for the catalogue *Georgia O'Keeffe: A Portrait by Alfred Stieglitz*. As O'Keeffe was reminded of the experience of being photographed, she had mystical experiences in which she saw her body separate from her soul. "When I look over the photographs Stieglitz took of me— some of them more than sixty years ago—I wonder who that person is. It is as if in my one life I had lived many lives."

O'Keeffe lived increasingly in the past. When she was in New York, she tended to spend time with Esther Johnson. The two women took long walks together in the woods on Johnson's 3,000-acre farm with her poodle Goony. Johnson wore red Keds sneakers; O'Keeffe carried a cane. In what had become a cause célèbre, Esther had recently divorced Seward because he had been conducting an affair with their maid, Basia, and she was particularly lonely at this time. Georgia was a good friend. "I remember seeing her walk in my mother's bedroom with her hair all down, and it must have come down to her waist. I guess she was eighty-nine by then. She really looked beautiful," recalls Esther's daughter, Jennifer Duke. "She was staying in my father's old bedroom, which is right next to my mother's bedroom. So they were sort of together. It seemed like Mother had other friends

who were like Georgia. As I remember, quite a few of them were very independent, strong-willed-type people. And a few of them weren't married . . . the more creative, artistic, independent sort of people. She had wound up living in a fairly conservative area of New Jersey, and I don't think she enjoyed the type of social life that was there. So she did bring in friends . . . like Georgia to stay." People who barely knew the artist were treated to bits of information about her past. She told one of the clerks at the Miller Gallery that she had had arthritis when she was in her thirties but had gotten over it when she moved to New Mexico.

Hamilton took care of all of O'Keeffe's sales as well as her many projects. She agreed to Perry Miller Adato's movie at his urging. When Robert Miller asked her about a detail of a transaction, she waved her hand and deflected it to her young companion. "Whatever Juan wants," he remembers her saying. Betsy Miller recalls, "She would comment on [Juan] all the time. His name was constantly coming up, as maybe one's children's names constantly come up, or the name of somebody you were close to." O'Keeffe made sales through other New York galleries besides the Millers'. The Andrew Crispo Gallery sold her paintings to various collectors, purchased by Crispo through Hamilton. Gerald Peters, a young and ambitious Santa Fe entrepreneur who had amassed a small fortune by renovating historic buildings in the old Spanish colonial capital, made sales for her as well. He worked through Hamilton, at O'Keeffe's insistence: "I had to" work with Hamilton, he recalls.

Doris Bry did not take lightly to being supplanted by Juan Hamilton. After a number of emotional phone conversations with O'Keeffe, during many of which the artist hung up on her old friend in midsentence, O'Keeffe had sued her, and Bry filed a civil suit in the state supreme court. In her suit, Bry maintained that she had a contract authorizing her as the exclusive agent for O'Keeffe's work. "Because of O'Keeffe's advanced age and poor eyesight," Bry alleged, Hamilton had been able to take advantage of her. He not only restricted Bry's access to her by "screening her

telephone calls, her written communications, and her contact with other people," but he made "knowingly false or recklessly false statements to O'Keeffe impugning [Bry's] integrity and competence" and "provoked O'Keeffe into emotional conflicts with plaintiff." Bry sought to recover $13.25 million in damages.

Juan Hamilton acquired the notoriety of the infamous almost overnight. Only adding to his enigmatic image, he spoke of omens and signs to Grace Glueck of *The New York Times* and even indicated that he and O'Keeffe were like husband and wife, responding, "No comment," when asked if he intended to marry the ninety-year-old artist. Around this time, the rumor that the two would marry was fueled by a provocative article in *People* magazine. In photographs accompanying the article, Hamilton struck a sexually suggestive, come-hither position inside his adobe house—not unlike a pose Stieglitz had adopted as a student in Germany. A week later some friends encountered him in a hamburger joint in Santa Fe, preening like a peacock over the publicity. "Can't you picture all those women out there in Middle America," the artist's companion said, "wishing they had their Juan Hamilton."

The rumor that Hamilton and O'Keeffe were dating and would wed was promoted by an attorney to whom the elderly artist talked around this time. She had gone to him to find out how she could insure that Hamilton inherited some of her property when she died. The attorney told her that it was difficult to make sure that a person who was not related would inherit. One method used by some people was either to marry or to adopt the person in question.

Jerry Richardson noticed that Georgia was excited by the talk. "All those rumors about them being married and all that sort of thing—I think Georgia got a big kick out of it because she would refuse to deny those rumors when she was asked. It was real flattery to her that people would even think that she could carry on a sexual relationship with this handsome buck when she was in her eighties." Jennifer Duke also observed their closeness: "Juan would be escorting her,

in a way. It didn't look like somebody was leading her somewhere. It was just that they were going someplace together, and she might have her hand on his arm. So you could see that he was helping her, but that she was still acting as if she were in charge."

There was no basis in truth for the rumors of marriage. Hamilton preferred to date people his own age. He washed O'Keeffe's hair when they were traveling, and he often touched her. O'Keeffe did not usually let people touch her, nor did Hamilton allow others to touch him. (When her good friend Rebecca Strand James was in the hospital dying, O'Keeffe kissed her on the lips. After O'Keeffe left, Beck said to a friend that the artist did not normally kiss people or touch them.)

Hamilton was in fact dating Joni Mitchell around this time. After her visit to Abiquiu, the young sculptor ran into the singer in the airport in Albuquerque. They flew to New York together, and Hamilton says that, at Mitchell's invitation, Hamilton stayed in her suite of rooms in the penthouse of the Regency Hotel on Park Avenue. By the night of Hamilton's opening, they had split up, although Mitchell acquired one of his sculptures: "He had a pot that I called Aretha Franklin. He gave it to me actually because he said he could no longer look at it without seeing Aretha Franklin. I think he wanted pure form. He didn't want Aretha Franklin." "It was all right," Hamilton recalls darkly of his visit with Mitchell, "until I got into some coke, and then I got paranoid."

Like other people who "get into some coke," Hamilton began to behave strangely. He said nasty things about people. Gretchen Johnson noticed that he sometimes seemed "hostile," but she thought he might have been doing drugs and attributed his behavior to that. Joni Mitchell noticed that he sometimes became "electrified," but she also attributed it to the drugs and confessed that drug use was so pervasive in her world at this time that "I was used to people being irritable."

Bry's suit brought further controversy into O'Keeffe's life,

and, in fact, the tension seems to have exhilarated her. Her friends were divided into two camps: those for Hamilton and those against Hamilton. Georgia's sisters and Peggy Bok Kiskadden supported Bry in her efforts to win back O'Keeffe's support. June O'Keeffe Sebring, Georgia's niece, even brought up the 1978 exhibition of Stieglitz's nude photographs of her famous aunt. Sebring found the nudes to have only prurient interest and spoke for O'Keeffe's conservative midwestern family when she disapproved of her style of life. "You know, those photographs of Georgia," she said with a sniff, "I didn't even know they existed. They were not discussed in the family until the book was published. . . . Claudia was horrified. She said, 'Would you put this on your coffee table so children could see it?' . . . [Georgia] had been very quiet about that particular dimension of her relationship with Stieglitz . . . it was just simply better not to discuss it."

Chapter 28

· · · · · · · · · · · ·

In the spring of 1980, Phoebe Pack opened a letter from her old friend Georgia O'Keeffe. It was one line long, hand-written in large characters on plain white linen paper. Since she was able to see only out of the sides of her eyes, O'Keeffe no longer wrote clearly, but Phoebe figured out what she had tried to say: "I need to see you." In the more than forty years that she had known Georgia, Phoebe had never heard her ask for help before. Sensing that it was urgent, she replied from Arizona over the phone that she would come to New Mexico in a few weeks. Since Arthur had died a few years before, Phoebe did not normally return to Abiquiu by herself. Her weak heart, which had compelled her and Arthur to give up life in high altitudes, did not function well at six thousand feet above sea level.

Phoebe flew from Tucson to Albuquerque, where she was met by a daughter-in-law. They drove through a blinding blizzard to Santa Fe; by the time they reached Española, Phoebe stopped and went no farther. She had not anticipated snow in May—and she would not continue the extra hour to the ranch. Thinking O'Keeffe would probably not have driven to see her, because in her memory "Georgia went to no one," Phoebe checked into the Chamisa Inn on the strip in Española and appealed to her friend to meet her there. Since nearby Los Alamos had brought jobs to the area, Española had grown from a small river pueblo into a motley town where those who cleaned up in the atomic energy labs lived. Cruising slowly from McDonald's to Lotaburger in big American cars lowered to within inches of the ground out-

side the inn, the locals in Española were known as "low-riders."

When O'Keeffe arrived at the inn the next day, Phoebe sensed that something was truly wrong. Not only had the artist ventured out in the snow to seek her counsel, but as she stepped out of the back of a white Mercedes-Benz sedan, Phoebe noticed that for the first time in her memory Georgia looked old and tired. Phoebe reached to steady her friend's shaky gait. O'Keeffe resisted. "I don't need your arm yet," she said defiantly. O'Keeffe steadied herself by placing a hand on a wall as she walked up the steps. Phoebe felt that the artist could not actually see her at all. Before long, however, as they reminisced about the past, O'Keeffe began to talk about her life in a way that was at once reflective and detached, as if the events had already passed by her and she were in another sphere. She talked excitedly about the book she had produced with Hamilton's help and about the movie that had been made about her. Phoebe was pleased to hear her old friend describe these events glowingly. Then O'Keeffe got closer to the reason for her visit when she began to describe Juan Hamilton. It was as if, Phoebe recalls, the artist were describing a prized child. Hamilton, O'Keeffe said, gave her a reason to go on. She could no longer see well enough to paint, but she could hear, feel, taste, and remember. He made her feel good about herself. He understood her, he took care of her, made sure the staff worked, listened quietly with her to records out at the ranch. He taught her how to make pottery. He picked her up and tickled her. He fixed her hair when she went to the opera in Santa Fe and suggested she wear it piled on top of her head.

The problem was her other friends' reaction to Hamilton. Many of her old friends, as well as her sisters, did not care for him: They felt he was using her for her money and name and controlling her like a Svengali. O'Keeffe was overwhelmed by doubt. She enjoyed having Hamilton look after her. They fought, as people who were close to her often did. Sometimes she could not rely on him. He would vanish for

days and would not appear when he had said he would. (O'Keeffe had followed the same muse in her own youth—going to Maine on a moment's notice, leaving Lake George after she had told Stieglitz she would stay home.) But her normally suspicious nature had been fired by the strong opinions of her friends. Hamilton had been rude and obstructive to Peggy Kiskadden, Claudia O'Keeffe, and others. Although he and O'Keeffe had developed a close friendship, he did not recognize how firmly entrenched a person in their nineties can be in a circle of friends and relatives.

Phoebe listened attentively while her old friend spoke of her problems. She had funded and operated a suicide hotline in Tucson, and in her capacity as a counselor, she had learned to listen attentively to those in need of help and to offer advice judiciously. Sometimes she did not know what to say. But when Georgia O'Keeffe—her old friend who had raided her vegetable garden, tried to extort a cake from her, and over the years grown away from her—asked, "Phoebe, tell me: Am I wrong to let Juan care for me?"—she knew what to say.

"No, Georgia," she said, "Juan has made a different person of you. For heaven's sake, keep him!"

In the early 1980s, Hamilton was not seeing O'Keeffe as often as he had in the first days of their relationship, when they had produced books, organized exhibitions, and coordinated the schedules of film crews and curators together. It is possible that the artist's doubts were accelerated by her fear that he would leave her. At this time, no one knew where Hamilton went when he was away. They did not know why he was going, or even when he left. He and O'Keeffe had no pressing projects together. There was no reason for him to continue to stay in Abiquiu—except for O'Keeffe herself. Friends recall that she was always in the company of a young female companion at this time, but that Hamilton was often absent—a situation that disturbed some of her relatives.

Raymond Krueger, grandson of her Wisconsin sister, Catherine, visited O'Keeffe around this time. Krueger had

last visited his great-aunt in the 1960s, when as a boy he had fallen and broken his wrist. They were not close. When O'Keeffe had visited Milwaukee in 1974, she had not found the time to see him. In the meantime, he had graduated from law school and had become a practicing attorney with a firm in Milwaukee. When he arrived in Abiquiu, the first thing O'Keeffe wanted to know was what he looked like: "She took me to the doorway of her studio and turned me around the way she wanted me in the light, and then she ran her hand all over my face for a few minutes. Then she said, 'Now I understand what you look like.' That was interesting, but it seemed that given her limitations, that's what she'd have to do to understand what you looked like. You'd have to speak to her in a stronger voice because she didn't hear as well as she used to. She noted on the second day that my voice was stronger. I had learned to speak up at that point in time at her so she wouldn't have trouble hearing me."

Krueger and his old aunt were alone for two days. "We did go out to the ranch, and we took the walk from the ranch to the foothills, then back to the ranch. Her comment to me was, 'I know the way, and we'll go for a walk, but you'll have to watch for the rattlesnakes because I can't see them anymore.' Sure enough, off we went and we walked out, and she still had her chair that she'd placed under some small trees out there. I don't know what kind of trees they are, but off her path she had a little chair that she'd put in the shade. She walked down the path from the ranch toward the cliffs, and she'd sit there in the shade and rest. And that was maybe two-thirds of the way to the cliff—a good distance. That anyone of ninety-two could make that journey I think is remarkable. We walked out there and talked all the way.

"Georgia told me that she didn't understand why Juan wasn't there. She had expected Juan to be there, and she was surprised that he wasn't, and she said that on probably three different occasions, saying, 'I wanted you to meet him.'

aid of a friend, he hoisted heavy timbers for roof beams and secured them in place. He used cocoa-colored adobe mud mixed with straw for the interior walls. The floors were wide pine planks. Decorations were minimal: a single rock, a smooth pink shell, a simple black clay pot that he had made himself. For years he did not own a sofa—people sat on pillows. Heat was supplied by a wood-fire pot-bellied stove.

O'Keeffe loved Hamilton's house. She told people proudly that he had built it by himself, and how the view was special, and how wonderful the light in the studio was. She was as pleased with his house as she was with her own. Some of her friends even detected a note of envy in her voice as she described his achievement. She could no longer climb to the top of the ladder in his studio, but she could lean on the bottom rung and look up into the white light coming through the skylights in the roof. "It has a very white feeling," she said of her protégé's studio. "The light comes in through the skylights . . . beautiful light. It makes the room seem very alive. It's a fine place to see the work he does because of the way the light comes in."

O'Keeffe oversaw practically everything Hamilton did and took an active interest in it. Hamilton was her project, now that her failing eyes prohibited her from working and her unsteady gait kept her from walking alone. She was extremely proud of him and was hurt when old friends and family members complained about his ways. She demanded a lot of him, and he in turn gave her what he could. "Do it properly!" she often said. She insisted that he be available when she needed him, and he sometimes became frustrated when her needs came before his. She took an interest in his friends and enjoyed their company, particularly Glen Myers and other young people he brought into her orbit. She told him his friends did not understand him. She encouraged him to marry and have children. He got the impression she wanted children around. She said that he would need someone to look after him when she was no longer around.

O'Keeffe let her other projects fall by the wayside. Around this time, after several uncomfortable altercations, she de-

I never had the chance to meet him because he was never around at all that weekend."

One day Hamilton appeared in El Rito at Glen Myers and Walter Pickette's house with Anna Marie Erskin. Erskin was a young divorcée from Scottsdale, Arizona, whose ex-husband was a nephew of former Senator Barry Goldwater. Anna Marie (née Prohoroff) was a dark-complected, fine-featured woman of Yugoslavian descent who dressed elegantly in suits by Giorgio Armani. She spoke softly in breathless intonations, giving her an airy quality. At Arizona State University she had majored in art, and she was, she said, a vegetarian-fruitarian. She told people somewhat defiantly that her favorite movie was *The Sound of Music*.

Anna Marie had met Juan one day at O'Keeffe's during the summer of 1979. Hamilton drove her around New Mexico, showing her sights he enjoyed. He liked the way she laughed at everything he said. He began to make extended trips to Scottsdale. In the fall, Anna Marie moved into Juan's house in Abiquiu. O'Keeffe encouraged his romance with Anna Marie, although when her sister Catherine visited, she complained about their relationship. When Catherine accused her sister of jealousy, O'Keeffe balked. She was worried, she explained, what the natives of Abiquiu would say about Hamilton living with a woman to whom he was not married—a strange concern from someone who, more than fifty years earlier, had lived defiantly out of wedlock with Stieglitz.

Juan and Anna Marie were isolated from Georgia in his house at the end of the road on the highest peak in the village. It was a beautiful spot. The white, yellow, and red sandstone badland of Abiquiu opened in endless splendor in several directions. He had completely redone a traditional run-down adobe, taking the old shell and adding onto it in several directions. He raised the roof to a sharp pitch, and in the eaves he designed an all-white studio for himself, complete with a balcony overlooking the valley. He was proud of his house, a product of his own hands. With the

manded that Barbara Rose return all the O'Keeffe–Stieglitz material in her possession and all her notes as well. Once O'Keeffe had turned against a project, she left no loose ends, insisting, as she had with Anita Pollitzer, that the person surrender their experience of her as well as the material. A rumor circulated that it was Hamilton who had convinced O'Keeffe to fire Rose, but Rose herself felt that O'Keeffe was upset because she was going to Italy during the summer and could not spend much time in New Mexico anymore.

John Bruce Hamilton and Anna Marie Erskin were married with little fanfare in the spring of 1980. Their union was not announced in the local papers; in fact, a few of O'Keeffe's friends felt that she did not even know they had been married. Anna Marie and Georgia kept their distance from each other. The new Mrs. Hamilton referred to the artist as Miss O'Keeffe. O'Keeffe liked the way Anna Marie looked and enjoyed stroking her hair, a form of intimacy she had employed with other women she liked over the years. But they were never friends.

Juan and Anna Marie provided the artist with the family she had never had. In the fall of 1980, Anna Marie gave birth to a boy, Albert. Anna Marie was a devoted mother who breast-fed her child well into infancy and lavished attention on his diet as well as his free time. I remember watching with awe as Anna Marie fed Albert a vegetarian meal of brown rice and broccoli, thinking that it was remarkable that she could get him to eat healthy food. O'Keeffe loved holding the baby, but she told Hamilton she was afraid babies did not like her—a strange response from someone who had wanted to have children. O'Keeffe enjoyed having the family around. After talking to her one day, Bob Miller called Grace Glueck of *The New York Times* and told her O'Keeffe was a grandmother. That was the impression he got from talking to the artist.

O'Keeffe receded further into the background. In October 1980, Hamilton and O'Keeffe visited Andy Warhol in his "factory" in New York. The year before, they had commissioned him to produce a portrait of both of them, and they

had struck up a friendship with him. In his portrait of them, Warhol used diamond dust to give luster to the unusual pairing of age and youth. "This time," Warhol noticed, "Georgia seemed really old. You have to catch her every minute as if she'll sit in a chair that isn't there." Warhol also made a video of the elderly artist while she was in New York. He observed that she seemed more alert once the video camera was focused on her. It was a Pavlovian reaction. For a camera, as she had for sixty years, the artist changed her personality. "She does know everything that's going on," he concluded, "it's just that she moves older now." One of his assistants noticed that the lights hurt her eyes and that she seemed like "an old, blind poodle who simply went where she was led."

O'Keeffe had no plans for her future. She accompanied Hamilton to New York, along with Anna Marie and young Albert, when Hamilton's sculpture was once again exhibited in the Robert Miller Gallery in the spring of 1981. Because she was not feeling well, she stayed in bed the evening of the opening. The next weekend she went to an outdoor party in Old Wick, New Jersey, where this author met her. Although I had heard she was losing touch with reality, I was impressed by how alert she seemed and by how attentive Hamilton could be. When she choked on a piece of food, I offered her a sip of wine. Seemingly out of nowhere, Hamilton swooped down and took the glass from her hand. "Miss O'Keeffe," he said, pronouncing the word *miss* as if it were *baroness* or *duchess,* "does not drink wine." I later learned that she didn't drink because of the medication she was taking for a cold.

Friends first began to notice she was not herself. She failed to recognize people she had known well in the past. Betsy Miller noticed that the artist's attempts to assert herself had become feeble: "She was making statements that seemed like declarations, and sometimes they were really insignificant, and she'd always deliver them as if they were the last word." Increasingly, Hamilton asserted even more control over who the artist saw and where she went. Claudia no

longer came to Ghost Ranch in the summer; when one of her nieces tried to contact Georgia, Hamilton said she was unable to receive visitors. Claudia was herself bedridden around this time, having suffered a debilitating stroke.

Bry's cases against O'Keeffe and Hamilton were settled out of court for an undisclosed sum of money and on the condition that Bry never discuss what had gone on between her and O'Keeffe. O'Keeffe's name was coming up in court-rooms all over. At Hamilton's urging, the artist had filed suit to retrieve stolen artworks that had surfaced in New Jersey. The works had been removed from An American Place the year Stieglitz died.

By the time O'Keeffe contacted Phoebe Pack in 1980, she was confused and lost. She had seriously doubted her judgment in selecting Hamilton to care for her. As her eyesight failed progressively, she became increasingly suspicious and paranoid. One of her friends noted that she was always losing things in this period and accusing other people of stealing them. It is possible that she wanted to have Hamilton around as much as she had in the past. There is no reason to doubt that she was also just a little jealous of Anna Marie and wished she could live with Juan all the time.

Like many disabled people, O'Keeffe discovered that her other senses were heightened as she lost her sight. Music became a great source of comfort for her, as it had been since, as a young girl at the convent in Wisconsin, she had discovered classical music. Beginning in 1974, she had do-nated a photograph of one of her paintings each year for the poster for the Santa Fe Chamber Music Festival. In exchange for her generosity, an ensemble from the festival performed in her garden in Abiquiu for her. She also con-tinued to attend performances of operas in Santa Fe. She listened to a recording of Beethoven piano concertos by Hans Richter over and over, and she had a wide range of musical recordings, including avant-garde music by John Cage and Philip Glass.

Around this time, Phoebe Pack gave the artist a shell necklace that she had been given in the airport in Bali. When

she presented her old friend with the necklace, she noticed that the artist's fingers moved rapidly over the shells—"she was always fingering something"—and that she thanked her profusely. It was just a cheap shell necklace made for tourists, but O'Keeffe acted, Phoebe observed, "as if I had brought her diamonds." She was ecstatic. "Oh, Phoebe!" she said. "That's something I—you couldn't have brought me anything that I would like as well." She held on to the necklace tightly. "She would not let go of it," her friend noted fondly.

Chapter 29

.

A silver helicopter descended from the blue sky over Bode's General Merchandise. Nearly everyone in the tiny village of Abiquiu rushed outside to see it land on a flat piece of desert near the store in a cloud of dust. Television had reached the village only a few years earlier, thanks to a booster for which O'Keeffe had paid. Now there was a helicopter landing behind the store. The passengers were awed by their reception. John Cheim, the astute director of the Robert Miller Gallery—who along with Robert Miller and Calvin Klein, was a passenger in the helicopter—compared the experience to being in a movie: "All these little Indian and Mexican children came running up, waving at us," he recalls. "It was very cinematic." He felt that the passengers were perceived "like these white gods coming down in this helicopter . . . like we were landing in the middle of Africa . . . going to visit the white goddess at the top of the hill."

O'Keeffe had never heard of Calvin Klein—she had no idea who he was or what he was noted for. She knew about contemporary artists like Mark Rothko and Ellsworth Kelly. She knew who John Cage and Merce Cunningham were. But the artist did not follow fashion and never had—although she had been friends with Elizabeth Arden and Lily Dache. But she liked Klein's energy immediately. He was like a rush of traffic into her quiet adobe village. Like many people who work in fashion, having adjusted his sleep patterns over the years to meet the demands of regular shows, Klein often stayed up all night when he was working, as he

had been just before he came to see O'Keeffe. In the Polaroid picture Cheim took, Klein had not shaved in several days and was wearing a loose, brightly colored Hawaiian shirt. He looked deliriously happy, and so did she. The elderly artist was wearing a putty-colored Calvin Klein cardigan that he had sent her in the mail a few weeks earlier. She told him she liked the sweater. He said he liked her paintings. According to Cheim, "Calvin was very charming and very kind of fannish to O'Keeffe. O'Keeffe liked the attention. He put his arm around her. She enjoys, in the right circumstances, being touched, squeezed."

O'Keeffe did not like being involved in the minutiae of deals concerning her paintings. She acted aloof around purchasers and dealers. But she liked to know that people wanted what she had created and would pay a lot of money for it. This would be her first million-dollar sale. In fact, several million dollars were exchanged for a couple of paintings, including *Summer Days,* a 1937 painting of a deer rack floating in a cloudy sky. Miller had arranged the sale for O'Keeffe and Klein.

Klein had discovered the world of Georgia O'Keeffe through his friend, photographer Bruce Weber. Weber, whose sleek, muscular models and sexually charged vignettes created the lush tone for Klein's fashion layouts, was a habitué of Miller Gallery exhibitions. Weber had taken Klein to an exhibition of summer landscapes the year before in the gallery. Klein, according to Cheim, had "flipped," over an O'Keeffe painting of the Black Place in the show—a small abstract landscape from the thirties. The fashion magnate wanted to know how he could acquire more O'Keeffe paintings. He and Miller discussed the matter. Then Klein wanted to know more about the artist. Weber showed him books about her and her homes in New Mexico.

For Klein to discover O'Keeffe at this time in his life seems to have been inevitable. Since the 1960s, when the designer had started his career, American fashion had increasingly moved away from selling clothing and toward the

concept of promoting an entire lifestyle. Although she did not know it, O'Keeffe had become a lifestyle in the sense that she had a distinctive and now well-known way of looking at things. Her thick-walled adobe fortress on the edge of a wild desert plain was as romantic as anything Hollywood could have imagined. The way she arranged a bunch of watercress in a basket, the way she pinned a man's handkerchief around her head, the way she wore a white kimono, and the way she organized a shelf of random rocks from a dry riverbed—her life was a study in aesthetics, from the moment she woke up to a sunrise over badlands until the moment she knelt in front of her narrow bed before going to sleep. She had taken what Arthur Dow's teaching proposed, that the purpose of art was to "fill a space in a beautiful way" and expanded it to cover her entire life. "Everything was style about her," observes Cheim. "When you go into her house in Abiquiu, in what was her little bedroom by her studio, there are all these clothes in boxes. I was there one day with Juan, and we were looking at them, and the way things are folded, it's incredible. Everything is folded perfectly in ways you wouldn't even think to fold."

Klein told her repeatedly during his first visit to Abiquiu how much he appreciated the way she lived. Cheim felt that Klein was overdoing his praise of the artist, but Klein had become obsessed with O'Keeffe. He had discovered something unique in her and, like a good arbiter of style, wanted to take some of it back to New York. The way she lived fit perfectly with his simple American fashions, a fashion of basics like a white T-shirt and blue jeans, a simple jacket and an A-line skirt. It was a fashion into which a U-shaped adobe house in an open desert with sagebrush growing between the flagstones' cracks could easily fit.

Klein got more than a group of paintings. In an unusual departure for the elderly artist, who did not generally open her houses to the public, she agreed to let him photograph his clothes on the patio at Ghost Ranch. With the exception of her movie, this was the first time she had opened her

private sanctuary for public exposure, though various photographers had been allowed to photograph O'Keeffe in her house.

Hamilton was criticized for allowing Klein to use her house, and he later said he regretted having gotten involved with him. When Joni Mitchell had expressed an interest in a painting, Hamilton had come unglued; a part of the young sculptor was always aware that people wanted to use him for his access to O'Keeffe, and he was hypervigilant about checking people's motives. Once, because Klein would not answer his calls, Hamilton told me he was "cruel and obnoxious." Weber remembers talking to Hamilton about the shoot: "He would say to me sometimes, 'Oh, I'm glad that happened. We had a great time together.' Then he'd say, 'Oh, I wish that hadn't happened.' That was so Juan because it really came from that fear that he might be losing her. But I feel that Calvin was incredibly respectful of her, and really felt honored to be there. I would have never taken the pictures if he hadn't felt that way. And I knew that he did."

Hamilton continued to be criticized for his arrogance. Shortly after Klein became intrigued with O'Keeffe, he called his friend Andy Warhol to see if he could introduce him to her. Warhol observed that Hamilton had become "grand." When he called, Hamilton was not helpful. Hamilton said Klein could fly to New Mexico but that he didn't know if O'Keeffe would see him. When Warhol explained that Klein, a world-famous designer who operated a multimillion-dollar empire "doesn't do things that way," Hamilton said: "That's how it goes."

Like the rest of the art market, which had been undergoing an unprecedented period of growth, the prices for O'Keeffe's paintings had appreciated wildly in a few years. The Klein deal improved her market noticeably. Pictures that had gone for $250,000 were now at $500,000. Hamilton became rich by agenting O'Keeffes. There was little doubt he deserved it—the work of running the affairs of an elderly person is never easy. At this point in O'Keeffe's career, with

her renascent fame and her failing body, it was a full-time job—and a very unpopular one. Increasingly, it was Anna Marie who looked after O'Keeffe, while Hamilton took care of her business. Although the elderly artist was fond of Anna Marie, she wanted Hamilton, and she could be curt with his wife. Once when they were together in Big Sur visiting her old friend, architect Nathaniel Owings, Sr., Anna Marie returned triumphantly from a shopping trip with new sunglasses. She told O'Keeffe she had been hunting all over for this particular pair. "That's nice, dear," the artist replied sardonically. "I think everyone should have a little project in life."

As the artist faced her ninety-fifth birthday at the end of 1982, it was she who had no project in life. Barbara Rose's plan to exhibit the abstract art of Georgia O'Keeffe had failed to materialize. Hamilton talked from time to time of mounting another retrospective, but his efforts bore no fruit. A major showing of Stieglitz's black-and-white photographs was slated for the following year. As shepherd of his work, O'Keeffe took pride in the show—although she took an increasingly small part in it. Her efforts at pottery had been left in the past, and she no longer attempted to work in her studio, even with an assistant.

O'Keeffe no longer stayed overnight at Ghost Ranch. It was hard finding helpers who would stay out in the badland with her. Most of her help came from girls who lived around her in the village. They were afraid of Ghost Ranch. Hamilton took her on rides in the white Mercedes roadster out to the ranch—and to his own house for meals. She loved the way Anna Marie had planted the garden at their house. Anna Marie was a triumphant gardener who worked wonders with squash and flowers in a place where O'Keeffe had questioned the receptivity of the soil. "You can't grow things where there is resistance," she had said. Now that Claudia no longer visited in the summer, her own garden did not look well.

So when Calvin Klein entered her domain, the artist felt enthused. Even though O'Keeffe stayed in the Abiquiu house most of the time Klein was being photographed in the patio

at Ghost Ranch, she enjoyed having a project in her life—
even if it only remotely concerned her. O'Keeffe's absence
was noted by members of the designer's crew, who were
quick to notice how much Hamilton resembled O'Keeffe in
speech and gestures. Some of the unkind among the stylists
nicknamed Juan "Norman," after the fictional Norman Bates
who dresses in his dead mother's clothes in the Alfred Hitch-
cock movie *Psycho*.

The comparison was meant to be playful and tongue-in-
cheek—Hamilton also resembles the actor Anthony Perkins,
who played Bates in the movie. But more people were be-
ginning to believe there was a case to be made against him.
Not that he was psychotic, but that he was manipulating
O'Keeffe to do what he wanted her to do. Several of her
friends pointed out that—in their opinion—O'Keeffe would
never in her right mind have allowed a designer to use her
beloved Ghost Ranch as a backdrop for his fashion—a ges-
ture of generosity the elderly artist would never have ex-
tended. "That ground was sacred," concluded one friend.
Not everyone agreed. "It was a very good thing," said Cheim.
"Everybody benefited. I don't think it was a bad thing for
O'Keeffe." Asked another friend, "How did that hurt her?"

Gretchen Johnson noticed that Hamilton could be
"pompous," but she felt "what he did for Georgia was great.
I think he cared about her as much or more than he said
he did or says he does." Cheim, who noticed that Hamilton
tickled the elderly artist and flirted with her, felt that Juan
was "very important to her living as long as she did be-
cause . . . he was the only person around who played with
her. She couldn't play with anyone else. She would have
been terribly alone." Bruce Weber, who devoted an entire
wall of his New York loft to pictures of O'Keeffe and Stieglitz,
supported Hamilton, too. One night as the sky turned purple
and red at sunset, when Weber was at Ghost Ranch taking
pictures of Klein's clothes in O'Keeffe's house, he and Ham-
ilton stood on the roof and spoke about the elderly artist.
Weber was impressed by Hamilton's devotion to her care.
Noticing that it was probably a lot of work to care for

someone like her, a person with specific needs honed over nearly a century, he felt that Hamilton loved O'Keeffe. "A lot of people are very, very critical of Juan. But I just remember the way he spoke. We were talking once. I asked Miss O'Keeffe if she always had her hair very long. And she told me that day at the table that she hadn't cut her hair in so many years. And Juan reminded her of the time when they took a trip to Mexico, and she was in the bathtub, and he helped her wash her hair, and her hair came down to almost her waist. And I always thought that was so beautiful, that here was this hippie sculptor guy just taking care of this woman, and they were hanging out together. It was so like her and so much like her luck in life, that at that time in her life she would have somebody."

Chapter 30

.

In the late spring of 1983, Juan Hamilton took Georgia O'Keeffe for a ride in a horse-drawn carriage through lush Central Park. It was the first time in years that she had ventured into the park. The ride ignited a blaze of memories in the elderly artist, whose attention had been moving in and out of the past with considerable ease since the first of the year. As a young art student in New York at the turn of the century, O'Keeffe had walked through the park by herself at night—something no one had been advised to do in decades. When she returned from Texas in 1917, she had walked in the park in the rain with Arthur Macmahon and told him she could not see him anymore. She had become obsessed about peacocks. When she was a young woman living in New York, she told Hamilton, there had been flocks of peacocks in the park. Stieglitz was arrested once, she recalled, for stealing the feathers from the tail of one of the birds. Her friend Elizabeth Arden had used white peacock feathers to decorate a wall of her house on Fifth Avenue. "There go those peacocks again," Hamilton said teasingly when the artist introduced the subject again. At night, when the air became chilly, Hamilton wrapped her in a black wool cape lined with scarlet satin. "This was Alfred's," the artist told a woman who happened to be standing next to her.

The year had begun strangely. At the February 1 opening of a retrospective exhibition of the photographs of Alfred Stieglitz at the National Gallery of Art in Washington, the ninety-five-year-old artist had seemed entirely unaware of

where she was. She was unable to recognize even her own niece, Catherine Krueger, and her husband, Earl. The year before, they had visited for some time, Catherine recalls, and O'Keeffe had known who she was then. Even after Catherine reminded her, Georgia failed to even suggest she recognized her. Earl Krueger later said he believed that Hamilton would have been better advised to leave O'Keeffe at home instead of bringing her to the opening. Hamilton explained that though O'Keeffe was unwell, she had wanted to attend the opening of Stieglitz's photographs and had insisted he take her along with him.

Since Stieglitz had died in 1946, O'Keeffe had been custodian of his vast body of work—a role she did not really enjoy, since performing the duties required skills of management and organization in which she had no interest. She was indebted to Stieglitz for having promoted her work when she was still an unknown schoolteacher from Texas, and she had returned the favor by overseeing his work after he died—a favor she hoped Hamilton would one day extend to her after she died. Along with Doris Bry, she had begun to catalogue Stieglitz's entire artistic output, sixteen hundred examples—the so-called key set—which she donated to the National Gallery.

The Stieglitz retrospective had not been brought about overnight. In the late sixties, when O'Keeffe had first asked Barbara Rose to read and edit her correspondence with Stieglitz, the elderly artist had intended to publish his and her own letters. Within a few years, understanding and appreciation of early photography had mushroomed into such a large field that professionals approached the elderly artist with requests for exhibitions of Stieglitz's work. Whereas once only a few had shown an interest in his work, now there were many. When Rose ceased her work with O'Keeffe, a young curator, Sarah Greenough, took over the role of reading and editing Stieglitz's vast correspondence. Greenough also began coordinating an exhibition of Stieglitz's photographs. It was not easy. For several years she sifted through the sixteen hundred images O'Keeffe had deposited

in the museum, along with O'Keeffe and Hamilton. It was Greenough's aim to uncover seventy-five examples of his work that would "demonstrate the evolution of both his photographs and his understanding of the medium." Greenough set out to "demystify" Stieglitz and put him in perspective as a photographer. She also was required to work closely with Hamilton, an experience that she indicated was not altogether pleasant, although they worked together for some time.

O'Keeffe traveled to Washington the last week in January on a first-class flight from Albuquerque. Accompanying her was her secretary, Agapita Lopez, who had worked for her for many years. O'Keeffe had paid for her to attend secretarial school, and she had assumed Hamilton's clerical duties as he took on other responsibilities. O'Keeffe's entourage occupied the presidential suite overlooking the White House in the Hay-Adams Hotel. These expensive lodgings were often taken by heads of state and movie stars. The day after the opening, Catherine and Earl Krueger visited their famous relative in her ornate suite. They observed that she seemed out of place in such a palatial setting.

The night of the opening, the museum sequestered the artist behind a red velvet rope, but more was needed than a rope to protect her from the throngs of well-wishers who pushed to get near her. It has been suggested that perhaps the confusion of faces caused her to forget who her niece was when she first approached her. The problem was that even after a prolonged conversation, Catherine Krueger felt her aunt did not know who she was. O'Keeffe, in the opinion of her family, had lost touch with reality. Krueger expressed some concern about Georgia to her mother, Georgia's sister Catherine Klenert. The latter, in turn, talked to Anita Young about how Georgia was being cared for by Juan.

The following day, when O'Keeffe attended an opening at the Lunn Gallery, she gave Harry Lunn the impression that she was remarkably alert for someone her age. He was aware that she did not remember who he was either, but he was impressed by her stamina. The exhibit recreated

through photographs and letters the atmosphere of 291. O'Keeffe remembered what that was. She also impressed Lunn by expounding on scenes that had taken place sixty years earlier. As for many old people, the past seemed more vivid to her than the present.

O'Keeffe asked Lunn to take her to visit the Vietnam Veterans Memorial the next day. The Veterans Memorial, a long wall of granite with the name of every American soldier killed in the Asian conflict etched onto its facade, had only recently opened. Lunn was impressed by the attention Hamilton showed O'Keeffe as they visited it. It was cold outside. The field around the memorial was muddy, and boards had been placed over the mud. Some boards had slipped and turned sideways. Hamilton lifted O'Keeffe from the car and carried her across the boards to where she could reach the wall. The woman who had vehemently opposed the First World War looked sadly at it. She could not see, but she could feel. Hamilton hoisted her closer to the wall. She placed her hand on one of the names and fingered the indentation in the stone where a name had been etched. She began to cry.

Since the twenties when she discovered Bermuda, O'Keeffe had enjoyed traveling to the tropics in winter. Around this time, she began to visit her old friend, Esther Johnson, on her estate on Jupiter Island in Hobe Sound, Florida. Johnson, who refused to fly, reached Florida by traveling aboard a private railway car; on Jupiter Island she lived simply in a small converted boathouse paneled with cypress wood on the Indian River. Her property, however, covered many acres of tropical splendor, stretching the width of the island to a private beach on the Atlantic. It was paradise. Wide green lawns gave way to lush beds of tropical flowers. Moss hung from old oak trees. There was a large saltwater swimming pool outlined with coral. A waterfall splashed into a grotto. O'Keeffe enjoyed swimming in the warm water. Her ankles had begun to swell with edemic fluid, and it felt good to move effortlessly through the water. She enjoyed the warmth of Florida but complained that the

slightest drop in temperature made her bones feel "creaky." Once Esther and Georgia were driven about an hour down the coast to Palm Beach, to eat dinner with Georgia's sister Anita. Anita had outdone herself after her husband, Bob, committed suicide in 1958, by tearing down her old mansion and putting up a stolid new Neoclassical fortress in its place. It looked like the embassy of a rich nation in Washington. The interior was decorated with French marquetry cabinets and Sèvres porcelain from palaces in Europe. One room contained several of Georgia's flower paintings. Anita had begun collecting her sister's pictures as early as 1926, when she had bought a painting of a calla lily. But because she was insecure, Anita was never sure what to make of her sister's work. "Do you like them?" she asked suspiciously when she discovered a guest admiring Georgia's paintings. The guest felt that because she wrinkled her brow as she asked him the question, she wanted to make sure he liked them before she committed herself.

Years later, Esther, who had been raised in quiet, rich circles in New England, still recalled the grandeur of Anita's small dinner party. What impressed her were the footmen. The three old women dined in a large room overlooking the Atlantic Ocean. Behind each, a footman dressed in a uniform stood at attention. Georgia was impressed not by the regal trappings but by her sister's "wall of glass." With the press of a button, she told people, marveling at the technology, Anita could open the wall of glass to let tropical breezes into the house. When the air cooled, she could bring the panel of glass back into place by pressing the same button. Juan was impressed by Anita's riches, too. "Juan tells me," Georgia said, "I should learn to like my sister."

O'Keeffe and Hamilton went to New York in June 1983 for a second gala opening of the Stieglitz retrospective. The show had traveled from Washington and opened in New York on June 28 at the Metropolitan Museum of Art. Within a hundred yards of the apartment in which Georgia and Alfred had been discovered by Emmy Stieglitz nearly seventy years before, the elderly artist held the arm of her friend

Juan Hamilton and walked under an enormous banner bla-
zoned with the name *Stieglitz*. The occasion was rich with
synchronicity. O'Keeffe's party stayed in a suite of rooms in
the Mayfair Regent Hotel, a building on East Sixty-fifth
Street—on the site, as coincidence would have it, of the
former house of Leopold Stieglitz, where O'Keeffe and Stieg-
litz had resided for many years. The Stieglitz town house
had been razed in 1924—the year Georgia and Alfred had
moved to the Shelton—to make way for the Mayfair.

One day, Andy Warhol visited the artist and her friend
in their elegant suite of rooms for a lunch of cold lobster
and champagne to tape a conversation with her for his mag-
azine, *Interview*. O'Keeffe had told Hamilton she did not feel
up to talking to others, and she had canceled all her inter-
views in Washington because she was not feeling well. In
the *Interview* article, O'Keeffe and Hamilton sparred with
each other good-naturedly like a pair of old friends. O'Keeffe,
Hamilton told Warhol on his arrival, felt that the interview
could be "trouble." "What kind of trouble?" Warhol wanted
to know. "Oh, it hasn't started yet," she replied. She told
Warhol she could not make out anything about him except
his glasses. "You see what you want to see," Hamilton re-
torted. O'Keeffe was spry. In a discussion about a new build-
ing that Philip Johnson had designed in New York for AT&T,
she announced that she had no use for his work. Warhol
was amazed by her arrogance. The elderly artist had attacked
a building "she can't see," he pointed out to his diary.

One evening around this time, Hamilton and O'Keeffe
attended a dinner in her honor in Ashton Hawkins's art-
filled East Side apartment. Hawkins, the secretary and gen-
eral counsel for the Metropolitan Museum of Art, invited a
group of famous women to his gathering, including former
first lady Jacqueline Onassis, playwright and novelist Lillian
Hellman, and former *Vogue* editor Diana Vreeland. One of
the other diners recalls that Vreeland hovered over the fa-
mous artist persistently. Although they had met in the 1960s,
when *Vogue* photographed her, O'Keeffe could not recall
who Vreeland was and did not want to talk to her. As she

had previously focused on Warhol's eyeglasses, her poor eyesight now picked up on Vreeland's birdlike nose. "Get that bird away from me," she instructed a friend. Later, when Vreeland was expounding on O'Keeffe's sister Anita Young, another guest said jokingly, "You're Anita Young's sister, aren't you?" O'Keeffe, failing to see the humor, walked away from him. "It's the eyes," he said. "You both have the same eyes." Hamilton recalls that he was pressed into service to cut the elderly artist's roast beef for her. For the better part of an hour, after dinner, the artist talked privately on a sofa in the sitting room with the former first lady.

As O'Keeffe approached her ninety-sixth birthday in November 1986, she was rapidly losing ground in her fight to live to one hundred. The summer of 1983, she succumbed to a long line of minor ailments. The worst was that she could no longer walk very well. The edemic fluid in her ankles had built up, and she was unable to move comfortably when she tried to continue her walks. The elderly artist practically had to be carried by a retinue of Spanish-speaking servants who were nearly as old as she, from one end of the village to another, recalls one visitor who happened upon the sight. Hamilton considered many options for her health care. Increasingly, it was becoming difficult to provide the care she needed in Abiquiu. He spoke of moving back to New York—he even looked for apartments there. They also considered moving to Florida, where the elderly artist could be located near her sister and her friend Esther Johnson. In November of 1983, she added a codicil to her will, leaving Hamilton a larger share of her possessions. A few weeks later, she accompanied the Hamiltons—Juan, Anna Marie, Albert, and their new baby, Brandon—on a trip to visit Juan's parents in Costa Rica.

Chapter 31

.

Strange things doubtless take place in Palm Beach in the middle of the night. While the rest of Anita Young's household slept soundly, Juan Hamilton opened the door to the bedroom where O'Keeffe had been resting for several days, suffering from a bad case of pneumonia. He carried his old friend down a flight of stairs, past the room where O'Keeffe paintings were echoed in the decor, across a wide, marble-lined hallway, out into a black limousine waiting patiently in front of the mansion. At the airport in West Palm Beach, the large black car whizzed across the tarmac to a Learjet that was waiting to speed them back to New Mexico. An ambulance met the plane in Santa Fe and transported the elderly artist and her friend to St. Vincent's Hospital, where she was admitted to intensive care.

O'Keeffe moved gracefully through the last two years of her life, waiting for death to finally take her away. While various parts of her body failed in succession, the many doctors and nurses who attended her during this period marveled at her strength and serenity. One nurse recalls that O'Keeffe "fought like a young man" and that she did not exhibit the resignation so often associated with elderly patients. Another nurse observed that the artist was incredibly stubborn about certain things. One day, while feeding her, O'Keeffe bit her on the hand.

O'Keeffe had deteriorated rapidly by the beginning of 1984. Her feet continued to be swollen with edemic fluid, and she could no longer walk at all. She contracted a cold she could not shake. Hamilton was distraught by her con-

dition. He found it hard to believe she had slipped so fast. He found it hard to accept her imminent death. O'Keeffe had been both parent and mentor to him for eleven years—the better part of his adult life—and now she was complaining about the cold in Abiquiu, about the pain in her feet, about how difficult it was to breathe. The artist began to suffer from periods of incontinence.

In March, Hamilton had decided to move O'Keeffe to Palm Beach. There, he later said, he felt she could receive the finest medical care. The warmth of subtropical Florida would make her feel better. Her sister's house was so large, they could share separate quarters in the same building. Anita, who was herself receiving treatment for throat cancer, welcomed the addition to her life. Gretchen Johnson observed, as did others, that Anita Young seemed lonely at this time in her life. It seemed to make sense, at least to Hamilton, to move O'Keeffe to Florida in order to prolong her life. Even as she began to deteriorate she spoke with determination about attaining the age of one hundred years. Her final goal was to conquer time.

While Hamilton's ends were noble, his means became a grand drama of foolhardiness. He seized on the idea of moving her to Florida with the tenacity of a mountain climber scaling a vertical sheet of rock. Most of her friends were surprised she had been moved out of her beloved Abiquiu compound to her sister's in Palm Beach. It had happened so quickly that O'Keeffe herself probably did not really know what had happened. She was installed in a suite of rooms that overlooked the Atlantic Ocean through a grove of palm trees. Each morning she was lifted by a therapist and carried outdoors to a heated swimming pool—the same pool Young's neighbor, John F. Kennedy, had used to relax his back injury twenty years earlier. There she swam as far as she could to help her circulation. A team of nurses attended to her needs, and she stopped feeling cold as she had in New Mexico.

Which is not to say that O'Keeffe enjoyed being in Florida. She was away from her familiar bed and room in Abiquiu,

and she felt dominated by her sister. A friend noticed that O'Keeffe pretended she did not recognize Anita. While the artist was not exactly sharp-minded, the friend felt she did know who she was. When Anita came into the room, however, O'Keeffe behaved like an invalid because Anita treated her like one. *"Georgia,"* she yelled, *"it's your sister Anita!"* O'Keeffe stared back blankly, leaving Anita to conclude, as she did frequently, "Georgia does not know who I am."

To make matters worse for the elderly artist, Hamilton came and went, as he had in the past, attending to his own business. O'Keeffe was extremely needy of his company at this time. Bob Miller noticed that she often thought he was Juan. Hamilton had deposited Anna Marie, Albert, and Brandon at Esther Johnson's in Hobe Sound—and drove back and forth between the two houses. Anita told her sister Catherine that Hamilton drank heavily and gave the help drugs. Hamilton denied the accusations.

Anita Young was beside herself with the drama that her sister and Hamilton had deposited into her manicured life. She conferred with Catherine over the phone. She called her lawyer. She took steps to keep Georgia away from Hamilton in Florida. O'Keeffe did not want to stay in Florida with her sister—she wanted to go where Hamilton was. Hamilton, for his part, was almost as distraught as Young—but for different reasons. He wanted to prolong his friend's life— he did not want to lose her. A young man—under forty— he had had little experience with death. Although Anna Marie had read Stephen Levine's book *Who Dies* and repeatedly advised her husband to "let go," he confused letting go with giving up. Gretchen Johnson observed that he seemed extremely frightened about what was going on. She said she felt sorry for him. He had given up his youth to care for an elderly person, and now that person was vanishing like a puff of smoke in a strong wind.

Hamilton had transported a ninety-six-year-old pneumonia patient across America on a jet equipped with a nurse and oxygen tanks. Perhaps it was a mistake for him to have done so. Perhaps O'Keeffe's relatives would accuse him of

not caring properly for her. Perhaps he should never have attempted to involve Anita Young. He had whisked her away at night, and he had aroused the suspicion of her relatives, who would no longer tolerate him.

O'Keeffe was installed in St. Vincent's Hospital, in a private room overlooking the Ortiz Mountains south of Santa Fe. She could not see the view. A team of nurses stayed with her around the clock. Hamilton slept the first night on the floor next to her bed. The nurses were impressed by his devotion to his elderly friend. "I don't care what people say," said one of the nurses in response to the later campaign to discredit his care, "she had a friend in Juan Hamilton. He was a true friend." The nurse recalls that Hamilton visited O'Keeffe several times a day and asked questions about her condition. Other nurses did not like him because he demanded things of them petulantly.

Hamilton was preoccupied with other O'Keeffe matters at this time as well. He was shopping for a new house for her near the hospital. Realizing that she would not accept nursing-home care (nor would he want it for her) but that she could not receive the care she needed in Abiquiu, he decided to find a house in Santa Fe for her. Locating a house for a person like O'Keeffe was a challenge. Over ninety-six years, she had developed a rarefied style of life that was extremely demanding of those around her and geared to her many needs. Hamilton finally picked the most expensive house on the market at that time in Santa Fe. Named *Sol y Sombra*, Spanish for "sun and shade," the 1937 pueblo Art Deco mansion was located on more than ten manicured acres in the fashionable Old Santa Fe Trail section of Santa Fe. Included in the estate were several guest houses and a large studio and garage. Hamilton, who had received power of attorney to sign O'Keeffe's name in 1978, purchased the property for more than three million dollars in her name.

The house was ideal for O'Keeffe. She occupied the ground floor library—a large room with its own fireplace, bathroom, and outside door, through which nurses could come and go easily. He positioned her large sculpture, *Spiral,*

on the lawn outside her bedroom window. Her staff from Abiquiu could be housed on the estate, as well as Hamilton and his wife and children. Some of the people who visited the artist there were impressed with the setup. "So often people, even rich people, die alone without any family around," says Bruce Weber. "Juan gave her a family and children." The night before O'Keeffe was to move in, Hamilton told me, he stayed up late, cleaning the house himself to make sure it was all right for her.

In March 1984, she moved in directly from the hospital, and she barely knew where she was. The nurses observed that her dream life seemed to merge with her waking life. She talked often of things that had happened with Stieglitz. She asked a nurse to read to her from Kandinsky's *Concerning the Spiritual in Art,* the 1914 publication that she and Anita Pollitzer had devoured like new converts with a Bible. The artist had kept a copy of it with her for years, referring to it constantly as a guide for her career as a spiritual artist. Now she was repelled by the text. "Oh, stop [reading]," she implored the nurse. "I can't believe I ever liked that [book]." On one occasion, she was driven to Ghost Ranch to her old house, with which she had once had what she described as a love affair she knew better than to resist. When she returned, she told the nurse who was attending her, "I can't believe I ever lived there."

O'Keeffe had lost contact with many of her friends and family members by this time. Claudia was too sick herself to visit. Anita never visited her. Louise Trigg stopped by occasionally, but she too had begun to suffer from medical problems that kept her at home. One of her regular visitors was Roberta Brosseau, who had grown up in the Abiquiu vicinity and, as a child, had known the artist. Some relatives were told they could not visit her, as was Maria Chabot. A friend who came to lunch with Hamilton on one hot day was surprised to find O'Keeffe bundled up sitting out in the sun. He later said the elderly artist looked uncomfortable because her face was contorted into an intense squint from being in the sun—but this was an appearance O'Keeffe often

adopted when sunbathing because she refused to wear dark
glasses. The friend suggested to Hamilton that he move
O'Keeffe out of the sun. "Oh, she's all right," he replied.

Hamilton's reputation suffered greatly shortly after the
move to Santa Fe. Stories about his behavior and neglect of
O'Keeffe began to circulate in the small and incestuous Santa
Fe art world. It was one thing for Hamilton to be viewed
using O'Keeffe's name to further his own interest, but quite
another to be accused of abusing an elderly woman artist
who was, in the opinion of many, "a national monument."
Stories like the one about Hamilton leaving O'Keeffe to roast
in the sun circulated rapidly. People who worked for Ham-
ilton reported that he requested they keep quiet about what
they saw at *Sol y Sombra,* which only fanned the flames of
gossip. Hamilton was seen drinking from an open vodka
bottle in the morning and drinking beers outside the house
before breakfast. Anna Marie told people her husband
thought he was the reincarnation of the spirit of Crazy Horse.
He went on shopping sprees. He purchased three Mercedes-
Benzes for O'Keeffe, who could no longer legally drive—a
roadster, a station wagon, and a convertible. He bought a
BMW for himself, as well as a four-wheel-drive Toyota Land-
cruiser and a Ford pickup truck. All six of the cars were
white. There was no furniture in the living room or dining
room. They ate their meals and spent their time in the
kitchen. O'Keeffe stayed in her bedroom most of the time.
Her friend Glen Myers from El Rito, who had fixed her
garden and prepared Christmas dinner for her one year,
came to cook for her. Hamilton spent most of his time in
his own bedroom, while Anna Marie stayed in hers. When
I first visited them in the house, Anna Marie explained that
this wasn't where they lived and never had been. "This is a
dormitory," she said.

In August 1984, O'Keeffe signed her name to a second
codicil to her 1979 will. It left Hamilton the bulk of her
worldly possessions and, because of the inflated value of art
at this time, turned him into an even richer man. It was a
hot and dry August day. The temperature reached ninety-

two, and the relative humidity measured twelve percent—just the kind of day O'Keeffe had always liked. The nurses who were attending her dressed her in white. Anna Marie had filled the house with roses and zinnias and cosmos from her garden in Abiquiu. There was talk about how O'Keeffe looked like a bride and about her getting married to Hamilton—an option that had been considered years earlier, when O'Keeffe had asked her attorney how she could insure Hamilton would remain her heir. From time to time, Hamilton and O'Keeffe joked about getting married—an option O'Keeffe had not wanted even when she had married. Now the joke was on the nurses, who overheard the elderly artist and her young friend banter about marriage.

"Looks like you're getting married, Georgia," said Juan, observing her surrounded by flowers in her white dress.

"Oh, Juan," she said, "I don't think I could make it to the altar today."

The codicil to the will had been prepared and executed by New York attorney Gerald Dickler. While Hamilton stayed upstairs in his room, O'Keeffe was read the addition to the will, and she nodded her head yes that she understood that she was increasing Hamilton's share to include most of her worldly possessions—which at that time were estimated at $65 million. O'Keeffe disinherited the museums and institutions that she had included in her previous bequests stretching back more than ten years, leaving the pictures she had earmarked for them to Hamilton. She also left Hamilton the house on Old Santa Fe Trail that he had purchased for her, as well as the cars.

No one would ever know exactly why the elderly artist overturned decades of bequests to museums and left nearly her entire estate to her young companion. Her relatives later maintained that she had been coerced by Hamilton into changing her will. Barbara Rose was under the impression when she spoke to O'Keeffe on her ninety-seventh birthday that a new estate tax law had influenced her. Under the old law, donations of artworks to museums had been fully deductible from the value of the estate for tax purposes. Under

the new law, they were not. Rose felt that the artist did not
want to support a government that did not support its artistic
legacy. Other people felt that she was merely rewarding her
friend for caring for her as an infirm elderly person.

Hamilton was ecstatic over this latest development in his
life. The knowledge that he would inherit so much money
seems to have gone to his head. "It was all he wanted to
talk about," a friend recalls. Another friend said that Ham-
ilton wanted to find out about old money and how it be-
haved. He hired a helicopter to take Carter Brown, director
of the National Gallery, on an aerial tour of Abiquiu. Al-
though the National Gallery's policy prohibited exhibits of
the work of living artists, a show of O'Keeffe's art was ten-
tatively planned to commemorate her one hundredth birth-
day, on November 15, 1987. The majority of the pictures
in the show were from the collection of Georgia O'Keeffe,
O'Keeffe's residual estate, which Hamilton would one day
own, a situation that would enhance the value of many of
the pictures considerably.

O'Keeffe made few public appearances around this
time—only fueling the persistent rumors that Hamilton was
mistreating her. In the fall of 1984, Bruce Weber and Calvin
Klein returned to New Mexico and visited Georgia and Juan.
(Weber was on an assignment to photograph the playwright
Sam Shepard and his girlfriend, the actress Jessica Lange,
who lived in nearby Arroyo Hondo.) The artist did not seem
to recognize either of them from their previous visits. Ham-
ilton had asked Weber to photograph O'Keeffe in front of
her sculpture, *Spiral,* which stood outside on the lawn.
O'Keeffe appeared dressed in a pink quilted house coat and
a silver concha belt. Weber felt she had been dressed in
pink to cheer her up. She seemed considerably diminished
to him. Klein remarked uncharitably, "I can see why you
normally wear black or white."

Weber noticed a change in both Hamilton and O'Keeffe
immediately. Hamilton appeared to be agitated and dis-
turbed. O'Keeffe was "very frail and couldn't stand very

long." What was more, "the sun was hurting her eyes so badly she insisted on wearing a hat." Hamilton did not want O'Keeffe to wear a hat. He took it off her head and told Weber to shoot the picture. Although Weber is a gentle, soft-spoken man who generally works around other egos, he can be stubborn—and this was one of those times. Because "she loved the hat so much—it had such a beautiful hole in it" and because he "really loves what this woman's been about all these years," he stood up to Hamilton. "Juan," he said, "I'd really like her to put the hat on. It'll also help her because her eyes were very sensitive to the sun."

Hamilton would not be easily moved. "He said, 'No, no, no! Just do the picture,'" to which Weber replied, "'Well, no, I don't think I really want to do the picture.' So, he kind of looked at me, and he was about to punch me out probably. And then he said, 'Oh!,' and he just grabbed the hat and he put it on her."

After the pictures had been taken, O'Keeffe was seated on a chair while Weber and his assistant put away the equipment. His assistant was a young woman who was a big fan of the elderly artist. She asked Weber if she could speak to O'Keeffe, and Weber asked the artist directly if his assistant could talk to her. "I said, 'Oh, Miss O'Keeffe, I have a young girl who works for me as an assistant. She admires your work very much. And it would mean so much to her to say something to you.' And she went down, and she held O'Keeffe's hand, and she got down on one of her knees and she said, 'You've meant so much to me just as another woman to see your work and to see the things that you've done in your life.'

"And Juan just flipped out. He said [to Weber's assistant]: 'You don't have a bra on.' He just went crazy. He said, 'That's terrible to let your assistant come and say hello to her.' And Miss O'Keeffe, you know, she just didn't know where to look. She then looked at my assistant and said, 'Oh, thank you very much. That's very sweet of you.' I forget the exact words. But she was very, very nice. I think what was hap-

pening was that [he was frustrated at] her getting sicker and the feeling that people would turn on him if she wasn't in his life anymore.

"So Hamilton felt very possessive about who got close to her. And a lot of people look at him in a very bad way. And I looked at him in a very bad way by the way he treated my assistant, who I really loved a lot. And afterwards, I realized that it was only because he was frightened. He was really like a frightened chow dog. Do you know what I mean? It's the best way to put it because he really felt that people wouldn't call him anymore. People wouldn't want to show his work. You know. And I think he really felt that fear."

By the beginning of 1985, Hamilton was seen at meetings of Alcoholics Anonymous in Santa Fe. He told people he had quit drinking and doing drugs. An art magazine falsely reported the artist's death, but people caring for her felt she might die at any time in any event. Hamilton had lost his contact with her. He said when he told her things she simply looked back at him blankly. It was very hard for him to accept her condition. He went to the gym every day and to therapy several times a week. It was excruciating for him to watch her fade. Anna Marie bought a face brush and ran the soft bristles across the artist's face. The boys jumped on a trampoline on the lawn outside O'Keeffe's window. Hamilton tried to work in his studio. On February 2, he went into her room and said, "Good morning, Georgia, how are you?" She replied, "I'm fine, Juan, thank you very much."

The artist drifted in and out of consciousness. In November, her ninety-eighth birthday was celebrated with little fanfare. One day she startled a nurse: "The passage of time," she suddenly blurted out in a panic. "I need to talk about the passage of time!"

In March, 1986, the Hamiltons took advantage of their sons' spring break to take a family vacation in Acapulco, where they stayed at the house of a friend. On the morning of March 6, a housekeeper from *Sol y Sombra* called him.

O'Keeffe had been taken to St. Vincent's by ambulance. She was having trouble breathing.

Hamilton returned to New Mexico the same day aboard the next Albuquerque-bound flight. He later said he was impressed by the coincidence. There were exactly four seats—the number he, Anna Marie, and the two boys needed—remaining on the plane. Unfortunately, his good luck did not continue. As he and his family waited in Houston for the connecting flight to Albuquerque, he placed a call to the hospital to inquire about his friend's condition. He learned that O'Keeffe, age ninety-eight, had died at twelve noon. She had spoken her final words earlier in the morning when she ordered dry toast and coffee for breakfast—her usual at that time in her life.

Both *The New York Times* and *The Washington Post* reported her death on the front page of their March 7 editions, but the passing of an American legend was otherwise a quiet and private affair. There was no memorial. No one spoke or read from inspirational passages. There was no singing. Carrying out her final instructions, Hamilton walked to the top of the Pedernal bearing an urn containing her cremated remains. He tossed the ashes into a strong wind.

"...calling, as distance has always called me."

· · · · · · · · · · · · · · ·

Epilogue

· · · · · · · · · · · · ·

A s with most great lives, the end of Georgia O'Keeffe's was not the end of her story. Even as I write these final words five years after her death, new insights into her work and her life are coming into place and a complete understanding of who she really was is beginning to unfold. The process of interpreting her life began only weeks after she died, as her true intentions were questioned by her relatives when they filed a suit against the estate she had left to Juan Hamilton and sought to overturn her last will and testament.

The suits were filed by June O'Keeffe Sebring, the daughter of Georgia's younger brother Alexius, and Catherine O'Keeffe Klenert, the artist's sole surviving sibling. Sebring, who had barely known her famous aunt, maintained she knew what O'Keeffe would have really wanted. Klenert, the sister who had once exhibited her own copies of Georgia's work in a gallery in New York, had been a regular visitor to Ghost Ranch during the summers and was in a better position to know what the artist's true intentions were.

Sebring and Klenert accused Juan Hamilton of exerting "undue influence" over O'Keeffe as she amended her will to leave him more and more of her property. There was no doubt that he had benefitted financially. In question was the will drafted in 1979 as well as the codicils made in 1983 and 1984. The 1984 codicil, executed after the artist had been wrested from her sister's house in Palm Beach in the middle of the night, was the clincher. Depending on who did the calculating, after the addition of the 1984 codicil,

which left Hamilton the residual estate previously given to museums, Hamilton stood to gain as much as $80 million, primarily from artworks. Before the addition of the 1984 codicil, he would have inherited approximately $15 million. Klenert and Sebring asserted that O'Keeffe had told them— and others—on many occasions that she intended to leave the majority of the artwork to museums and institutions.

To try to establish undue influence, the contestants took two positions. First, they attempted to establish that O'Keeffe was weak-minded at the time she had executed the documents and that she had given away her fortune because of Hamilton's strong-arm tactics. Second, they attempted to establish what these strong-arm tactics were. They explored Hamilton's character and sought to show behavior that would lead to the conclusion that he was able to coerce the artist to do things against her will.

Proving that O'Keeffe had been feeble during her final years, particularly in 1983 and 1984, was not difficult. By 1983, she drifted in and out of reality and sometimes did not know where she was or who she was with. Her health care had become so regimented that daily log books documented her condition for much of this period. In Washington, in 1983, she had failed to recognize her niece, Catherine Krueger, or her husband, Earl. Other people had also noticed that she did not know where she was or who she was with during this period.

It was also easy to find fault with Juan Hamilton. In his years as O'Keeffe's assistant, he had never won many popularity contests, and there were plenty of people who were eager to report on his bad behavior. Nothing worked in Hamilton's favor. He had screamed at people in rages of anger, fired nurses, and harassed assistants who were helping him install shows at galleries in New York—all established a character that could be seen as coercive. Although he had probably been a poor match for O'Keeffe, who had left a trail of periodic rages over the better part of a century, it was not O'Keeffe's behavior that was under scrutiny here. Whether she deserved the type of treatment she sometimes

received from Hamilton was not the issue in the proceedings, although it is worth noting that she attracted volatile situations throughout her life—in her relationships with Stieglitz, Chabot, Bry, and many others.

Hamilton's entire life with O'Keeffe was opened for public inspection. His therapists were deposed, his relationship with his wife was scrutinized, as were his relationships with nearly everyone else. Articles were published portraying him as a villain who took advantage of an old lady. Sebring and Klenert's cases were handled by canny New Mexico attorneys who were confident that the law was on their side. The attorneys even deferred their fees to the inevitable conclusion of the case. O'Keeffe had never named either Klenert or Sebring in her wills dating back decades, and they could not prove that they had any claim on her property. But New Mexico probate law favors the family in claims of undue influence. The family, because of its biological relationship, does not need to establish its stake.

When I arrived in Santa Fe to begin this book in January 1987, Hamilton seemed to be reconciling himself to an inevitable defeat. He was worn down. His inheritance had been frozen during probate, and not only were the costs of the legal proceedings mounting, his style of life required more income than the sales of his sculptures were able to generate. A few weeks later, faced with the possibility that he could lose his entire inheritance, Hamilton agreed to settle with the relatives. In exchange for dropping their suit against him, he agreed to turn over more than two-thirds of his inheritance to the museums and institutions the artist had named in the original will and to allow her estate to be managed by committee. Hamilton was left with approximately $15 million, primarily in the form of the late artist's works. The relatives were each given about a million dollars in cash and artworks.

Whether Hamilton had actually pressured O'Keeffe into changing her will to leave him her fortune, no one will ever know for sure. During the years I followed him and interviewed him for this book, I found him to be a warm and

sensitive human being, although I have certainly also felt the force of his personality and questioned what he was all about. People don't generally give up tens of millions of dollars unless they think they might be found in the wrong, and Hamilton has indicated that he has been afraid people would think this was the case with him when he settled.

On the other hand, in spite of her weakened condition, most people felt that O'Keeffe really had intended to leave Hamilton all her wealth. As mentioned, Barbara Rose was under the impression that the artist had been swayed by the change in the tax laws that repealed deductions for charitable contributions of artworks. Others noted that O'Keeffe constantly asked for Hamilton during her final period, and several men told me she mistakenly—or wishfully—thought they were he.

It was not an easy life, Georgia O'Keeffe's. Born into a family that was on a disaster course, suffering from major illnesses as a young adult, ridiculed for the way she dressed, the way she painted, and even the way she talked—by the time she received a measure of success in her early thirties, she already bore the heavy armor of the seriously abused. Following a marriage in which she had not wanted to participate and a series of nervous breakdowns, the victim became the victimizer, as she proceeded to subjugate a series of women who worshipped her like a goddess. A soft touch for good-looking, ornery men, O'Keeffe eventually found her match in a young man who told people he had been sent to her by a spirit.

In some ways, O'Keeffe's life is an American success story: A gaunt schoolteacher from the Texas Panhandle becomes the best-known American woman artist of this century. Its appeal is immediate. Overcoming adversity, doing the best she could, turning liabilities into assets—these are O'Keeffe's subthemes, worthy ones at that. Rumbling beneath the surface, however, are the weightier issues of repressed homosexuality, incest-induced rage, madness, coercion, and deceit. "Making your unknown known is the thing," the artist had stated as her aim in a letter to Sherwood Anderson

in 1926. Near the end of her life, the artist may have regretted having set such a lofty goal for herself. However she fell short of her aim, the beauty of her story lies in the fact that she attempted to explore uncharted realms at all—and for periods of time with complete abandon.

"Kick your heels in the air!" she once exclaimed to a friend. "I'm going. I'm chasing it—hunting for it at a great rate."

Source Notes

· · · · · · · · · · · · · ·

Much of the material in this book is based on primary sources, especially interviews with the people I thanked in the acknowledgments who knew Georgia O'Keeffe. In the notes, when I have quoted from an interview, I give the source. A few people requested anonymity. I have granted them this when citing quotations. All of the interviews for this book took place between 1986 and 1992.

Most of the letters I consulted for this book are found in the Stieglitz/O'Keeffe Archive in the Yale Collection of American Literature at Beinecke Rare Book and Manuscript Library at Yale University. Other letters are housed at the Newberry Library in Chicago, the Center for Creative Photography at the University of Arizona in Tucson, the Berg Collection at the New York Public Library, and the Archives of American Art in Washington, D.C.

Secondary sources quoted in the text are keyed to the bibliography with a page number. The complete reference can be found by looking under the author's last name. The bibliography, although thorough, is by no means a complete record of every last article, volume, and manuscript reviewed during the six years of research for this book.

PREFACE

PAGE

 ix "the entire earth cracked open": Lisle, p. 226.
 "It's like an ailment": Braggioti.

x "Where I was born": O'Keeffe, *Georgia O'Keeffe,* un-
 paginated.
 "Words and I": Letter, Georgia O'Keeffe to Alfred
 Stieglitz, February 1, 1916, Cowart et al., p.
 150.

EPIGRAPH

xv Letter, Georgia O'Keeffe to Sherwood Anderson,
 Lipsey, p. 374.

PROLOGUE

2 "I believed": Juan Hamilton to author.
 "her way": O'Keeffe, *Georgia O'Keeffe,* unpaginated.
 "When so few people": Hurt.
3 "The Faraway": O'Keeffe, *Georgia O'Keeffe,* unpag-
 inated.
 "the end of the earth": Warhol, "Georgia O'Keeffe
 & Juan Hamilton."
 "mad country": O'Keeffe, *Georgia O'Keeffe,* unpag-
 inated.
 "It is really absurd": Letter, Georgia O'Keeffe to
 Cady Wells, possibly 1940s, in Cowart et al., p.
 273.
 "a religion": Letter, Alfred Stieglitz to Sherwood
 Anderson, September 24, 1926 (Newberry Li-
 brary).
 "My pleasant disposition": Seiberling.
5 "Front side": Lisle, p. 331.
7 "Dealing with Georgia": Tomkins.
 "She looked right past me": Juan Hamilton to au-
 thor.
 "You know about the Indian eye": Tomkins.
 "I am not a creature": Root.

PAGE

8 "my boy": Juan Hamilton to author.
 "Alfred": Virginia Christianson to author.
9 "Juan was sent to me": Phoebe Pack to author.

CHAPTER 1

13 "she scolded me": O'Keeffe, *Georgia O'Keeffe,* unpag-
 inated.
 "that made me think and feel": O'Keeffe, *Georgia
 O'Keeffe,* unpaginated.
 "To find a woman": Greer, p. 105.
14 "I think that deep down": Pollitzer, p. 58.
16 "As a little girl": Ibid.
17 "Speeny, Spawney": Ibid., p. 55.
 "I had a sense": Eisler, p. 16.
 "run the girls": Roxana Robinson, p. 18.
 "From the time I was": Roxana Robinson, p. 23.
19 "naughty child": Pollitzer, p. 59.
 "funny": Ibid., p. 61.
 "I like bread": Ibid.
 "the headache of my life": Ibid., p. 59.
 "sing very high": Kotz.
 "I did a drawing": Roxana Robinson, p. 23.
20 "[Georgia] always wondered": Pollitzer, p. 61.
 "I couldn't think of anything": O'Keeffe, *Georgia
 O'Keeffe,* unpaginated.
 "Why shouldn't you get": Pollitzer, p. 68.
21 "I love the Irish": Joni Mitchell to author.
23 "You'd push the past": Roxana Robinson, p. 23.

CHAPTER 2

24 "the question": Nochlin, p. 158.
 "lady": Ibid., p. 159.

PAGE

 "It was a suffering": O'Keeffe, *Georgia O'Keeffe*, un-
 paginated.

25 "blushed a hot": O'Keeffe, *Georgia O'Keeffe*, unpag-
 inated.
 "teeming with O'Keeffes": Hurt.

26 "I like to see": Juan Hamilton to author.
 "Williamsburg": Hurt.

27 "so warm": Roxana Robinson, p. 34.

28 "I knew": Zito.
 "Nearly every": Cocke.
 "she would have made": Cocke.

29 "In the studio": Ibid.
 "Georgia": Ibid.
 "One day I'm going to be": Hurt.
 "A Girl who would be different": *Mortar Board*.
 "hugs": Cocke.

30 "marriage of convenience": Phoebe Pack to author.
 "All her life": Virginia Christianson to author.

31 "respected her privacy": Anonymous to author.
 "Those kinds of people": Anonymous to author.
 "The problem with her": Jerry Richardson to au-
 thor.

33 "what is hidden in me": Cowan, p. 125.
 "on the horizon": O'Keeffe, *Georgia O'Keeffe*, unpag-
 inated.

34 "I guess you would say": Tomkins.

35 "I don't remember": O'Keeffe, *Georgia O'Keeffe*, un-
 paginated.
 "When color is": *Phaidon Encyclopedia of Art and
 Artists*, p. 118.

36 "I am going to live": Roxana Robinson, p. 46.

CHAPTER 3

37 "It doesn't matter": O'Keeffe, *Georgia O'Keeffe*, un-
 paginated.

PAGE

38 "To be truly excellent": Greer, p. 75.
 "The men were always": Agapita Lopez to author.
 "Honestly, Pat": Roxana Robinson, p. 76.
39 "I'd wish I lived in a tent": Lisle, p. 234.
 "There was something fresh": O'Keeffe, *Georgia O'Keeffe,* unpaginated.
40 "nothing [is] more difficult": Pisano, p. 36.
 "The successful picture": Ibid., p. 74.
 "Great work comes from": Ibid., p. 56.
 "wideness and wonder": O'Keeffe, *Georgia O'Keeffe,* unpaginated.
 "I saw that any idiot": Seiberling.
41 "There": *Camera Work,* January 1915.
 "some of them were supposed": O'Keeffe, *Georgia O'Keeffe,* unpaginated.
43 "There was nothing to sit on": Ibid.
 "wet and swampy": Ibid.
44 "[Father] is having hard luck": Eisler, p. 53.
45 "You are and always will be": Roxana Robinson, p. 78.
46 "I'd been taught to paint": Seiberling.

CHAPTER 4

47 "and the SKY": Letter, Georgia O'Keeffe to Anita Pollitzer, September 11, 1916, Cowart et al., p. 157.
 "This was my country": O'Keeffe, *Georgia O'Keeffe,* unpaginated.
49 "Oh, now I suppose you'll": Anonymous to author.
50 "No one ever told": Roxana Robinson, p. 18.
 "You": Jerry Richardson to author.
 "Georgia O'Keeffe has scorched her feet": Hartley.
52 "That which *anybody* can do": Dow, p. 37.
53 "The most important fact": Ibid.

PAGE

"My sisters think": Letter, Georgia O'Keeffe to Anita Pollitzer, 1916 (Beinecke Library).

54 "To see and hear such wind": Pollitzer, p. 108.

"three dinners, one": Vivian Robinson.

55 "She dressed like a man": Kochka, *O'Keeffe Remembered.*

"recipient of the highest degree": *Amarillo Daily News,* May 5, 1912.

56 "And we never thought": Cornelia Wolflin Patton to author.

"Everybody": Kochka, *O'Keeffe Remembered.*

57 "seemed to be drawing": Pollitzer, p. 108.

CHAPTER 5

58 "dirty and anarchistic": Letter, Emmeline Stieglitz to Alfred Stieglitz, August 12, 1917 (Beinecke Library).

"part Marxist": Letter, Anita Pollitzer to Georgia O'Keeffe, September 12, 1914 (Beinecke Library).

"I wonder if I am": Pollitzer, p. 40.

59 "At certain moments": Ibid., p. 46.

"Finally": Ibid., p. 48.

60 "There's something about black": Braggioti.

62 "pick her up": Eisler, p. 72.

"you are little you know": Letter, Georgia O'Keeffe to Anita Pollitzer, late June 1915, Cowart et al., p. 141.

"Your letters": Letter, Georgia O'Keeffe to Anita Pollitzer, August 25, 1915, Cowart et al., p. 142.

"daring, imaginative designs": Pollitzer, p. 2.

"rotten": Letter, Georgia O'Keeffe to Anita Pollitzer, thought to have been after October 8, 1915 (Beinecke Library).

"There was never an idle moment": Pollitzer, p. 1.

PAGE

"So far no one but you": Letter, Georgia O'Keeffe to Anita Pollitzer, thought to have been after October 8, 1915 (Beinecke Library).

63 "the cleanest": Pollitzer, p. 1.

64 "mushy": Letter, Georgia O'Keeffe to Anita Pollitzer, undated (Beinecke Library).

65 "The woman who finds": Dell, p. 10.
"jumping around that way": Tomkins.

66 "things in my head": O'Keeffe, *Georgia O'Keeffe*, unpaginated.
"I'm the gladdest person": Roxana Robinson, p. 126.
"The world looks": Pollitzer, p. 39.

67 "Did you ever": Ibid.
"What woman did these?": Ibid., p. 48.

68 " 'Madame,' he said": Sylvia Loomis to author.
"I think I will": Pollitzer, p. 48.

CHAPTER 6

70 "Who gave you permission": Pollitzer, p. 134, and various other sources.

71 "a brass band": John Cheim to author.

72 "you get mightily twisted": Pollitzer, p. 35.
"There seems to": Letter, Georgia O'Keeffe to Anita Pollitzer, January 4, 1916, Cowart et al., p. 147.
"essentially a womans feeling": Ibid.
"If you remember": Pollitzer, p. 123.

73 "I am afraid": Ibid., p. 28.
"Kick your heels": Letter, Georgia O'Keeffe to Anita Pollitzer, February 25, 1916, Cowart et al., p. 153.

74 "celestial solitaire": Eisler, p. 124.
"the snakebite": Juan Hamilton to author.

PAGE

"You don't know": Pollitzer, p. 134, and various
other sources.

75 "no more right": Norman, *Stieglitz*, p. 57.

CHAPTER 7

76 "I am loving": Letter, Georgia O'Keeffe to Anita
Pollitzer, September 11, 1916, Cowart et al., p.
157.
"riveted": Letter, Alfred Stieglitz to Georgia
O'Keeffe, March 26, 1917 (Beinecke Library).

77 "were never a close family": Lisle, p. 340.

79 "I can't believe": Roxana Robinson, p. 154.
"a cucumber-shape . . . standing": Letter, Anita Pol-
litzer to Georgia O'Keeffe, June 1917 (Beinecke
Library).

80 "Tonight": Letter, Georgia O'Keeffe to Anita Pol-
litzer, September 11, 1916, Cowart et al., pp.
156–157.
"There was no wind": Letter, Georgia O'Keeffe to
Anita Pollitzer, September 18, 1916, Ibid., p.
157.
"get to work": Juan Hamilton to author.

81 "visions": Lipsey, p. 42.
"eyes should be": Ibid., p. 43.
"I don't sleep well nights": Letter, Georgia O'Keeffe
to Anita Pollitzer, September or October 1916
(Beinecke Library).
"Well I just sat there": Letter, Georgia O'Keeffe to
Anita Pollitzer, September 11, 1916, Cowart et
al., p. 157.

82 "Well": Lisle, p. 84.
"it is a shame": Letter, Georgia O'Keeffe to Anita
Pollitzer, undated (Beinecke Library).

83 "like a hot cake": Eisler, p. 131.

PAGE

"I almost died laughing": Letter, Georgia O'Keeffe to Anita Pollitzer, January 17, 1917 (Beinecke Library).

"I wonder that": Ibid.

"a pink pill": Letter, Georgia O'Keeffe to Anita Pollitzer, undated (Beinecke Library).

84 "veiled symbolism": Chave.

"any work by a woman": Greer, p. 4.

85 "Now perhaps for": Chave.

"woman artist": Letter, Georgia O'Keeffe to Henry McBride, June 1946 (Archives of American Art).

"I don't care": Letter, Georgia O'Keeffe to Alfred Stieglitz, July 1916, Cowart et al., p. 157.

86 "Here's my hand—": Letter, Alfred Stieglitz to Georgia O'Keeffe, March 26, 1917 (Beinecke Library).

88 "Did you meet": Letter, Georgia O'Keeffe to Anita Pollitzer, June 20, 1917, Cowart et al., p. 163.

CHAPTER 8

90 "The single most striking fact": Greer, p. 12.

93 "I've been looking for Georgia": Eisler, p. 173.

94 "Both entirely against": Letter, Georgia O'Keeffe to Elizabeth Stieglitz (Davidson), January 1918, Cowart et al., p. 167.

"their course of study": Letter, Georgia O'Keeffe to Alfred Stieglitz, November 30, 1917 (Beinecke Library).

"It was great to just": Ibid.

96 "We are both cold women": Eisler, p. 164.

97 "female inverts": Duberman et al., p. 192.

CHAPTER 9

99 "weren't doing anything": Lowe, p. 217.
100 "Here, O'Keeffe is": Sarah Greenough, unpublished lecture, Metropolitan Museum of Art, November 20, 1988.
102 "Ma, I was the organ grinder": Frank et al., p. 64.
 "the throbbing essence . . .": Ibid., p. 132.
104 "Camera Work is published": *Camera Work*, July 1912.
 "Not to do so": Lowe, p. 104.
105 "Mr. Flower": Ibid., p. 223.
 "I was photographed": *Georgia O'Keeffe: A Portrait.*
 "that was difficult": Ibid.
106 "There were nudes": Ibid.
 "The Great Child—purely—": Letter, Alfred Stieglitz to Georgia O'Keeffe, March 31, 1918, in Pollitzer, p. 159.
 "Stieglitz": *Georgia O'Keeffe: A Portrait.*
 "was neither tall nor thin": Ibid.
107 "frothy creature": Lowe, p. 130.
 "She knew he was a swimmer": *Georgia O'Keeffe: A Portrait*, unpaginated.

CHAPTER 10

108 "an ascetic, almost saintly": Lynes, p. 212.
 "put [O'Keeffe] at once": McBride, "O'Keeffe at the Museum."
109 "We were very happy": Letter, Georgia O'Keeffe to Elizabeth Stieglitz (Davidson), August 15, 1918, Cowart et al., p. 167.
 "not a very good": *Georgia O'Keeffe: A Portrait*, unpaginated.
110 "Oh": Hurt.

PAGE

111 "The barn is a very important": Letter, Georgia
 O'Keeffe to Mitchell Kennerley, January 29,
 1929, Cowart et al., p. 187.
 "The parents and grandparents": Lowe, p. 230.
112 "That night when": *Georgia O'Keeffe: A Portrait*, un-
 paginated.
 "like mad people": Ibid.
 "so he could grab": Ibid.
113 "For me he was": Ibid.
114 "She told me Stieglitz always": Robert Miller to au-
 thor.
 "nothing about such matters": Lowe.
115 "I hope that": Ibid., p. 53.
 "unbearable about pregnancies": Ibid., p. 92.
 "Madame, can you tell me": Ibid., p. 196.
116 "There was such a power": *Georgia O'Keeffe: A Por-
 trait,* unpaginated.
118 "If they had known": Ibid.
 "one of the profoundest": Rosenfeld, p. 132.
 "He loves her so": Hapgood, p. 109.
 "I was born in Hoboken": Stieglitz.
 "I have not been to Europe": O'Keeffe, "Can a Pho-
 tograph . . . ?"

 CHAPTER 11

123 "I decided I": O'Keeffe, "Introduction."
124 "Flowers and fruits": *New York Sun*, February 3,
 1923.
 "the men": O'Keeffe, *Georgia O'Keeffe,* unpagi-
 nated.
 "Even many advanced art lovers": Rich and Kir-
 stein, p. 167.
 "What men have always wanted": Lynes, p. 81.
125 "Her body acknowledges": Ibid., p. 67.

PAGE

"the shameless naked statements": Ibid., p. 67.

"the shrine to St. Georgia": Letter, Georgia O'Keeffe to Mitchell Kennerley, fall 1922, Cowart et al., p. 171.

"Georgia O'Keeffe": Hartley, p. 157.

"Something rare and significant": Lynes, p. 84.

126 "people buy pictures": Letter, Georgia O'Keeffe to Doris McMurdo, July 1, 1922, Cowart et al., p. 169.

"greasy": Lisle, p. 111.

"queer feeling of being invaded": Letter, Georgia O'Keeffe to Mitchell Kennerley, fall 1922, Cowart et al., p. 171.

"I thought I could never": Glueck, "Art Notes."

"They were only writing": Letter, Georgia O'Keeffe to Mitchell Kennerley, fall 1922, Cowart et al., p. 170.

127 "besieged by her sisters": Rich and Kirstein, p. 168.

"get herself to a nunnery": Ibid.

128 "Her solitary walks": Lowe, p. 234.

129 "a gruel of anemic pink": Ibid., p. 225.

"Then, in haughty silence": Ibid.

130 "she could have been an understudy": Ibid., p. 254.

131 "My particular kind of vanity": Letter, Georgia O'Keeffe to Henry McBride, February 1923, Cowart et al., p. 171.

"potentially embarrassing terms": Townsend, p. 200.

"Strength and beauty": Ibid.

132 "He was a better friend": Eisler, p. 246.

"The splendid cook": Letter, Alfred Stieglitz to Paul Strand, July 26, 1922, Greenough and Hamilton, p. 205.

"The Female of the Species": *Vanity Fair*, June 1922.

PAGE

133 "The woman": Lynes, p. 33.

134 "They make me seem": Letter, Georgia O'Keeffe to Mitchell Kennerley, fall 1922, Cowart et al., p. 171.

CHAPTER 12

135 "love, honor and obey": Lowe, p. 268, and other sources.

"What do you think?": Lowe, p. 276.

"What does it matter?": Eisler, p. 333.

136 "Would he be able": Lowe, p. 266.

138 "all those words": O'Keeffe, *Georgia O'Keeffe,* unpaginated.

139 "nerves": Letter, Georgia O'Keeffe to Sherwood Anderson, August 1, 1923, Cowart et al., p. 173.

"I loved running": O'Keeffe, *Georgia O'Keeffe,* unpaginated.

"take him to my broad bosom": Eisler, p. 305.

140 "the Old Crow Feather": Letter, Alfred Stieglitz to Ida O'Keeffe, November 3, 1924 (Beinecke Library).

"Ida-Iter": Ibid.

"breasts that challenge God": Ibid.

141 "I think after you get married": Letter, Ida O'Keeffe to Alfred Stieglitz, July 11, 1924 (Beinecke Library).

"I wonder if man has ever": Letter, Georgia O'Keeffe to Sherwood Anderson, September 1923, Cowart et al., p. 176.

"[O'Keeffe's] art was related": Lynes, p. 79.

142 "Psychoanalysts tell us": Ibid.

143 "How do you do": Lowe, p. 225.

"Don't ever call me": Ibid.

PAGE

"I dont know why": Letter, Georgia O'Keeffe to
 Sherwood Anderson, June 11, 1924, Cowart et
 al., p. 178.

145 "Well": Juan Hamilton to author.

CHAPTER 13

146 "until the girl": Letter, Georgia O'Keeffe to Ettie
 Stettheimer, September 21, 1928, Cowart et al.,
 p. 186.
 "If it was a nuisance": Phoebe Pack to author.

147 "it isn't nice here": Letter, Georgia O'Keeffe to Ida
 O'Keeffe, December 26, 1926 (Beinecke Library).

148 "like the huge buildings": Eisler, pp. 327–28.
 "I don't know how": Lisle, p. 137.
 "beside herself . . . weeping": Eisler, p. 330.

149 "When you take a flower": Braggioti.
 "a languid floating flower": Joyce, p. 71.
 "Thank god you": Interoffice memo, Whitney Mu-
 seum of American Art, artist file.

150 "she does these flowers": Warhol, *Warhol Diaries*,
 p. 397.
 "this show is": Lynes, p. 90.
 "Her new paintings": Ibid., p. 99.
 "Her calla lilies": Moore.
 "We intuitively feel": Lynes, p. 240.

152 "a man who had pushed": Morgan, p. 275.
 "funny mob": Eisler, p. 322.

153 "[her] bright candor of youth": Sagar, p. 7.
 "What I want written": Letter, Georgia O'Keeffe to
 Mabel Luhan, 1925?, Cowart et al., p. 180.

154 "feels indelicate looking": Rudnick, p. 235.
 "a super-female and free": Ibid., p. 274.
 "Women never helped": Wallach.

PAGE
155 "making your unknown known": Letter, Georgia
 O'Keeffe to Sherwood Anderson, Lipsey, p. 374.
156 "whitest of the white": Letter, Alfred Stieglitz to
 Sherwood Anderson, July 22, 1925 (Newberry
 Library).
 "She was very much against": Maria Chabot to au-
 thor.
157 "Miss O'Keeffe's paintings": Lynes, p. 264.
 "unprepared for direct contact": Ibid., p. 118.
158 "I feel like a little plant": Letter, Georgia O'Keeffe
 to Blanche Matthias, March 1926, Cowart et al.,
 p. 183.
 "She painted the Lily": Lynes, p. 285.
159 "An annual exhibition": Ibid., p. 274.
 "I like to feel": Letter, Georgia O'Keeffe to Cather-
 ine O'Keeffe Klenert, February 8, 1924, Roxana
 Robinson, pp. 263–64.
 "Well, I know how it is": Letter, Ida O'Keeffe to
 Alfred Stieglitz, July 2, 1925 (Beinecke Library).

CHAPTER 14

160 "the rage of the 1929 season": Lowe, p. 3.
161 "I would like": Letter, Georgia O'Keeffe to Waldo
 Frank, January 10, 1927, Cowart et al., p. 185.
 "dead on me": Letter, Georgia O'Keeffe to Ettie
 Stettheimer, August 24, 1929, Ibid., p. 195.
 "The others went to Europe": Juan Hamilton to au-
 thor.
162 "Taos": Rudnick, p. 165.
 "the mysteries of propagation": Rudnick, p. 184.
 "Lady Brett—the": Charles Stockly to author.
163 "the garden of Allah": Rudnick, p. 169.
 "kiss the sky": Letter, Georgia O'Keeffe to Mabel
 Luhan, March 1925, Cowart et al., p. 180.

PAGE

164 "Bit by bit": Lawrence, *Mornings in Mexico*, pp.
 126–28.

165 "A sea of sage": O'Keeffe, *Georgia O'Keeffe*, unpag-
 inated.

166 "Brett remembered those": Rudnick, p. 213.
 "The skies and land": Eldredge et al., p. 179.

167 "a saucer of alfalfa": O'Keeffe, *Georgia O'Keeffe*, un-
 paginated.

168 "the stirring restlessness": Lawrence, *Lady Chatter-
 ley's Lover*, p. 112.
 "Take an exquisite": Eldredge et al., p. 153.

170 "the surface doings": Letter, Georgia O'Keeffe to
 Mabel Luhan, June 1929, Cowart et al., p. 191.
 "I must die—": Rudnick, p. 239.
 "found nothing finer": Letter, Georgia O'Keeffe to
 Mabel Dodge Luhan: Roxana Robinson, p. 339.

171 "Do take a bit of care": Letter, Alfred Stieglitz to
 Ida O'Keeffe, July 29, 1929 (Beinecke Library).
 "May I kiss": Letter, Georgia O'Keeffe to Mabel
 Luhan, August 1929, Cowart et al., p. 192.
 "I mostly when I think": Phoebe Pack to author.

172 "I just feel": Letter, Georgia O'Keeffe to Ettie
 Stettheimer, August 24, 1929, Cowart et al., p.
 195.
 "I have frozen": Ibid.
 "large enough to crucify": O'Keeffe, *Georgia
 O'Keeffe,* unpaginated.
 "If you ever go": Eldredge et al., p. 156.
 "All the summers at the lake": Letter, Georgia
 O'Keeffe to Ettie Stettheimer, August 24, 1929,
 Cowart et al., p. 195.

173 "I wish I could give you": Letter, Georgia O'Keeffe
 to Rebecca Strand, August 24, 1929, Ibid., pp.
 192–93.

PAGE

CHAPTER 15

174 "First Kitty, now Georgia": Lowe, p. 323.

175 "Anyone who doesn't": McBride, "O'Keeffe in Taos."

 "a chef-d'oeuvre of": Ibid.

176 "guess you've won": Letter, Georgia O'Keeffe to Rebecca Strand, November 5, 1929, Cowart et al., p. 199.

 "I should like": McBride, "O'Keeffe in Taos."

 "burning hot": Letter, Georgia O'Keeffe to Blanche Matthias, April 1929, Cowart et al., p. 188.

177 "was all over": Herrera, p. 198.

178 "lay off Tony": Rudnick, p. 240.

 "most unpleasant habit": Ibid.

179 "a culture-carrier": Sagar, p. 21.

 "Mabeltown": Lisle, p. 192.

 "When Georgia hated": Phoebe Pack to author.

180 "the country had": O'Keeffe, *Georgia O'Keeffe*, unpaginated.

 "raged": Lowe, p. 315.

 "The rose in": Tomkins.

 "Mourning Becomes Georgia": McBride, "O'Keeffe in Taos."

181 "cut to the": Lisle, p. 192.

 "make me feel": Letter, Georgia O'Keeffe to Russell Vernon Hunter, January 1932, Cowart et al., p. 205.

 "Whenever I photograph": Eisler, p. 424.

184 "Georgia": Dorthy Fredericks to author.

 "I hate being": Letter, Georgia O'Keeffe to Henry McBride, Cowart et al., p. 203.

 "Everything is so": Letter, Georgia O'Keeffe to Russell Vernon Hunter, late August 1931, Cowart et al., p. 204.

185 "One suffocatingly hot": Lowe, p. 316.

 "a . . . Mexican disease": Lisle, p. 204.

PAGE

186 "I am divided": Letter, Georgia O'Keeffe to Russell
Vernon Hunter, spring 1932, Cowart et al., p.
207.

187 "blighted the young": Eisler, p. 418.
"O'Keeffe": Ibid., p. 436.
"As I remember": Letter, Georgia O'Keeffe to Mar-
jorie Content: Roxana Robinson, p. 393.

189 "I felt": Eisler, p. 444.
"I seem to": Letter, Georgia O'Keeffe to Mitchell
Kennerley, January 20, 1929, Cowart et al., p.
187.

CHAPTER 16

190 "Santa Fe friends": Pack, p. 28.

191 "I wish you": Letter, Georgia O'Keeffe to Arthur
Dove, September 1942, Cowart et al., p. 233.

192 "I really have": Letter, Georgia O'Keeffe to Rebecca
Strand, April 26, 1934, Ibid., p. 221.
"I feel more": Letter, Georgia O'Keeffe to Jean
Toomer, undated, Ibid., p. 219.

193 "—the not talking": Letter, Georgia O'Keeffe to
Paul Strand, December 26, 1933, Ibid., p. 214.

194 "I always felt": Frank Prosser to author.
"I see no light": Eisler, p. 442.

195 "Reading over your": Roxana Robinson, p. 394.
"I wish so": Letter, Georgia O'Keeffe to Jean
Toomer, undated, Kerman and Eldridge, p. 213.
"more able to": Ibid., p. 214.

196 "be loved and": Ibid.
"The sort of": Ibid.
"I was neither": Letter, Georgia O'Keeffe to Jean
Toomer, undated, Ibid., p. 213.
"I must be": Letter, Georgia O'Keeffe to Rebecca
Strand, April 26, 1934, in Cowart et al., p. 221.

198 "Georgia": Lisle, p. 218.

PAGE

"She tried to be": Pack, p. 69.

"We were all": Anonymous to author.

199 "The Faraway.": O'Keeffe, *Georgia O'Keeffe,* unpaginated.

CHAPTER 17

200 "a piece of": Letter, Georgia O'Keeffe to Ettie Stettheimer, Cowart et al., p. 230.

201 "It is like": Richard Pritzlaff to author.

"Georgia came up": Phoebe Pack to author.

202 "We rented the house": Ibid.

"Why don't you": Ibid.

203 "A patrician dilettante": Lowe, p. 325.

"sexual inconsistencies of": Ibid., p. 333.

"but from the": Anonymous to author.

"It was exactly": Lowe, p. 349.

204 "Georgia liked children": Phoebe Pack to author.

"I think you could": Ibid.

205 "When I think": O'Keeffe, *Georgia O'Keeffe,* unpaginated.

"The flowers": Ibid.

"aboriginal": Lisle, p. 329.

206 "Sorry": Lowe, p. 339.

"She was the": Warhol, "Georgia O'Keeffe & Juan Hamilton."

207 "hated Bob": Phoebe Pack to author.

"Georgia was apt": Ibid.

"I make no attempt": Eliot Porter to author.

"I know what": Pack, p. 63.

208 "I couldn't figure": Phoebe Pack to author.

209 "When Georgia O'Keeffe": Lisle, p. 226.

"an old man": Miller, p. 4.

210 "so many thought": Letter, Georgia O'Keeffe to Helen Torr and Arthur Dove, January 1938, Cowart et al., p. 222.

PAGE

"A red hill": Exhibition Catalogue, An American Place, 1/22/39–3/17/39.

"She seemed strangely": Lisle, p. 241.

"O'Keeffe's apartment": Ibid., p. 328.

211 "Artists Look Like This": *Life,* 1938.

"I loved the": Lisle, p. 212.

212 "never again. Never": Phoebe Pack to author.

"soft fuzz on": Richard Pritzlaff to author.

213 "bare lava land": Letter, Georgia O'Keeffe to Russell Vernon Hunter, November 1939, Cowart et al., p. 229.

214 "As far as": Letter, Georgia O'Keeffe to Henry Mc-Bride, July 22, 1939, in Cowart et al., p. 228.

"You": Beaumont Newhall to author.

215 "You know the": Catherine Klenert Krueger to author.

"I had no": Ibid.

216 "so glamorous": Jennifer Johnson Duke to author.

"Mom used to": Ibid.

217 "—a dry open": Letter, Georgia O'Keeffe to William Einstein, July 19, 1938, Cowart et al., p. 226.

"A lot of": Phoebe Pack to author.

"I see Alfred": Letter, Georgia O'Keeffe to Henry McBride, thought to be early 1940s, Cowart et al., p. 244.

CHAPTER 18

218 "O'Keeffe's name": McBride, "O'Keeffe at the Museum."

219 "Her art": Greenberg.

"Oh, Georgia": Eisler, p. 477.

220 "*No*—they cannot": Phoebe Pack to author.

221 "trotted along": Richard Pritzlaff to author.

222 "stinking": Maria Chabot to author.

"She is a great": Richard Pritzlaff to author.

PAGE

"slave": Richard Pritzlaff to author.
223 "You": Phoebe Pack to author.
"I had to": Ibid.
"come back any time": Ibid.
"I wouldn't dream": Ibid.
"a mile of": O'Keeffe, *Georgia O'Keeffe,* unpaginated.
224 "such a beautiful": Ibid.
225 "But where's your": Pollitzer, p. 232.
"their": Phoebe Pack to author.
226 "Georgia came over": Ibid.
227 "With all the": Letter, Georgia O'Keeffe to Ettie Stettheimer, August 15, 1940, Cowart et al., p. 231.
"poor little Georgia": Lisle, p. 250.
"embarrassing": Speech, Bryn Mawr College, Bryn Mawr, Pennsylvania, June 1971.
"so we could": Roxana Robinson, p. 452.
228 "so frail a": Pollitzer, p. 244
"You got the": Eliot Porter to author.
"Moments after our": Lowe, p. 375.
229 "husband of Georgia": *New York Times,* July 14, 1946.

CHAPTER 19

233 "Come quickly": Pollitzer, p. 269.
"flaming orange and": Ibid., p. 270.
234 "Isn't it worth": Ibid.
"That wall with": O'Keeffe, *Georgia O'Keeffe,* unpaginated.
235 "Georgia": Maria Chabot to author.
236 " 'Do you know": Jerry Richardson to author.
"carte blanche to": Maria Chabot to author.
238 "I have a": Letter, Georgia O'Keeffe to Henry McBride, July 19, 1948, Cowart et al., p. 248.

PAGE

239　"absolutely disgusting": Maria Chabot to author.

240　"malignant whipping": Eisler, p. 480.

242　"The inertia of": Letter, Georgia O'Keeffe to Daniel
　　　　Catton Rich, November 13, 1949, Cowart et al.,
　　　　p. 250.
　　　"white and not": Ibid.
　　　"I had no": Ibid.
　　　"If we gave": Mildred Hudson to author.

243　"Maria, who really built this": Roxana Robinson, p.
　　　　476.

245　"an exclusive school": Ibid., p. 435.
　　　"When I look": June O'Keeffe Sebring to author.

CHAPTER 20

247　"Where are they": *Newsweek*, 1957.
　　　"She didn't have": Eliot Porter to author.
　　　"center of everything": Richard Pritzlaff to author.
　　　"Those dogs bite": Lisle, p. 285.
　　　"It was just": Phoebe Pack to author.

248　"top dog of": Richard Pritzlaff to author.
　　　"The Beau is": Ibid.

249　"I wrote to him": Letter, Georgia O'Keeffe to Mar-
　　　　garet Bok [Kiskadden], September 3, 1950, Cow-
　　　　art et al., p. 254.

250　"working girl": Richard Pritzlaff to author.
　　　"the best blood": Ibid.
　　　"crooks who are": Ibid.

251　"In that case": Ibid.
　　　"Lazy Natives!": Ibid.
　　　"old, old friend": Warhol, "Georgia O'Keeffe &
　　　　Juan Hamilton."

252　"the boys": Roxana Robinson, p. 490.

253　"I wouldn't give": Eliot Porter to author.

254　"like cats and dogs": Jerry Richardson to author.
　　　"Oh, she said": Ibid.

PAGE
255 "good for the": Esther Johnson to author.
 "Christmas is very": Roxana Robinson, p. 486.
 "I have never": Ibid., p. 487.
257 "The Gotham Book": Frances Steloff to author.
 "I know you": Letter, Georgia O'Keeffe to Frances
 Steloff, probably early 1950s (Berg Collection,
 New York Public Library).
258 "You": Frances Steloff to author.
259 "this country when": Richard Pritzlaff to author.
260 "must be something": Roxana Robinson, p. 491.
 "I don't speak": Lisle, p. 292.
 "Georgia O'Keeffe!": Juan Hamilton to author.

CHAPTER 21

261 "My world is": Margaret Bok Kiskadden to author.
 "I best not": Ibid.
263 "girlie": Phoebe Pack to author.
 " 'Well, of all": Ibid.
264 "She was my": Dorthy Fredericks to author.
 "You can't quit": Ibid.
265 "I drove, cooked": Ibid.
 "I can't stand": Ibid.
266 "her million-dollar": Richard Pritzlaff to author.
 "Horse and rider": Podhajsky, p. 23.
 "her black outfit": Richard Pritzlaff to author.
267 "I am not": Lisle, p. 287.
268 "She wanted to know": Betsy Miller to author.
 "The role that": Ibid.
269 "In some odd": Roxana Robinson, p. 543.
 "O'Keeffe kept her around": Anonymous to author.
 "Georgia called": Margaret Bok Kiskadden to author.
 "You understand": Ibid.
270 "suspicious": Ibid.
 "all sorts of things": Ibid.

"She had an active": Ibid.

"very, very limited": Ibid.

"[Georgia] said": Ibid.

"quite quietly": Ibid.

271 "Louise! What are": Louise Trigg to author.

"Well, then, I'll come": Ibid.

272 "Isn't that pretty?": Ibid.

"I just pulled": Charles Stockly to author.

"HELLO!": Ibid.

273 "Oh, no": Louise Trigg to author.

"the sun that": Letter, Georgia O'Keeffe to Russell Vernon Hunter, early February 1933, Cowart et al., p. 211.

"It's my private": Lisle, p. 235.

274 "My mother was": Anonymous to author.

CHAPTER 22

275 "Working with Georgia": Tomkins.

276 "My, you look": Ruby Reid to author.

"People buy art": Letter, Georgia O'Keeffe to Doris McMurdo, in Cowart et al., p. 170.

278 "There's nothing abstract": Goodrich and Bry, p. 28.

279 "little girl": O'Keeffe, *Georgia O'Keeffe,* unpaginated.

"I looked at it": Phoebe Pack to author.

280 "I thought it": Lisle, p. 312.

281 "Are you Georgia": Juan Hamilton to author.

283 "You have written": Letter, Georgia O'Keeffe to Anita Pollitzer, February 28, 1968 (Beinecke Library).

284 "She's no friend": Vivian Robinson to author.

"She looked at them": Ibid.

285 "pin their associations": Margaret Bok Kiskadden to author.

"Like an opossum": Vivian Robinson to author.

PAGE
286 "Georgia had a": Anonymous to author.
 "She is the": David Robinson to author.
287 "She wouldn't know": Jim Hall to author.

CHAPTER 23

288 "a life of": Virginia Christianson to author.
 "Oh, my": Ibid.
 "Well": Ibid.
290 "It was really": Ibid.
 "Sit there": Ibid.
 "She would just": Ibid.
291 "did what needed": Ibid.
 "I don't think": Ibid.
 "a power struggle": Ibid.
 "Oh, look": Ibid.
 "*Virginia*": Ibid.
292 "Okay!": Ibid.
 "She was deeply": Ibid.
 "Well then, don't": Ibid.
293 "Virginia": Ibid.
 "still vigorous in": Seiberling.
 "It was their": Williams.
294 "when you get": Warhol, "Georgia O'Keeffe & Juan
 Hamilton."
 "I know you": Virginia Christianson to author.
 "You would come": Ibid.
 "This is the": Ibid.
295 "She couldn't stand": Ibid.
 "I used to": Ibid.
 "I hear you take": Ibid.
 "in fits that": Ibid.
296 "He called me": Jim Hall to author.
297 "Miss O'Keeffe": Juan Hamilton to author.
 "This": Ibid.

PAGE

CHAPTER 24

298 "private world": Rose, *American Art,* p. 36.
 "Nature is imbued": Ibid.
299 "What do you": Rose, "The Truth."
 "I took one": Virginia Christianson to au-
 thor.
300 "Juan was sent": Anonymous to author.
 "They were off": Juan Hamilton to author.
 "She went off": Ibid.
301 "So they had": Jim Hall to author.
 "like a hot": Bruce Weber to author.
 "nothing but a": Johnston.
 "a gigolo": Roxana Robinson, p. 536.
302 "Typical artist—obsessed": Rose, "The Truth."
 "I don't see": Root.
303 "tested": Rose, "The Truth."
 "entertained by the": Ibid.
304 "foot draggers": Ibid.
 ". . . dealing with my": Lisle, p. 329.

CHAPTER 25

306 "You can live": Jerry Richardson to author.
307 "because such odd": O'Keeffe, *Georgia O'Keeffe,* un-
 paginated.
 "My first memory": Ibid.
308 "nobody was as": Rose, "The Truth."
 "the old snakebite": Juan Hamilton to author.
 "the kind of person": Gretchen Johnson to au-
 thor.
 "Oh": Ibid.
309 "She kept wanting": Ibid.
 "speak": O'Keeffe, *Georgia O'Keeffe,* unpaginated.
310 "It was a": Juan Hamilton to author.
 "became quite miserable": Rose, "The Truth."

PAGE

312 "A friend who": Weinberg.
 "The trouble with": Ibid.
 "It's all right": Ibid.
313 "Juan": Anonymous to author.
 "Why": Juan Hamilton to author.
 "We had told him": Jerry Richardson to author.
315 "It can be": Davis.
 "I have a": Ibid.

CHAPTER 26

316 "When I was": Joni Mitchell to author.
317 "So we": Ibid.
 "The irony of": Ibid.
318 "crush": Juan Hamilton to author.
 ". . . In the enlarged": Joni Mitchell to author.
 "So I got": Ibid.
319 "I mean": Juan Hamilton to author.
 "You know": Joni Mitchell to author.
 "Oh, you won't": Ibid.
 "a young friend": Ibid.
320 "it would be good": Ibid.
 "Just as I was": Ibid.
 "I knocked": Ibid.
 "she opened": Ibid.
321 "So, that": Ibid.
 "I only": Ibid.
 "The following": Ibid.
 "Then": Ibid.
322 "That day": Ibid.
 "But there": Ibid.
 "Then—": Ibid.
323 "It was quite": Ibid.
324 "Georgia": Ibid.
 "It was cranky": Ibid.
 "I had these": Ibid.

CHAPTER 27

328 "I will not": Robert Miller to author.
"I was photographed": *Georgia O'Keeffe: A Portrait.*
"I remember seeing": Jennifer Johnson Duke to author.

329 "Whatever Juan wants": Robert Miller to author.
"She would comment on [Juan]": Betsy Miller to author.
"I had to": Gerald Peters to author.
"Because of O'Keeffe's": *Doris Bry v. John Bruce ("Juan") Hamilton,* Index #19500/78 complaint, Supreme Court of the State of New York, County of New York, p. 9.

330 "Can't you picture": Anonymous to author.
"All those rumors": Jerry Richardson to author.
"Juan would be": Jennifer Duke to author.

331 "He had a pot": Joni Mitchell to author.
"It was all right": Juan Hamilton to author.
"hostile": Gretchen Johnson to author.
"electrified": Joni Mitchell to author.

332 "You know": June O'Keeffe Sebring to author.

CHAPTER 28

333 "I need to see you": Phoebe Pack to author.
"Georgia went to no one": Ibid.

334 "I don't need your arm": Ibid.

335 "No, Georgia": Ibid.

336 "She took me to the doorway": Raymond Krueger to author.
"We did go": Ibid.
"Georgia told me": Ibid.

338 "It has a very white feeling": Warhol, "Georgia O'Keeffe & Juan Hamilton."

PAGE

"Do it properly!": Raymond Krueger to author.

340 "This time": Warhol, *Warhol Diaries,* p. 337.
"She does know": Ibid.
"Miss O'Keeffe": Juan Hamilton to author.
"She was making": Betsy Miller to author.

342 "she was always": Phoebe Pack to author.

CHAPTER 29

343 "All these little": John Cheim to author.
344 "Calvin was very": Ibid.
"flipped": Ibid.
345 "Everything was style": Ibid.
346 "cruel and obnoxious": Juan Hamilton to author.
"He would say to me sometimes": Bruce Weber to author.
"grand": Warhol, *Warhol Diaries,* p. 439.
"doesn't do things": Ibid.
347 "That's nice, dear": Anna Marie Hamilton to author.
"You can't grow": Juan Hamilton to author.
348 "That ground was": Anonymous to author.
"It was a": John Cheim to author.
"How did that": Anonymous to author.
"pompous": Gretchen Johnson to author.
"very important to": John Cheim to author.
349 "A lot of people are": Bruce Weber to author.

CHAPTER 30

350 "There go those": Warhol, "Georgia O'Keeffe & Juan Hamilton."
"This was Alfred's": Anonymous to author.
352 "demonstrate the evolution": Greenough and Hamilton, p. 9.

PAGE

354 "creaky": Robert Miller to author.

"Do you like them?": Anonymous to author.

"Juan tells me": Warhol, "Georgia O'Keeffe & Juan Hamilton."

355 "trouble": Ibid.

"You see what": Ibid.

"she can't see": Warhol, *Warhol Diaries,* p. 523.

356 "Get that bird": Anonymous to author.

"You're Anita Young's sister": Ibid.

CHAPTER 31

357 "fought like a young man": Anonymous to author.

359 *"Georgia"*: Ibid.

"Georgia does not": Private papers.

360 "I don't care": Anonymous to author.

361 "So often people": Bruce Weber to author.

"Oh, stop [reading]": Nurses' log book.

"I can't believe": Ibid.

362 "Oh, she's all": Anonymous to author.

"This is a dormitory": Anna Marie Hamilton to author.

363 "Looks like you're": Juan Hamilton to author.

364 "It was all": Anonymous to author.

"I can see": Bruce Weber to author.

"very frail": Ibid.

365 "she loved": Ibid.

"He said": Ibid.

"I said": Ibid.

366 "Good morning": Juan Hamilton to author.

"The passage of": Nurses' log book.

369 ". . . calling": O'Keeffe, *Georgia O'Keeffe,* unpaginated.

PAGE

EPILOGUE

374 "Making your unknown": Lipsey, p. 374.
375 "Kick your heels": Letter, Georgia O'Keeffe to Anita
 Pollitzer, February 25, 1916, Cowart et al., p.
 153.

Selected Bibliography

.

Abbott, Berenice. *New York in the Thirties as Photographed by Berenice Abbott.* Text by Elizabeth McCausland. New York: Dover Publications, 1973.

Adams, Ansel. *Examples: The Making of 40 Photographs.* Boston: Little, Brown and Co., 1985.

Anderson, Sherwood. *The Portable Sherwood Anderson.* Edited by Horace Gregory. New York: Penguin Books, 1987.

Bach, Ira J. *Chicago's Famous Buildings.* Chicago: University of Chicago Press, 1980.

Berger, Meyer. *The Eight Million: Journal of a New York Correspondent.* New York: Columbia University Press, 1983.

Bowles, Paul. *Without Stopping: An Autobiography.* New York: Ecco Press, 1985.

Braggioti, Mary. "Her Worlds Are Many." *New York Post,* May 16, 1946.

Callaway, Nicholas, ed. *Georgia O'Keeffe: One Hundred Flowers.* New York: Alfred A. Knopf in association with Callaway, 1989.

Cather, Willa. *Death Comes for the Archbishop.* New York: Vintage Books, 1971.

Chase, W. Parker. *New York, the Wonder City, 1932.* New York: New York Bound, 1983.

Chave, Anna C. "O'Keeffe and the Masculine Gaze." *Art in America,* January 1990.

Church, Peggy Pond. *The House at Otowi Bridge: The Story of Edith Warner and Los Alamos.* Albuquerque: University of New Mexico Press, 1987.

Cocke, Christine McRae. "Georgia O'Keeffe as I Knew Her." *The Angelos,* Nov. 1934.

Cohen, Barbara, Seymour Chwast, and Steven Heller, eds. *New York Observed: Artists and Writers Look at the City, 1650 to the Present.* New York: Harry N. Abrams, 1987.

Cowan, Thomas. *Gay Men and Women Who Enriched the World.* New Canaan, CT.: Mulvey Books, 1988.

Cowart, Jack, Juan Hamilton, and Sarah Greenough. *Georgia O'Keeffe: Art and Letters.* Washington, D.C.: National Gallery of Art, 1987.

Craven, Thomas. *Modern Art: The Men, the Movements, the Meaning.* New York: Simon & Schuster, 1934.

Davis, Douglas. "O'Keeffe Country." *Newsweek*, November 22, 1976.

Decker, Andrew. "The Battle Over Georgia O'Keeffe's Multimillion-dollar Legacy." *ARTnews*, April 1987.

Dell, Floyd. *Women as World Builders.* Chicago: Forbes & Co., 1913.

Didion, Joan. *The White Album.* New York: Simon & Schuster, 1979.

Douglas, George H. *Women of the 20s.* Dallas: Saybrook Publishers, 1986.

Dow, Arthur Wesley. *Composition.* 20th ed. New York: Doubleday, Doran and Co., 1938.

Dreiser, Theodore. *Sister Carrie.* New York: Penguin Classics, 1986.

Duberman, Martin, Martha Vicinus, and George Chauncey, Jr. *Hidden From History: Reclaiming the Gay and Lesbian Past.* New York: Meridian, 1990.

Eisler, Benita. *O'Keeffe and Stieglitz: An American Romance.* New York: Doubleday, 1991.

Eldredge, Charles C., Julie Schimmel, and William H. Truettner. *Art in New Mexico, 1900–1945: Paths to Taos and Santa Fe.* Washington, D.C.: National Museum of American Art, Smithsonian Institution, 1986.

Ellis, Richard N., ed. *New Mexico Past and Present: A Historical Reader.* Albuquerque: University of New Mexico Press, 1979.

Federal Writers' Project. *The WPA Guide to New York City.* New York: Pantheon Books, 1982.

Frank, Waldo, Lewis Mumford, Dorothy Norman, Paul Rosenfeld, and Harold Rugg, eds. *America and Alfred Stieglitz: A Collective Portrait.* New York: Doubleday, Doran and Co., 1934.

Franks, Ray, ed. *Palo Duro Canyon State Park.* n.p.: Franks-Zulauf Publishing Company, 1966.

Franks, Ray, and Jay Ketelle. *Amarillo, Texas, The First Hundred Years: A Picture Postcard History.* Amarillo: Ray Franks Publishing Ranch, 1986.

Georgia O'Keeffe: A Portrait by Alfred Stieglitz. New York: Metropolitan Museum of Art, 1978.

Glueck, Grace. "Art Notes: It's Just What's in My Head . . ." *The New York Times,* October 18, 1970.

———. "Miss O'Keeffe and Friend." *The New York Times,* November 17, 1978.

Goetzmann, William H., Joseph C. Porter, and David C. Hunt. *The West as Romantic Horizon.* Omaha: Center for Western Studies, Joslyn Art Foundation and the Inter-North Art Foundation, 1981.

Goldberger, Paul. *The City Observed: New York—A Guide to the Architecture of Manhattan.* New York: Vintage Books, 1979.

Goodchild, Peter. *J. Robert Oppenheimer: Shatterer of Worlds.* New York: Fromm International Publishing Corporation, 1985.

Goodrich, Lloyd, and Doris Bry. *Georgia O'Keeffe.* New York: Whitney Museum of American Art, 1970.

Gray, Andrea. *Ansel Adams: An American Place, 1936.* Tucson: Center for Creative Photography, University of Arizona, 1983.

Green, Martin. *New York 1913: The Armory Show and the Paterson Strike Pageant.* New York: Charles Scribner's Sons, 1988.

Greenberg, Clement. *The Nation,* June 15, 1946.

Greenough, Sarah. Unpublished lecture. Metropolitan Museum of Art, November 20, 1988.

Greenough, Sarah, and Juan Hamilton. *Alfred Stieglitz: Photographs and Writings.* Washington, D.C.: National Gallery of Art, 1983.

Greer, Germaine. *The Obstacle Race: The Fortunes of Women Painters and Their Work*. New York: Farrar, Straus & Giroux, 1979.

Griego y Maestas, José, and Rudolfo A. Anaya. *Cuentos: Tales from the Hispanic Southwest*. Santa Fe: Museum of New Mexico Press, 1980.

Gurdjieff, G. I. *Meetings with Remarkable Men*. New York: E. P. Dutton, 1974.

Hapgood, Hutchins. *Victorian in the Modern World*. New York: Harcourt, Brace, 1939.

Harrison, Helen A. *Dawn of a New Day: The New York World's Fair, 1939/40*. New York: Queens Museum, 1980.

Hartley, Marsden. *Adventures in the Arts*. New York: Boni and Liveright, 1921.

Herrera, Hayden. *Frida: A Biography of Frida Kahlo*. New York: Harper and Row, 1983.

Hurt, Frances Hallam. "The Virginia Years of Georgia O'Keeffe." *Commonwealth*, October 1980.

Jenkins, Myra Ellen, and Albert H. Schroeder. *A Brief History of New Mexico*. Albuquerque: University of New Mexico Press, 1974.

Johnston, David. "Portrait of the Artist and a Young Man." *Los Angeles Times*, July 23, 1987.

Joyce, James. *Ulysses*. New York: Random House, 1986.

Kandinsky, Wassily. *Concerning the Spiritual in Art*. Translated by M.T.H. Sadler. New York: Dover Publications, 1977.

Kazin, Alfred. *A Writer's America: Landscape in Literature*. New York: Alfred A. Knopf, 1988.

Kerman, Cynthia Earl, and Richard Eldridge. *The Lives of Jean Toomer: A Hunger for Wholeness*. Baton Rouge: Louisiana State University Press, 1987.

Kertess, Klaus. *Marin in Oil*. Southampton, NY: Parrish Art Museum, 1987.

Kochka, Al. *Georgia O'Keeffe and Her Contemporaries*. Amarillo, TX: Amarillo Art Center, 1985.

———. *O'Keeffe Remembered*. Unpublished manuscript.

Kotz, Mary Lynn. "Profile of Georgia O'Keeffe." *ARTnews*, December 1977.

La Farge, Oliver. *Laughing Boy*. New York: Signet Classic, New American Library, 1971.

Lamb, Wallace E. *Historic Lake George*. Father Jogues, ed. Glens Falls, NY: printed by Guy Printing Co., 1946.

Lanz, Daniel J. *Railroads of Southern and Southwestern Wisconsin: Development to Decline*. Blanchardville, Wis.: printed by Ski Printers, 1986.

Lawrence, D. H. *Lady Chatterley's Lover*. New York: New American Library, 1962.

———. *Mornings in Mexico*. Salt Lake City: Gibbs M. Smith, 1982.

Lipsey, Roger. *An Art of Our Own: The Spiritual in Twentieth Century Art*. Boston: Shambhala, 1989.

Lisle, Laurie. *Portrait of an Artist: A Biography of Georgia O'Keeffe*. New York: Seaview Books, 1980.

Lowe, Sue Davidson. *Stieglitz: A Memoir/Biography*. New York: Farrar, Straus & Giroux, 1983.

Lynes, Barbara Buhler. *O'Keeffe, Stieglitz and the Critics, 1916–1929*. Chicago: University of Chicago Press, 1991.

McBride, Henry. "O'Keeffe at the Museum." New York *Sun*, May 18, 1946.

———. "O'Keeffe in Taos." New York *Sun*, January 8, 1930.

McPhee, John. *Rising from the Plains*. New York: Farrar, Straus & Giroux, 1986.

Mann, Thomas. *The Magic Mountain*. New York: Vintage Books, 1969.

Mayer, Harold M., and Richard C. Wade. *Chicago: Growth of a Metropolis*. Chicago: University of Chicago Press, 1969.

Melville, Herman. *Moby-Dick*. New York: Bantam Books, 1986.

Merton, Thomas. *Cables to the Ace, or, Familiar Liturgies of Misunderstanding*. Greensboro, N.C.: Unicorn Press, 1986.

———. *Disputed Questions*. New York: Harcourt Brace Jovanovich, 1985.

Messinger, Lisa Mintz. *Georgia O'Keeffe*. New York: Thames and Hudson and Metropolitan Museum of Art, 1988.

Miller, Henry. *The Paintings of Henry Miller: Paint as You Like and Die Happy*. San Francisco: Chronicle Books, 1982.

Moore, Harry T. *The Priest of Love: A Life of D. H. Lawrence*. New York: Penguin Books, 1981.

Moore, Marianne. *The Dial*, August 1925.

Morand, Sheila. *Santa Fe Then and Now*. Santa Fe: Sunstone Press, 1984.

Morgan, Ted. *Maugham*. New York: Simon & Schuster, 1980.

Morris, Jan. *Manhattan '45*. New York: Oxford University Press, 1987.

Morris, Margaret. *Georgia O'Keeffe: Selected Paintings and Works on Paper*. Dallas: Gerald Peters Gallery, 1986.

The Mortar Board. Chatham Episcopal Institute, Chatham, VA, 1905.

Munson, Gorham. *The Awakening Twenties: A Memoir-History of a Literary Period*. Baton Rouge: Louisiana State University Press, 1985.

Neihardt, John. *Black Elk Speaks: Being the Life Story of a Holy Man of the Oglala Sioux*. New York: Washington Square Press, 1972.

Newcomb, Franc Johnson. *Hosteen Klah: Navajo Medicine Man and Sand Painter*. Norman: University of Oklahoma Press, 1985.

Nochlin, Linda. *Women, Art, and Power and Other Essays*. New York: Harper and Row, 1988.

Norman, Dorothy. *Stieglitz: An American Seer*. New York: Random House, 1960. Republished as *Alfred Stieglitz: An American Seer*. New York: Aperture, 1973.

―――. *Encounters: A Memoir*. New York: Harcourt Brace Jovanovich, 1987.

―――, and Mark Holborn. *Dorothy Norman/Alfred Stieglitz. Beyond a Portrait: Photographs*. New York: Aperture, 1984.

O'Brien, Kathryn E. *The Great and the Gracious on Million-aires' Row*. Utica, NY: North Country Books, 1978.

O'Keeffe, Georgia. "Can a Photograph Have the Significance of Art?" *MSS*, December 1922.

O'Keeffe, Georgia. *Georgia O'Keeffe*. New York: Viking Press and Penguin Books, 1985.

————. "Introduction." *Alfred Stieglitz Presents One Hundred Pictures: Oils, Water-colors, Pastels, Drawings by Georgia O'Keeffe, American*. The Anderson Galleries, January 29–February 10, 1923.

————. *Some Memories of Drawings*. Edited by Doris Bry. Albuquerque: University of New Mexico Press, 1988.

Pack, Arthur Newton. *We Called It Ghost Ranch*. Abiquiu, NM: Ghost Ranch Conference Center, 1979.

Pearce, T. M., ed. *New Mexico Place Names: A Geographical Dictionary*. Albuquerque: University of New Mexico Press, 1980.

Peters, Fritz. *My Journey with a Mystic*. Laguna Niguel, CA: Tale Weaver, 1986.

Phaidon Encyclopedia of Art and Artists. New York: E. P. Dutton, 1978.

Phaidon Encyclopedia of Art and Artists. Oxford: Phaidon Press, 1978.

Pisano, Ronald G. *William Merritt Chase*. New York: Watson-Guptill Publications, 1982.

Podhajsky, A. *The Spanish Riding School of Vienna*. Vienna: printed by Brüder Rosenbaum, 1964.

Pollitzer, Anita. *A Woman on Paper: Georgia O'Keeffe*. New York: Simon & Schuster, 1988.

Rich, Daniel Catton. *Georgia O'Keeffe*. Chicago: Art Institute of Chicago, 1943.

Rich, Daniel Catton, and Lincoln Kirstein, eds. *The Flow of Art: Essays and Criticisms of Henry McBride*. New York: Atheneum, 1975.

Robinson, Roxana. *Georgia O'Keeffe: A Life*. New York: Harper and Row, 1989.

Robinson, Vivian. "Famed Artist Remembers Amarillo as Brown Town." *Amarillo Globe-Times*, August 26, 1965.

Root, Susan. "O'Keeffe: Star of the Desert Sky." *Chicago Daily News*, January 7, 1970.

Rose, Barbara. *American Art Since 1900*. New York: Praeger Publishers, 1975.

————. "The Truth about Georgia O'Keeffe." *Journal of Art,* February 1990.

Rosenfeld, Paul. *Port of New York: Essays on Fourteen American Moderns.* New York: Harcourt, Brace and Co., 1924.

Rudnick, Lois Palken. *Mabel Dodge Luhan: New Woman, New Worlds.* Albuquerque: University of New Mexico Press, 1984.

Russell, Marian. *Land of Enchantment: Memoirs of Marian Russell along the Santa Fe Trail as dictated to Mrs. Hal Russell.* Edited by Garnet M. Brayer. Albuquerque: University of New Mexico Press, 1981.

Sagar, Keith, ed. *D. H. Lawrence and New Mexico.* Salt Lake City: Gibbs M. Smith, 1982.

Schumann, Hans Wolfgang. *Buddhism: An Outline of Its Teachings and Schools.* Translated by Georg Feuerstein. Wheaton, Ill.: Theosophical Publishing House, 1983.

Seiberling, Dorothy. "Georgia O'Keeffe in New Mexico." *Life,* March 1, 1968.

Simmons, Marc. *New Mexico: A Bicentennial History.* New York: W.W. Norton and Company, 1977.

————. *Taos to Tomé: True Tales of Hispanic New Mexico.* Albuquerque: Adobe Press, 1978.

————. *Witchcraft in the Southwest: Spanish and Indian Supernaturalism on the Rio Grande.* Lincoln: University of Nebraska Press, 1980.

Sontag, Susan. *Illness as Metaphor.* New York: Farrar, Straus & Giroux, 1978.

Spenser, Edmund. *The Faerie Queene.* Oxford: Clarendon Press, 1918.

Steele, Thomas J., and Rowena A. Rivera. *Penitente Self-Government: Brotherhoods and Councils, 1797–1947.* Santa Fe: Ancient City Press, 1985.

Stern, Robert A. M., Gregory Gilmartin, and Thomas Mellins. *New York 1930: Architecture and Urbanism Between the Two World Wars.* New York: Rizzoli International Publications, 1987.

Stettheimer, Florine. *Crystal Flowers.* New York: privately published, 1949.

Stieglitz, Alfred. "A Catalogue Statement by Stieglitz." Anderson Galleries, February 7, 1921.

Talese, Gay. *New York: A Serendipiter's Journey.* New York: Harper and Row, 1961.

Thomas, Henry, and Dana Lee Thomas. *Living Biographies of Great Painters.* New York: Garden City Publishing Co., 1940.

Tomkins, Calvin. "Profiles: The Rose in the Eye Looked Mighty Fine." *The New Yorker,* March 4, 1974.

Townsend, Kim. *Sherwood Anderson.* Boston: Houghton Mifflin Company, 1987.

Turner, David. *Georgia O'Keeffe: Paintings.* Santa Fe: Museum of Fine Arts, Museum of New Mexico, 1986.

Turner, Frederick. *Rediscovering America: John Muir in His Time and Ours.* San Francisco: Sierra Club Books, 1985.

Udall, Stewart L. *To the Inland Empire: Coronado and Our Spanish Legacy.* New York: Doubleday, 1987.

Van Haaften, Julia. *From Talbot to Stieglitz: Masterpieces of Early Photography from the New York Public Library.* New York: Thames and Hudson, 1982.

Viskochil, Larry A. *Chicago at the Turn of the Century in Photographs: 122 Historic Views from the Collections of the Chicago Historical Society.* New York: Dover Publications, 1984.

Waldberg, Michael. *Gurdjieff: An Approach to His Ideas.* Translated by Steve Cox. Boston: Routledge and Kegan Paul, 1981.

Wallace, Susan E. *The Land of the Pueblos.* New York: John B. Alden, 1890.

Wallach, Amei. "Georgia O'Keeffe." Bergen County (NJ) *Sunday Record,* November 6, 1977.

Warhol, Andy. *The Andy Warhol Diaries.* Edited by Pat Hackett. New York: Warner Books, 1989.

————. "Georgia O'Keeffe & Juan Hamilton." *Andy Warhol's Interview,* September 1983.

Weaver, Mike. "Paul Strand: Native Land." *Archive* 27. Tucson, AZ: Center for Creative Photography, University of Arizona, 1990.

Weigle, Marta. *Brothers of Light, Brothers of Blood: The Penitentes of the Southwest*. Santa Fe: Ancient City Press, 1976.

———, compiler. *A Penitente Bibliography*. Albuquerque: University of New Mexico Press, 1976.

———, and Kyle Fiore. *Santa Fe and Taos: The Writer's Era 1916–1941*. Santa Fe: Ancient City Press, 1982.

Weinberg, Jane. "First Person: Me and Georgia O'Keeffe." *Chicago's Free Weekly*, March 4, 1988.

White, E. B. *Here Is New York*. New York: Harper and Brothers, 1949.

Whitman, Walt. *Leaves of Grass*. New York: Heritage Press. Undated special edition of 1855 original.

William Carlos Williams: Selected Poems. Edited by Charles Tomlinson. New York: New Directions, 1985.

Williams, Michaela. "Georgia O'Keeffe, 80, Revisits Chicago." *Chicago Daily News*, June 17, 1967.

Zito, Tom. "Georgia O'Keeffe." *The Washington Post*, November 9, 1977.

Index

· · · · · · · · · · · · ·

Photo Credits

· · · · · · · · · · · · ·

FIRST INSERT:

(1) Collection of Jeffrey Hogrefe. (2) Holsinger Studio Collection, University of Virginia Library. (3) Photograph, courtesy The Art Students League of New York. (4) Holsinger Studio Collection, University of Virginia Library. (5) Holsinger Studio Collection, University of Virginia Library. (7) All rights reserved, The Metropolitan Museum of Art, The Alfred Stieglitz Collection, 1949. (8) All rights reserved, The Metropolitan Museum of Art, Purchase, Mr. and Mrs. Milton Petrie Gift, 1981. (9) Yale Collection of American Literature. (10) Collection, The Museum of Modern Art, acquired with matching funds from the Committee on Drawing and the National Endowment for the Arts. (11) Yale Collection of American Literature. (12) All rights reserved, The Metropolitan Museum of Art. Gift of Mrs. Alma Wertheim, 1928. (13) All rights reserved, The Metropolitan Museum of Art. Gift of Mrs. Alma Wertheim, 1928. (14) Bettmann. (15) Yale Collection of American Literature. (16) Yale Collection of American Literature. (17) Yale Collection of American Literature. (18) Yale Collection of American Literature. (20) Copyright © 1958, Aperture Foundation, Inc. Paul Strand Archive. (21) Yale Collection of American Literature. (22) Yale Collection of American Literature. (23) All rights reserved, The Metropolitan Museum of Art, The Alfred Stieglitz Collection, 1949. (24) UPI/Bettman.

SECOND INSERT:

(25) Photograph, Georgia Engelhard. (26) Yale Collection of American Literature. (27) Yale Collection of American Literature. (28) UPI/Bettmann. (29) UPI/Bettmann. (30) AP/Wide World Photos (31) Bettmann. (32) Courtesy of the Trustees of the Ansel Adams Publishing Rights Trust. (33) Collection of

About the Author

JEFFREY HOGREFE is a former arts columnist for the *Washington Post,* as well as a contributor to *Vogue, New York* magazine, *Esquire,* and *Vanity Fair.* He is the author of *Wholly Unacceptable: The Bitter Battle for Sotheby's.* Hogrefe lives in New York.